THE FLOWERING OF

AMERICAN FOLK ART

1776-1876

The Flowering of
AMERICAN

FOLK ART
1776-1876

Jean Lipman
and
Alice Winchester

PHILADELPHIA, PENNSYLVANIA
IN COOPERATION WITH
THE WHITNEY MUSEUM OF AMERICAN ART

Dedicated to Edgar William and Bernice Chrysler Garbisch,
Bertram K. and Nina Fletcher Little, and all the other
collectors who pioneered in making this subject
an important chapter in the history
of American art

This book was in work for a year in a special office—a temporary folk-art department—in the Whitney Museum. The project involved, besides the editorial team and the Viking group which produced the book, the consultants listed below. The advice of other specialists in various branches of the folk-art field is credited in the Acknowledgments.

JEAN LIPMAN, ALICE WINCHESTER

Assistant: Margaret Aspinwall • Consultants: Mary Allis, Adele Earnest, Herbert W. Hemphill, Jr., Gerald Kornblau, Nina Fletcher Little, Cyril I. Nelson, Peter H. Tillou • Editorial Consultant: Ruth Wolfe • Viking Editor: Barbara Burn

The publication of the book was the occasion for a major traveling exhibition based on its content: at the Whitney Museum of American Art, New York, February 1—March 24, 1974; at the Virginia Museum of Fine Arts, Richmond, April 22—June 2; at the Fine Arts Museums of San Francisco: M. H. de Young Memorial Museum, San Francisco, June 24—September 15. The exhibition was sponsored by Philip Morris Incorporated. Alice Winchester acted as Curator, and Marcel Breuer designed the installation.

John I. H. Baur, Director of the Whitney Museum, served as consultant and director of the book and exhibition.

This edition published by Courage Books, an imprint of Running Press Book Publishers.

Canadian representatives: General Publishing Co., Ltd., 30 Lesmill Road, Don Mills, Ontario M3B 2T6.
International representatives: Worldwide Media Services, Inc., 115 East 23rd Street, New York, NY 10010.
This book may not be reproduced in whole or in part in any form
or by any means electronic or mechanical, including photocopying,
recording, or by any information storage and retrieval system
now known or hereafter invented, without written permission
from the publisher.

9 8 7 6 5 4 3 2 1
The digit on the right indicates the number of this printing.
Printed in Hong Kong.
This book can be ordered by mail from the publisher. Please include $2.00 postage and handling for each copy. *But try your bookstore first!*

an imprint of
Running Press Book Publishers, 125 South 22nd Street, Philadelphia, Pennsylvania 19103.

CONTENTS

PREFACE

The signing of the Declaration of Independence in 1776 also signaled the beginning of a new independence for American art. The seeds of the native folk tradition, planted with the founding of the American colonies in the seventeenth century, sprouted and throve all along the eastern seaboard from the last quarter of the eighteenth century through the first three quarters of the nineteenth. Folk art was a prime product of the new American democracy, strongly representative of the spirit of the country. By the time of the Centennial this art had reached its peak; the machine age marked the start of its decline, despite some reseeding and blossoming through the late-nineteenth and twentieth centuries.

No single stylistic term, such as primitive, pioneer, naïve, natural, provincial, self-taught, amateur, is a satisfactory label for the work we present here as folk art, but collectively they suggest some common denominators: independence from cosmopolitan, academic traditions; lack of formal training, which made way for interest in design rather than optical realism; a simple and unpretentious rather than sophisticated approach, originating more typically in rural than urban places and from craft rather than fine-art traditions.

The decorative and utilitarian functions and styles of folk art are closely interwoven. It is interesting to note relationships between, for instance, a watercolor still life and stenciled details on a plaster wall and on a bedspread and a tablecloth (Nos. 123, 277, 396, and 405); a Shaker drawing and an appliqué quilt (Nos. 107 and 387); a fractur and a gravestone carving (Nos. 144 and 161); an ink portrait and a wooden tailor's sign (Nos. 26 and 211); and a watercolor portrait and an inn sign (Nos. 46 and 299).

The relationship between some folk art and twentieth-century art is equally striking and has had a good deal to do with the steadily increasing appreciation of folk art. In the twenties and thirties, artists, sensing an affinity with their own work, began to collect this material; prominent among them were Elie Nadelman, Robert Laurent and William Zorach. There are also provocative parallels between the work of folk artists and artists who came to prominence in the mid-century decades. One can see in these pages, for instance, a penmanship drawing reminiscent of one by Saul Steinberg (No. 135); a woolwinder that looks like the prototype for a sculpture by H. C. Westermann (No. 356); a chest decorated with sponging that is astonishingly similar to abstract expressionist painting (No. 315); a valentine that looks as if Jim Dine had designed it (No. 129); an Amish quilt pieced the way the "stripe painters" paint (No. 401), another quilt that looks like an op canvas by Larry Poons (No. 384), and one with a repeat pattern of houses arranged like Andy Warhol's rows of Campbell's soup cans (No. 398). Such specific relationships are coincidental, but they exist because of certain common attitudes and achievements: both groups of artists, at their best, developed bold personal styles with uninhibited inventiveness and achieved coherent, compelling results.

In this book we show what we consider outstanding examples of American folk art in the century of its prime. Although we didn't try for complete coverage of subjects, periods, media, or even name artists, we found, finally, that nothing basic to the history of the subject has been omitted and that the examples illustrate the full range of life in America in the late eighteenth and nineteenth centuries—the people at home, at sea, at war, in prison, at church; and their towns, streets, taverns, barns, schools, as well as their household furnishings and decorations.

The process of selection was similar to that of the *Guide Michelin*, where, from thousands of restaurants and hotels in France, a small number is listed for special quality. Our project began with the scanning of thousands of ex-

amples of folk art owned by institutions, collectors and dealers. Many of these we knew and quite a number have been published, but many were newly rediscovered and photographed for us during our year's treasure hunt; our final choices were made from about eight hundred photographs and color transparencies. The examples that we liked best are shown in this book and were invited for the three-museum exhibition based on its content. (A few that had changed ownership and could not be located are reproduced under the names of former owners; we hope publication will bring them to light.) We are aware that there will be disagreement with some of our inclusions and, more, with our omissions. To permit students and collectors to scrutinize our choice, the semifinal photo file and the research file for the entire project have been microfilmed by the Archives of American Art (a branch of the Smithsonian Institution) and duplicated for its five regional offices.

The fact that almost any piece we feature could reasonably be replaced by one or many others is gratifying rather than disturbing; the body of American folk art is rich beyond belief. Our final selection is personal, of course: it is actually a collection in print, and the taste of collectors is always apparent. But it is also based on the group opinion—a real editorial "we"—of experts who contributed time and knowledge to the project. There was a surprising (or not surprising, perhaps) agreement among our volunteer jurors. The qualities that came through consistently with every piece we were enthusiastic about, from tiny boxes to monumental sculpture—qualities that originated, of course, with the artist—were, we agreed, a sense of personal commitment to the work and of pleasure, even excitement, in carrying it out in a fresh, free way.

Whatever revaluation is implied in this presentation is the result of the selection; it's what the book and the coordinated traveling show—a temporary collection—are all about. The weight given to various categories, as well as certain omissions, will suggest possible changes in emphasis: the interest inherent in painted furniture and quilts as opposed to tinware and hooked rugs, for instance; the importance of the nineteenth century versus the eighteenth for the most creative achievement; the quality of recently rediscovered painters such as Jurgan Frederick Huge, Ammi Phillips, Jacob Maentel and Sheldon Peck, as against the better-known Thomas Chambers, Joseph Stock and William Prior.

This is the first publication and exhibition to survey the entire range of American folk art, and it is interesting to note that the very first exhibition in this field was organized by Juliana Force, director of the Whitney Studio Club (the progenitor of the Whitney Museum) exactly fifty years ago. Mrs. Force, the first director of the Whitney Museum, was a pioneer collector of folk art, and we were pleased to discover that a group of animal toys we had selected (No. 227) came from her collection. Her 1924 folk-art exhibition catalogue, incidentally, was simply titled *Early American Art*. She evidently didn't wish to stress distinctions between the work of unsophisticated limners and carvers and that of formal painters and sculptors, or, indeed, between craft and fine arts; and she obviously did not believe that the product of the folk artists was a minor achievement.

In 1942 and again in 1966, in my two books on American folk painting, I expressed the opinion, "radical though this may seem," that a number of gifted folk artists arrived at a power and originality and beauty that were not surpassed by the greatest of the academic painters. I have never changed my mind and am convinced that the entire field of activity of the folk artists was absolutely not, as has often been said, a charming postscript. I believe it was a central contribution to the mainstream of American culture in the formative years of our democracy.

—JEAN LIPMAN

INTRODUCTION

American folk art was "discovered" in the 1920s, and the first exhibition devoted to it was held in 1924 at the Whitney Studio Club in New York City. The Studio Club, established by Gertrude Vanderbilt Whitney in 1918 as an informal center for artists, had grown out of the Friends of the Young Artists which Mrs. Whitney had formed three years earlier, and from the Studio Club in turn grew the Whitney Museum of American Art, which was founded in 1930. There is a beautiful coincidence in the fact that a major exhibition of American folk art is presented by the Whitney Museum just fifty years later.

Thousands of examples of American folk art have been found in these fifty years, a great deal of research has been done regarding them and the people who created them, seminars have been held and courses of study given, and a whole reference library of books, catalogues, monographs and articles has been published. This is a fitting moment to consider again the scope and character of American folk art, to review the growth of interest in it and to attempt a revaluation.

The book and the coordinated exhibition

This book and the exhibition that coincides with its publication present the finest achievement of American folk art during the century of its highest development.

So superlative a claim must be promptly followed by a few disclaimers. While everything included in the book and exhibition is considered to be of prime quality, not all the finest examples that exist are shown, by any means. And while folk art is represented in all its generally accepted categories, some aspects that may be of more than tangential or subordinate interest have been deliberately omitted. Among these is a class of utilitarian objects, such as a wooden scythe or a wrought-iron trivet, in which purely functional form has involuntarily been given decorative quality or successful design. Also omitted are the Spanish-American art of the Southwest and the distinctive art of the American Indian. While both of these are folk arts of great importance, they are separate from our subject, as they stemmed from very different traditions and flourished in different regions and periods from the folk art presented here.

A number of the objects included are shown here for the first time; others have been published and exhibited many times before and through long familiarity have come to be accepted as the "classics" of American folk art. For this is more a retrospective than an innovative showing. It is, in short, an anthology—which means, literally, a gathering of flowers: it is an ideal collection of works that are outstanding in themselves and that, brought together in this way, make a stunning bouquet of the fairest flowers of American folk art.

The emphasis here is upon the art in folk art, not the folk. That is another way of saying that the approach is esthetic rather than historical. Yet necessarily the criteria for selection are not quite those applied to academic painting or the formal decorative arts. In folk art one does not look for subtleties of composition and sophisticated organization, painterly qualities or masterly technique. But one may look for, and find, originality of concept, creativity of design, craftsmanly use of the medium, and flashes of inspiration, even genius. Folk art makes its appeal directly and intimately, even to people quite uninitiated into the mysteries of art.

This ideal collection is intended to show esthetic quality and not to give a historical survey of the century covered—yet inevitably it does that as well. "Paintings often talk to us when histories are dumb," wrote Harry B. Wehle in his introduction to the exhibition catalogue *Life in America*. "What written account of a man can convey his quality as immediately as a portrait does, and what description of a city can reveal the flavor of its streets as does a painting

with its peculiar gift of color and its faculty of presenting simultaneously all the elements of the scene? But it must be a simple painting, and it is this quality of simplicity in many American paintings that gives them especial suitability as vehicles of historic data." Wehle went on to speak of Stuart, Sully, Allston, Inness and other academic painters. "In a history of cultivated American taste these are the very men whose works would be shown, but such poets of the brush are the last to be depended upon to tell what people and things really looked like . . . for the most part we have to depend on obscure painters whose names are unfamiliar, if not indeed entirely unknown."

These obscure, anonymous painters who tell us "what people and things really looked like" were folk artists. Others, who painted walls and chairs and who carved, potted, molded and stitched, also contribute to our knowledge of the daily life of the people of this country.

What is American folk art?

In simplest terms, American folk art consists of paintings, sculpture and decorations of various kinds, characterized by an artistic innocence that distinguishes them from works of so-called fine art or the formal decorative arts. This is hardly a definition: it is necessarily an imprecise, even subjective designation. Properly speaking, folk art is a traditional, often ethnic expression which is not affected by the stylistic trends of academic art. In that sense much American folk art is not folk art at all. Indeed, the line that separates it from academic art is not always sharp and clear; there is a wide borderland in which they merge and overlap. But American folk art as we have come to understand it has its own qualities of vigor, honesty, inventiveness, imagination and a strong sense of design. While it shows imperfect technical mastery on the part of the maker, it makes effective use of color and of the pattern in form and line.

Its obvious ineptitudes and distortions give it a special charm for many people, but there are those who reject it as simply bad art. To such critics Maxim Karolik, the Russian collector who had a greater appreciation of American art than many Americans, had a positive answer: "One wonders whether, from the artistic point of view, the question of Folk Art versus Academic Art has any meaning. The question I continue to ask is whether lack of technical proficiency limits the artist's ability to express his ideas. I do not believe that it does. . . . Among the unknown painters in this country were a number of men of exceptional talent. Fortunately, they had no academic training. Because of this they sometimes lacked the ability to describe, but it certainly did not hinder their ability to express."

The main categories in which American folk art has been classified are represented in this book. The pictures, executed in oil, watercolor, ink, pastel, charcoal, pencil and stitchery, cover a wide range of subject matter: portraits, landscapes and seascapes, scenes of daily life, religious, literary and historical pieces, still life and fractur. The sculpture, in wood, metal, stone and bone, includes portraits, shipcarvings, weathervanes, shop signs, toys, decoys and certain household ornaments. Among architectural decorations are the painted overmantels, fireboards, cornices, walls and floors that once enlivened interiors, and the carving and painting that ornamented exteriors. Certain types of furniture, principally those embellished with painted decoration, and other domestic appurtenances are also treated here. As folk art has become increasingly popular in recent years, its limits have grown more and more indistinct. To some people nowadays folk art includes every sort of household, farm, trade and shop equipment or product that has an unsophisticated or "country" character. The categories we have chosen to consider, however, are those that we feel make up the core of American folk art.

Even when American folk art has been identified and defined, critics have often disagreed as to what this large, diverse body of work should be called. The term naïve, chosen by Colonel and Mrs. Edgar W. Garbisch for their important collection, is generally accepted for the paintings, in place of other descriptive words, such as primitive or pioneer. But discussions of terminology for the whole field can go on endlessly, and they have. When the magazine *Antiques* published a symposium on "What is American folk art?" in 1950, thirteen specialists offered as many different views not only of what it is but of what it should be called. Finally by common consent the term folk art has been widely if still not universally adopted, even though it may not be the most accurate or precise name. We use it here, recognizing its shortcomings but also its convenience. Perhaps it seems more suitable if we think of it as referring not to the artistic expression of a folk but simply to the unpretentious art of "the folks."

The specific dates 1776–1876, marking the period covered by this book and exhibition, have been chosen with an obvious bow to the forthcoming Bicentennial, but quite justifiably, for that century from the Declaration of Independence to the Centennial saw the greatest development of folk art in this country. Other writers have set slightly different limits to the period, and these are equally valid, though of course it did not begin or end in a single year. American folk art had its roots in the eighteenth century and even in the seventeenth; it came into flower during the early years of our nationhood; and by the last quarter of the 1800s it had begun to fade.

It is hard to speak of that century when folk art flourished without resorting to terms that have become trite—such expressions as the emergence of the individual, the era of

the common man, the dawn of the machine age. But the folk artists *were* individuals, and they were the common people of the young machine age. Many of those who painted portraits and landscapes also produced painted decorations on furniture and walls. They were carriage and sign and house painters, and jacks of other trades as well. Those we dignify by the name of sculptor were carpenters, shipwrights, stonecutters, potters, blacksmiths, tinsmiths, sailors, farmers. Many were trained craftsmen, but trained perhaps in a craft other than the one that produced their art. Some did learn something about painting or carving from established artists, but many were self-taught and learned by doing. They were not professional artists in the academic sense, but most of them made at least a part of their living from their art. And there were the amateurs —female, chiefly: girls who learned at school to stitch and draw and paint pictures, and hardworking women who brought color and pattern into their homes by making pretty coverings for beds and floors.

Such generalizations as these should not, however, obscure the individuality of the folk artists, for that is their outstanding characteristic. To cite just one example, a man about whom we are fortunate enough to know a good deal was Jonathan Fisher, who seems extraordinarily versatile and yet was not atypical. A minister by profession, he painted pictures and made drawings and cut wood engravings. He built his own house and furniture in the Maine seacoast village of Blue Hill, farmed his land, made a clock, straw hats and pumps, read Hebrew, Greek, Latin and French, devised his own shorthand, wrote books, studied mathematics and natural history, and taught school. He would undoubtedly be astonished to know he is thought of today as a folk artist.

The people for whom the folk artists worked were very like themselves. They too were the common people—tradesmen, artisans, farmers, neither rich nor poor, not the intelligentsia and the tastemakers but not ignorant or lacking in sensibility. For the most part they lived in small towns, in the country and at the seaside, working hard for their living and trying to improve it. To keep their houses from being drab, they could have their walls and floors and furniture painted in cheerful colors and gay patterns. They could have their portraits painted by local or itinerant limners and buy pictures of familiar scenes and important events. Some, with the help of art instruction books, learned to do these things themselves. Americans have always had a fondness for design and color, and from the time of the Revolution it was increasingly possible for them to satisfy it.

By the 1820s they were beginning to replace their candles with whale-oil lamps, their old pine settles with Hitchcock chairs, and their pewter plates with Staffordshire china and pressed glass. They were learning to save their own labor by means of machines. When eventually the machine invaded the field of art in the form of inventions for making pictures as well as household necessities and ornaments of many sorts, the demand for what the folk artist could provide diminished. But the old-fashioned crafts were not immediately discarded by either the artists or their customers. For long into the nineteenth century they persisted, particularly in rural regions. That is why folk art came into its full flowering then, and why we can sense the strong artisan tradition in the work of the folk artist.

Exhibitions and publications

For half a century previous to the 1920s, when folk art began to be recognized in this country, Americans had been actively collecting the useful and decorative objects made and used by their forefathers, which they called antiques. Some of these were fine silver, mahogany furniture and paintings by Copley and Stuart; some were such unassuming domestic appurtenances as slip-decorated pottery and painted pine chests and Currier & Ives prints. Occasionally, too, they picked up a redoubtable portrait of somebody's ancestor or a landscape with amusingly distorted perspective or a crisply carved eagle. These were not called folk art, and they were differentiated from other antiques only by the fact that they were not so skillfully executed. The cult of American folk art did not exist until the artists of the 1920s began seeking the roots of American art in early nonacademic work. It was they who acclaimed those lowly antiques as American folk art.

That first exhibition at the Whitney Studio Club in 1924 has been almost overlooked as the trail blazer it was, and at the time it did not cause any such furor as might well have greeted the discovery of a whole new world of American art. The show was titled "Early American Art," and the forty-five items shown consisted of paintings in oil and watercolor, pastels and a miniature portrait, paintings on glass and on velvet, a lithograph, carvings in wood and bone, a brass bootjack, a plaster cat and a pewter pitcher and sugar bowl. They were selected by the painter Henry E. Schnakenberg, and, among others, the lenders included the gallery's director, Juliana R. Force, and the artists Charles Sheeler, Alexander Brook, Yasuo Kuniyoshi, Peggy Bacon and Charles Demuth. This new interest on their part reflected a similar trend among contemporary European painters who were turning for inspiration to the traditional folk arts of their own countries. The American artists had discovered that here, too, the eighteenth and nineteenth centuries had produced a native art that was simple, straightforward, unsophisticated and of high esthetic value, and they felt in it a kinship to their own work.

Interest in this American folk art spread from the artists to collectors and was fostered by further exhibitions in

museums and dealers' galleries in New York and Boston, in Newark, Cambridge, Buffalo and Detroit. One of the most memorable of the early exhibitions was "American Folk Art/The Art of the Common Man in America 1750–1900," which was held in 1932 at the Museum of Modern Art in New York City. It was directed by Holger Cahill, and the catalogue still stands as an indispensable reference on American folk art. The show presented 175 items of painting and sculpture, including oils, pastels, watercolors, paintings on velvet and on glass, sculpture in wood and in metal, and plaster ornaments. It went far toward establishing folk art as an important American expression, and also toward popularizing the name now generally used for what is still perhaps best understood as the art of the common man.

"The conjunction of the Museum of Modern Art and American naïve and artisan art of the eighteenth and nineteenth centuries is significant," E. P. Richardson wrote in his *Painting in America*. "The date of that exhibition, 1932, may be taken as marking the triumph of a new taste and a new way of seeing. Stylized design and emotional (rather than intellectual or literary) expression were now what was expected and admired not only by artists but by the most discerning and sympathetic members of their audience." And as living artists and their public turned toward abstraction and the other innovations of the twentieth century, the new taste and the new way of seeing turned another part of the public toward the nonacademic art of earlier centuries, which made the same kind of esthetic appeal but with overtones too of historical interest, nostalgia and often humor.

The first serious writing on American folk art had appeared in the early 1920s in two magazines, *Art in America*, edited by Frederic Fairchild Sherman until 1940 and by Jean Lipman from then until 1971; and *Antiques*, edited by Homer Eaton Keyes from 1922 to 1938 and thereafter until 1972 by me. Each of the two magazines took up the subject—though not at first the name—of American folk art in 1922, and from then on both published voluminously about it. Scores of folk artists were recorded, their lives recounted and their works illustrated; theories and opinions and interpretations were aired and discussed at length. From the mid-1920s on, articles on folk painting and sculpture appeared also in other art periodicals, and there were numerous articles and a few books on such specialized aspects of folk art as wall and floor painting, stenciling on walls and furniture, and Pennsylvania German pottery, fractur and ironwork.

But the first books devoted to American folk art as such were concerned primarily or exclusively with painting. In 1941 *Some American Primitives* by Clara Endicott Sears appeared, discussing and illustrating paintings in the author's collection. In 1942 Jean Lipman's *American Primitive Painting* was published, providing a critical definition of its subject and establishing the basic categories of which it is made up—portraiture, landscape, genre, "ladies' work," architectural decoration. In the same year Carl W. Drepperd's *American Pioneer Arts & Artists* supplemented his view of folk painting and carving with a discussion of the art instruction books available to American folk artists. Two years later Mrs. Lipman's second book, *American Folk Art in Wood, Metal and Stone*, made a thorough and analytical study of American folk sculpture comparable to that of painting in her previous volume.

Since then books on American folk art have appeared with increasing frequency, and the subject has been treated in general books on art and in all sorts of periodicals besides art magazines. There are factual and critical discussions of folk art as a whole and specialized works on single categories such as weathervanes, figureheads, quilts, tinware, and on individual folk artists such as Winthrop Chandler, Rufus Porter, Ammi Phillips. There are catalogues of exhibitions and of permanent collections. Articles on the charms of folk art and the joys and hazards of collecting it appear constantly in popular magazines and newspapers, and there is even a book on how to make your own folk art. The list of publications in our Authors' Bookshelf names those we have consulted most frequently and most fruitfully, but it does not pretend to be a complete bibliography on the subject, which could well fill another hundred pages.

Collectors and collections

The major collections of American folk art that may be seen in museums today have almost all grown out of private collections, some of which were begun as early as the 1920s. One of the first, and to this day one of the finest, was formed by Mrs. John D. Rockefeller, Jr. Part of it was given to the Museum of Modern Art in New York City and to the Metropolitan Museum of Art; then in 1957 the entire Abby Aldrich Rockefeller Folk Art Collection was reassembled and housed in a building of its own in Williamsburg, Virginia. It has continued to grow, enriched by frequent acquisitions, among them the private collection formed by J. Stuart Halladay and Herrel George Thomas.

Juliana Force was another early collector. Her enthusiasm for folk art led her to form a collection of her own, which was later sold at auction. In the 1920s Mrs. J. Watson Webb began assembling collections of folk art, especially weathervanes and figureheads, quilts and paintings. These she later installed in the Shelburne Museum, which she and her husband founded at Shelburne, Vermont. She also acquired for the museum the comprehensive collection of wildfowl decoys brought together by the architect Joel D. Barber. Henry F. du Pont, inspired by Mrs. Webb's collection,

began also in the 1920s to collect folk art of all kinds. It is exhibited along with the other American decorative arts that make up the rich and varied holdings of the Winterthur Museum which he founded at Winterthur, Delaware.

The early collectors were, of course, dependent on the early dealers, of whom several specialized in folk art. Names that come readily to mind as pioneers in this field include Isabel Carleton Wilde, Valentine Dudensing, Harry Shaw Newman, and Harry Stone. The most influential of them all was Edith Gregor Halpert, owner of the Downtown Gallery in New York City. It was she who interested Mrs. Rockefeller in collecting American folk art, and she played a large part in forming Mrs. Webb's collection. In addition, she assembled a distinguished collection of her own, which is now dispersed.

Among the collectors of the twenties were Mr. and Mrs. Elie Nadelman, who created a folk-art museum at Riverdale-on-Hudson, New York, and held some of the first public exhibitions there. Folk paintings and sculpture from their collection are now at the New-York Historical Society in New York City and the New York State Historical Association in Cooperstown.

The collection brought together by Jean and Howard Lipman, consisting of about four hundred paintings and sculptures, was acquired in 1950 by Stephen C. Clark for the New York State Historical Association. It included a few paintings from the Horace W. Davis collection, which the Lipmans acquired in its entirety for the sake of these few paintings; they subsequently sold the rest at auction. The Association at Cooperstown has continued to make frequent additions to its folk-art holdings, among them the large collection of Mr. and Mrs. William J. Gunn.

Old Sturbridge Village presents in its various buildings at Sturbridge, Massachusetts, the folk-art collection begun in the 1920s by the brothers Albert B. Wells and J. Cheney Wells. The significant collection of the Henry Ford Museum in Dearborn, Michigan, was begun at about the same time by Henry Ford. The Smithsonian Institution in Washington, D. C., exhibits notable folk art, of which the largest single group was formerly the private collection of Eleanor and Mabel Van Alstyne, acquired by the Smithsonian as recently as 1965.

The National Gallery of Art in Washington has been the principal recipient of the Edgar William and Bernice Chrysler Garbisch collection of American naïve paintings, the largest assemblage of such pictures ever brought together; some of its more than two thousand items have been presented to the Metropolitan Museum of Art and some are dispersed among other museums, including the Whitney.

The Metropolitan's outstanding collection of many kinds of folk art, distributed through the American Wing and the painting galleries, has benefited greatly over the years from the perspicacity and generosity of private collectors. In its library is the specialized collection assembled by Carl W. Drepperd, consisting of American and English art instruction books published from the mid-1700s to the Civil War.

The M. and M. Karolik collections of American paintings, watercolors, drawings and sculpture at the Museum of Fine Arts, Boston, while not limited to folk art, include many distinguished examples. They were assembled by Maxim Karolik expressly for the museum, and when they were complete, he continued to acquire paintings for a collection of his own, most of which is now also in the museum.

Several of these museums hold loan exhibitions in addition to showing their permanent collections, and they sponsor lectures and seminars on folk art. The New York State Historical Association has been conspicuous in such educational activities: for twenty-five years it has consistently devoted programs to folk art in its annual Seminars on American Culture, and since 1964 it has cooperated with the State University of New York in a graduate program on American folk culture leading to a Master of Arts degree.

The Museum of American Folk Art in New York City, while basically an exhibiting museum, has a small permanent collection, and a number of other institutions have folk-art collections of a general nature. A good many also have specialized topical or regional collections, such as the Mariners Museum at Newport News, Virginia, and the Whaling Museum at New Bedford, Massachusetts, both rich in shipcarvings, marine paintings and scrimshaw. The Philadelphia Museum of Art has important holdings of Pennsylvania German arts of which a large part was the private collection of Titus C. Geesey; the Schwenkfelder Museum in Pennsburg, Pennsylvania, also has noteworthy Pennsylvania German arts. A number of local historical societies, such as the Connecticut Historical Society, have significant regional collections.

These collections together, and some of them individually, cover the whole range of American folk art as it is thought of today—paintings, sculpture and a great variety of architectural decorations and domestic furnishings. Besides there are innumerable private and dealers' collections, small and large, some including works familiar through publication and exhibition, some quite unknown.

"The unconventional side of the American tradition"

Holger Cahill's discussions of American folk art in exhibition catalogues of forty years ago are as sound and perceptive as anything that has been written since. The first scholar to interest himself actively in American folk art, Cahill brought to it a broad background in the arts and an unusually thorough knowledge of all the American

arts and crafts. He became national director of the Index of American Design, that remarkable survey of this country's arts and skills, and he made it one of the most successful and significant of the WPA projects of the Depression years.

With regard to folk painting, he did, to be sure, share certain misconceptions commonly held at the time, such as the unfounded notion that folk painters worked up stock figures and backgrounds for their portraits during the winter months and then traveled about the country in summer painting in the faces from life when they got commissions. He also believed that virtually all American folk artists were anonymous (as indeed they were at the time), and that they were all self-taught and itinerant. In the years since then research on the part of other scholars has revised this simplistic conception and supplied much missing information: it has revealed the names of a long list of American folk artists and has made possible the identification of many of their works and the confident attribution of many more. We have a much clearer idea of what sort of people our folk artists were, and of how and where and when they worked—though most of them still remain shadowy, nameless figures. But Cahill had an understanding of the scope and quality of folk art, of its importance in our art history and our social history, which set standards for all who have approached the subject since, and even in the light of what we like to think of as our present greater knowledge it would be hard to improve on his analysis and critique.

American folk art, he wrote in the 1932 exhibition catalogue of the Museum of Modern Art, is "the unconventional side of the American tradition in the fine arts. . . . It is a varied art, influenced from diverse sources, often frankly derivative, often fresh and original, and at its best an honest and straightforward expression of the spirit of a people. This work gives a living quality to the story of American beginnings in the arts, and is a chapter . . . in the social history of this country."

Again and again Cahill emphasized that folk art is "an overflow from the crafts," that its makers perpetuated an ancient tradition of training in the crafts. "It is the expression of the common people, made by them and intended for their use and enjoyment. . . . While the folk art tradition has had little to do with the development of American professional art, yet the main stream of American art was fed by the crafts during the seventeenth, eighteenth and early nineteenth centuries."

If the folk-art tradition has had little to do with the development of American professional art, the reverse is not true. Folk art is far from being a mere imitation or offshoot of academic art, but it was strongly influenced by academic art and reflects its changing tastes and styles. To quote Cahill again, "Many of the makers of American folk art had seen European paintings and sculptures, or copies of them made by artists who had been in Europe. Most of them had seen pictures of works of art in books. They borrowed freely, but borrowing has not been disdained by the greatest masters, in fact one of the signs of a vital art is the ability to assimilate the work of others."

It has often been said that American folk art flourished principally in the northeastern part of the country—New England, New York State and Pennsylvania—with a visible overflow into the Ohio Valley—Ohio, Indiana and Kentucky—and a few sporadic manifestations in parts of the South. Certainly more examples have been discovered in the Northeast than elsewhere, and more folk artists there have been identified. It is a region where craft traditions were strong from earliest colonial days on. It is also the region where latter-day interest in folk art has mainly been concentrated, though whether as an effect or as a cause may be debatable—that is, whether the profusion of folk art stimulated the interest or whether the interest focused on the region fostered discovery. Collectors and dealers have fairly combed New England and Pennsylvania for fifty years, but the search for objects and for information has been far less thorough in the Midwest, South and West.

Now it is increasing, and finds are multiplying. An exhibition titled "The Arts and Crafts of the Old Northwest Territory" held at the Henry Ford Museum in 1964 presented unsuspected examples of interest and quality not only from the Ohio Valley but also from Illinois, Michigan, Wisconsin and Minnesota. Current research in western Virginia is unearthing hitherto unknown painted furniture of local origin. Recent investigation in Tennessee has brought out native folk art in the form of paintings, carvings, musical instruments, pottery and furniture. At Old Salem in North Carolina are little-known paintings, pottery and ironwork created by the Moravians of the early settlement there. The fine and decorative arts of New Orleans and the lower Mississippi Valley are being reexamined, and among them is found folk art of a distinctly local character. Discoveries made in California include such folk art as carved shop signs and painted views of the region that reveal the New England background of the nineteenth-century settlers there, just as a few frame houses that could have been transplanted from Massachusetts or Connecticut survive along with early adobes.

Naturally, the western regions that were not settled until the mid-1800s and later, when the industrial age had become established, did not produce folk art in the quantity or quality to be found in the older East. But it seems extremely likely that, as interest continues to grow, more and more folk art related to that of the Northeast, but with its own regional accent, will be discovered in the South, the Midwest, the Southwest and the Far West.

American folk art makes a strong emotional appeal to

many people, and to some a passionately patriotic appeal. They claim it as a peculiarly and exclusively American thing, expressing our great native qualities of originality, inventiveness and independence. In the Newark Museum's exhibition catalogue of 1930 Cahill wrote, "Some collectors have seen in these primitives an indigenous American growth, but even this simple art cannot be called altogether indigenous. Here as elsewhere, the European influence is at the heart of the native American development. Certain influences, Dutch or English mainly, are definitely recognizable. Most of these artists had seen paintings of one kind or another, or had seen engravings in books. It is evident that they tried to approximate effects achieved by academic artists whose paintings they had seen in the original or in reproduction."

Not only does American folk art show European influences—and Oriental too, as Cahill also brought out—but its development is paralleled in many other countries. Most American folk art does indeed have a distinctively American character, but the origin of many examples is disputed, and some once accepted as typically American are now known to have come from somewhere else. We have learned that most European countries have their own provincial art—informal, naïve, nonacademic—which is quite comparable to ours. Portraits and landscapes very like some of ours hang, misprized or forgotten, in back halls in English country houses and Scottish castles. France, Holland, Germany, the Scandinavian countries, all have their own versions of eighteenth- and nineteenth-century folk art, which are not the same thing as the peasant art often associated with the name.

Nearer home, Canada has folk art very like ours, in the English Maritimes and Ontario as well as in the French province of Quebec. Investigation in Mexico and other Latin American countries has uncovered provincial versions of Spanish work in paintings and carvings and certain decorative arts which, while not easily confused with the folk art of our Northeast, are certainly comparable in vigor and originality. Quite similar work has been found in New Orleans, whose culture is close to that of Latin America as well as of France, and in the older parts of our Southwest.

The interest in American folk art has increased steadily for fifty years, and it is keener and more widespread today than ever before. The main emphasis continues to be on the painting and sculpture, while minor fashions come and go in this art as in any other: now and then some specific category, such as quilts or painted furniture, enjoys a burst of popularity sparked by an exhibition or a new book. Each discovery helps to expand the whole field and brings out fascinating relationships between one aspect and another. Research continues to give identity to anonymous folk artists, and it tends increasingly not merely to supply names and dates but to interpret the social setting and the intellectual climate in which American folk art flowered.

The artisan tradition discernible in all folk art is perhaps its chief unifying characteristic, but it is the eye of the artist directing the hand of the craftsman that gives it esthetic validity. The works gathered together here demonstrate the heights American folk art could achieve in all its amazingly varied forms. They represent the "unconventional side of the American tradition in the fine arts," yet they are an integral part of that tradition, as they have always been an integral part of American life.

—ALICE WINCHESTER

NOTE ABOUT CAPTIONS

Author: Artist is unknown where no name appears.
Medium: For the paintings listed, oil is on canvas, and watercolor and ink on paper, unless otherwise specified.
Dimensions: Height precedes width.
Dating: Material covers hundred-year period datable as c. 1775– c. 1875. Quarter centuries allow maximum leeway (c. 1825); decades and half decades suggest closer approximation (c. 1840, c. 1845); other numbers indicate specific evidence for more exact date (c. 1832); actual dates indicate that the object is dated or documented (1863).
Provenance: Specific places are listed when documented; otherwise origins are located as closely as possible.

PICTURES:
PAINTED, DRAWN
AND STITCHED

PORTRAITS

What we today call folk art was, indeed, art of, by and for the American people—ordinary, everyday "folks"—who, with increasing prosperity and leisure, created a market for art of all kinds, and especially for portraits. Citizens of prosperous, essentially middle-class republics—whether ancient Romans, seventeenth-century Dutch burghers, or nineteenth-century Americans—have always shown a marked predilection for portraiture. The impulse to record and preserve for posterity likenesses of oneself and one's family is an expression of self-confidence and healthy self-satisfaction. In increasing numbers America produced just such people, and the artists who could meet their demands.

The earliest portraits shown here come, not surprisingly, from New England—especially Connecticut and Massachusetts—for this was a wealthy and populous region and the center of a strong craft tradition. Within a few decades after Independence the population was pushing westward, and portrait painters could be found at work in western New York, Ohio, Kentucky, Illinois and Missouri. Midway through its first century as a nation, the United States's population had increased roughly five times, and eleven new states had been added to the original thirteen. During these years the demand for portraits grew and grew, eventually to be satisfied by the camera. In 1839 the daguerreotype was introduced to America, ushering in the age of photography, and within a generation the new invention put an end to the popularity of painted portraits. Once again an original portrait became a luxury, commissioned by the wealthy and executed by the professional.

But in the heyday of portrait painting—from the late eighteenth century until the 1850s—anyone with a modicum of artistic ability could become a limner, as such a portraitist was called. Local craftsmen—sign, coach and house

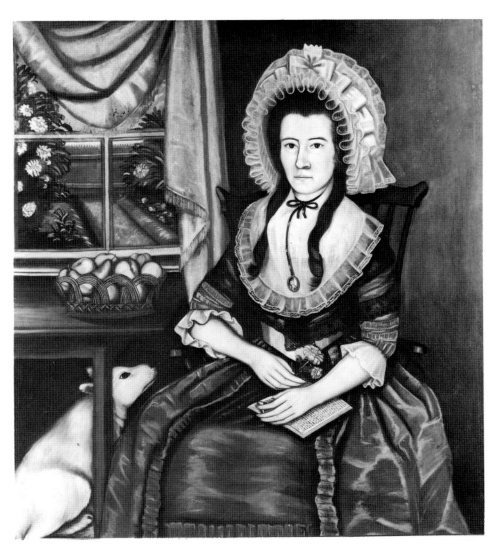

1. *Elizabeth Davis* (Mrs. Hezekiah Beardsley), oil, 45 x 43", 1788–90, Connecticut. Companion portrait, Hezekiah Beardsley. Fourteen portraits attributed to this artist have been exhibited and published as "The Beardsley Limner." Yale University Art Gallery, New Haven, Conn.

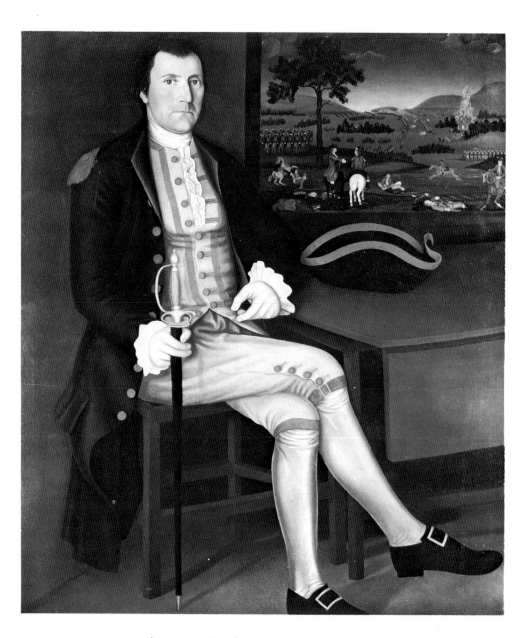

painters—began to paint portraits as a profitable sideline; sometimes a mature housewife or a talented young man or woman who began by sketching family members gained a local reputation and was besieged with requests for portraits; artists found it worth their while to pack their paints, canvases and brushes and to travel the countryside, often combining house decorating with portrait painting. These artists drew their knowledge of materials and techniques from the craft rather than the fine-arts tradition, and able craftsmen they often were, grinding their own pigments, mixing the paints, stretching and sizing canvases and varnishing the finished work in such a way that many paintings survive in excellent condition. Skilled though they were, few had any formal training. Erastus Salisbury Field spent a few weeks in the studio of one of America's best-known academic painters, Samuel F. B. Morse, but such an opportunity was not open to most. The great majority of America's folk painters were self-taught and lived out their lives in rural areas where they had little exposure to the work of other artists.

Who were these artists, and what kind of work did they produce? Even a cursory examination of the portraits reproduced here and the biographies of their painters will suggest how difficult it is to generalize. There are innumerable formal oil portraits of individuals and of family groups. Self-portraits are rare, but a Maine preacher, the Reverend Jonathan Fisher, is known to have made several of his stern countenance. While work in watercolor tends to be more casual, in the hands of an artist such as Jacob Maentel it became a vehicle for impressive full-figure portraits. The earliest portraits presented here, by such Connecticut artists as Winthrop Chandler and John Brewster, Jr., are strongly related to the English tradition, as one might expect of works by men whose formative years preceded the Revolution. Typically, the subject is shown full-face or with head slightly turned, seated amid identifying symbols or attributes—a sword for a military man, a fan or flower for a lady, a doll, hobbyhorse or other favorite toy for a child. In the background there is usually elaborate drapery or a detailed scene recalling the subject's personal history or surroundings. While many painters continued to observe these conventions, especially the use of personal symbols, there was a marked tendency toward simplification and stylization of the background. The increased number of profiles reflects the influence of a cheap and very popular form of portraiture, silhouetted figures and heads snipped from black paper with scissors and mounted on a light background. It is quite possible that James Sanford Ellsworth, who specialized in miniature profile portraits, began as a silhouette cutter but improved on this rather impersonal form by exchanging scissors for watercolors and meticulously recording his subjects' features and costumes in lifelike color. Ellsworth was a typical itinerant

artist; from his native Connecticut he roamed as far away as Ohio and Kentucky looking for subjects. Ellsworth developed a distinctive formula in which a rigidly posed body floats in a cloudlike chair, while the profiled face is silhouetted against a stylized clover-leaf foil. Using the same device for most of his portraits, he was able to work quickly, concentrating his attention on catching a good likeness of the individual and finishing the rest of the painting in his standardized manner.

Ellsworth and many itinerants like him were professionals in that they painted for profit, as other men worked at a trade. Typical of their down-to-earth approach was William Matthew Prior, a Maine itinerant who set up shop in Boston and found his "Painting Garret" so successful that he employed his in-laws to help with the pictures. The Prior group turned out paintings to suit the pocketbook and taste of its patrons: there were quite finished portraits at relatively high prices, but, as one of his advertisements stated, "Persons wishing a flat picture can have a likeness without shade or shadow at one-quarter price." One of Prior's "flat" pictures still shows the price, penciled on the back: $2.17.

Not all folk artists had to travel to find work. Winthrop Chandler spent his entire career in or near his native Woodstock, Connecticut, finding a few portrait commissions among relatives and neighbors while plying the trade of house decorator. Ammi Phillips never strayed beyond the New York-Connecticut-Massachusetts region known in the early nineteenth century as the Border Country. Within that area Phillips literally worked his way through entire families, painting the portraits of one household and the in-laws and then moving on to another branch of the same family in a neighboring town. Phillips's career spanned fifty years, and the surviving paintings number more than two hundred. Erastus Salisbury Field had an even longer career. He became an itinerant portraitist while still in his teens, traveling about his native Massachusetts, as well as Connecticut and eastern New York. In the 1840s he moved to New York City to study photography. Ten years later he returned to the Connecticut Valley and for a while operated a daguerreotype studio. Living on a small farm called Plumtrees, Field never stopped painting, but portrait work soon dwindled. Increasingly, he turned to the Bible and history for subjects that fired his imagination even though they had little popular appeal. He died at the age of ninety-five, in the first year of the twentieth century. Field's career is an interesting study in the changing relationship of the folk artist and society: the man who had begun as a successful itinerant, satisfying the demands of simple country people for portraits of themselves and their families, found a potent rival in the camera, which provided quicker, cheaper and—to literal-minded subjects—"better" likenesses. Left behind by

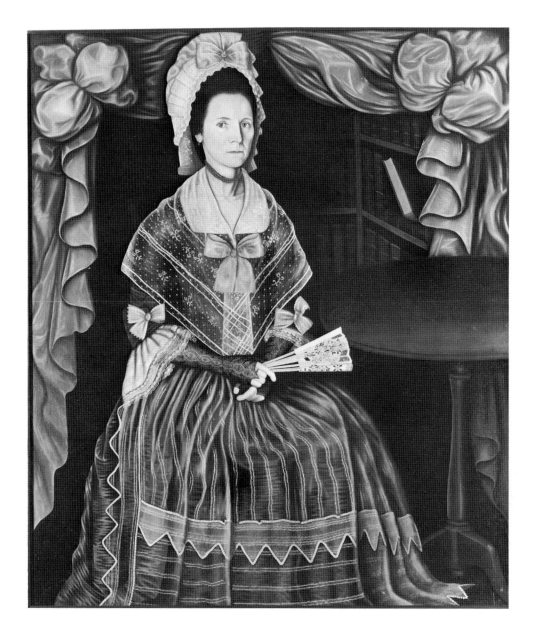

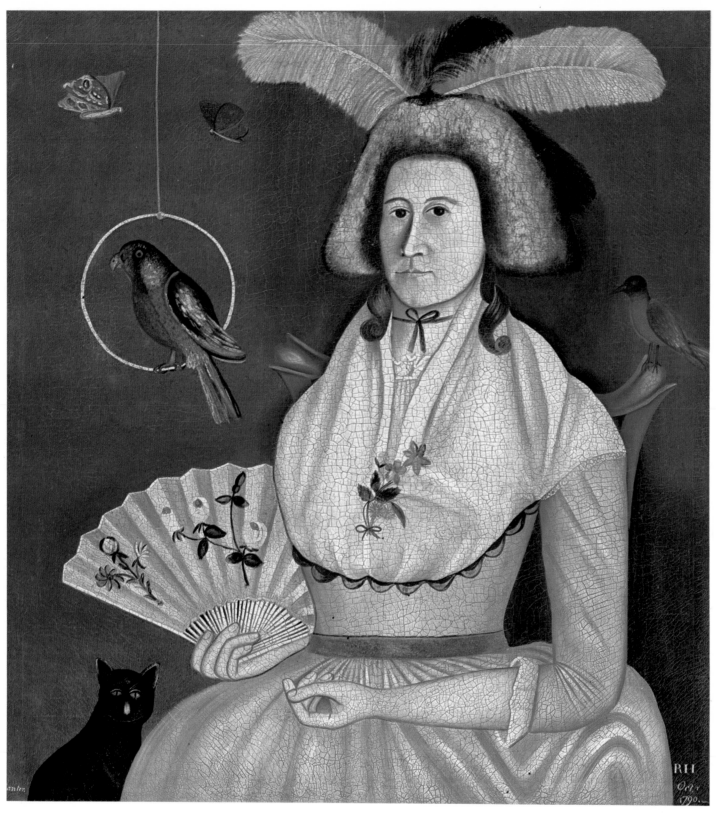

4. Rufus Hathaway, *Lady with Her Pets*, oil, 34¼ x 32″, 1790, Massachusetts. Inscribed "R H Octʳ 1790." and "Canter." Metropolitan Museum of Art, New York; Gift of Edgar William and Bernice Chrysler Garbisch.

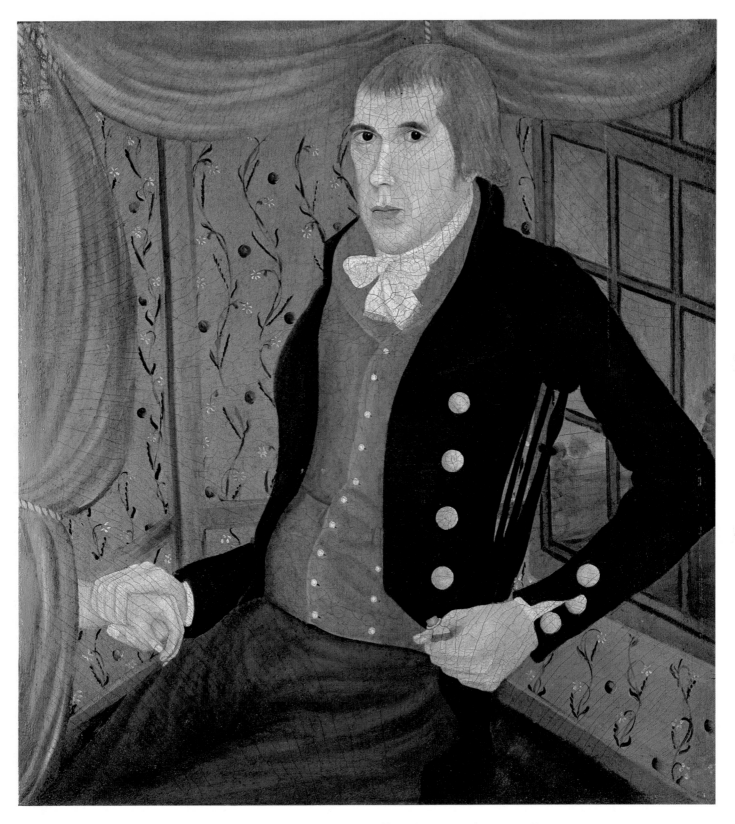

5. *Dr. Philomen Tracy*, oil, 31 x 29¼″, c. 1780, Massachusetts. Collection of Edgar William and Bernice Chrysler Garbisch.

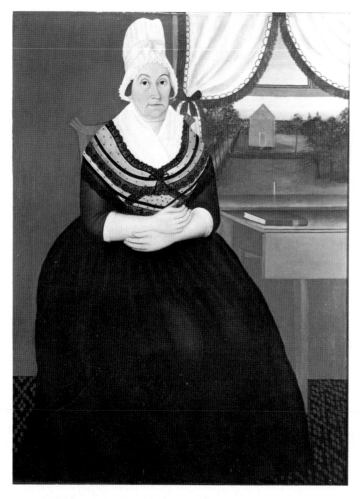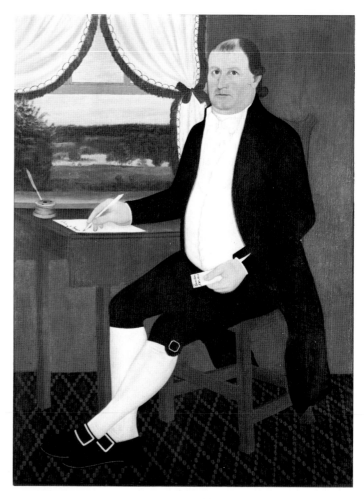

6 and 7. John Brewster, Jr., *Mr. and Mrs. James Eldredge*, oil, each 54 x 40½", 1795, Brooklyn, Conn. Eldredge's portrait dated "July 5ᵗʰ 1795." Card in his left hand, inscribed "Execution £10.0.0," may represent the artist's bill. On loan to the Connecticut Historical Society, Hartford, from Mrs. Phyllis Brown French, Mrs. Charles A. Morss, Mrs. John Hoar, Mrs. Franklin Quimby Brown, Jr. and Dudley Bradstreet Williams Brown.

technology and popular taste, Field ended as a typical twentieth-century primitive painter, who is often an aged eccentric, isolated from the mainstream of both life and art.

These case histories of representative folk artists would not be complete without the women. Eunice Pinney and Ruth Henshaw Bascom were both housewives of uncommon artistic abilities. In keeping with the traditional feminine role of their day, neither woman pursued painting as a career or took money for her work. They both had husbands and families, and apparently took up painting in their middle years. Mrs. Bascom did only pastel portraits, while Mrs. Pinney's watercolor subjects were astonishingly

varied, ranging from portraits to landscapes and scenes from the Bible, literature and everyday life. Deborah Goldsmith presents a different story. To support her aged and impoverished parents, she became a genteel itinerant, traveling from one house to the next in the vicinity of Hamilton, New York, and painting portraits for each family. When business among their immediate relatives and social connections was exhausted, she moved on to other homes. Marriage—to the son of one of the families she painted—put an end to Deborah's travels, and her artistic career was cut off by her premature death at the age of twenty-seven.

For every named folk painter, there are many who must be labeled anonymous, although in various cases a group of works is recognizable as by the same unidentified hand; distinctive, individual styles are as personal as signatures. An artist as remarkable as Ammi Phillips was not "rediscovered" until 1960, much of his work having been identified as that of a painter known only as the "Kent limner." Diligent research, such as that which finally reconstructed Phillips's career, will surely uncover the names and histories of other important folk artists.

However different their personal circumstances and individual solutions to esthetic problems, these artists were alike in their approach to their work. Lacking academic training, they nevertheless aimed to approximate, in paint, the visible appearance of things. Although the folk artist might be able to produce a good likeness—or at least one that pleased his patrons—he usually found detailed anatomy and linear perspective beyond his technical abilities. As a result, his paintings took on a decorative quality that today we call abstract. The limitations of his technique opened the way for a compensating emphasis on pure design, which is the distinguishing quality of American folk painting.

In our twentieth-century view, these artists were fortunate in their remoteness from the traditions of Western European painting. Unhampered by academic standards, each was free to develop his native sense of color, form and, above all, design. Their state of artistic innocence was not enjoyed by more sophisticated American artists. An acute sense of cultural inferiority, leading to excessive reliance upon European models, was the rule rather than the exception in much American artistic endeavor until well into the twentieth century. It has been argued that American painters like West and Copley—who started out as unschooled amateurs but went off to Europe for study and eventually "graduated" to the rank of professional academic artist—lost much of their originality and power along the way. What is certain is that their untutored, often anonymous contemporaries, who stayed close to home painting the ordinary citizens of country towns and villages, created a body of work that is remarkable for its originality, vigor and variety.

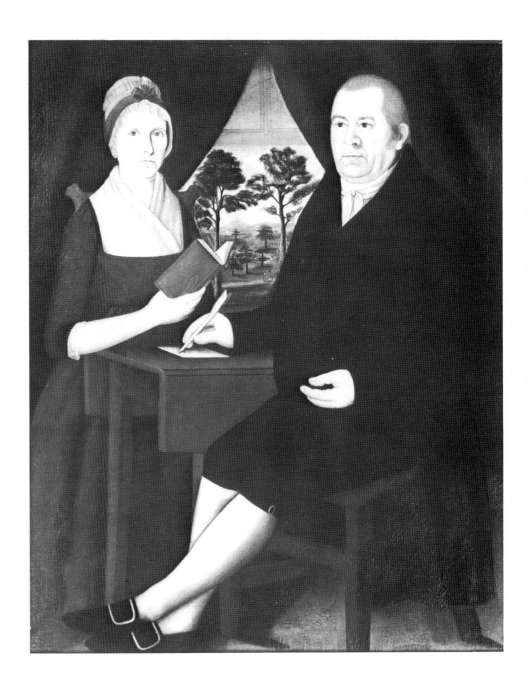

8. John Brewster, Jr., *Dr. and Mrs. John Brewster*, oil, 49⅝ x 40½", c. 1798, Hampton, Conn. Subjects are father and stepmother of the artist. Old Sturbridge Village, Sturbridge, Mass.

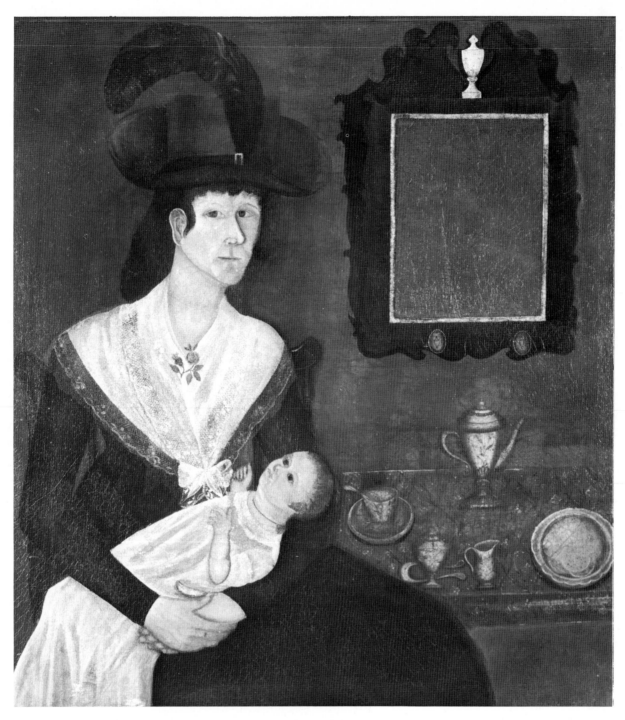

9. Attributed to Richard Brunton, *Mrs. Reuben Humphrey*, oil, 44½ x 40½″, c. 1800, East Granby, Conn. Attribution based on one of Brunton's engraved bookplates. Connecticut Historical Society, Hartford.

OPPOSITE: 10. *Miss Denison*, oil, 34½ x 27¼″, c. 1792, Connecticut. Collection of Edgar William and Bernice Chrysler Garbisch.

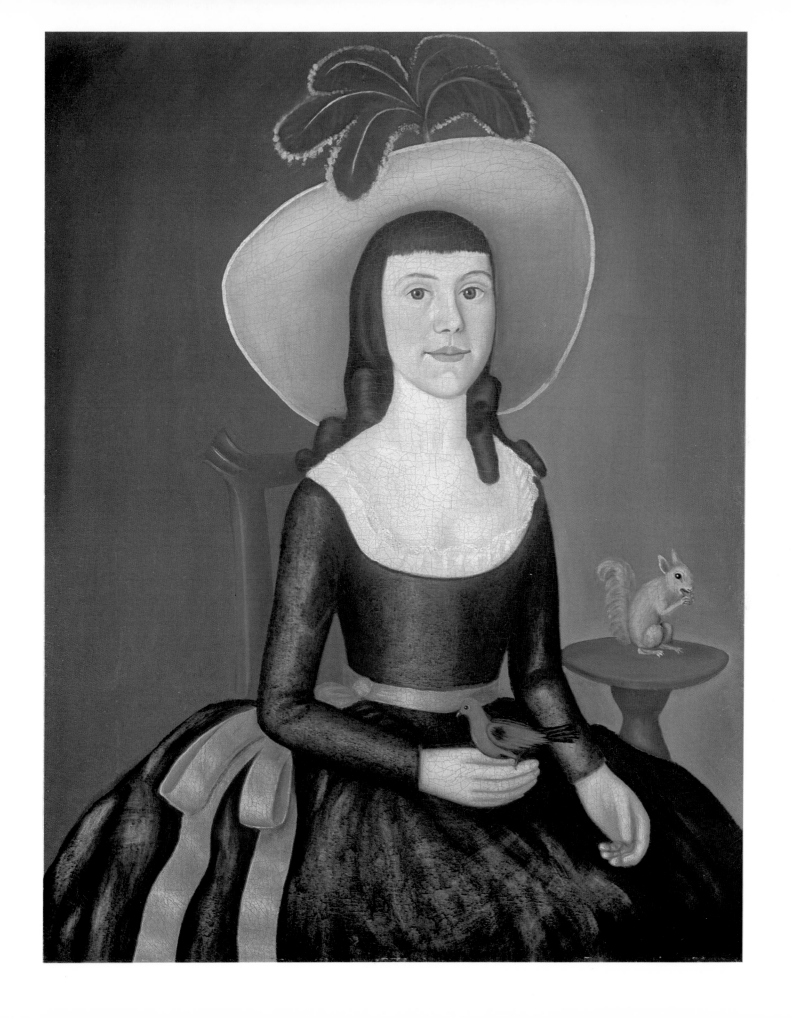

11. Emily Eastman, *Young Girl with Stylish Coiffure*, watercolor, 14 x 10″, c. 1820, Loudon, N.H. Collection of Mr. and Mrs. Peter H. Tillou.

12. Ruth Henshaw Bascom, *Profile of a Young Lady*, cut paper, pastel, pencil and metal foil, 18⅜ x 13″, c. 1835–40, Massachusetts or New Hampshire. Collection of Mr. and Mrs. Peter H. Tillou.

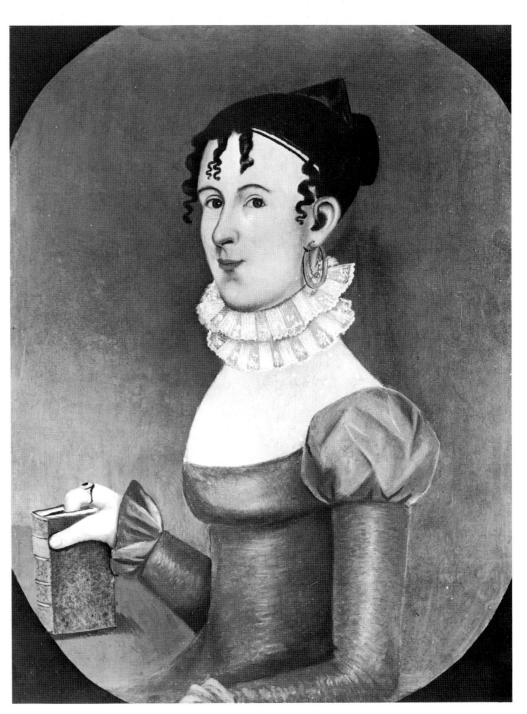

RIGHT: 13. *Adeline Harwood*, oil, 28 x 21½″, c. 1820, Vermont. Collection of Edgar William and Bernice Chrysler Garbisch.

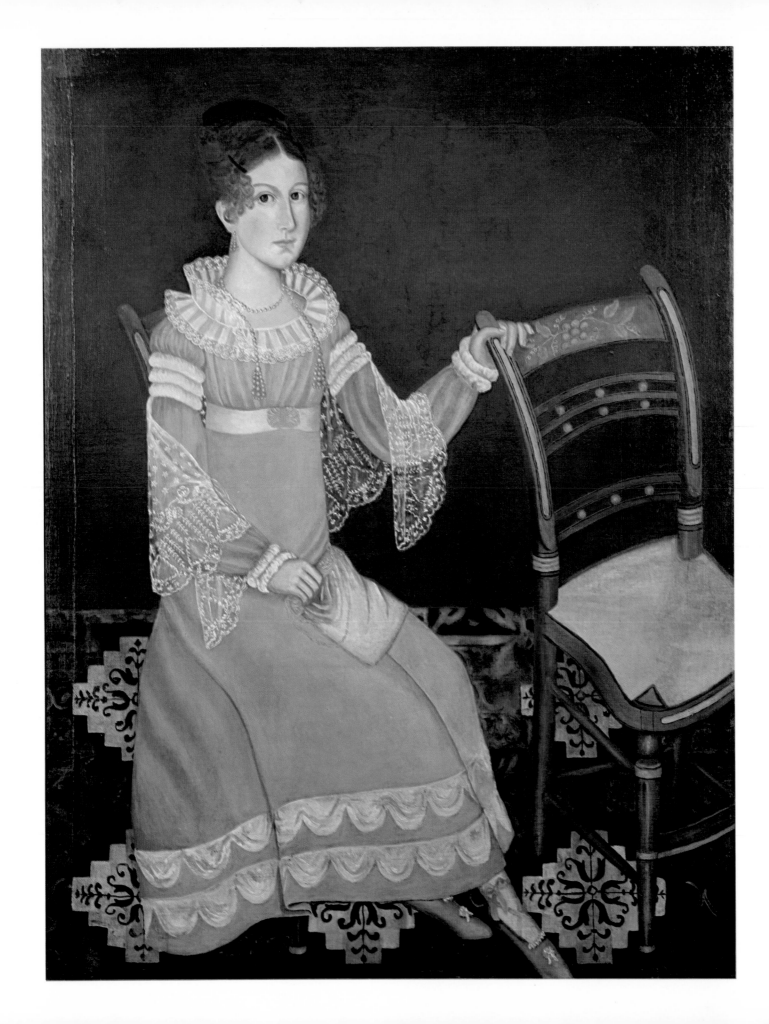

OPPOSITE: 14. *Martha Eliza Stevens Paschall*, oil, 51 x 39″, c. 1830, St. Louis, Mo. Subject was married in 1833; this may have been a wedding portrait. Owned by Mrs. Kenneth M. Doty and Mrs. Andrew S. Keck.

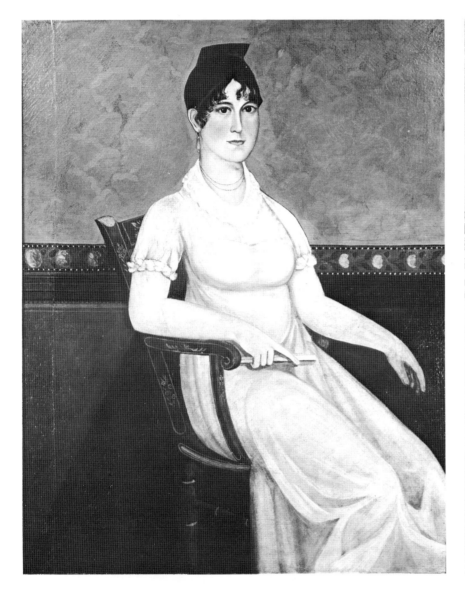 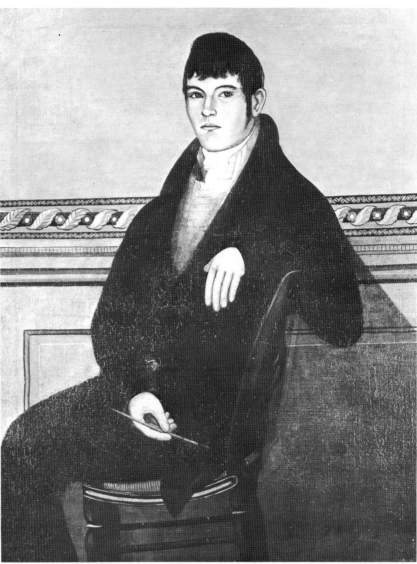

15 and 16. *The Artist's Wife* and *The Artist*, oil, each 44¼ x 34⅞″, c. 1825, New England. *The Artist* is apparently a self-portrait; painter may have been a furniture and wall decorator. New York State Historical Association, Cooperstown.

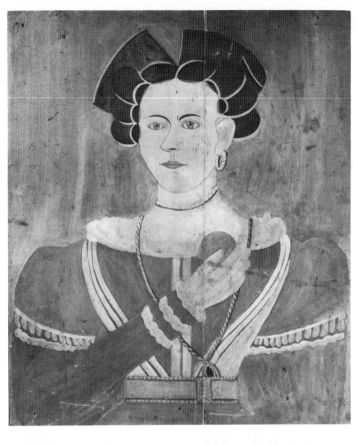

17. Attributed to A. Ellis, *Diantha Atwood Gordon,* oil on wood with gilding, 25 x 21½″, 1832, Fairfield, Me. Collection of Bertram K. and Nina Fletcher Little.

18. Noah North, *Eunice Spafford,* oil on wood, 27⅜ x 23⅝″, 1834, Holley, N.Y. Shelburne Museum, Shelburne, Vt.

19. *Portrait of a Lady,* oil, 28 x 25″, c. 1825–30, Philadelphia. Companion to a portrait of a gentleman. Collection of Edgar William and Bernice Chrysler Garbisch.

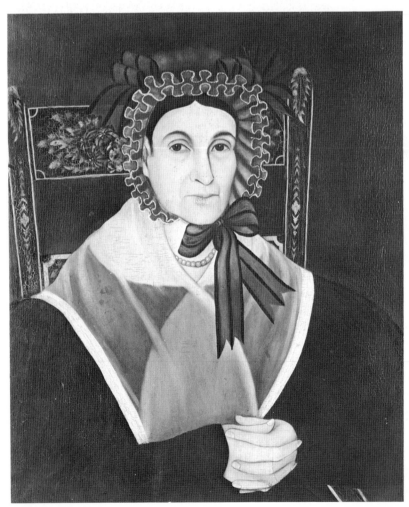

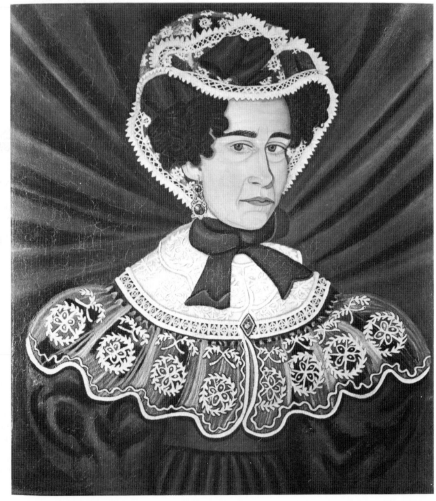

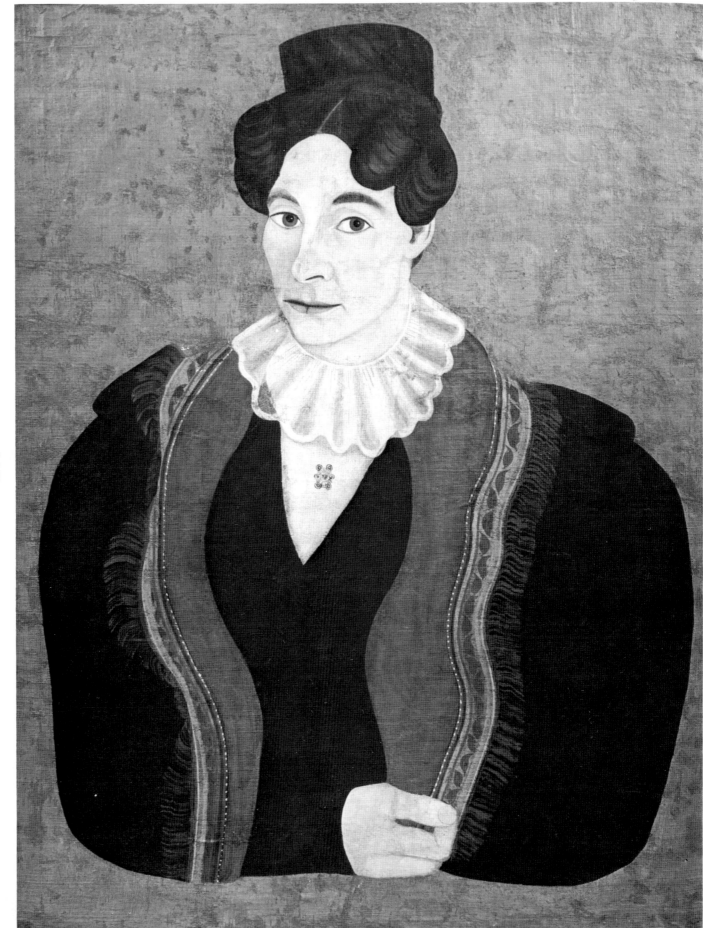

20. *Portrait of a Lady*, oil,
27½ x 21½″, c. 1830, Con-
necticut. Collection of Howard
A. Feldman.

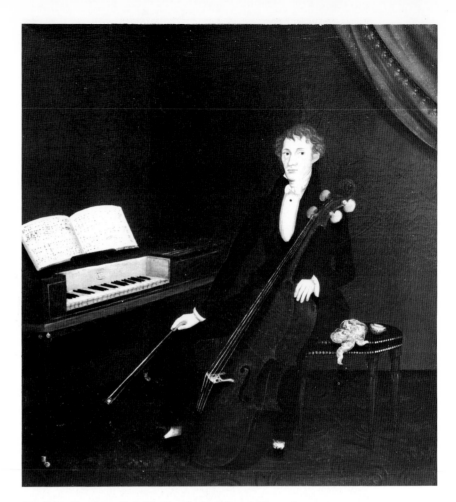

21. John Brewster, Jr., *Sarah Prince*, oil, 50½ x 40″, c. 1801, Newburyport, Mass. Collection of Mr. and Mrs. Jacob M. Kaplan.

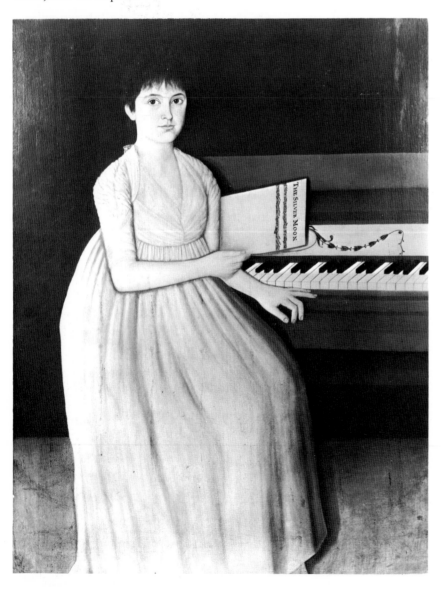

22. John Bradley (I. J. H. Bradley), *The Cellist*, oil, 17¾ x 16″, 1832, New York or Staten Island, N.Y. Signed "I. Bradley" and dated. Phillips Collection, Washington, D.C.

OPPOSITE: 23. Jonathan Fisher, *Self-portrait*, oil, 31¼ x 27″, 1838, Blue Hill, Me. Inscribed "Jonᵃ. Fisher pinx. 1824. Aetatis 56. Transcr. 1838." One of three replicas of the 1824 original, the others painted in 1825 and 1838. Collection of Robert L. Fisher.

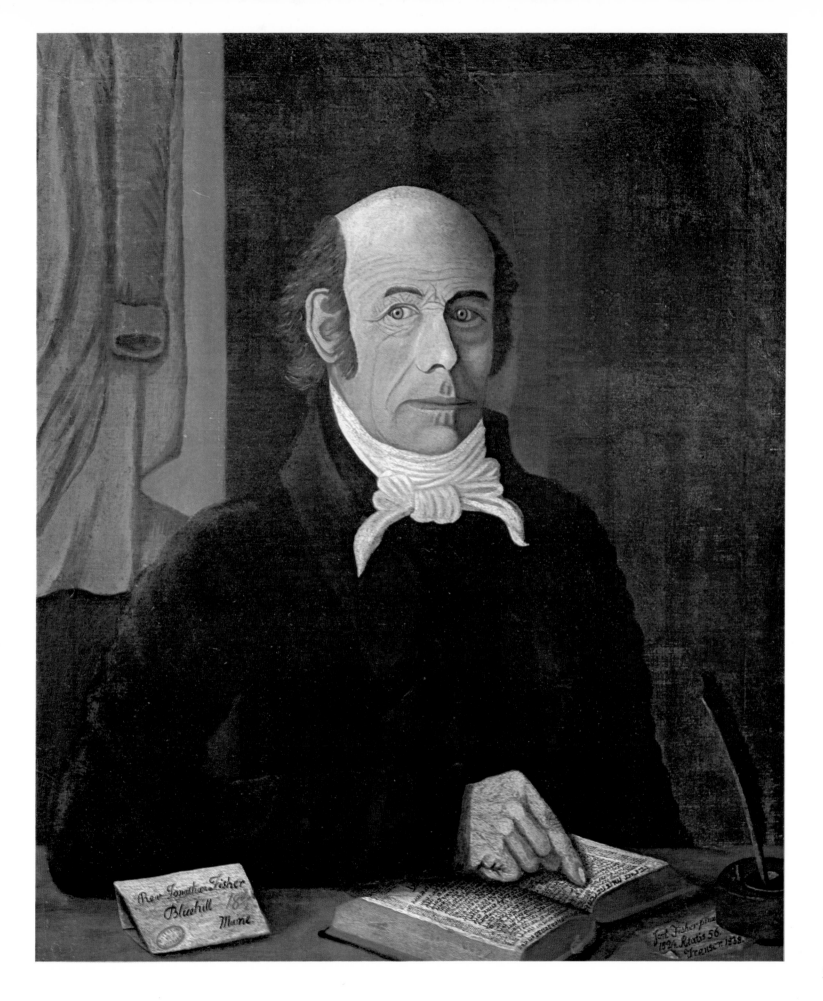

24 and 25. Sheldon Peck, *Mother and Son* and *Man Holding Bible*, oil on wood, each 31½ x 25½", c. 1830, western New York. Munson-Williams-Proctor Institute, Utica, N.Y.

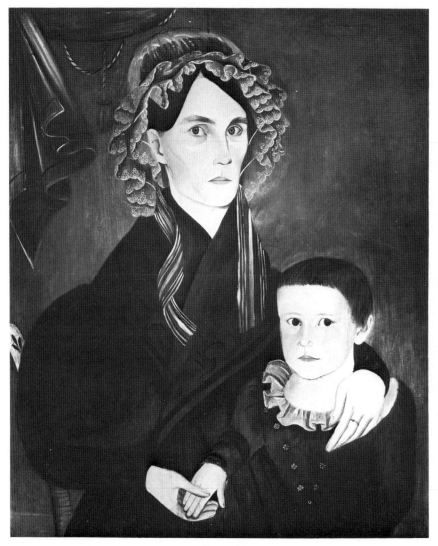
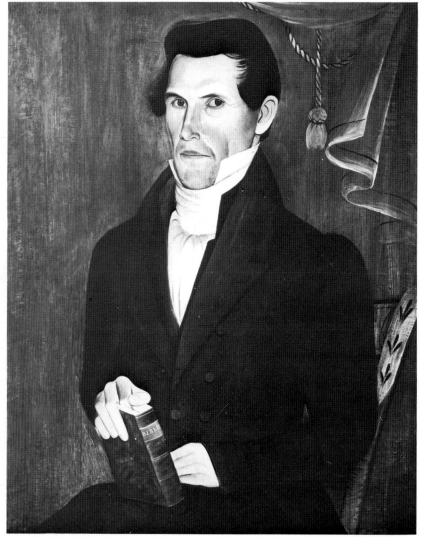

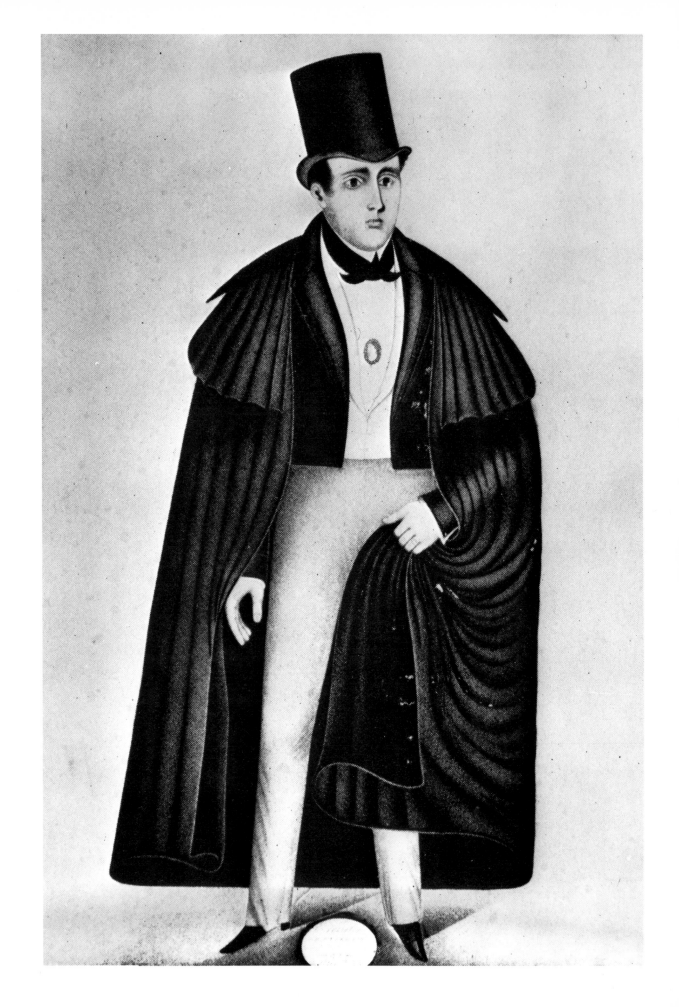

26. J. B. Giles, *Man in Cloak*, ink and pinprick, 23 x 17″, c. 1810, found in Vermont. Formerly collection of Edith Gregor Halpert.

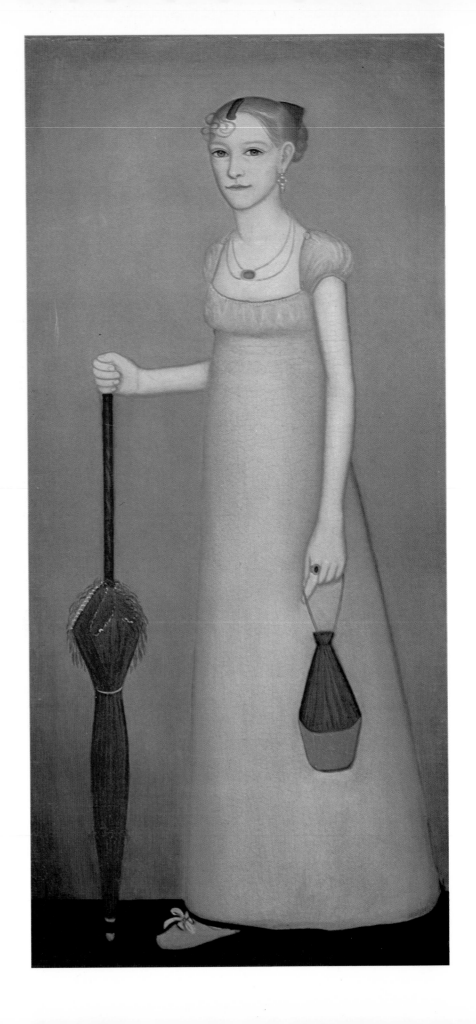

27 and 28. James Sanford Ellsworth, *Mr. and Mrs. C. T. Gunn*, watercolor, each 2⅞ x 2¼″, c. 1845, Connecticut, probably Windsor or Norwich. Collection of Howard Graff.

34

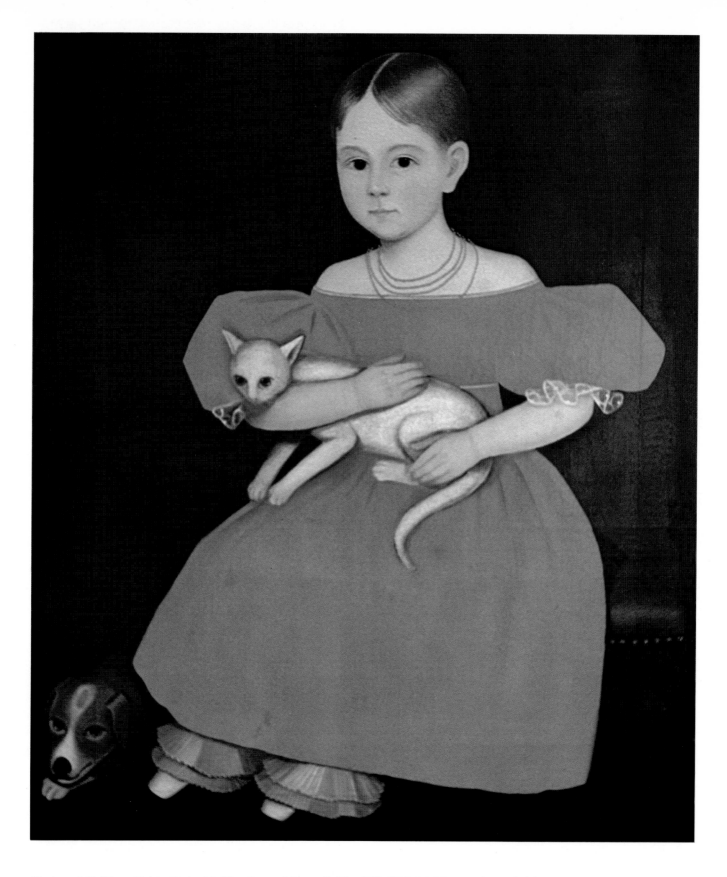

30. Ammi Phillips, *Girl in Red with Her Cat and Dog,* oil, 32 x 28″, 1834–36, New York, probably Amenia area. Privately owned.

OPPOSITE: 29. Ammi Phillips, *Harriet Leavens,* oil, 56¼ x 27″, c. 1815, Troy, N.Y. Fogg Art Museum, Harvard University, Cambridge, Mass.

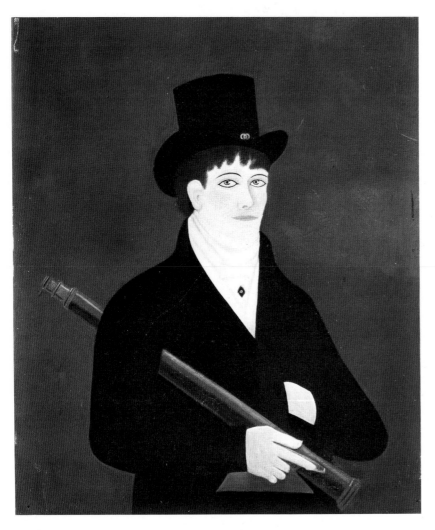

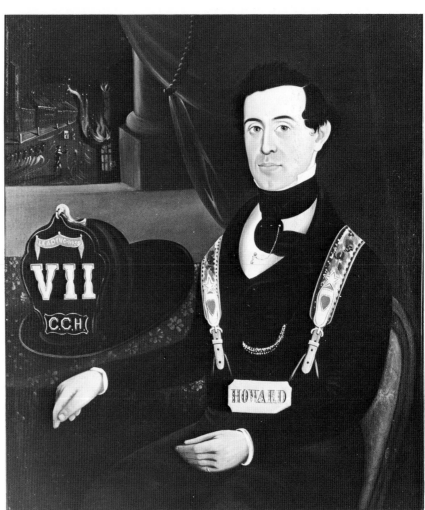

31. *Captain Thomas Baker*, oil, 39⅝ x 31½", c. 1800, Kennebunkport, Me. Abby Aldrich Rockefeller Folk Art Collection, Williamsburg, Va.

32. Group of William Matthew Prior, *Fireman*, oil, 36 x 29", c. 1840, probably Boston. New York State Historical Association, Cooperstown.

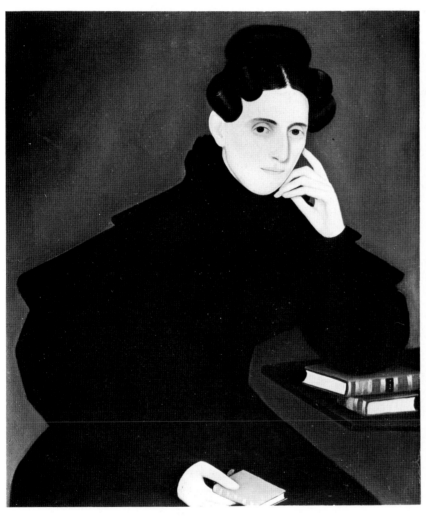

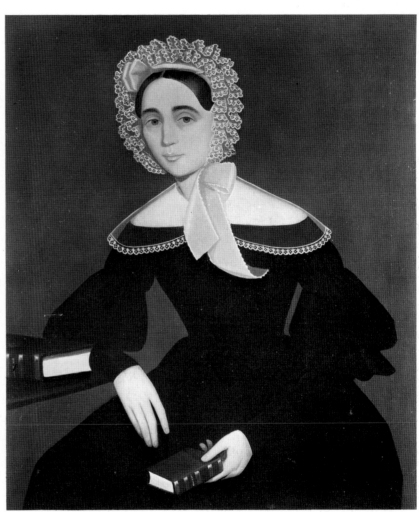

33. Ammi Phillips, *Portrait of a Lady in Black*, oil, 31 x 26¼″, c. 1837, vicinity of Kent, Conn. Collection of Mr. and Mrs. Jacob M. Kaplan.

34. Ammi Phillips, *Lady with Books*, oil, approximately 26 x 32″, c. 1835, vicinity of Kent, Conn. Formerly collection of Harry Stone.

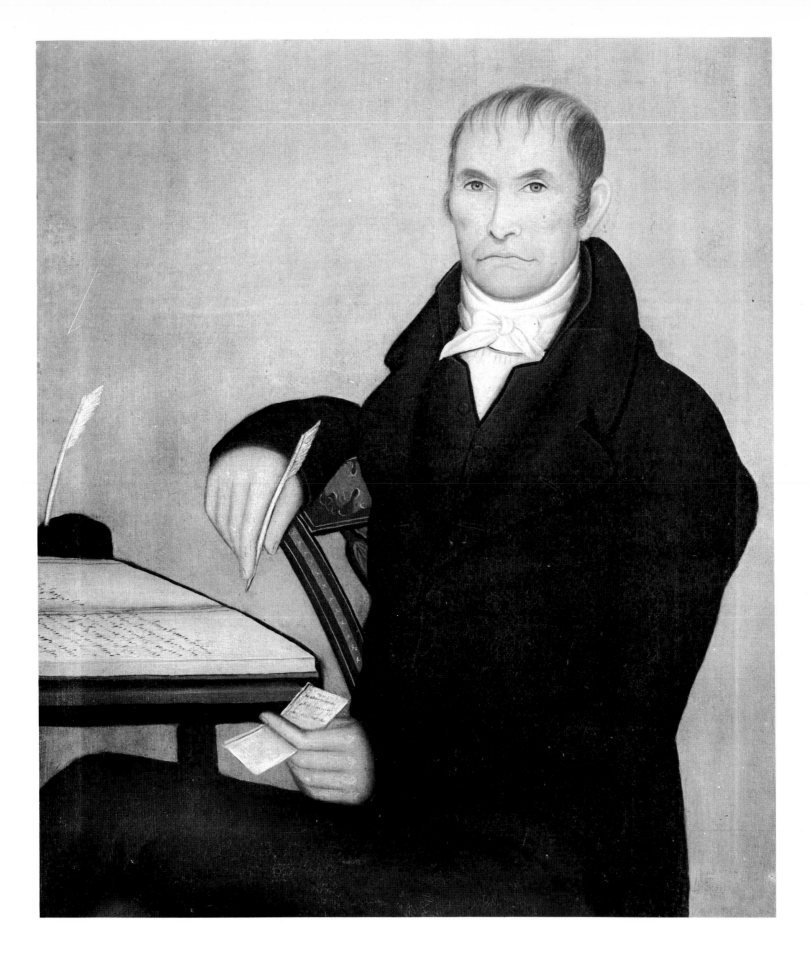

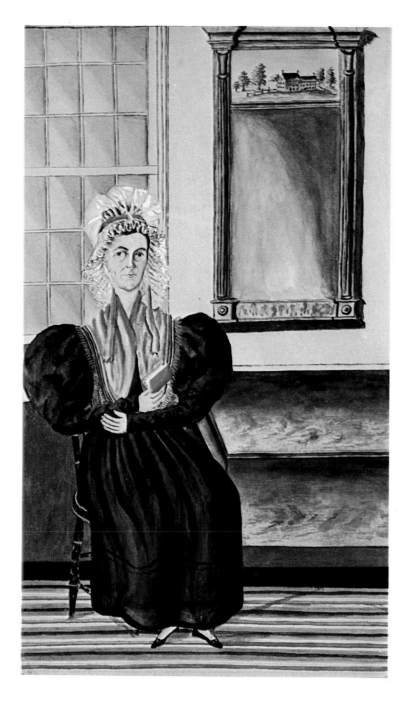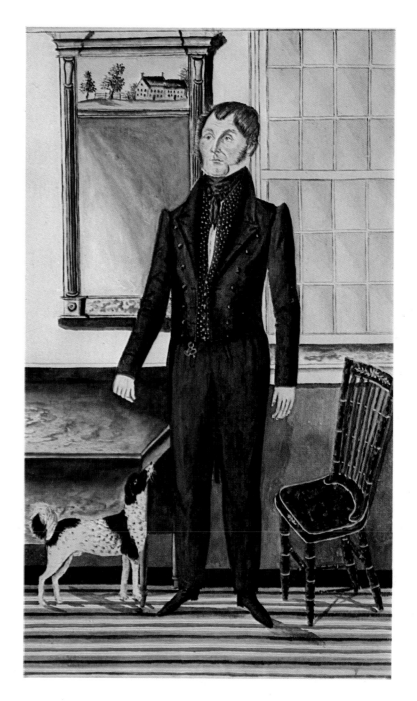

36 and 37. Jacob Maentel, *Elizabeth and Michael Haak*, water-
color, each 18 x 11¼″, c. 1835, Lebanon, Pa. Collection of
Edgar William and Bernice Chrysler Garbisch.

OPPOSITE: 35. Ammi Phillips, *Colonel Joseph Dorr*,
oil, 40 x 33″, c. 1814–16, Hoosick Falls, N.Y. Col-
lection of Bertram K. and Nina Fletcher Little.

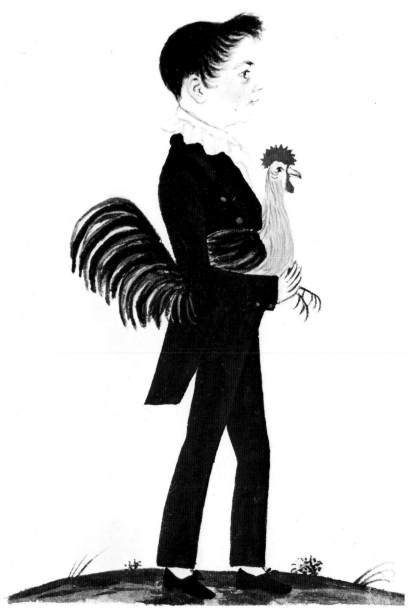

38. Jacob Maentel, *Boy with Rooster*, watercolor, 7⅛″ x 5¾″, 1815–25, Pennsylvania or Indiana. Henry Francis du Pont Winterthur Museum, Winterthur, Del.

39. Jacob Maentel, *Major Will^m. Rees Commander of the 113. Regim^t. in the 1^t. Brigade 5th. Divⁿ. York Militⁿ. his Age 33, and his Daughter Mary 9 Year. 1814. Feb^r. 7th,* watercolor, 18⅜ x 10 7/16″, 1814, York, Pa. Inscribed strip, glued to painting, is probably contemporary with it. Historical Society of York County, York, Pa.

41. Erastus Salisbury Field, *Miss Margaret Gilmore*, oil, 54 x 34″, c. 1845, possibly painted in New York, found in Shelton, Conn. Museum of Fine Arts, Boston; Bequest of Maxim Karolik.

40. Henry Walton, *Elizabeth Cortleyou, Aged 34 Yrs Elizabeth Riggles Aged 7 Yrs Drawn by H. Walton Geneva 1836*, watercolor, 9¾ x 8¼″, 1836, Geneva, N.Y. Elizabeth Riggles was niece of Elizabeth Cortleyou and great-grandmother of the present owner. Collection Mrs. A.V.S. Olcott, Jr.

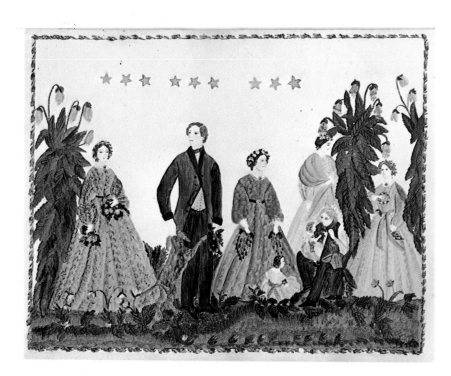

42. *New Bedford Memorial Group*, oil on cardboard, 14⅜ x 18¼″, c. 1840, New Bedford, Mass. New York State Historical Association, Cooperstown.

43. J.N. Eaton, *Conversation Piece: William and Mary*, oil on wood, 23 x 23½″, c. 1830, Greene County, N.Y. Based on illustration in a children's book. Abby Aldrich Rockefeller Folk Art Collection, Williamsburg, Va.

44. *Intimate Conversation*, ink and watercolor, 12 x 15″, c. 1825–30, probably New England. Collection of Mr. and Mrs. Peter H. Tillou.

OPPOSITE: 46. Joseph H. Davis, *Page Batchelder, Aged 48. July 8ᵗʰ 1836. Betsey Batchelder. Aged 50. June 18ᵗʰ 1836*, watercolor, 10½ x 15½″, 1836, Maine or New Hampshire. Collection of Mr. and Mrs. Samuel Schwartz.

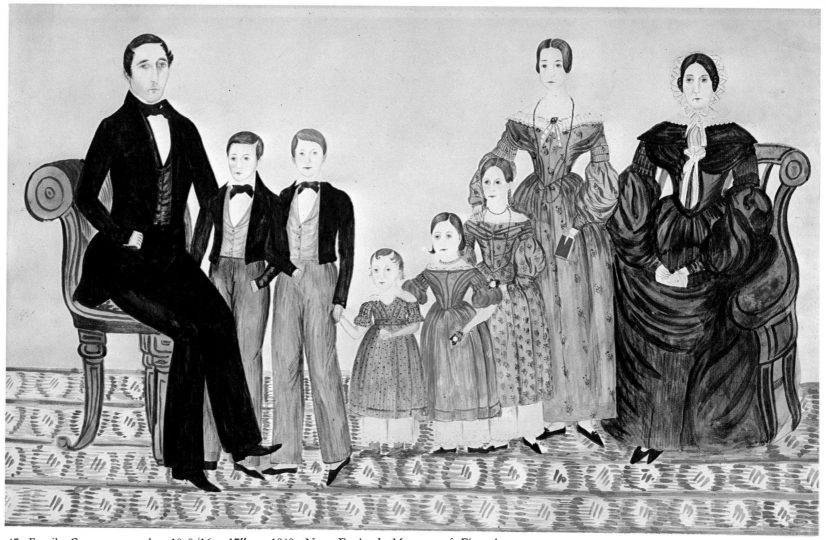

45. *Family Group*, watercolor, 10 9/16 x 17″, c. 1840, New England. Museum of Fine Arts, Boston; M. and M. Karolik Collection.

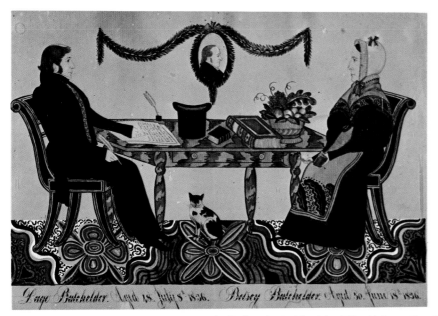

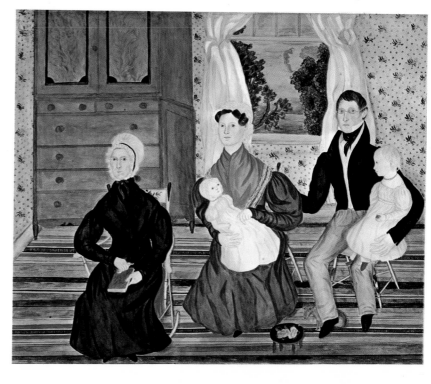

RIGHT: 47. Deborah Goldsmith, *The Talcott Family*, watercolor, 14 x 18″, 1832, vicinity of Hamilton, N.Y. Abby Aldrich Rockefeller Folk Art Collection, Williamsburg, Va.

48. *Emma Clark*, watercolor, 5½ x 4½″, 1829, probably New York or New England. Abby Aldrich Rockefeller Folk Art Collection, Williamsburg, Va.

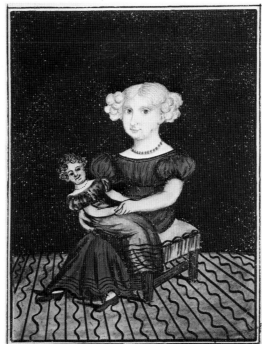

51. *George Richardson,* oil, 21 x 17″, c. 1820, Boston. Collection of Bertram K. and Nina Fletcher Little.

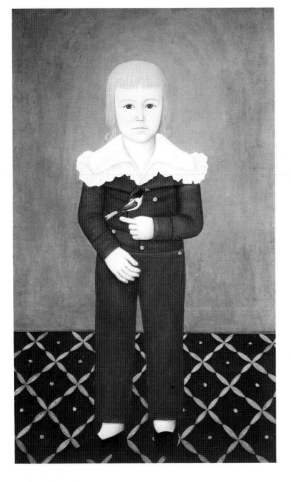

LEFT: 49. John Brewster, Jr., *Boy with Finch*, oil, 38½ x 23¾″, c. 1800, possibly Maine. Abby Aldrich Rockefeller Folk Art Collection, Williamsburg, Va.

BELOW: 50. *Little Boy in Windsor Chair*, oil, 31¼ x 24″, 1800–1805, Connecticut or Massachusetts. Attributed to artist exhibited and published as "The Beardsley Limner." Montclair Art Museum, Montclair, N.J.

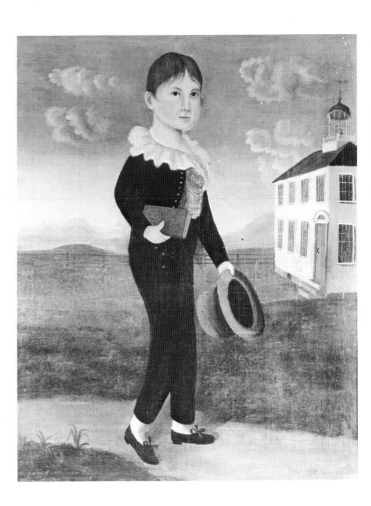

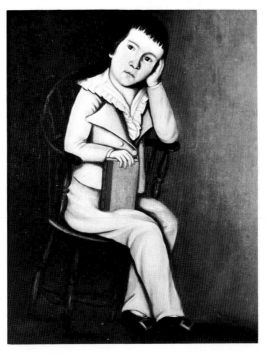

OPPOSITE: 52. *Girl with Lemon*, oil, 42 x 22¾″, c. 1830, New England. Smithsonian Institution, Washington, D.C.

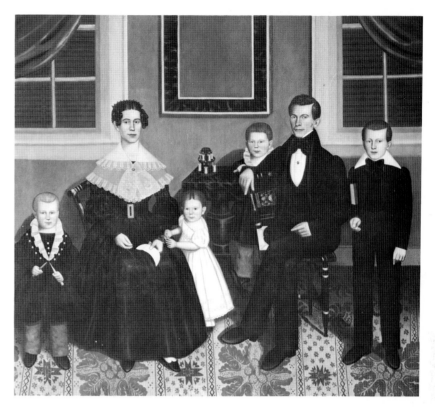

53. Erastus Salisbury Field, *Joseph Moore and His Family*, oil, 82¾ x 93¼″, 1839, Ware, Mass. Museum of Fine Arts, Boston; M. and M. Karolik Collection.

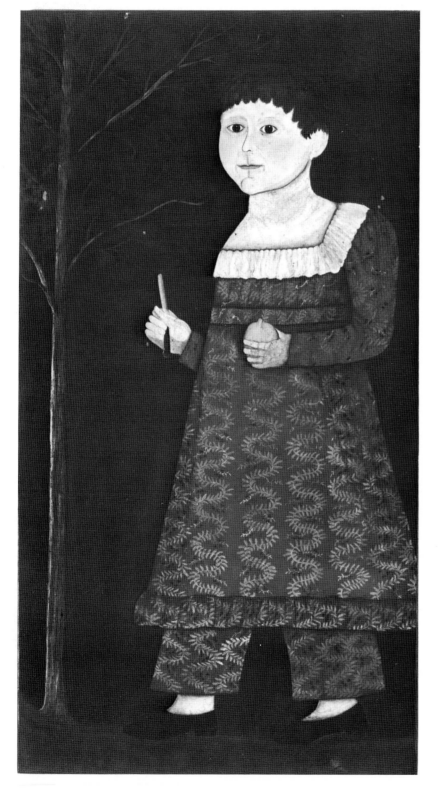

BELOW: 54. Sheldon Peck, *Mr. and Mrs. William Vaughan*, oil, 29 x 33½″, c. 1845, Aurora, Ill. In original frame painted by Peck. Collection of Mr. and Mrs. Bernard M. Barenholtz.

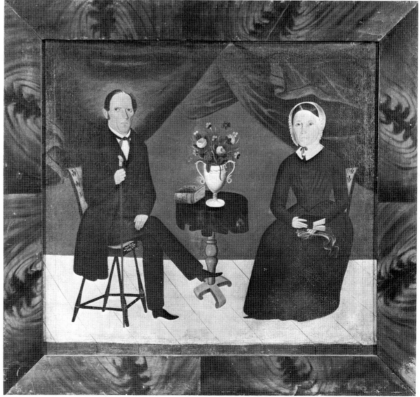

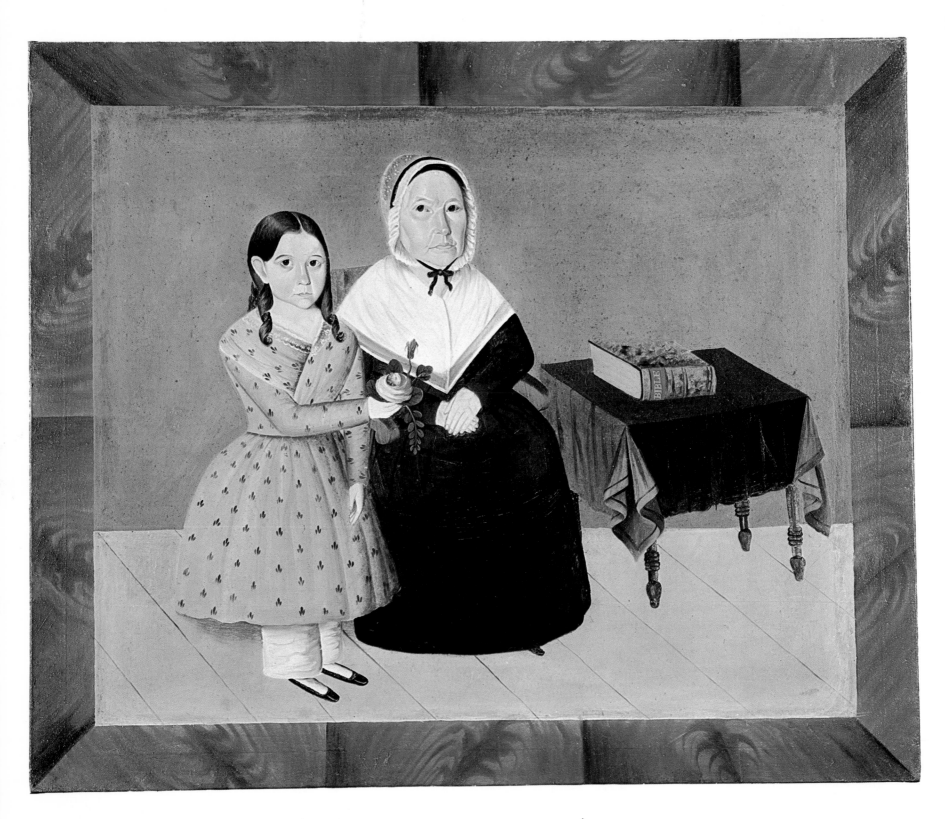

55. Sheldon Peck, *Ann Gould Crane and Granddaughter Jennette*, oil, 35½ x 45½'', c. 1838, Lombard, Ill. *Trompe l'oeil* frame a part of the canvas. Collection of Mr. and Mrs. Peter H. Tillou.

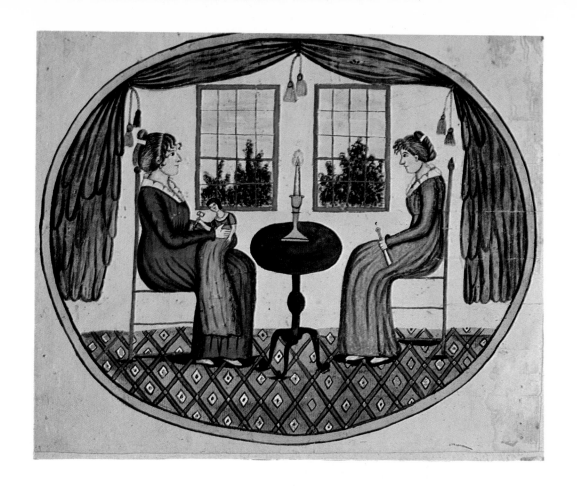

56. Eunice Pinney, *Two Women*, watercolor, 11 x 14⅜", c. 1815, Windsor, Conn. New York State Historical Association, Cooperstown.

57. Attributed to J. Evans, *Mother and Daughter of the Chase Family*, watercolor, 9½ x 13½", c. 1830, Deerfield, N.H. Attribution based on analogy to signed examples. Painting in original stenciled frame. Collection of Mrs. Cyril A. Nelson.

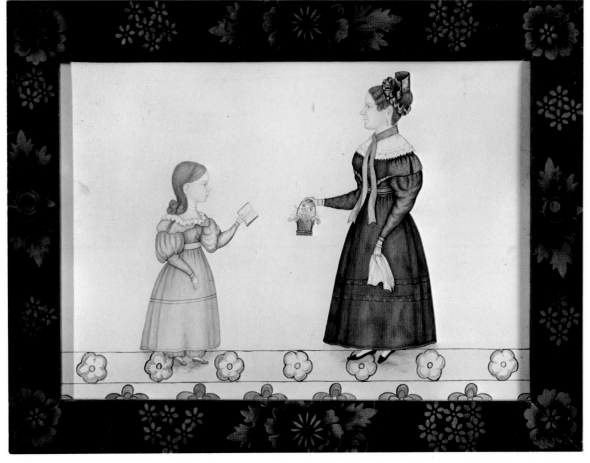

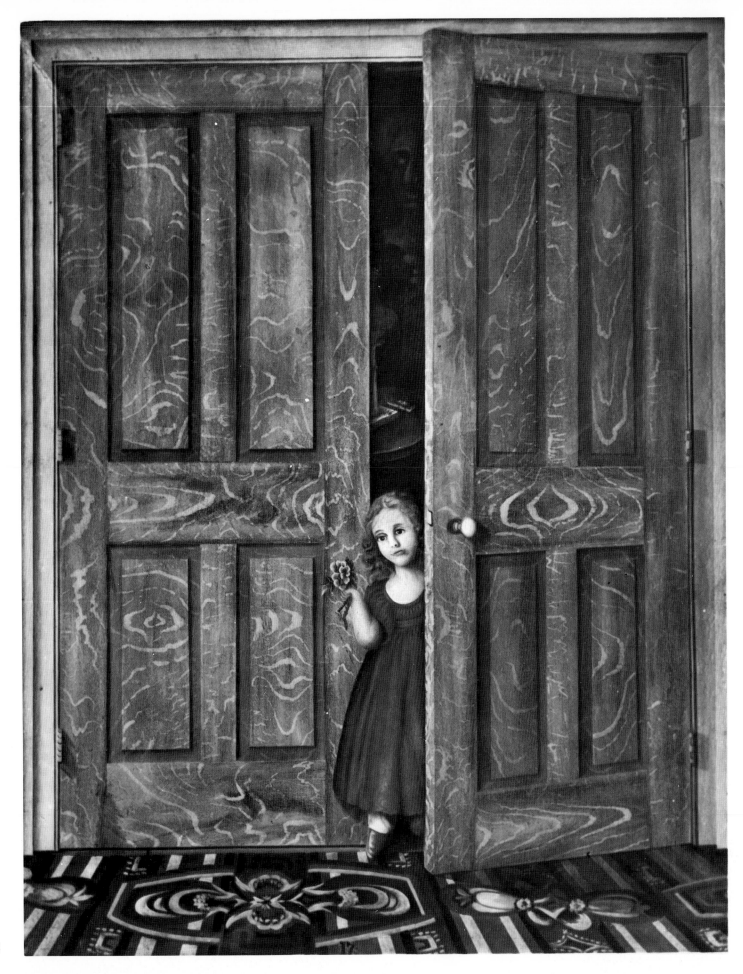

48

OPPOSITE: 58. George Washington Mark, *Girl Coming through Doorway*, oil, 72½ x 56⅜", c. 1845, Greenfield, Mass. Painted for Mark's exhibition gallery, to which he charged an admission fee. Henry Ford Museum, Dearborn, Mich.

59. Asahel Lynde Powers, *Charles Mortimer French*, oil on wood, 36 x 21¾", c. 1839, Ludlow, Vt. Inscribed on back: "Charles Mortimer French taken at 6 years old. Asahel Powers. Painter." New York State Historical Association, Cooperstown.

60. Attributed to William Thompson Bartoll, *Boy with Toy Drum*, oil, 26 x 21¾", c. 1845, Massachusetts, Marblehead area. Attribution based on analogy to several signed portraits. New-York Historical Society, New York.

Together with portraits of themselves and their families, the citizens of the young American republic often hung another kind of "portrait"—a view of their town or village, their farm with its barnyard and cultivated fields, a sailing ship, or one of the steamboats that plied the nation's rapidly growing network of canals. Just as the family portraits reveal their subjects' deep sense of personal accomplishment, so the townscapes and farmscapes reflect the collective pride of a people who created towns and farms in the wilderness. Similarly, the sturdy whalers, sleek clipper ships and jaunty steamboats that dominate the seascapes were reminders of the accomplishments of American shipbuilders and seamen.

The men and women who pushed the boundaries of the United States westward did not hold a romantic view of nature. They had encountered it as an unyielding, often cruel force that had to be subdued and civilized. Folk artists celebrated—in a simple, homely way—nothing less than the triumph of man over nature, of civilization over wilderness. They stand at the opposite pole, in feeling as well as style, from the Hudson River School artists, America's first academic landscape painters.

The scenes reproduced here form a panorama of nineteenth-century America, from the Virginia plantation to the rolling farmland of Pennsylvania, from the small towns of New York State and New England westward as far as Wisconsin; and the seascapes take us to the very edge of the continent where determined whalemen struggle with their prey off the coast of California. Most of these paintings are the work of amateurs who took brush in hand for the fun of it, or sometime-painters who sold pictures on the side while pursuing other callings. Edward Hicks, the Quaker preacher best known today for his many versions of *The Peaceable Kingdom*, also painted the prosperous farms of his native Pennsylvania as gifts for his family and friends. Joseph Hidley—said to have been a cabinetmaker and taxidermist—is known to us only by his paintings of his home town, Poestenkill, and of a few other towns near Troy, New York.

Hicks and Hidley worked in oil, but early in the nineteenth century watercolors gained in popularity, largely because of the development of a wide range of colors in solid form, an improvement over the hand-ground pigments that had to be dissolved in water. Amateur painters found the small boxes of colors inexpensive, easy to transport and simple to use, a medium that lent itself to rapid, informal work. Courses in watercoloring, as well as other art techniques, were part of the curriculum in young ladies' seminaries where, in increasing numbers, young women were given educational opportunities that previously had been available only to their brothers. Mary Keys and Prudence Perkins, who signed paintings of the Erie Canal and a New England town, respectively, were probably schoolgirl artists, as was the unknown painter of *Venice*, an exotic subject that surely held great appeal for a youthful imagination. Another art considered the special province of the proper young lady was needlepoint, in which landscapes and other pictures were worked. Phebe Kriebel's *Townscape* exhibits not only a sure command of the medium but an unusual talent for combining brilliant color and strong design.

In a class by themselves are the ship "portraits" by such artists as James Bard and Jurgan Frederick Huge. Bard, who worked with his twin brother, John, until the latter's early death, was a professional; he found lucrative commissions among shipowners and especially ship captains, who proudly displayed paintings of their vessels in their offices and homes. Huge combined the occupation of grocer with that of painter, specializing in ships as well as private residences and commercial establishments like the Burroughs Building in Bridgeport, Connecticut, where he made his home after emigrating from Germany as a youth. Bard worked mostly in oil, Huge in watercolor, and both were as meticulous as any professional portraitist in their efforts to present exact likenesses of their subjects. It was said that Bard personally measured each vessel from end to end and took careful notes on coloring and other details. Although Bard and Huge portrayed each ship accurately and to scale, the exact profiling, the sharply detailed treatment of the background, the stylized waves and stiff, oddly proportioned people mark their works as true folk art.

The great majority of the landscape and marine artists remain anonymous or are known only by a signature on a lone work. Like the early portraitists, they exhibit a common approach to painting, one determined primarily by lack of formal training. These painters were almost totally innocent of the techniques needed for a faithful reproduction of the actual appearance of things. Unable to paint realistically, they had to organize and stabilize their compositions from the point of view of design. In all folk paintings—portraits, landscapes, scenes of daily life, or Biblical, literary and historical subjects—the unifying element is design rather than a realistically consistent perspective, natural lighting or enveloping atmosphere, all of which are notably missing. It is unlikely that any of these landscapes or sea-

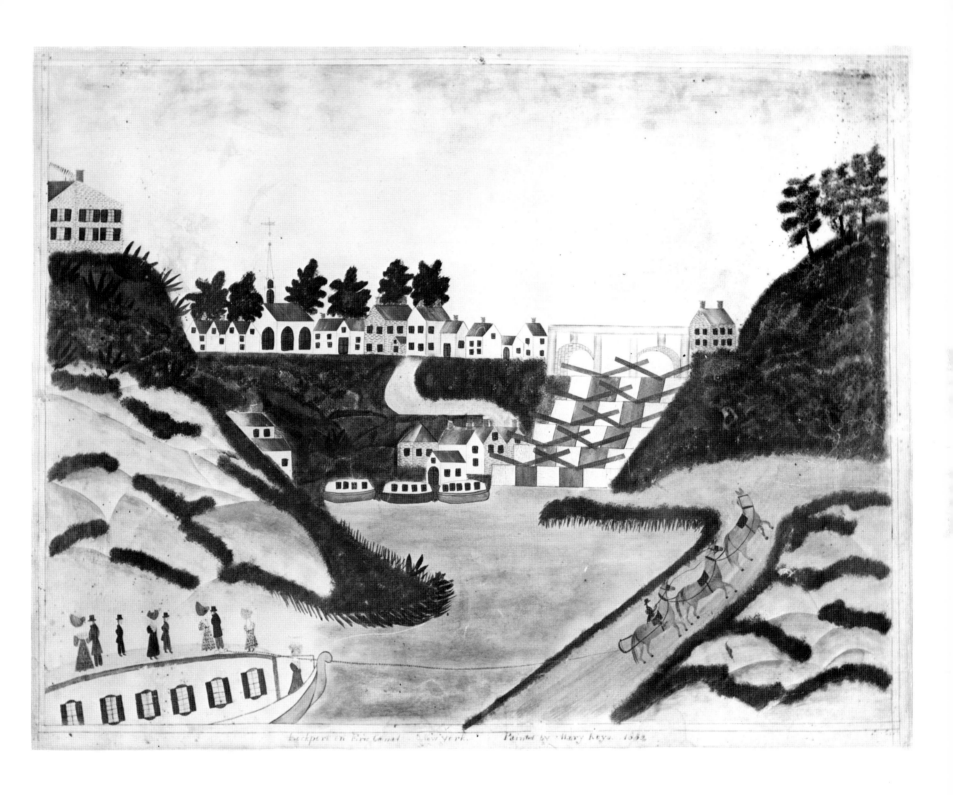

61. Mary Keys, *Lockport on Erie Canal New York,* watercolor, 14⅜ x 19⅜″, 1832, Lockport, N.Y. Signed and dated. Munson-Williams-Proctor Institute, Utica, N.Y.

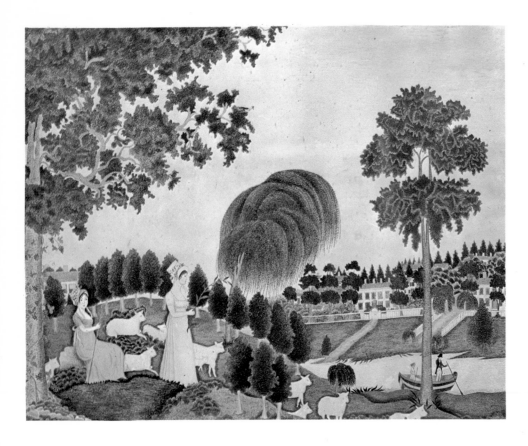

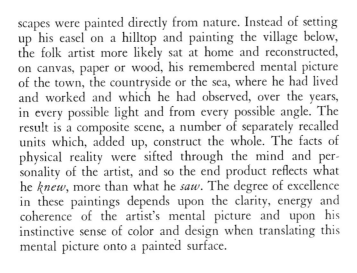

62. Prudence Perkins, *River Town-scape with Figures,* colored inks and watercolor, 18½ x 22¾", c. 1810, Rhode Island. Collection of Mr. and Mrs. Peter H. Tillou.

63. *Echo Rock,* oil, 36 x 29", c. 1875, Echo Rock, N.J. Collection of Herbert W. Hemphill, Jr.

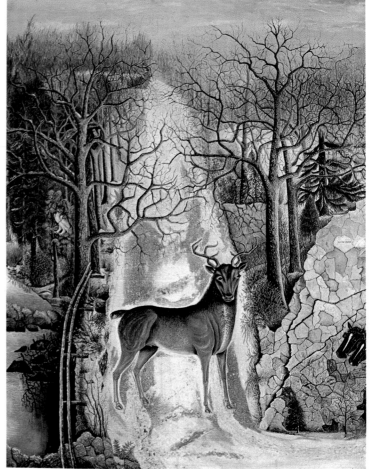

scapes were painted directly from nature. Instead of setting up his easel on a hilltop and painting the village below, the folk artist more likely sat at home and reconstructed, on canvas, paper or wood, his remembered mental picture of the town, the countryside or the sea, where he had lived and worked and which he had observed, over the years, in every possible light and from every possible angle. The result is a composite scene, a number of separately recalled units which, added up, construct the whole. The facts of physical reality were sifted through the mind and personality of the artist, and so the end product reflects what he *knew,* more than what he *saw.* The degree of excellence in these paintings depends upon the clarity, energy and coherence of the artist's mental picture and upon his instinctive sense of color and design when translating this mental picture onto a painted surface.

One folk artist, Paul A. Seifert, lived well into our own century, so we have firsthand recollections of his personality and ways of working. An immigrant from Germany, Seifert settled in Wisconsin and worked as a gardener and taxidermist. His real love, however, was painting, and he often took to the countryside with his sketchbook of colored papers and a box of watercolors. He walked from one farm to the next, sketching the neat homesteads set against wide skies and empty plains, and he sold the results to the farm owners. Profit could hardly have been his sole motive, for the paintings were never more than $2.50 framed. If we could ask any of the folk artists represented here why they painted, their answer would probably be not very different from Seifert's matter-of-fact explanation, as recalled by his granddaughter: "People like my work, and I like to paint for them."

64. Phebe Kriebel, *Townscape*, wool embroidery on canvas, 27 x 25″, 1857, Towamencin Township, Pa. Schwenkfelder Museum, Pennsburg, Pa.

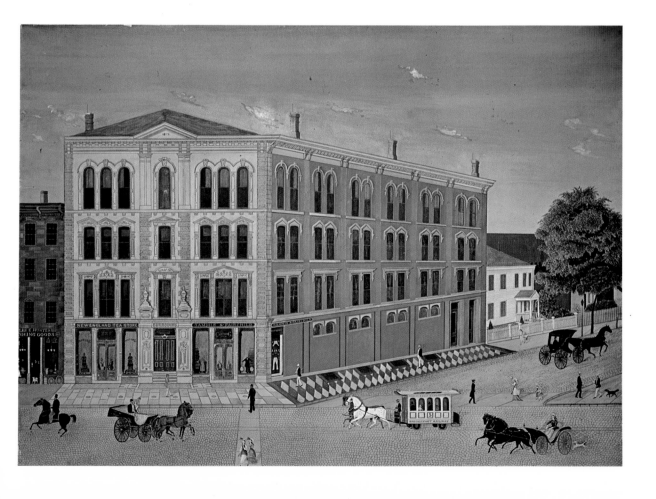

65. Jurgan Frederick Huge, *Burroughs*, ink, gilt, watercolor, 29¼ x 39½″, 1876, Bridgeport, Conn. Inscribed "J. F. Huge. North B-P. Conn. 1876." Bridgeport Public Library, Bridgeport, Conn.

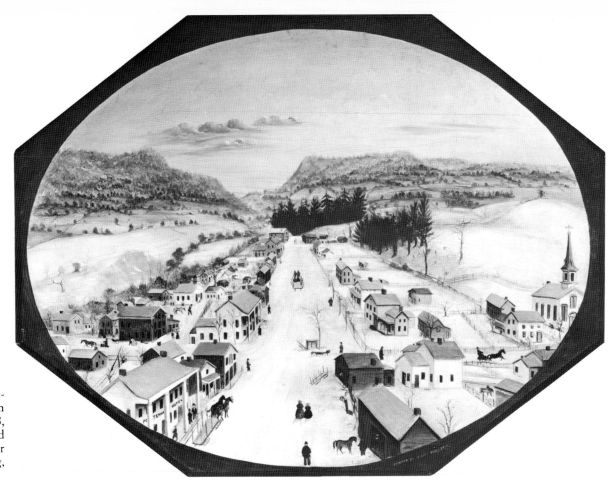

66. Joseph Henry Hidley, *Poesten-kill, New York: Winter*, oil on wood, 18 3/16 x 24 7/16″, 1868, Poestenkill, N.Y. Initialed and dated. Abby Aldrich Rockefeller Folk Art Collection, Williamsburg, Va.

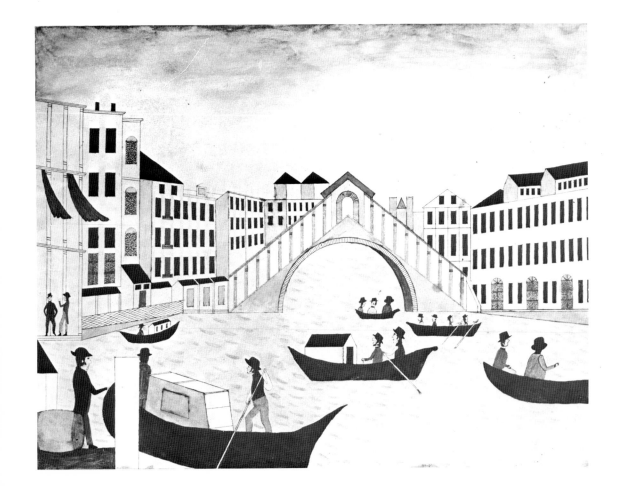

67. *Venice*, watercolor, 14¾ x 19¾″, c. 1840, probably New England or New York. New York State Historical Association, Cooperstown.

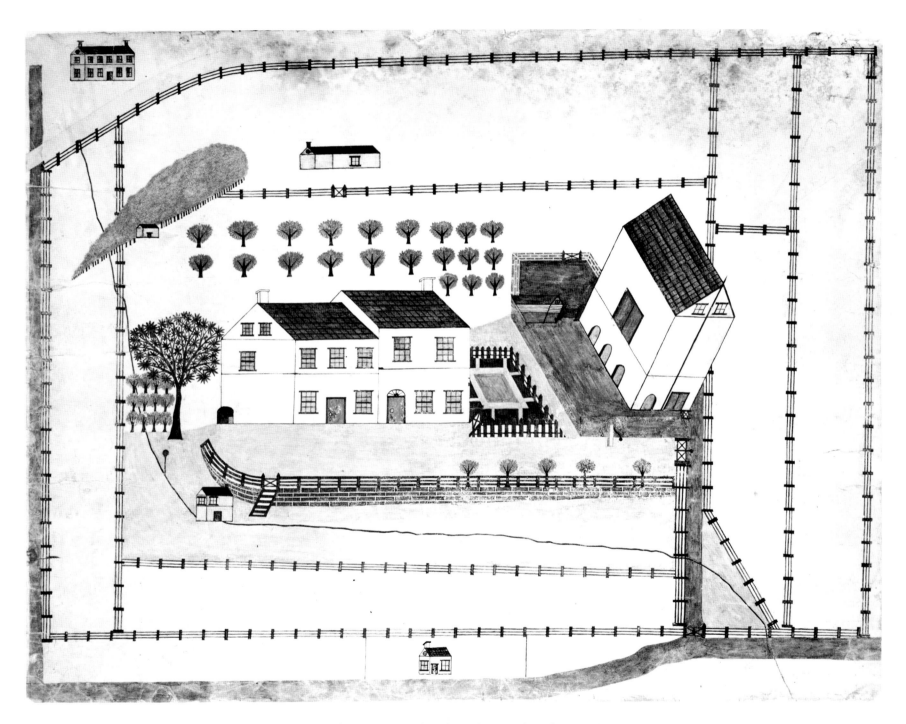

68. *Pennsylvania Farmstead with Many Fences*, ink and watercolor, 18 x 23⅞″, c. 1830, found in Pottsville, Pa. Museum of Fine Arts, Boston; M. and M. Karolik Collection.

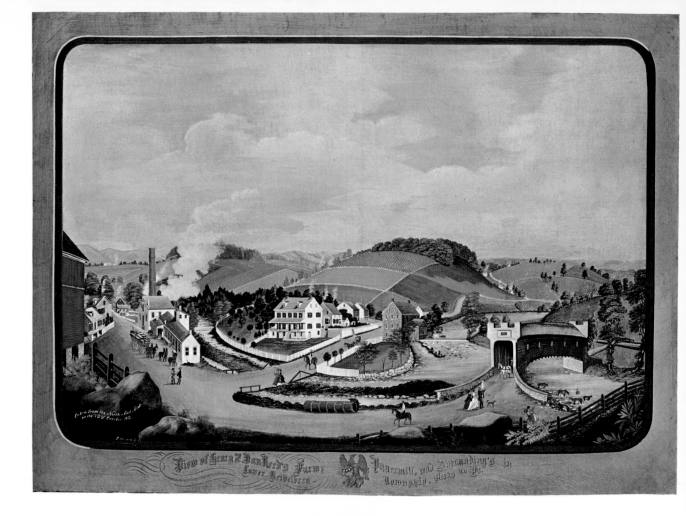

69. Charles C. Hofmann, *View of Henry Z. Van Reed's Farm, Paper-mill, and Surroundings in Lower-Heidelberg-Township, Berks Co. Pa.*, oil, 39 x 54″, 1872, Berks County, Pa. Inscribed "taken from the North-East-Side on the 5th of October 1872" and signed. The man depicted in left foreground is presumably Henry Z. Van Reed talking with his drover. Abby Aldrich Rockefeller Folk Art Collection, Williamsburg, Va.

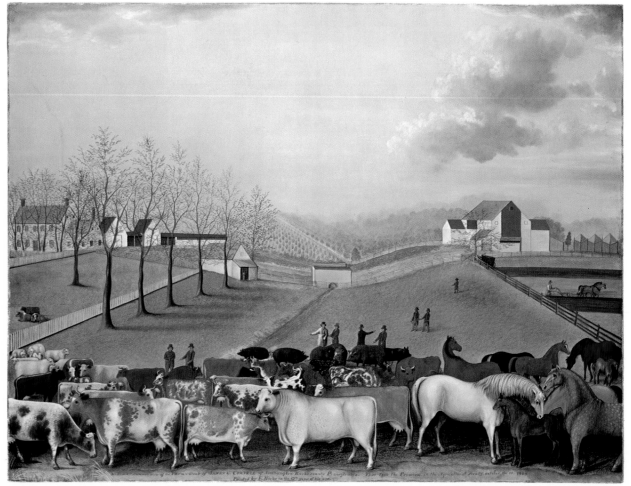

70. Edward Hicks, *An Indian summer view of the Farm & Stock of James C. Cornell of Northampton Bucks County Pennsylvania. That took the Premium in the Agricultural Society, october the 12, 1848*, oil, 36¾ x 49″, 1848, Newtown, Pa. Signed "Painted by E. Hicks in the 69th. year of his age." The man in gray belted coat has been identified as James C. Cornell. National Gallery of Art, Washington, D.C.; Gift of Edgar William and Bernice Chrysler Garbisch.

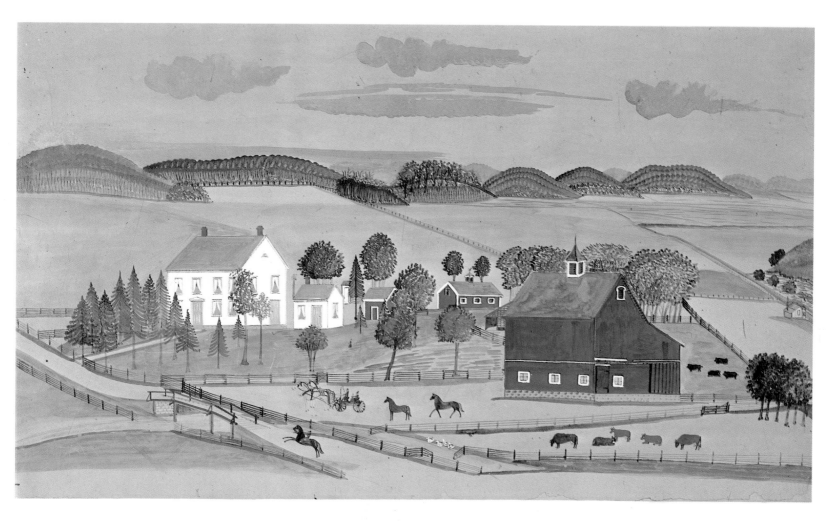

71. Paul A. Seifert, *Wisconsin Farm*, watercolor, oil and tempera on cardboard, 15½ x 28″, c. 1875, vicinity of Plain, Wis. New York State Historical Association, Cooperstown.

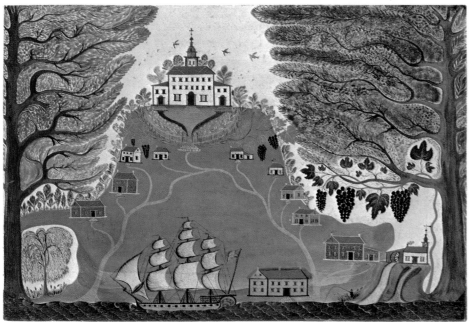

72. *The Plantation*, oil on wood, 19⅛ x 29½″, c. 1825, found in Virginia. Metropolitan Museum of Art, New York; Gift of Edgar William and Bernice Chrysler Garbisch.

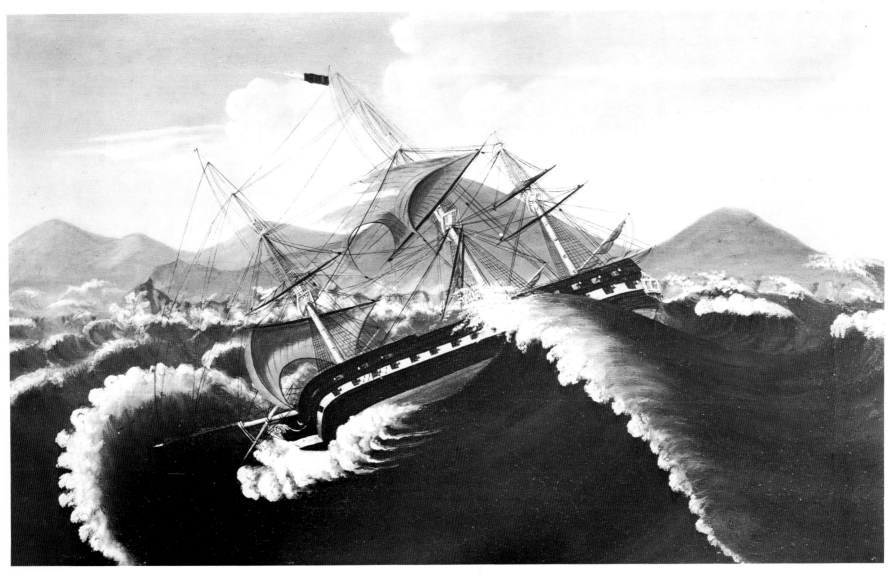

73. James Henry Wright, *U.S. Ship Constellation*, oil, 20 x 30″, c. 1833, possibly painted aboard ship, more likely ashore somewhere along eastern seaboard. Inscribed "Painted by J. H. Wright" and "U.S. Ship Constellation Capt. Reed. 16 Dec. 1833." Scene represents a rough passage through the channel separating two mountainous islands of the Grecian Archipelago, as recorded in the ship's log for December 16, 1833. Museum of Fine Arts, Boston; M. and M. Karolik Collection.

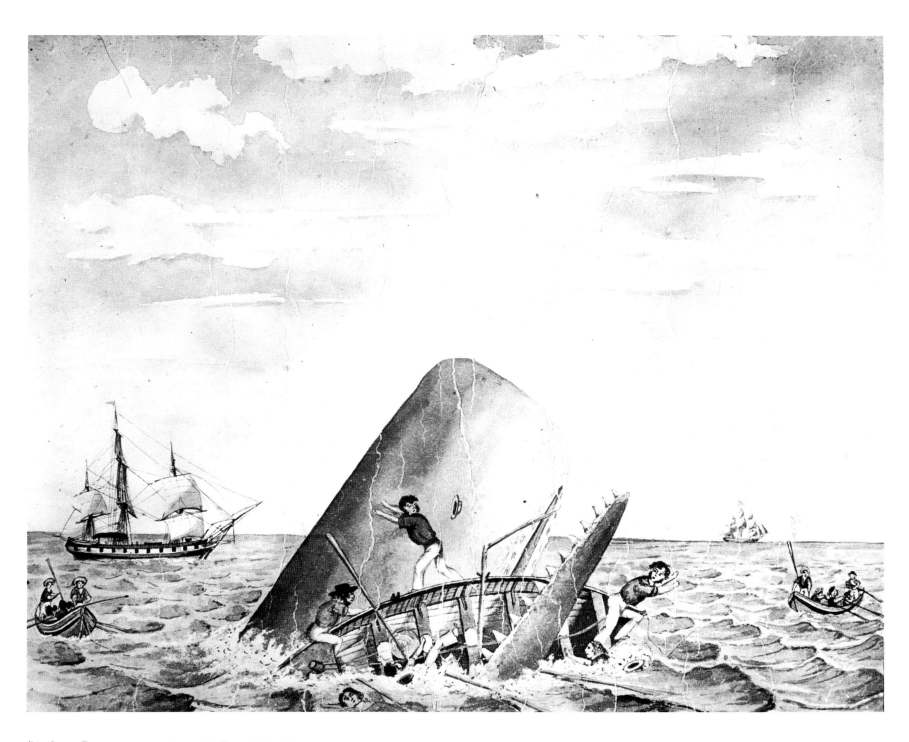

74. *Stove Boat*, watercolor, 9 x 11½", c. 1840, New
Bedford, Mass. Whaling Museum, New Bedford, Mass.

75. *Seaport Town*, oil, 28 x 36″, c. 1850, New England. Collection of Mr. and Mrs. Harvey Kahn.

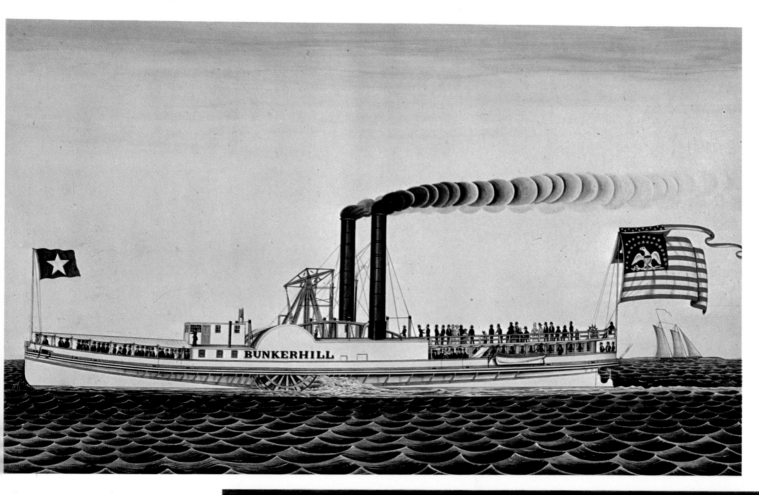

76. Jurgan Frederick Huge, *Bunkerhill,* watercolor and ink, 19 x 32″, 1838, Bridgeport, Conn. Inscribed "Drawn & Painted by J. Frederick Huge, 1838." Mariners Museum, Newport News, Va.

77. Coleman, *Coast of California,* chalk on board, 18⅜ x 28″, c. 1858, aboard ship. Inscribed on back of frame: "Ship 'Joseph Grinell' (built in Fairhaven, Mass., 1858) Captain William W. Thomas. This picture was crayoned on board the ship by mate named Coleman." Museum of Fine Arts, Boston; M. and M. Karolik Collection.

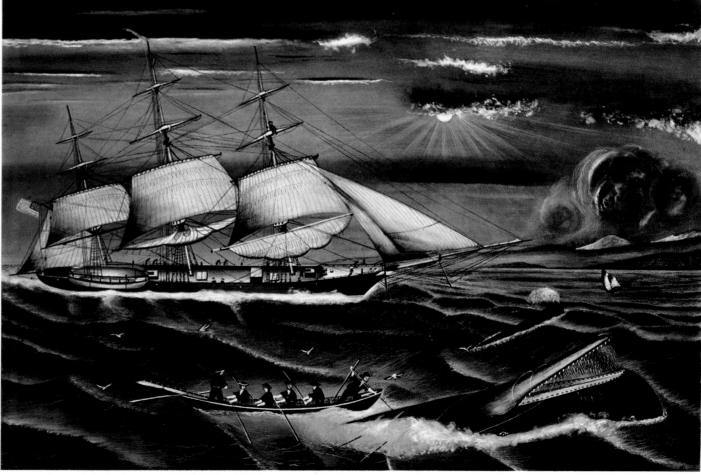

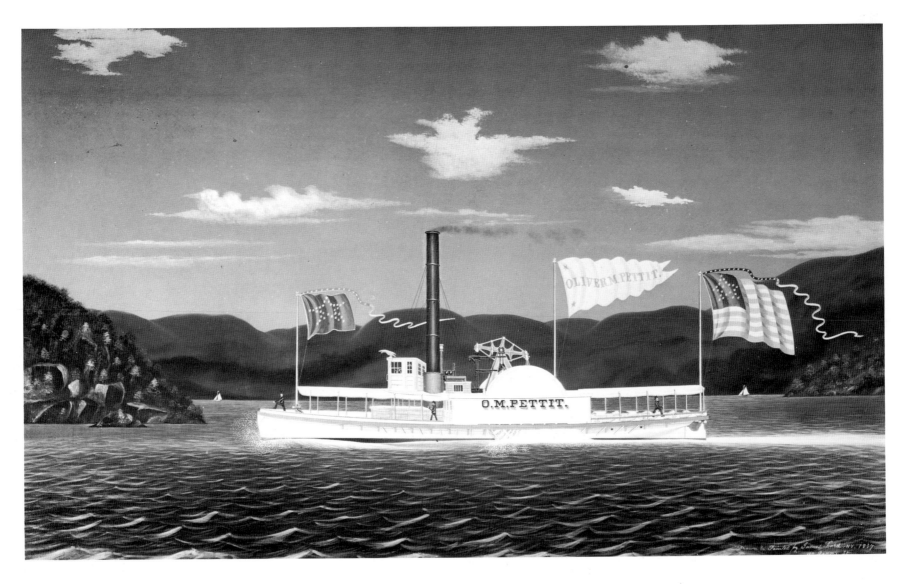

78. James Bard, *O. M. Pettit*, oil, 28 x 48″, 1857, New York City. Signed and dated at lower right. New-York Historical Society, New York.

OPPOSITE: 79. *The First Odd Fellows in America*, oil, 32½ x 37½″, c. 1850, found in Connecticut. History of beginning of Odd Fellows Lodge in America is written on sheets of paper mounted below painting. Collection of Bertram K. and Nina Fletcher Little.

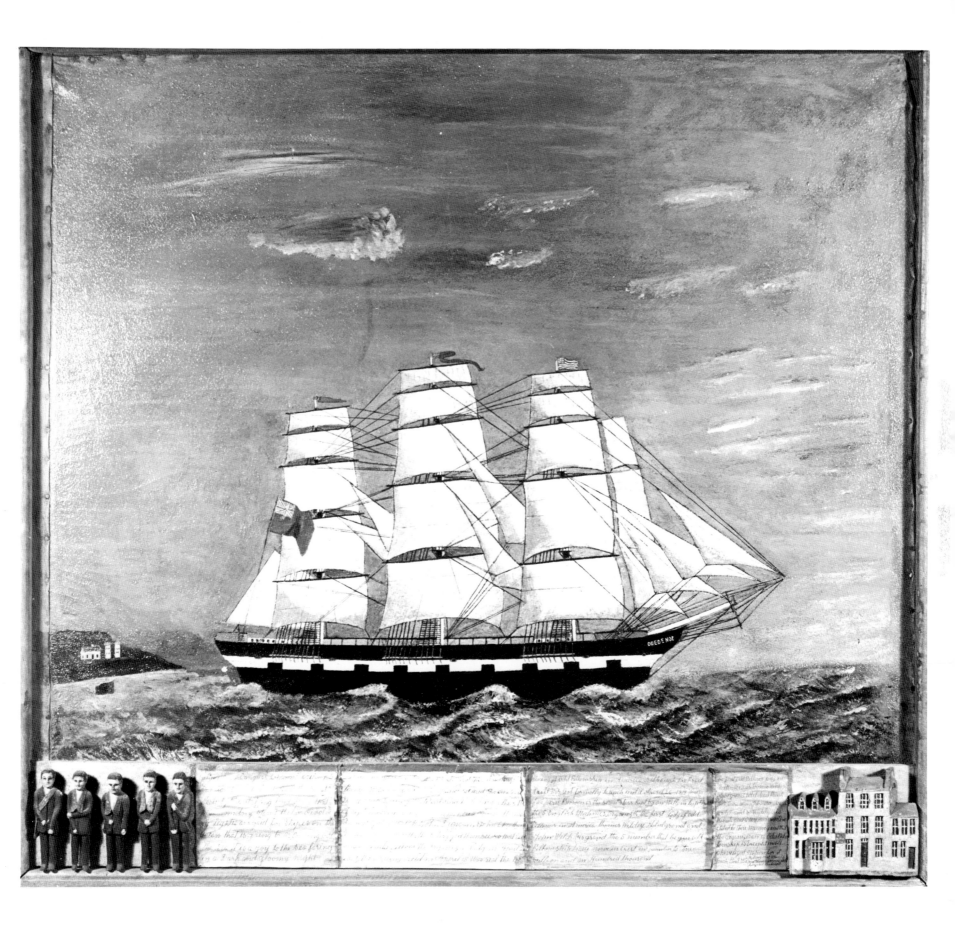

Americans can be grateful to the early folk artists not only for their considerable artistic legacy but for their lovingly detailed record of life in the first century of the nation's history. These everyday scenes, set down in the folk artist's straightforward style, are invaluable source material for the student of social history. For all of us they evoke a vision of a vanished way of life: how vividly we sense the conviviality of the quilting bee, the unabashed patriotism of the Fourth of July picnic, the excitement of the circus parade, the drama of the balloon ascent, and the leisurely pace of a Sunday sleigh ride in Maine or an outing on the scenic shores of an unpolluted Hudson River. Even death takes on a certain allure in the peaceful setting of the York Springs, Pennsylvania, graveyard.

The artists who painted these scenes were not recording them for posterity any more than they viewed their subject matter as quaint or nostalgic. By and large they made pictures for their own pleasure and chose their subjects from the life around them. We sense that they were as much participants as observers, for their works have a freshness and immediacy that set them apart from genre scenes by more sophisticated artists of the time or the popular mass-produced prints of Currier & Ives.

Susan Merrett is known only by her signature on the Fourth of July picnic painting, but we can imagine that this resident of Weymouth Landing, Massachusetts, recorded the scene from memory shortly after attending the town's great annual celebration. Her technique is what today would be called collage, for the tiny figures are actually cutouts, painted separately and painstakingly pasted onto a watercolor background.

Miss Merrett's uninhibited use of materials is typical of folk artists' nonacademic approach to their work. They used whatever techniques they wished: among the scenes shown here we find not only the conventional oils and watercolors but also fancy calligraphy, embroidery, painting on glass, monochromatic drawing. No one was self-conscious about borrowing from other artists. Research has uncovered an interesting fact: many folk paintings—*The Quilting Party*, for example—were copied from en-

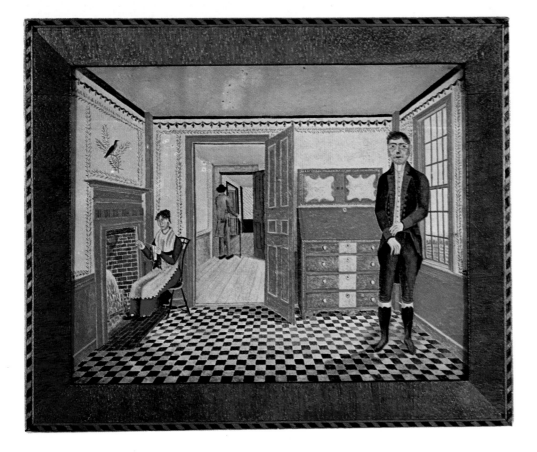

TOP: 80. *Man Feeding a Bear an Ear of Corn*, watercolor, 5¾ x 7½", c. 1870, Pennsylvania. Collection of Fred Wichmann.

LEFT: 81. Joseph Warren Leavitt, *Interior of Moses Morse House*, watercolor, 7 x 9", c. 1824, Loudon, N.H. Moses Morse was a cabinetmaker. Collection of Bertram K. and Nina Fletcher Little.

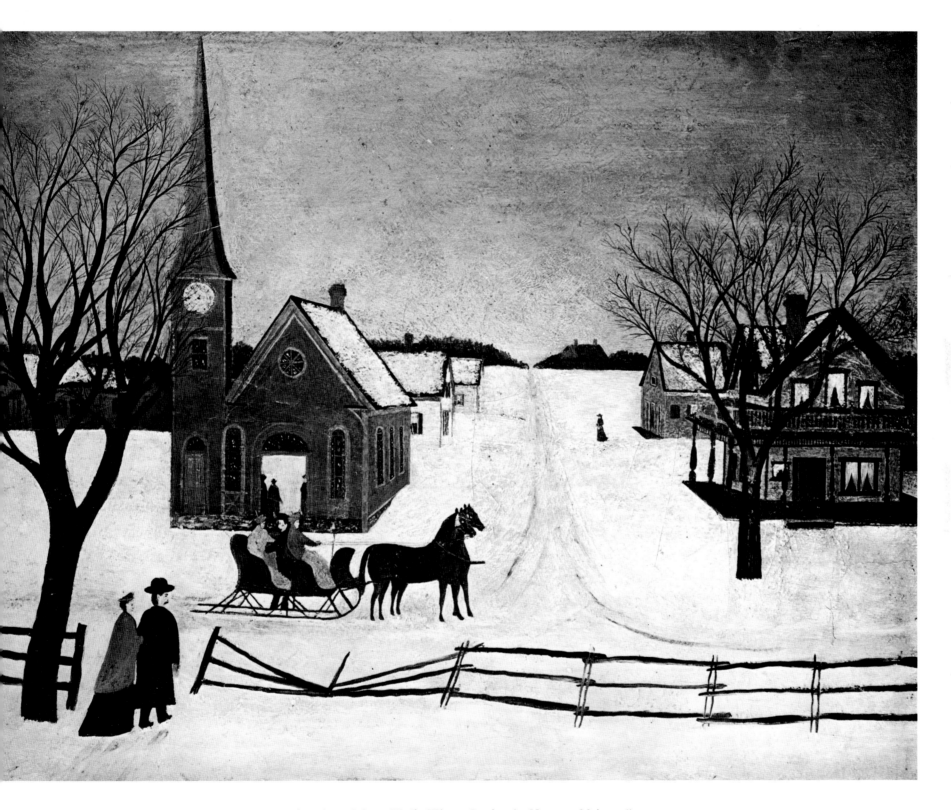

82. Attributed to Celesta Huff, *Winter Sunday in Norway, Maine*, oil, 21⅛ x 27⅛″, c. 1875, Norway, Me. Attribution based on analogy to a signed example. New York State Historical Association, Cooperstown.

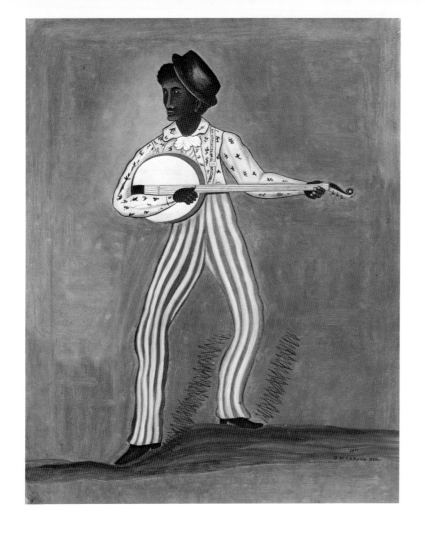

gravings of academic paintings or from magazine illustrations. It was from such mass-produced images that most of the artists of America's small towns and remote rural areas received their total art education. It is fascinating to follow a painting from an academic engraving to its final metamorphosis in the hands of a folk artist, and a study of the differences between the original and the folk "copy" reveals the essence of the folk artist's style. The compositions are simplified, forms flattened, movements restricted, outlines emphasized and colors sharpened. The separate units of the painting reflect the series of memory images in the artist's mind, which seem to be combined in a preconceived design rather than optically synthesized in the final representation. This is typical of the folk artist's style, whether the scene is drawn from his surroundings or distilled and re-created from an illustrated magazine just arrived in the mail.

84. *Holiday*, oil on glass, 17½ x 23½", c. 1870, found in New Jersey. New York State Historical Association, Cooperstown.

83. D. Morrill, *Banjo Player*, oil, 23½ x 19", 1860, found in New England. Signed and dated. Wadsworth Atheneum, Hartford, Conn.

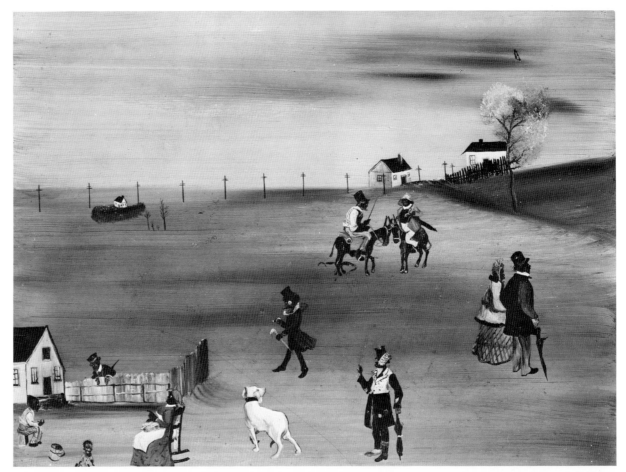

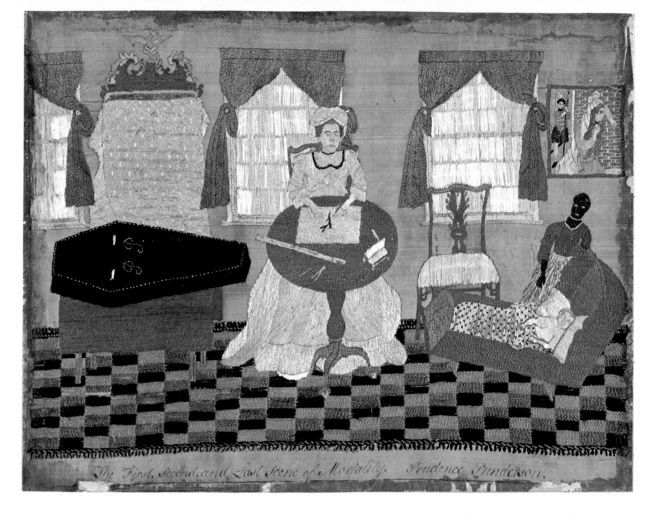

85. Prudence Punderson, *The First, Second, and Last Scene of Mortality*, silk thread on satin, 12¾ x 17″, c. 1775, Preston, Conn. Connecticut Historical Society, Hartford.

86. R. Fibich, *York Springs Graveyard*, oil, 18 x 24″, c. 1850, York, Pa. New York State Historical Association, Cooperstown.

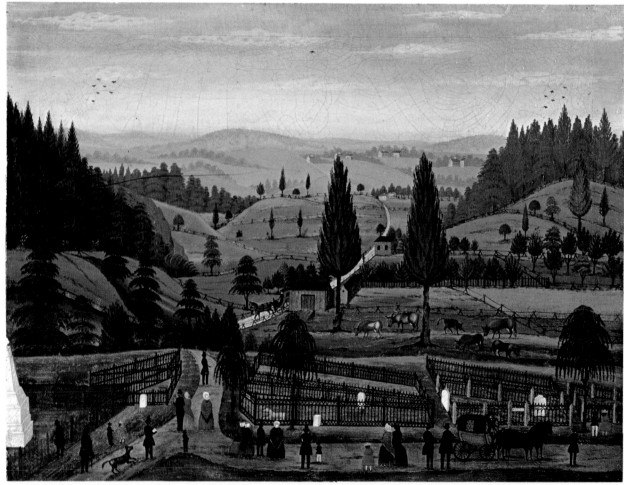

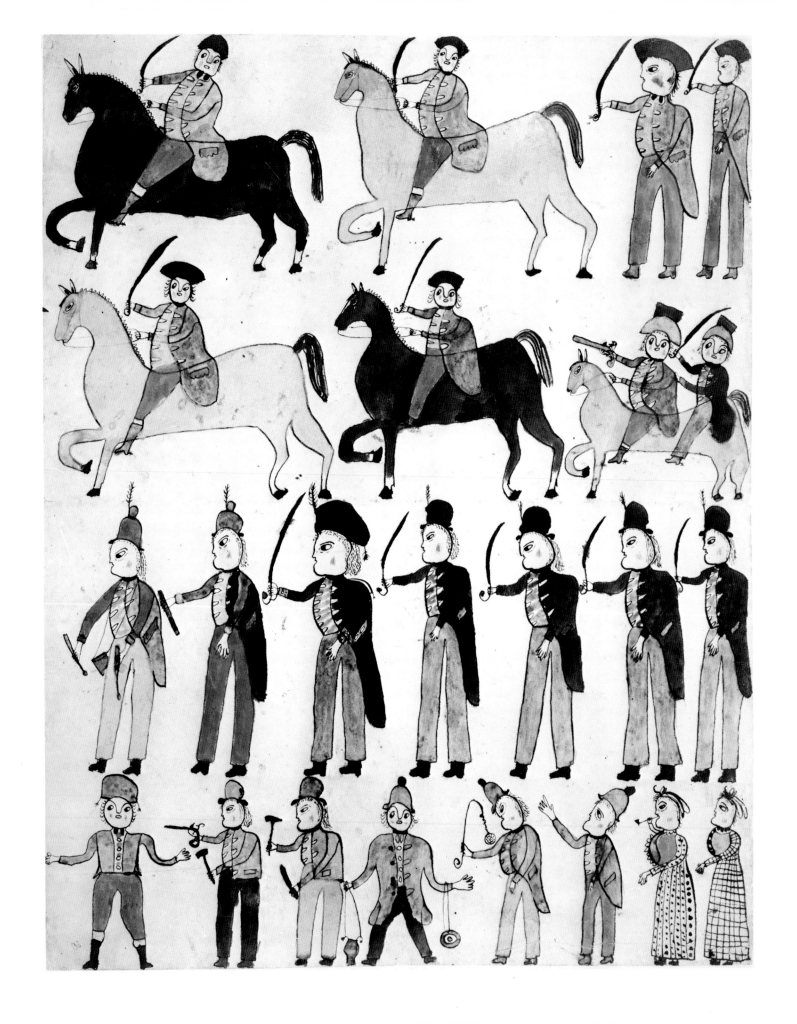

88. *Band Chariot*, colored inks and gold paint, 16 x 26″, 1850–60, probably New England. Collection of Mr. and Mrs. Peter H. Tillou.

OPPOSITE: 87. *Victory Parade*, ink and watercolor, 15⅝ x 12⅝″, c. 1790–1800, found in Ohio. Collection of Edgar William and Bernice Chrysler Garbisch.

89. *Balloon Flight*, charcoal and chalk on paper, 12½ x 15″, c. 1860, found in Wallingford, Conn. Collection of James Thomas Flexner.

90. Susan Merrett, *Fourth of July Picnic at Weymouth Landing*, watercolor and cut paper, 26 x 36¼", c. 1845, Weymouth Landing, Mass. Art Institute of Chicago.

91. *The Quilting Party*, oil on wood, 13¼ x 25¼", c. 1854, western Virginia. Based on an engraved illustration published in Gleason's *Pictorial* for October 21, 1854. Abby Aldrich Rockefeller Folk Art Collection, Williamsburg, Va.

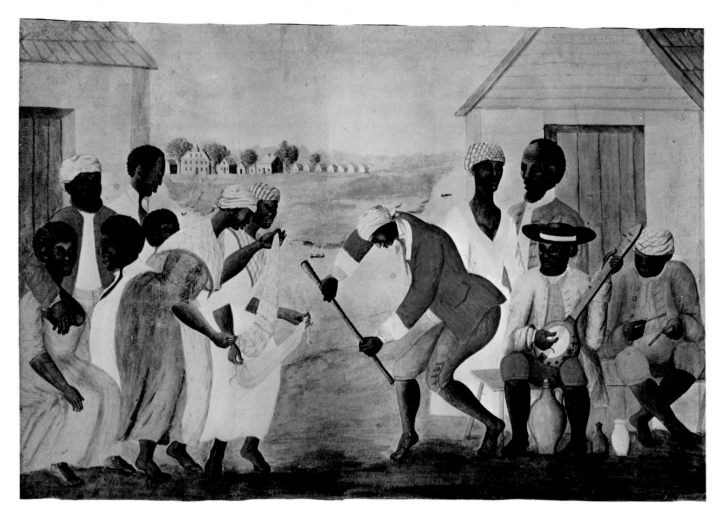

92. *The Old Plantation*, watercolor, 16 x 20″, c. 1800, found in Columbia, S.C. Abby Aldrich Rockefeller Folk Art Collection, Williamsburg, Va.

93. *Outing on the Hudson*, oil on cardboard, 19 x 24⅜″, c. 1876, found in Woodstock, N.Y. Abby Aldrich Rockefeller Folk Art Collection, Williamsburg, Va.

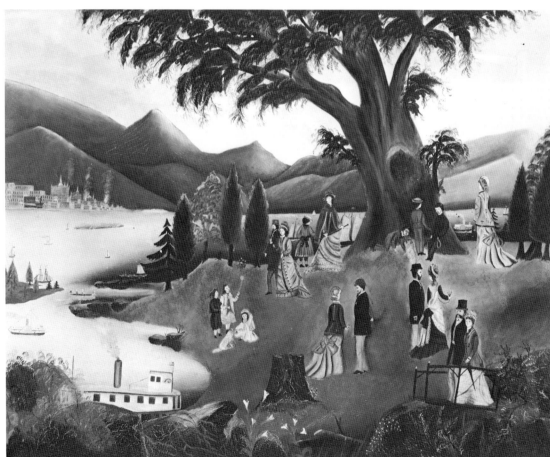

95. *Sailor*, oil, 23½ x 16⅜″, c. 1825, found in New York. Whitney Museum of American Art, New York; Gift of Edgar William and Bernice Chrysler Garbisch.

94. Henry Walton, *The Great Ithaca Fire of 1840,* oil on linen, 48 x 62″, c. 1840, Ithaca, N.Y. Firemen's parade banner; signed. Veteran Volunteer Firemen's Association, Ithaca, N.Y.

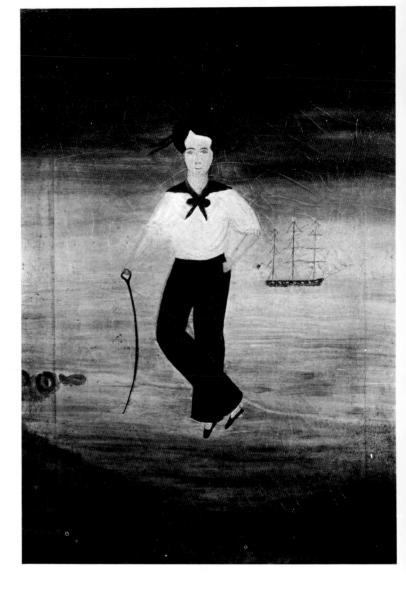

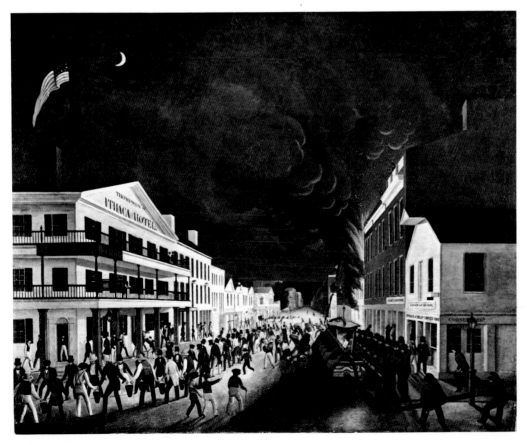

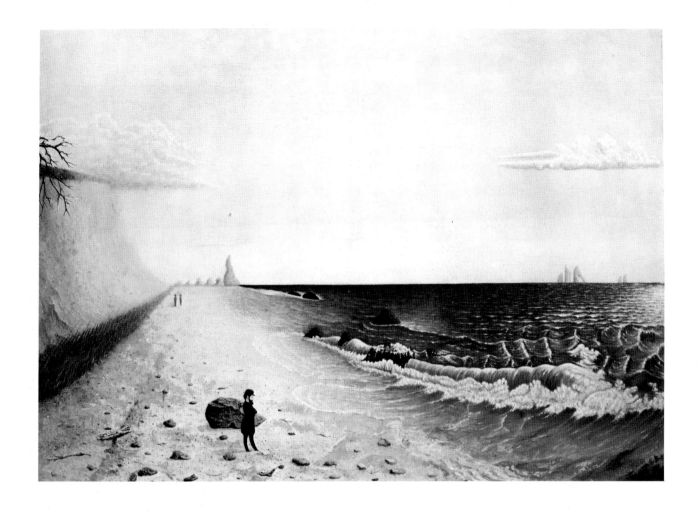

96. *Meditation by the Sea*, oil, 13½ x 19½″, c. 1855, probably northern New England. Museum of Fine Arts, Boston; M. and M. Karolik Collection.

97. *Charlestown Prison*, watercolor, 15¾ x 20½″, c. 1840, Charlestown, Mass. May have been painted by a prisoner. Privately owned.

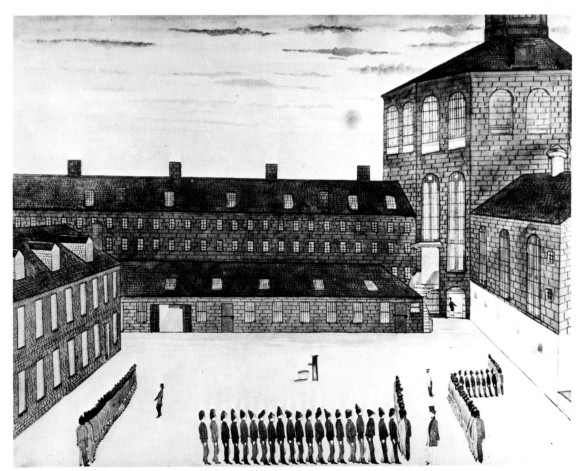

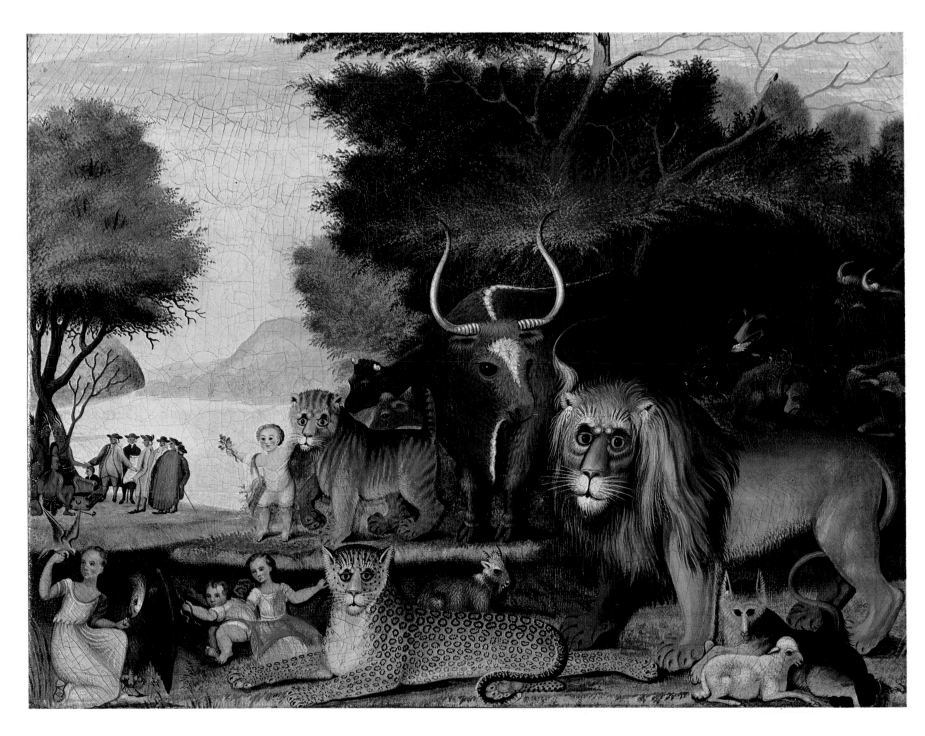

98. Edward Hicks, *The Peaceable Kingdom*, oil, 17¾ x 23¾", c. 1840, Newtown, Pa. Holger Cahill Collection.

RELIGIOUS, LITERARY
AND HISTORICAL SUBJECTS

No matter how far the folk artist's imagination ranged, his vision remained firmly rooted in the world around him. When he painted scenes from the Bible, mythology or the annals of history, faraway landscapes inevitably looked like the hills of home and the characters of the drama were often dressed more like fashionable ladies and gentlemen of the day than ancient Israelites or Greek goddesses. A true historical perspective was as hard to come by as a true visual perspective. As in all folk art, the specific subject was no more than a point of departure for these painters, and the finished work was more closely related to their mental picture than to nature, a model or a literary source.

Scenes from the Bible

For the strict Calvinists of New England as well as members of the evangelical sects that flourished in remote frontier areas, religion was the organizing principle of their lives, and the Bible was the source of their knowledge, culture and history. The stories of the Old Testament were read over and over, and for some Americans the trials and wanderings of the ancient Hebrews became a parable of their own search for religious and personal freedom in the wilderness of the New World.

Edward Hicks, a devout Quaker, saw William Penn's "holy experiment"—which resulted in the establishment of religious freedom and self-government in the colony of Pennsylvania—as a fulfillment of Isaiah's Old Testament prophecy: "The wolf also shall dwell with the lamb, and the leopard shall lie down with the kid; and the calf and the young lion and the fatling together; and a little child shall lead them." Hicks had been raised by a Quaker family following his mother's early death, and after a career as a coach and sign painter he became a Quaker preacher in Newtown, Pennsylvania. He never stopped painting, however, and the subject that fascinated him beyond all others was *The Peaceable Kingdom*. In almost one hundred canvases, many painted as gifts for friends, Hicks combined Isaiah's menagerie with a scene of Penn purchasing Pennsylvania from the Indians. Penn's dealings with the Indians were unique in the sorry history of relations between white and red men in America: as a Quaker, he could not take oaths, yet as Voltaire wryly remarked, Penn's was the only treaty between Christians and Indians that was "never sworn to and never broke."

In the version of *The Peaceable Kingdom* shown here, Hicks has filled the foreground with an exact pictorial

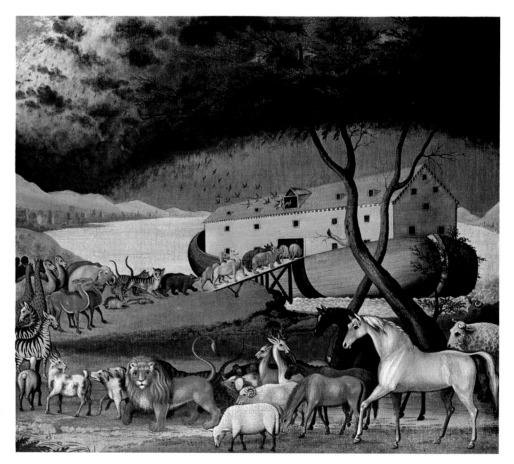

99. Edward Hicks, *Noah's Ark*, oil, 26½ x 30½", 1846, Newtown, Pa. Copied from the 1844 lithograph of the subject issued by Nathaniel Currier. Philadelphia Museum of Art.

rendition of the animals listed in the Biblical text; the historical happening is shown at a distance. His unhesitating combination of "events" that could never have taken place simultaneously is characteristic of folk artists, who did not feel themselves restricted by the demands of reality, visual or historical.

Hicks's vision of the ideal made real on the banks of Neshaminy Creek, a small stream near his home in Newtown, is full of personal symbolism; the style is distinctive—especially the portrayal of animals, who stare out from canvas after canvas with expressive, almost human eyes. Although his interpretation is totally original, Hicks—like many other folk artists—used popular prints and engravings as source material. The scene beneath the elm tree, in which Penn and his deputies, wearing broad black Quaker hats, present an enormous scroll to a band of Indians, is drawn from an engraving after Benjamin West's great historical canvas *Penn's Treaty with the Indians*. In this version of *The Peaceable Kingdom*, a kneeling woman in classical robes feeds an eagle from a cup; this figure seems to be modeled after *Liberty as the Goddess of Mercy* by

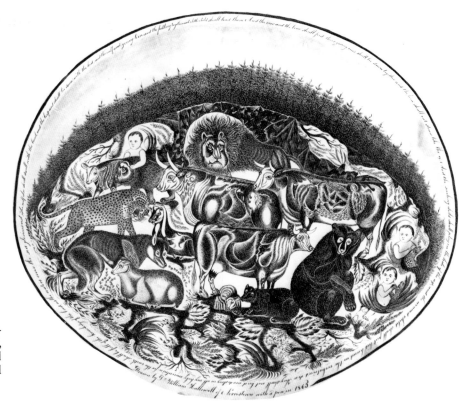

100. William Hallowell, *The Peaceable Kingdom*, ink, 15¾ x 19¾", 1865, Norristown, Pa. Signed and dated. New York State Historical Association, Cooperstown.

Edward Savage, one of West's less illustrious students. The two children closely resemble figures in a French print known to have hung in Hicks's home. Another instance of the artist's borrowing from printed sources is *Noah's Ark*, which is based on an 1844 lithograph by Nathaniel Currier, still in the possession of the painter–preacher's descendants. The composition follows the print, but Hicks has transformed the ark into a sturdy Pennsylvania barn, and in the sweeping procession of animals we quickly recognize the appealing felines of his *Peaceable Kingdom*.

During the nineteenth century the volume of illustrated books and popular periodicals grew under the impetus of rapidly developing printing technology, especially in the area of lithography. When an artist turned to printed sources for his subject matter, he often found illustrations that he incorporated in his compositions. Mary Ann Willson's painting of *The Prodigal Son Reclaimed* and Erastus Salisbury Field's religious canvases were modeled after engravings, but the results can hardly be classified as copies. Miss Willson's *Prodigal Son* is based on a series of popular prints by Amos Doolittle, but she reversed the composition, drastically simplified the figures, and rendered the whole in bold, startling colors made from the juice of berries, bricks and other native materials. This artist's life was as remarkable as her art: about 1810 she went to Greene County, New York, with her "romantic attachment," a Miss Brundage, and set up an unusual ménage on what was then the frontier. Apparently they were accepted by their neighbors, who helped Miss Brundage farm the land and bought Miss Willson's self-styled "works of art."

In his old age Field, whose talents as a portrait painter were rendered obsolete by the daguerreotype, turned to religion for consolation and to the Bible for inspiration. Like Hicks, he took the Scriptures as his point of departure, freely borrowed from other artists' versions of a scene and yet produced canvases that were completely his own. *The Garden of Eden*, for example, was modeled after a Bible illustration by an English artist, John Martin, with details borrowed from Jan Brueghel the Elder and Thomas Cole, both of whose works were known to Field through engravings.

No specific source has been found for Betsy B. Lathrop's watercolor of *Japhthah's Return*, but the Moorish-Gothic temple in the background has been recognized as the folly built at Stowe in Buckinghamshire, England, in the 1730s. Many popular prints depicted the beauties of this famous estate, and Miss Lathrop probably copied her temple from one of them. There is nothing in this scene to give us a hint of the bloody tale that inspired it: the Old Testament story of the warrior Jephthah who, in keeping with a vow to God, sacrificed his daughter upon his victorious return from battle. Miss Lathrop's scene is lighthearted and romantic: she was undoubtedly a schoolgirl, and the young women in her composition, dressed in the flowing neoclassical robes then in style, could be her classmates at a fashionable seminary.

Divine inspiration

The Shakers were original in everything they did, and in the middle years of the nineteenth century they produced a pictorial form unique among America's visual arts. Shaker furniture and textiles are widely known and admired today; less familiar are the inspirational drawings whose brilliant colors and exuberant draftsmanship present a dramatic contrast with the bare geometry of a Shaker room or table. The austere architecture and furnishings reflect a way of life that idealized simplicity and withdrawal from worldly things, but the drawings reflect the ecstatic mysticism of Shaker religious celebrations, during which the True Believers sang, fell into trances and performed the famous dances that gave the sect its name.

Officially named the United Society of True Believers in Christ's Second Appearing, the Shaker community was founded by Mother Ann Lee, who fled from England in 1774, bringing a tiny band of persecuted followers to Watervliet, New York. They lived communally, practiced celibacy and believed in equality of the sexes, as one might expect of a sect that believed Christ would return to earth in female form.

At its peak the sect had more than five thousand adherents who lived in nineteen communities scattered from Maine to Indiana. In 1837, almost half a century after the founder's death, a group of young girls in Watervliet was mysteriously entranced and announced Mother Ann's Second Coming. A spirit of revivalism swept the Shaker communities, expressing itself in song, dance, prose and a variety of inspirational drawings.

The Shakers, who believed in absolute simplicity in all their belongings, obviously had an ambivalent attitude toward these drawings. They were revered as divine revelations and in many cases lovingly preserved by their owners, yet it seems that they were never displayed publicly. Shaker writers are silent on the subject, save for a passing reference in 1843 to "many drawings, signs and figures of objects in the spirit world, with mysterious writing, etc. which will, it is said, at some future time be revealed & explained."

In the earliest examples, called Sacred Sheets, the text predominated, and was arranged in neat geometric compartments. Gradually the "drawings, signs and figures" increased in number and complexity, and the colors became brighter and more varied; the inscriptions—said to be messages from Mother Ann and other inhabitants of the spirit world—still continued to occupy a central place. Sometimes the messages, accompanied by decorative borders, were written on leaf- or heart-shaped cutouts called "rewards" and exchanged as gifts.

About mid-century the inspirational drawings reached their height in the communities of New Lebanon, New York, and Hancock, Massachusetts. Very little is known about the artists or their methods of work. Apparently the drawings were done by sisters of the order, such as Hannah Cohoon, one of the few Shaker artists who signed her work. Hannah lived in the "City of Peace," as Hancock was known to its members, and in her late fifties and sixties produced a remarkable series of watercolor drawings. The inscription on her *Tree of Life* implies that it was merely a copy of one that had been sent to her from the spirit world: "I received a draft of a beautiful Tree pencil'd on a large sheet of white paper. . . . Afterwards the spirit show'd me plainly the branches, leaves and fruit, painted or drawn upon paper. The leaves were chedk'd or cross'd and the same colors you see here." Although she made her drawing in July 1854, it was several months before its meaning was revealed, in supernatural fashion: "I entreated Mother Ann to tell me the name of this tree which she did Oct. 1st 4th hour P.M. by moving the hand of a medium to write twice over Your Tree is the Tree of Life." Her *Bower of Mulberry Trees* depicts a much more complex vision experienced during one of the ritual feasts held by the Hancock Shakers. According to the inscription, Hannah saw the Elders of the community feast on cakes at a table beneath mulberry trees and then leave the bower to drink from the small stream at right in the drawing.

The anonymous *Emblem of the Heavenly Sphere* was also painted in Hancock about 1854. Inscribed at the top are several verses describing "the world above/ where saints in order, are combined in love. . . ." The saints, virtually identical in expression and dress, appear in neat vertical columns with Mother Ann, her successor Father James, her brother William and Christopher Columbus in the top row. "The Saviour" comes next, directly below Mother Ann, and is followed by an array of Old and New Testament figures. Like Hannah Cohoon, this artist made extensive use of beautiful fruit-bearing trees. It is not surprising that these Shaker artists depicted the glories of heaven in terms of the beauties of the natural world, for the sect had a special feeling for nature. Shaker communities were situated in the unspoiled countryside, and one of their most profitable industries was the preparation of medicinal herbs and packaged seeds.

By about 1860 the Shaker revival had run its course. As the atmosphere of the communities changed, inspirational drawings ceased to be made, and a fascinating chapter in the history of American folk art came to a close.

In memoriam

Death was an all-too-frequent visitor to the early American household, and the rituals of mourning occupied an important place in everyday life. Grief was given visible shape in the memorial picture, an art form that was popular in the early decades of the nineteenth century, especially in New England. After George Washington's death in

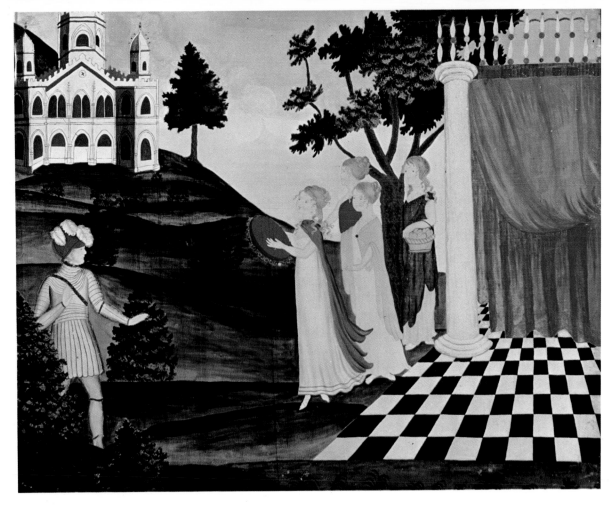

101. Betsy B. Lathrop, *Japhthah's Return*, watercolor on silk, 22 x 25¾″, 1812, New England, probably Massachusetts. Signed, dated. Abby Aldrich Rockefeller Folk Art Collection, Williamsburg, Va.

102. *The Prodigal Son Reveling with Harlots*, watercolor, 5 13/16 x 6 15/16″, c. 1790, probably Lancaster County, Pa. Abby Aldrich Rockefeller Folk Art Collection, Williamsburg, Va.

OPPOSITE: 103. Mary Ann Willson, *The Prodigal Son Reclaimed*, ink and watercolor, 12⅝ x 10″, c. 1820, Greenville, N.Y. National Gallery of Art, Washington, D.C.; Gift of Edgar William and Bernice Chrysler Garbisch.

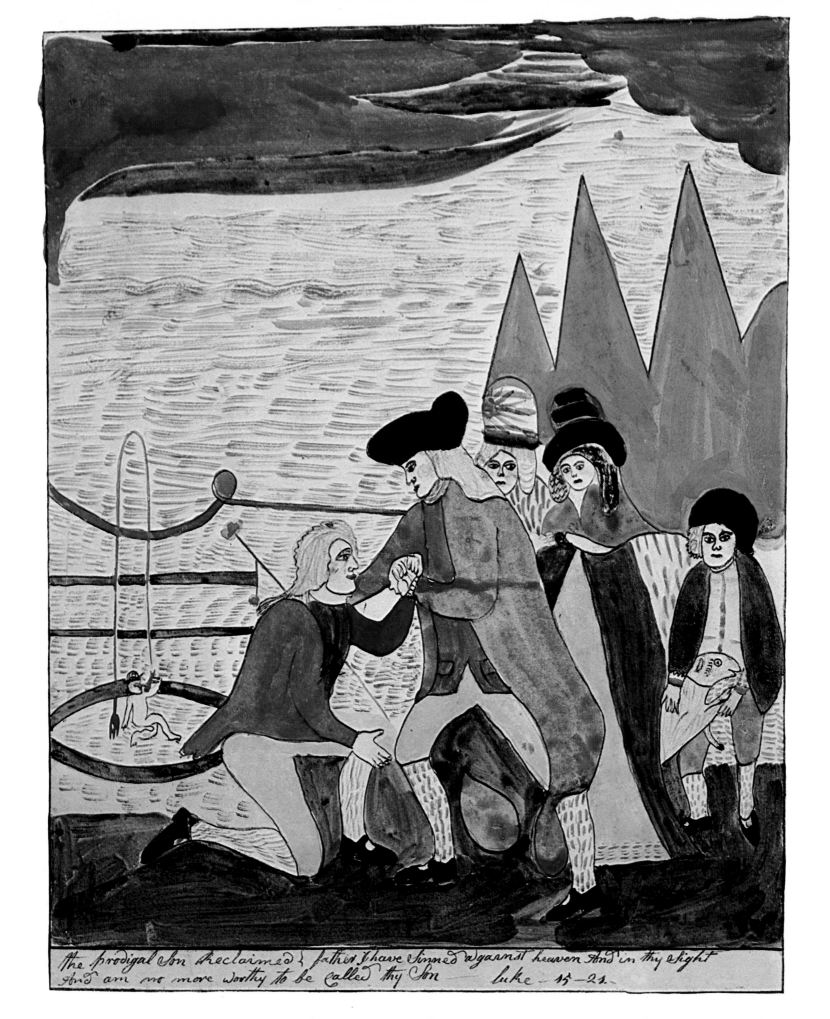

The prodigal Son Reclaimed & father I have Sinned against heaven And in thy Sight
And am no more worthy to be Called thy Son Luke - 15 - 21.

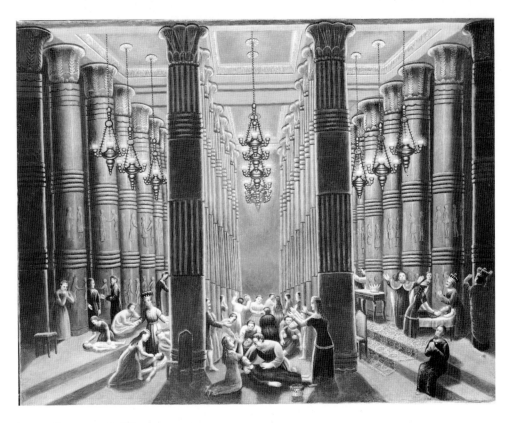

104. Erastus Salisbury Field, *The Death of the First Born*, oil, 35 x 46", c. 1875, Sunderland, Mass. Metropolitan Museum of Art, New York; Gift of Edgar William and Bernice Chrysler Garbisch.

1799 a large number of memorial pictures appeared, and these set the style for subsequent examples.

The memorial's practical function, in an age when there were no public records, was to set down for posterity the vital statistics of the deceased. The compositions adhere more or less to a standard formula, with a familiar array of props: the tomb surmounted by an urn, weeping willows, a group of sorrowing relatives, and in the distance a village, a few houses or a church. The memorials were the work of young women and originated as needlework creations. Soon, however, they began to use ink and watercolor, sometimes combining these with stitchery. Eventually the more laborious needlework technique was abandoned altogether, although its memory was preserved in stylized brushstrokes which, especially in the tree foliage and plant forms, exactly imitated stitchery. Memorials were generally made by relatives of the deceased as gifts for the family or close friends. A number, however, have been found without inscriptions, suggesting that they were prepared in advance and offered for sale. *The Orphans*, a mourning scene rather than a conventional *memento mori*, bears a notation of "$10 paid," a considerable sum in 1808.

As the nineteenth century progressed, the increased volume of printed material included lithographed memorials in a variety of designs with blank tombstones that could be filled in by the purchaser. Thus the memorial painting,

like many other folk arts, was rendered obsolete by technology. The surviving hand-painted examples are memorials not only to long-dead individuals but to a charming art form.

Scenes from literature and history

Two of the literary subjects shown here, like the Biblical scenes and memorials, were probably painted by young women as a part of their schoolwork. Almost identical examples of *Venus Drawn by Doves* have been found, indicating that this classical subject was assigned to a group of girls as a watercolor exercise. Another subject guaranteed to appeal to an educated young woman in the early nineteenth century was Goethe's Werther, who wooed but never won the beauteous Charlotte—and died of a broken heart in the process. Werther was the epitome of the romantic hero for an entire generation, and the novel describing his "Sorrows" was a best seller, as widely read in its day as it is forgotten in ours. The watercolor of Charlotte and Werther was probably inspired by an illustrated edition of the novel.

Schoolgirl paintings such as these and Besty B. Lathrop's Old Testament scene reflect both the artists' adolescent interests and the spirit of the times, when the romantic movement was at its peak. Regardless of subject matter, these works have a sentimental naïveté that is reinforced by their pale colors and delicate draftsmanship. Eunice Pinney's watercolors, by contrast, are the work of a mature artist whose outlook and intellectual formation belong to an earlier, more austere generation. In the first decade of the nineteenth century, when she took up painting in earnest, Mrs. Pinney was in her thirties, had been married, widowed and remarried and had borne three children. She brought to her work a bold draftsmanship, flair for design and dramatic sense, as well as a wide range of intellectual and literary interests. Her *Cotters Saturday Night* was inspired by an English engraving, but she undoubtedly knew Robert Burns's poem firsthand and endowed the scene with a dramatic intensity that captures the spirit of the poet's verse.

History painting was a major category of academic art in the eighteenth and early nineteenth centuries, and American academic painters like Benjamin West and John Trumbull won considerable fame for their depictions of the great events that marked their country's struggle for independence. Their compositions were copied by engravers and widely distributed, satisfying the citizenry's growing sense of national pride. The taste for historical scenes was shared by America's folk artists, who interpreted history in their own special idiom.

Frederick Kemmelmeyer's sweeping composition has a carefully lettered title stretching the width of the lower canvas, a device that appears in the engravings of the

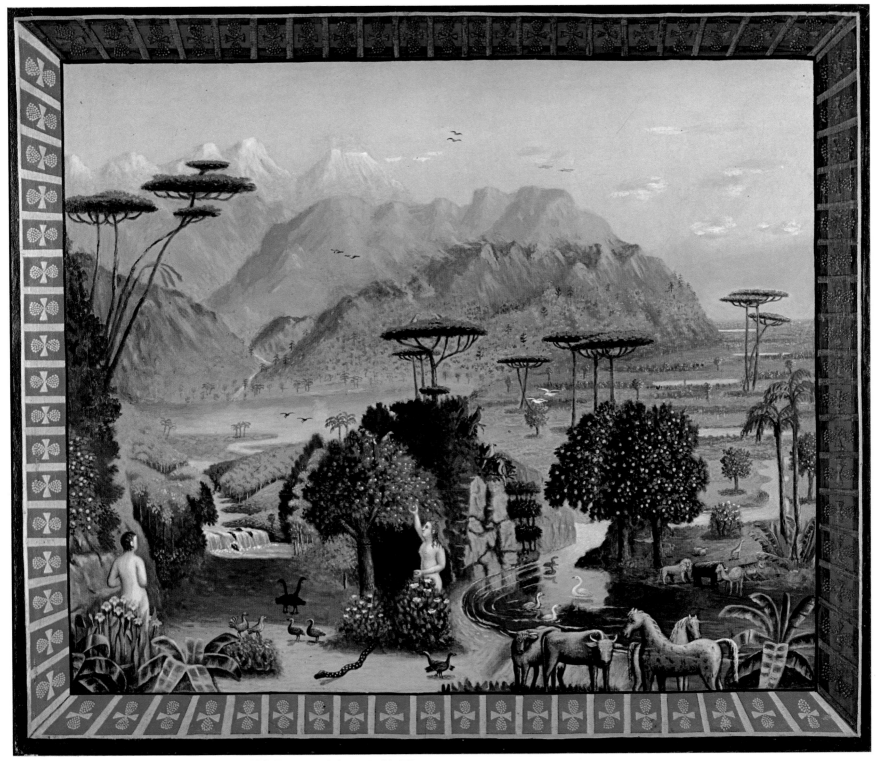

105. Erastus Salisbury Field, *The Garden of Eden,* oil, 35 x 41½″, c. 1860, Sunderland, Mass. *Trompe-l'oeil* frame a part of the canvas. Shelburne Museum, Shelburne, Vt.

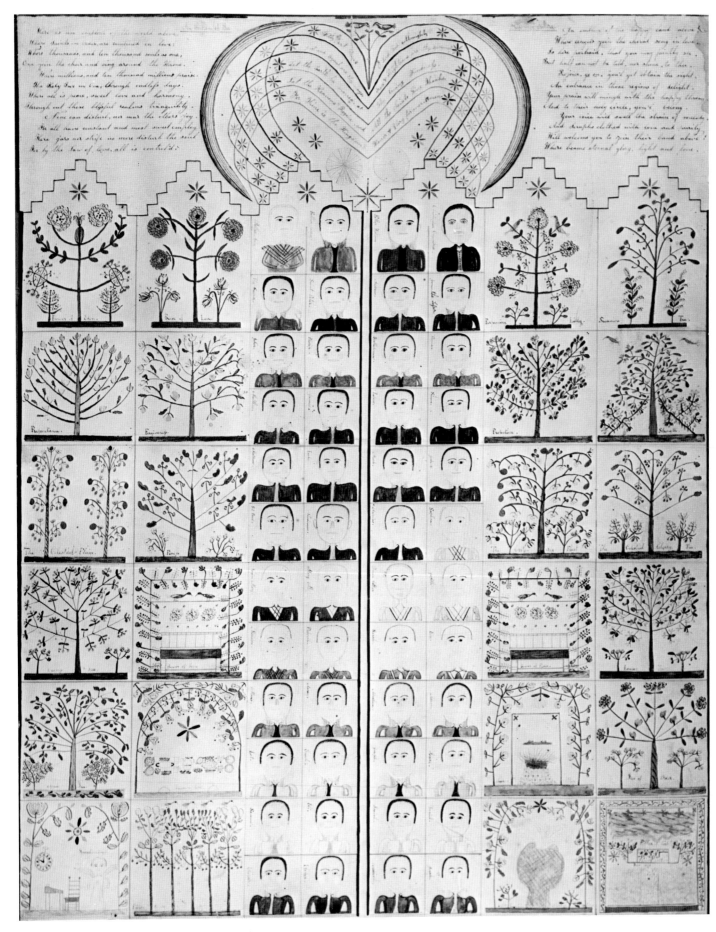

106. *An Emblem of the Heavenly Sphere*, watercolor, 24¾ x 18⅝″, c. 1854, Hancock, Mass. Shaker Community, Hancock, Mass.

OPPOSITE: 107. Hannah Cohoon, *A Bower of Mulberry Trees*, watercolor, 18½ x 23 1/16″, 1854, Hancock, Mass. Inscribed "Sept. 13th 1854. . . . Seen and painted in the City of Peace by Hannah Cohoon." Shaker Community, Hancock, Mass.

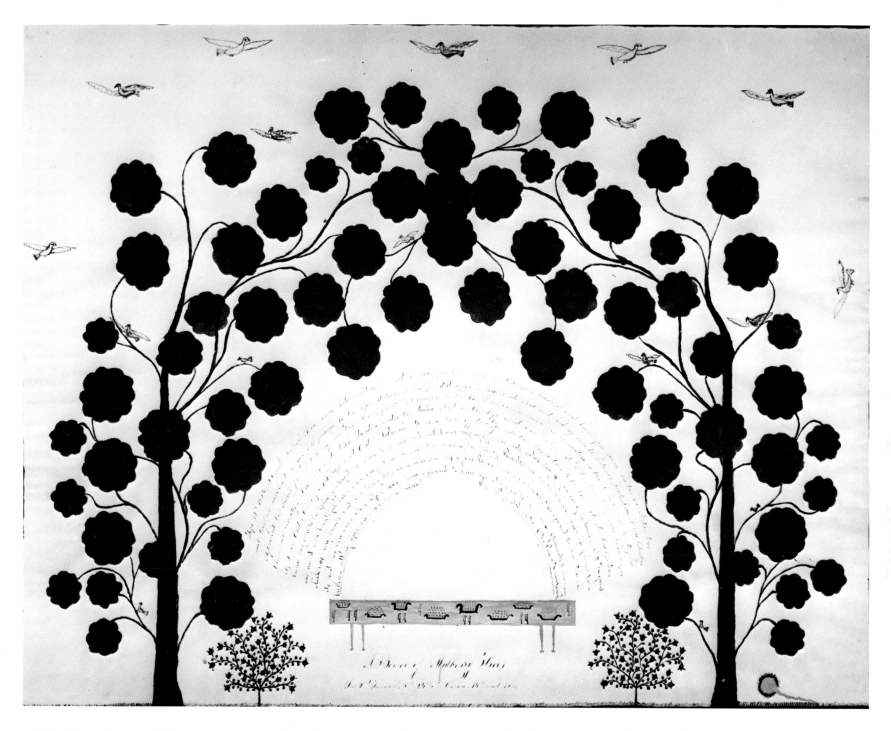

period. There the resemblance to conventional art forms ends. The figure of Washington on horseback assumes monumental proportions, dwarfing his toy-soldier army and giving visual form to the artist's feeling of awe for his country's first great hero. The ever-original Mary Ann Willson presents a naïve view of the father of our country in a watercolor where Washington looks rather like a toy soldier himself, seated stiffly on his horse and discharging his pistol in the air.

The Civil War was the first in American history to be documented by photographers and battle artists, whose sketches were reproduced in newspapers and illustrated weeklies. One such illustration was probably the point of departure for the unknown artist of the animated Civil War painting shown here. Whatever the source, and regardless of the amusing naïveté, this battle scene is reconstructed with a sure instinct for color and design that might be the envy of a sophisticated historical painter.

108. Hannah Cohoon, *Tree of Life*, ink and tempera, 18⅛ x 23 5/16″,
1854, Hancock, Mass. Inscribed "City of Peace Monday July 3ʳᵈ 1854."
Shaker Community, Hancock, Mass.

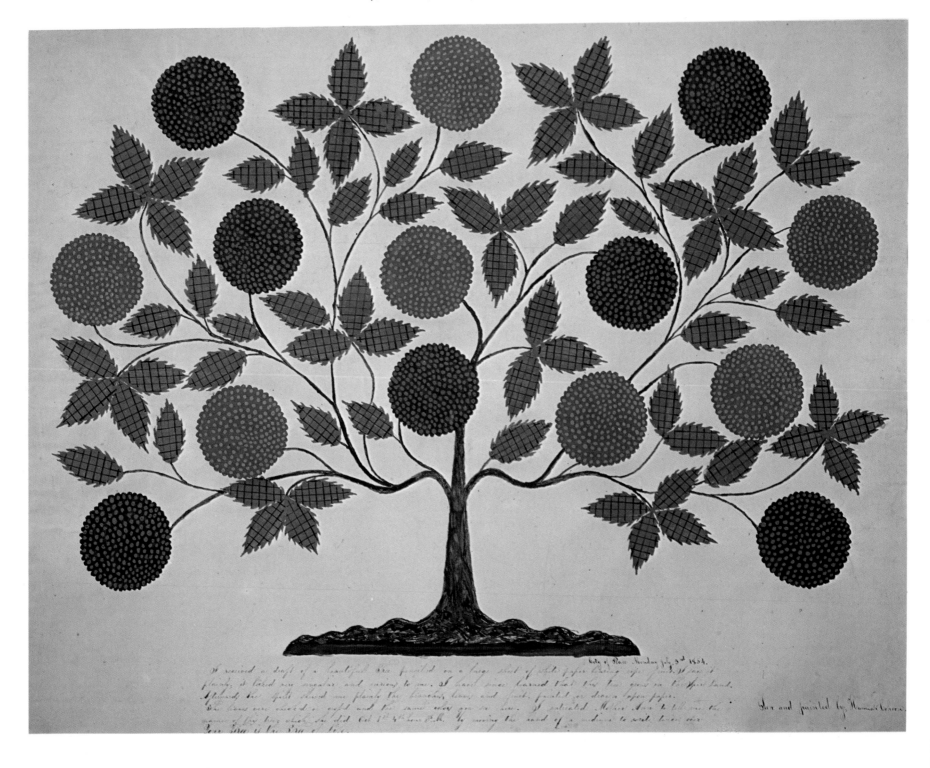

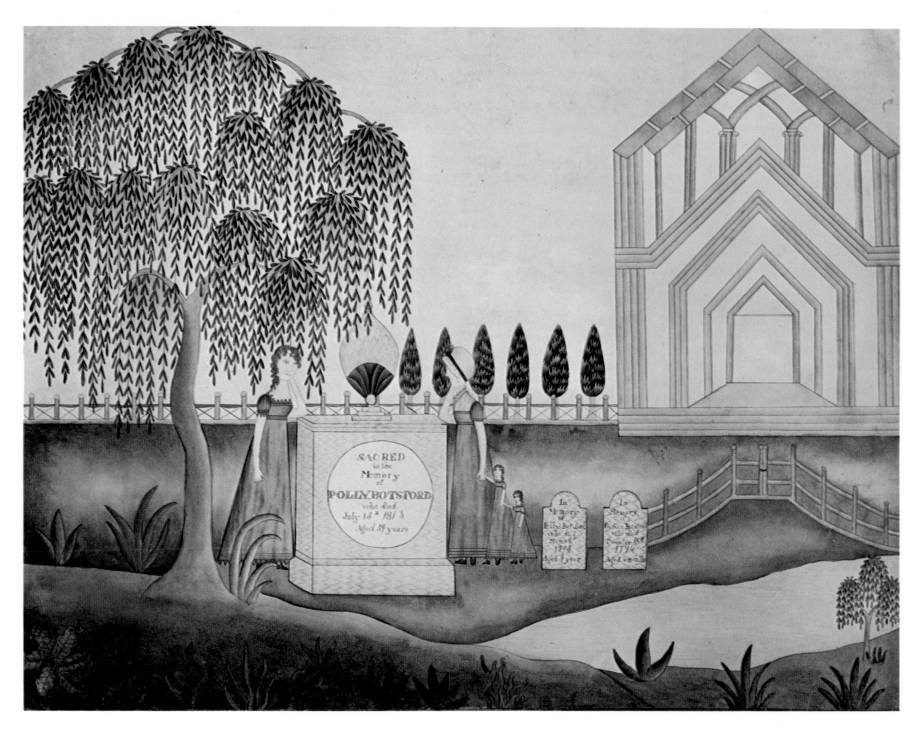

109. *Mourning Picture for Polly Botsford and Her Children*, watercolor,
18 x 23½″, c. 1813, found in Connecticut. Abby Aldrich Rockefeller Folk
Art Collection, Williamsburg, Va.

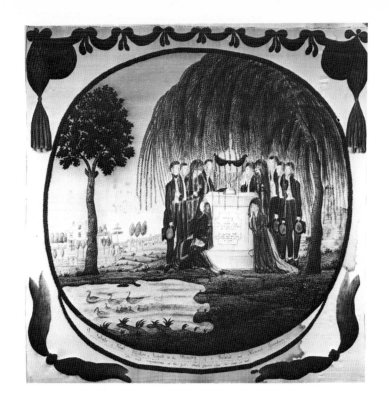

110. Anna Maria Holmes, *Mourning Picture for Wm. Card Esqr.*, ink and needlework on silk, 20¼ x 20¾", c. 1820, New England. Old Sturbridge Village, Sturbridge, Mass.

111. *Memorial for George H. Hills*, ink and stenciled and sponged watercolor, 17¾ x 22⅝", 1839, found in Massachusetts. National Gallery of Art, Washington, D.C.; Gift of Edgar William and Bernice Chrysler Garbisch.

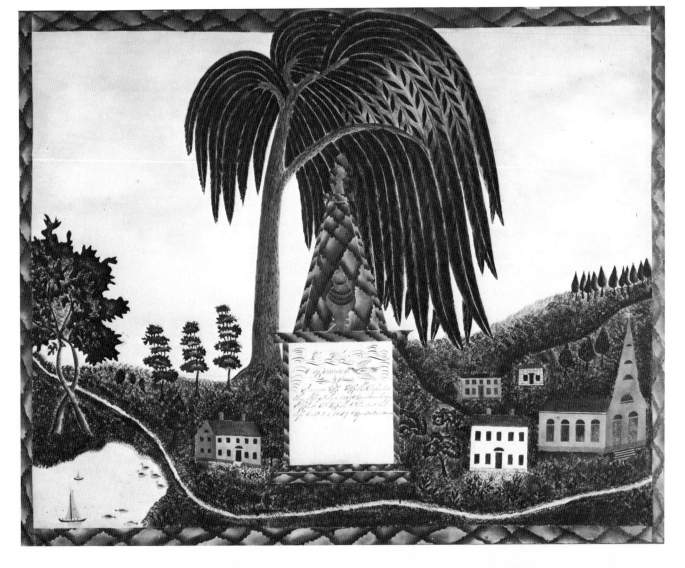

OPPOSITE: 113. *Memorial for Mrs. Ebenezer Collins*, velvet, metallic braid, ink on paper, embroidery and watercolor on satin, 17½ x 17½", 1807, South Hadley, Mass. Inscribed "So. Hadley July 15 1807." Collection of Howard and Jean Lipman.

OPPOSITE, FAR RIGHT: 114. Harriett Moore, *Memorial for Nancy and Fanny Richardson*, watercolor, 17¼ x 23", c. 1817, Concord, Mass. New York State Historical Association, Cooperstown.

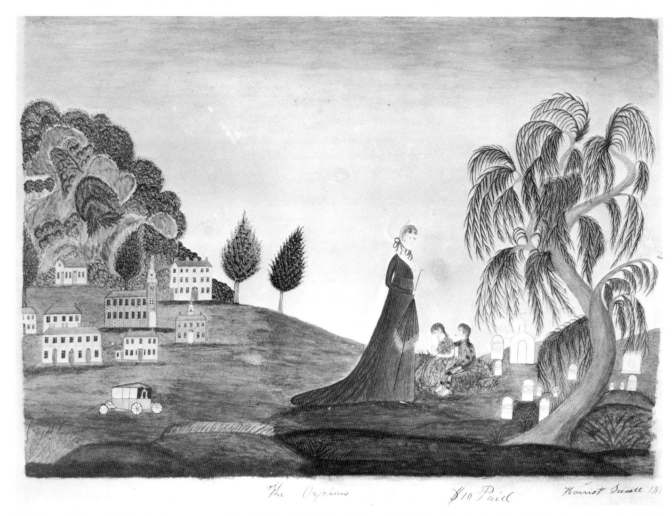

112. Harriot Sewall, *The Orphans*, watercolor, 14¾ x 21 5/16″, 1808, probably New England. Signed, dated and inscribed "$10 Paid." Museum of Fine Arts, Boston; M. and M. Karolik Collection.

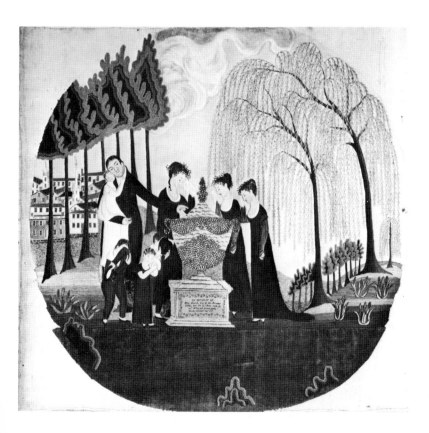 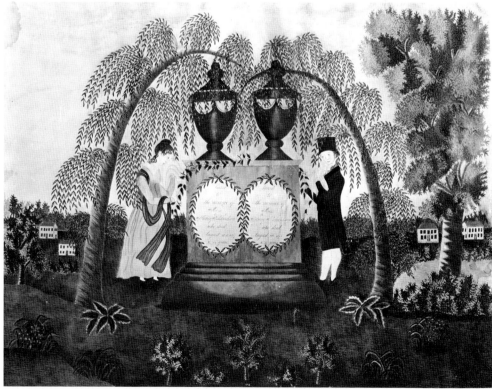

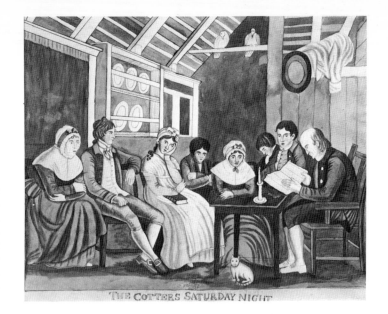

THE COTTERS SATURDAY NIGHT

115. Eunice Pinney, *The Cotters Saturday Night*, watercolor, 12⅛ x 14⅝″, c. 1815, Windsor, Conn. Based on an English engraving illustrating Burns's poem. National Gallery of Art, Washington, D.C.; Gift of Edgar W. and Bernice Chrysler Garbisch.

OPPOSITE: 117. Attributed to Betsy B. Lathrop, *Venus Drawn by Doves*, watercolor and cut paper on silk, 15¾ x 15½″, c. 1815, found in Quincy, Mass. Attribution based on analogy to a signed example. Abby Aldrich Rockefeller Folk Art Collection, Williamsburg, Va.

116. *Prince Ruperts Hunting Lodge, from Charlotte & Werter,* watercolor, 9⅛ x 13⅜″, c. 1810, possibly Virginia. One of a pair; the other painting is of Mount Vernon. Collection of Burton E. Purmell.

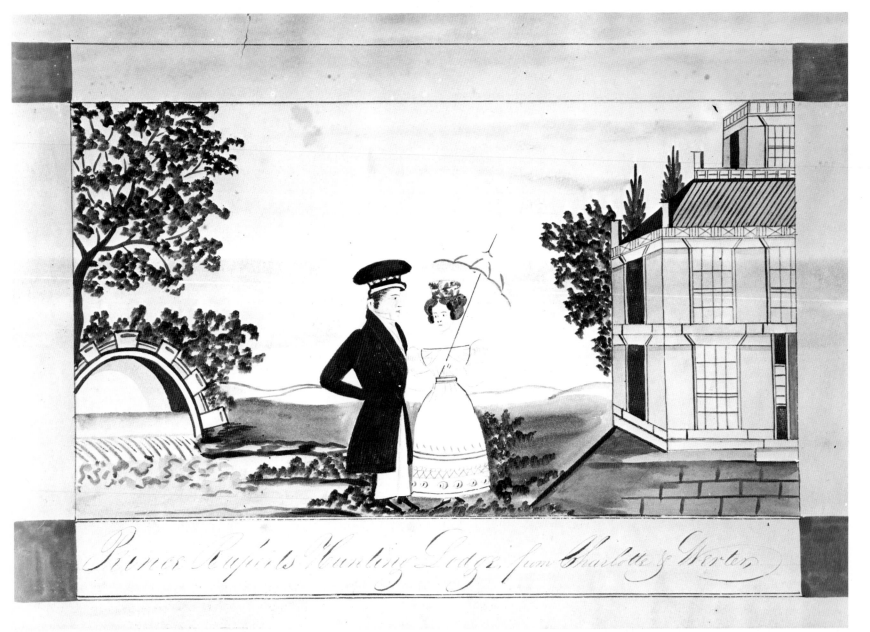

Prince Ruperts Hunting Lodge, from Charlotte & Werter

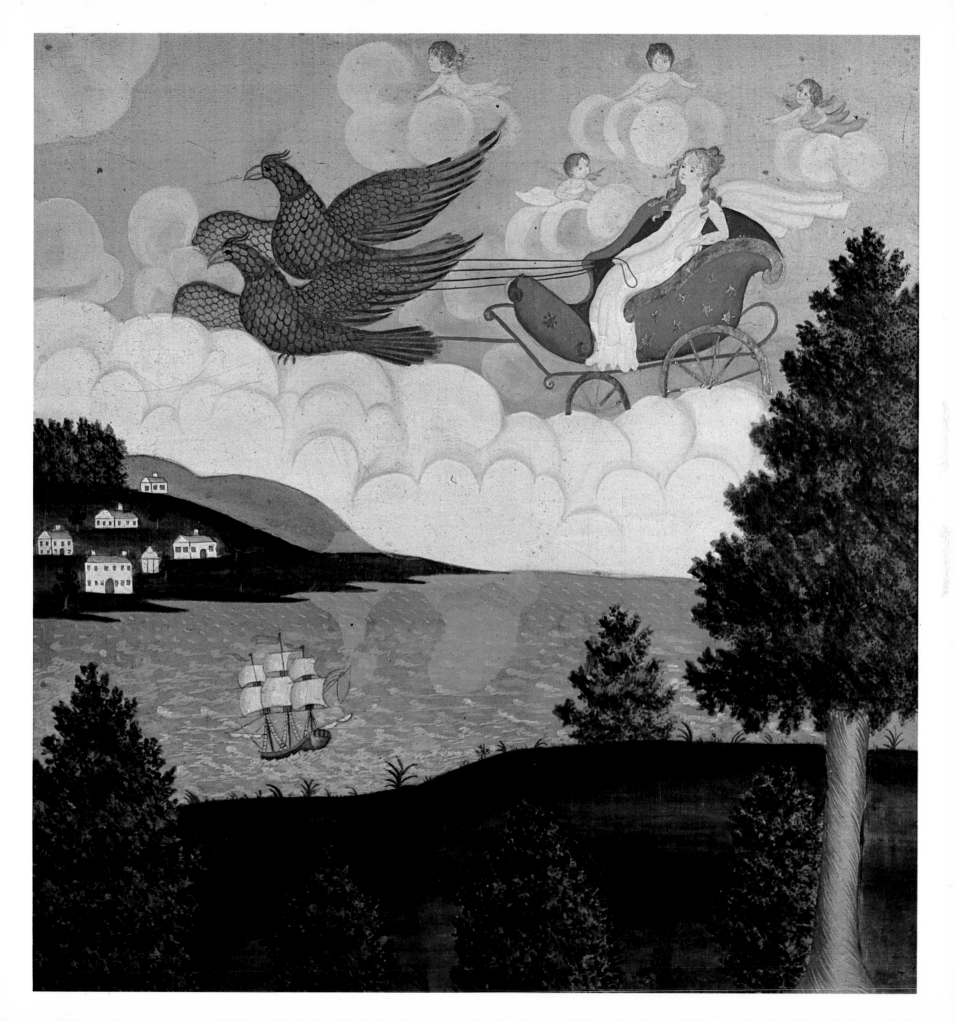

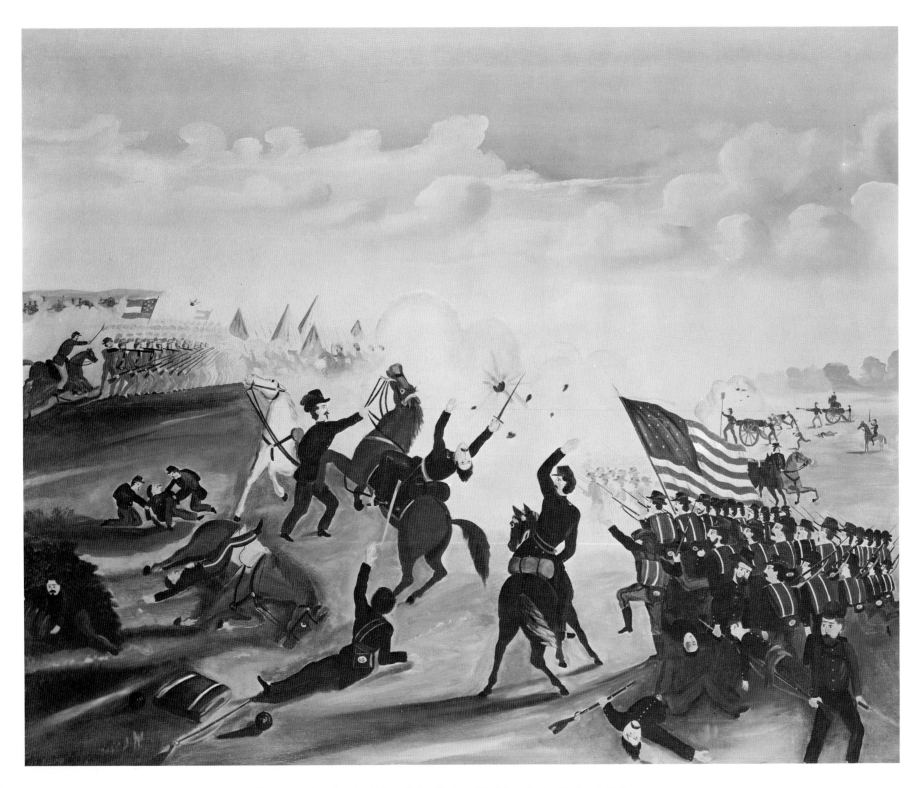

118. *Civil War Battle*, oil, 36 x 44″, c. 1861–65, found in New York. National Gallery of Art, Washington, D.C.; Gift of Edgar William and Bernice Chrysler Garbisch.

119. Mary Ann Willson, *General Washington*, watercolor, 12¼ x 15⅝", c. 1820, Greenville, N.Y. Museum of Art, Rhode Island School of Design, Providence.

120. Frederick Kemmelmeyer, *Gen¹; Geoᵉ; Washington. Reviewing the Western Army at fort Cumberland sepembʳ; 19ᵗʰ 1794*, oil, 18 x 23", c. 1794, Baltimore, Md. Signed. Formerly collection of Hall Park McCullough.

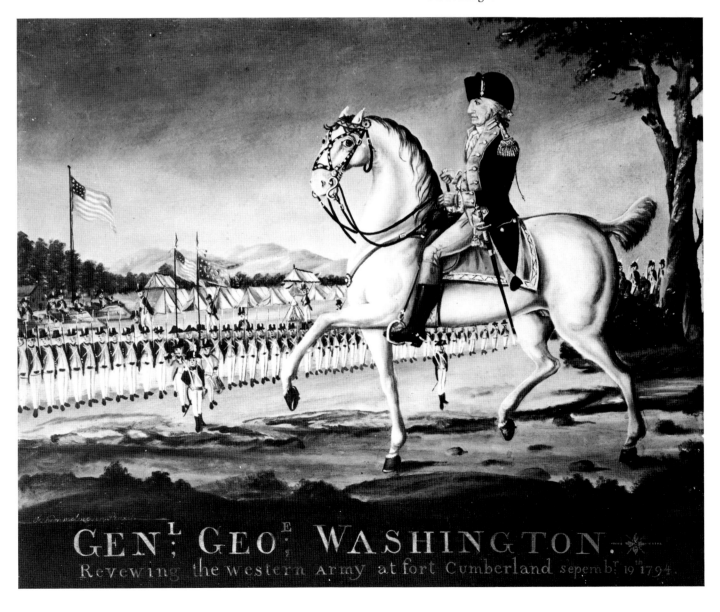

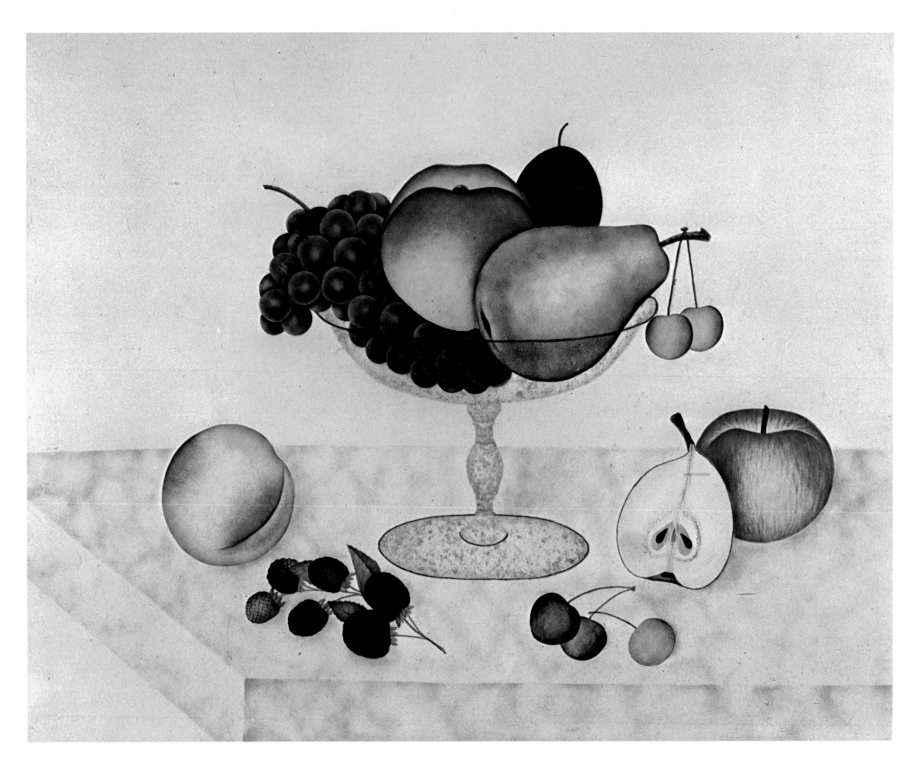

121. Emma Cady, *Fruit in Glass Compote*, water-
color and mica, 16 x 19½″, c. 1820, New Lebanon,
N.Y. Abby Aldrich Rockefeller Folk Art Collection,
Williamsburg, Va.

STILL LIFE, CUTOUTS
AND SAMPLERS

Women are well represented among America's folk artists. Indeed, mastery of many kinds of handiwork was once considered an essential feminine accomplishment, and no young lady's education was complete without instruction in needlework, drawing and painting. In the year 1834 a Mrs. Smith of West Chester, Pennsylvania, invited the town's residents to send their daughters to her newly opened school where they could receive, for a modest fee, "instruction in Reading, Writing, Arithmetic, History, Geography, Grammar, Composition, and Needle-work." For an additional eight dollars, lessons in drawing and painting were available. Throughout the new country, schools such as these multiplied, a sure index of America's growing prosperity and of its womenfolk's increased opportunities for leisure-time activities. No longer harnessed to the pioneer household's endless round of chores, daughters of well-to-do families attended female seminaries, day schools such as Mrs. Smith's and countless specialized classes, many of which were conducted by itinerant instructors. For women everywhere, there were do-it-yourself aids in the form of instruction books, some of which were so popular that as many as ten editions were published; "drawing cards" were sold in decks, each one printed with a study suitable for copying; and for the not-so-skilled painter there were ready-made stencils. Later in the nineteenth century ladies' magazines appeared, and these usually included a regular feature on arts and crafts with step-by-step instructions for the home artist.

Still life and "fancy pieces"

For schoolgirls and housewives desiring "fancy pieces" as gifts for friends or to brighten the home, the still-life composition was a perennial favorite. Homely symbols of abundance—the groaning board, a basket overflowing with fruit, a vase of flowers—were painted in watercolor or oil on fabric as well as on paper. For a time velvet painting was the rage, and sometimes silk or satin was used to achieve a luxurious effect.

The still-life compositions shown here all exhibit the stylization that is characteristic of American folk art. Rather than being spontaneously drawn from nature, these paintings were constructed bit by bit, according to specific formulas. Sometimes the artist "arranged" her painted fruits in a painted bowl, using stencils to render each element. Some artists—were they more gifted or simply too impatient to work with stencils?—sketched their compo-

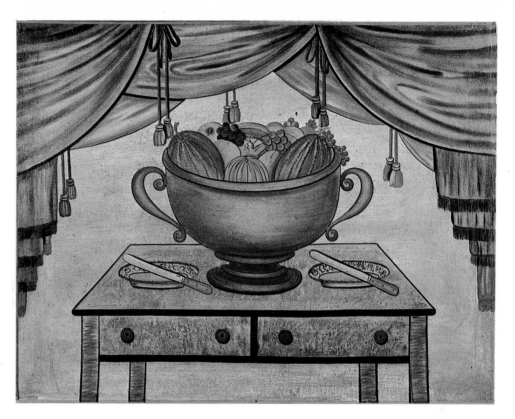

122. *Bowl of Fruit with Plates*, oil, 29 x 38", c. 1835, found in Windham, Conn. New York State Historical Association, Cooperstown.

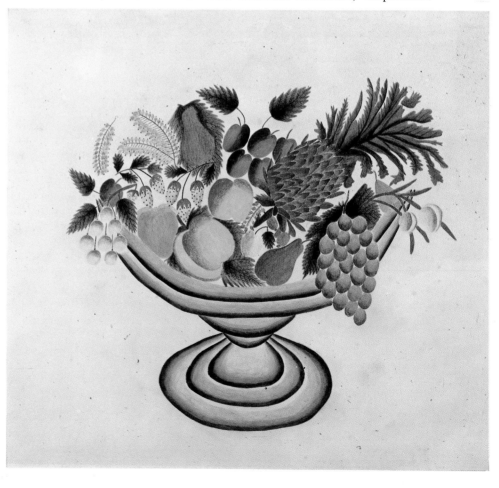

123. *Fruit in Blue Compote*, watercolor, 13⅜ x 15¾", c. 1840, probably New York or New England. Abby Aldrich Rockefeller Folk Art Collection, Williamsburg, Va.

sitions freehand, in careful imitation of stenciled still lifes or of popular prints such as those by Currier & Ives. Multiple examples of the same subject have been found—*Bowl of Fruit with Plates*, a large oil canvas from Connecticut, has an almost exact twin—indicating that once the artist found a successful formula, it was repeated with only minor variations.

Whether they worked with stencils or copied printed sources, these still-life artists achieved results that were far from mechanical. Moreover, their method of painting was anything but a casual affair. Serious young women devoted the same painstaking efforts to their painting that they bestowed on fine needlework. A typical lady's painting portfolio—several of which have been preserved intact—included study notes, color samples and practice sheets, colored prints for use as models, a large number of stencils, detailed tracings with full color notes, drawing paper, oiled paper and tracing paper. The artist often prepared her own tracing and oiled papers, ground and mixed her paints and—if she was skillful with scissors—cut her own stencils and assembled them into a theorem, as the finished design was called.

Stencils were also used for other paintings which were not, strictly speaking, still life. *Exotic Bird and Fruit* is akin in spirit and style to the "fancy pieces" and was probably created for the same decorative purpose. *Bear in Tree*, a diminutive watercolor found in Texas, was executed in part with stencils, as can be seen in the crisp outlines of the animals and the grass, and in the identical, but reversed, images of tree trunks at left and center of the composition.

Paper cutouts

The same precisionist technique required for cutting still-life stencils is apparent in the decorative cutout scenes and the valentine collage shown here. Only a hard heart and a jaded eye could have resisted this dynamically symmetrical design composed of cutout hands, decorated with hearts and bands of colored papers ingeniously threaded through slits. The cutout animal scene is a dazzling display by an anonymous virtuoso of the scissors. Still visible at the center is the line where the sheet of paper was folded. The design was traced on the folded paper and carefully cut out with fine scissors or possibly a sharp blade. Unfolded, the paper presents a neat composition of mirror images embellished with pinpricked holes and cleverly varied with watercolor painting. At the bottom of the composition, for example, the figures on dogback have identical contours, but one has been painted as a lady in a hoop skirt and the other as a gentleman in a fine waistcoat. The other cutout scene presents the viewer with an even more tantalizing hide-and-seek game. Careful study reveals that the entire "frame" was cut from folded paper, while the central figures, which strongly resemble the work of the popular silhouette cutters, were clipped out separately, painted, and pasted within the frame. The eagle at the top, also a separate cutout, and the flag rendered in watercolor add patriotic touches to the scene.

Samplers

Drawing and painting might have been optional features in a young lady's education, but needlework was a practical necessity and, as such, was an integral part of every basic school curriculum. Young girls learned "plain" sewing, mending and basic embroidery stitches at home, as they helped their mothers make and mend clothing and mark the household linen. After only a few years in school a girl had learned enough different stitches to undertake a sampler. The youngest artist represented in this entire book is Nabby Dexter of Providence, Rhode Island, whose sampler was made "in her tenth year." Elizabeth Finney was only sixteen years old when she worked an elegant scene in silk, using a dazzling array of stitches—cross, flat, bullion knot, outline, buttonhole and satin stitches—creating what has been called "the most elaborate sampler ever found in Pennsylvania." This is high tribute, for Pennsylvania was one of the first colonies to have schools for girls, and they were famed for their needlework.

Originally made as records of frequently used motifs and border designs, the "exemplar," or sampler, became a showpiece in which a young woman exhibited her mastery of innumerable embroidery stitches. The designs, which were drawn directly on silk or linen with pen or pencil, were rarely original; rather, the girls copied the models presented by their instructresses. The anonymous sampler from Pennsylvania, dated 1795, with its overall, somewhat random design and lettering featured only in the date, is reminiscent of the early types, which served as reference "notes" for the needleworker. By the end of the eighteenth century elaborate compositions had evolved, in which a symmetrical border framed a central scene or scenes. Not one but several types of alphabets, verses from the Scriptures or other inspirational sources, pastoral scenes, architectural compositions and detailed biographical information were included in these displays of painstaking handiwork.

A young girl's sampler was displayed with pride, first in her parents' home and then in her own, eventually becoming a family heirloom. Today many of the best of these samplers have found their way to museums, where they are striking testimonials to the talents of America's youngest artists, whose eye for color and design was as keen as their fingers were nimble.

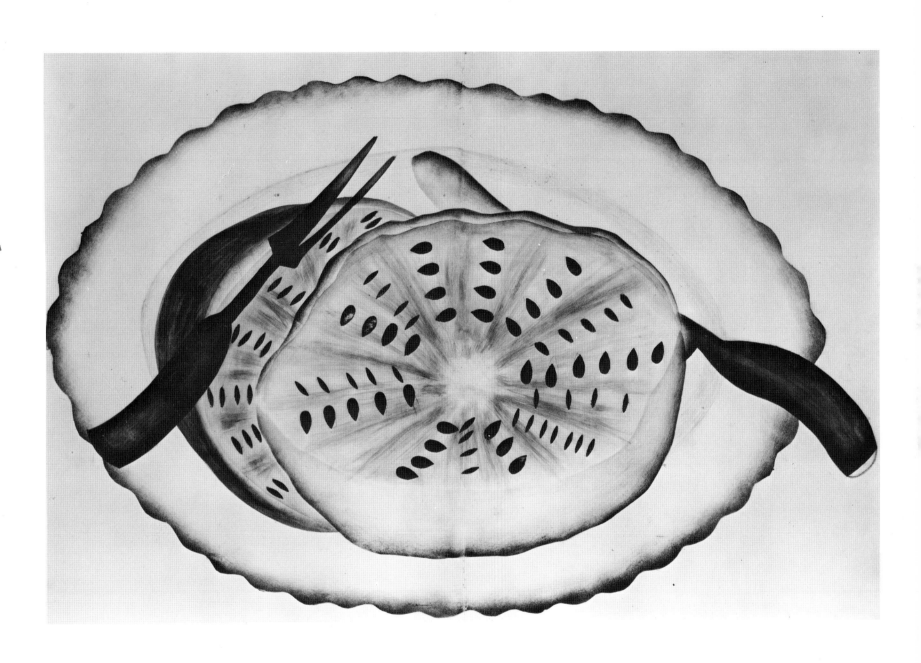

124. *Watermelon in Blue-bordered Dish*, watercolor, 9½ x 14⅞", c. 1840, probably New England. Abby Aldrich Rockefeller Folk Art Collection, Williamsburg, Va.

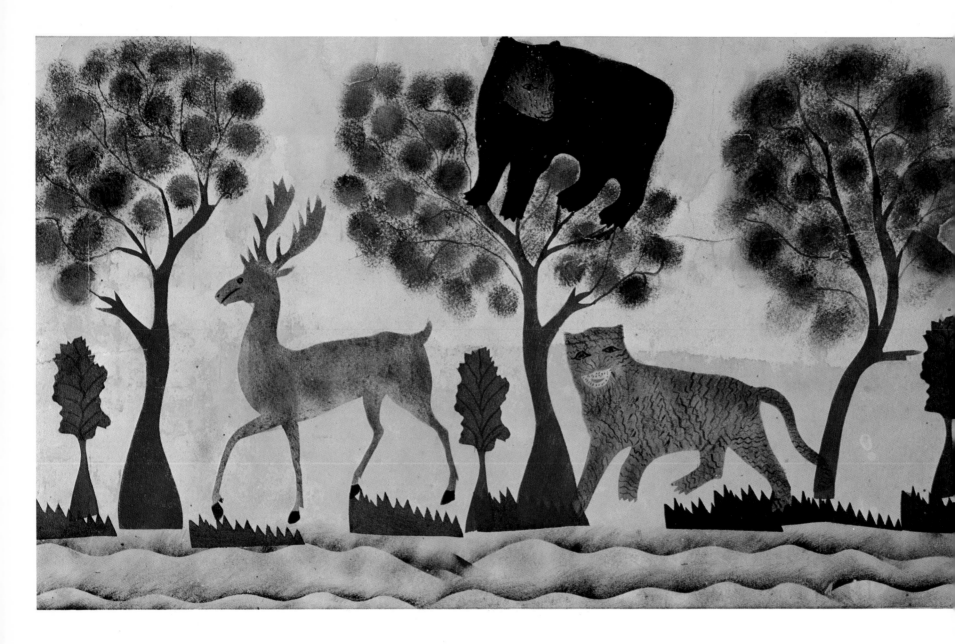

125. *Bear in Tree*, stenciled and sponged watercolor, 8¼ x 14½", c. 1850, found in Texas. National Gallery of Art, Washington, D.C.; Gift of Edgar William and Bernice Chrysler Garbisch.

OPPOSITE: 126. *Exotic Bird and Fruit*, stenciled and freehand watercolor, 24½ x 18¾", c. 1830, found in Pennsylvania. New York State Historical Association, Cooperstown.

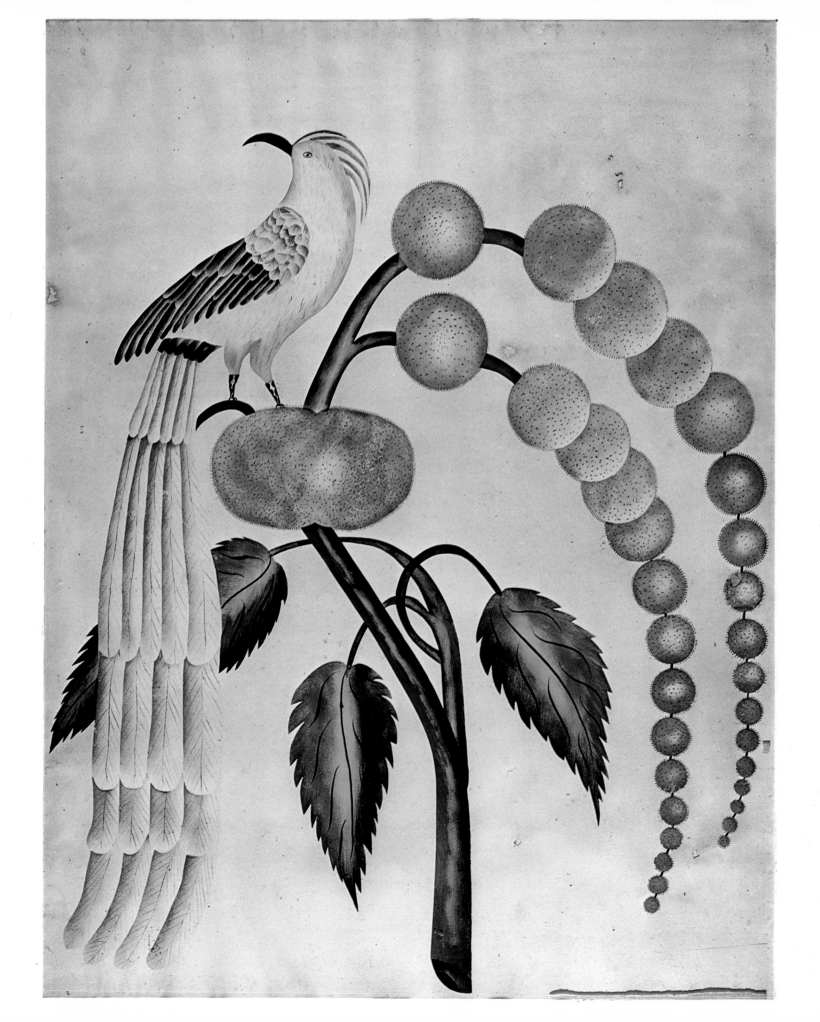

127. *American Fantasy*, cut paper with embossed details and watercolor, 15 x 18″, c. 1860, Lebanon County, Pa. Collection of Fred Wichmann.

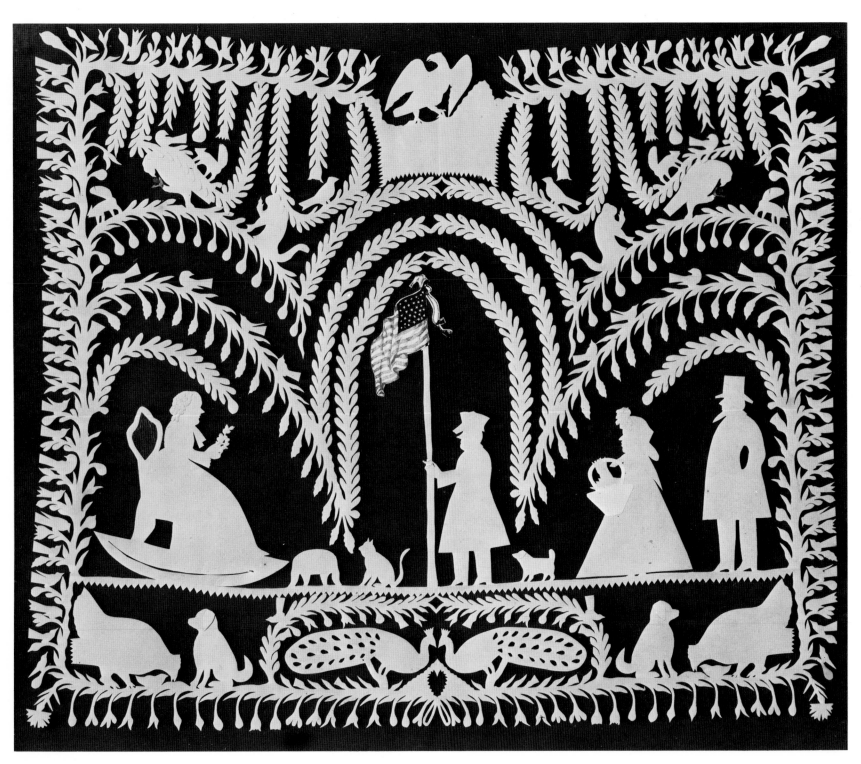

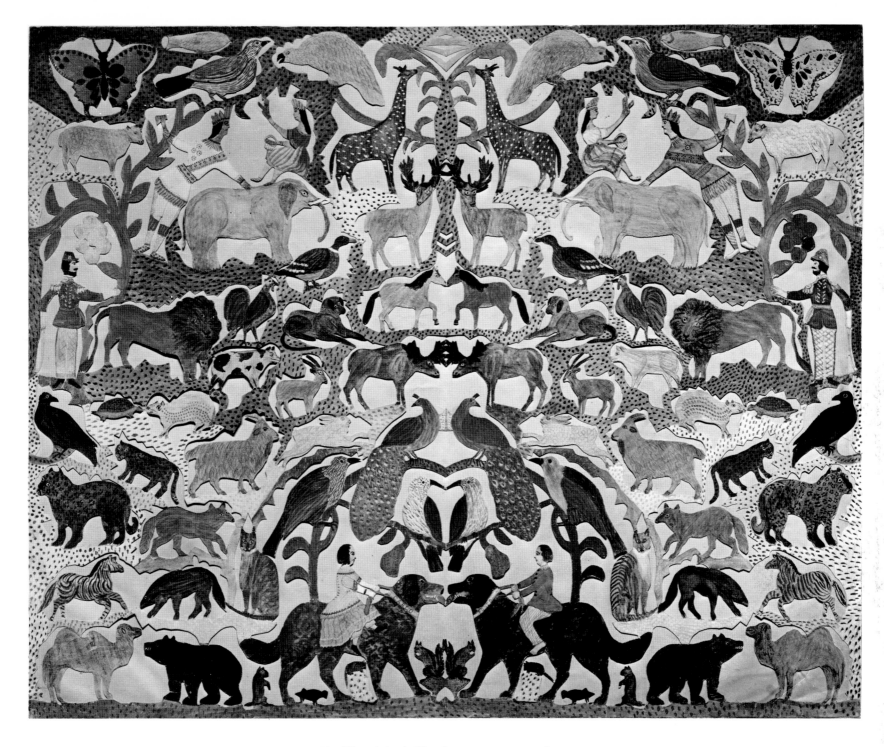

128. *The Animal Kingdom*, cut paper and water-color, 18⅞ x 23¾″, c. 1825–50, found in Massachusetts. National Gallery of Art, Washington, D.C.; Gift of Edgar William and Bernice Chrysler Garbisch.

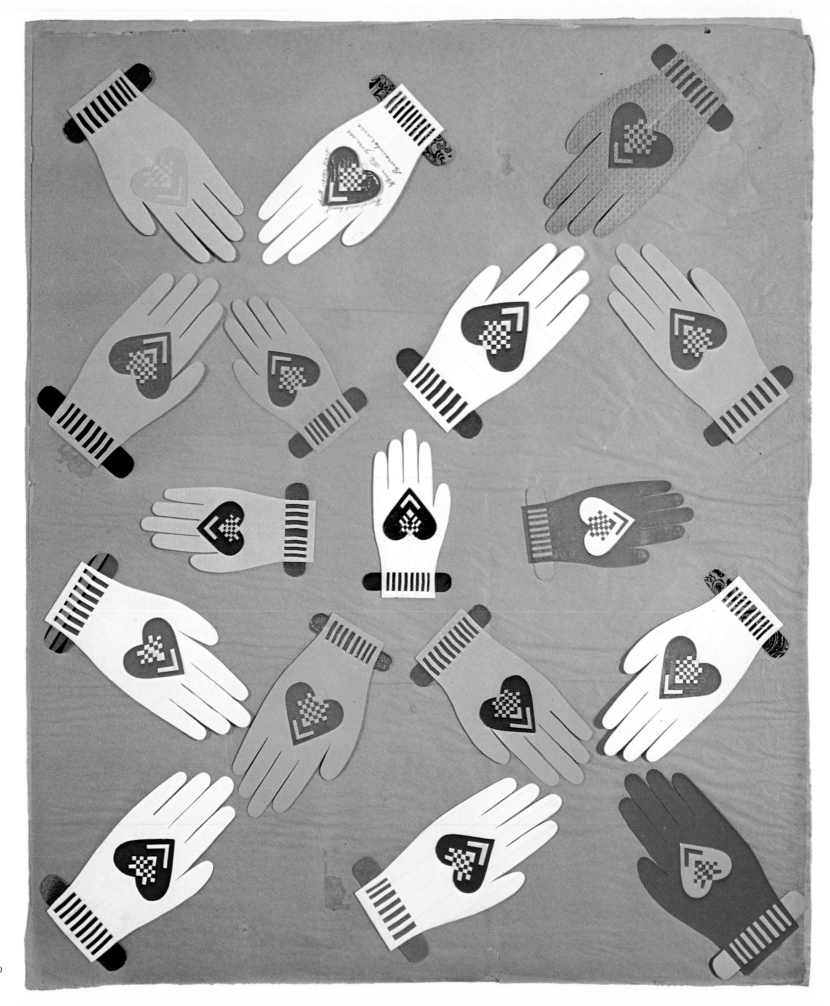

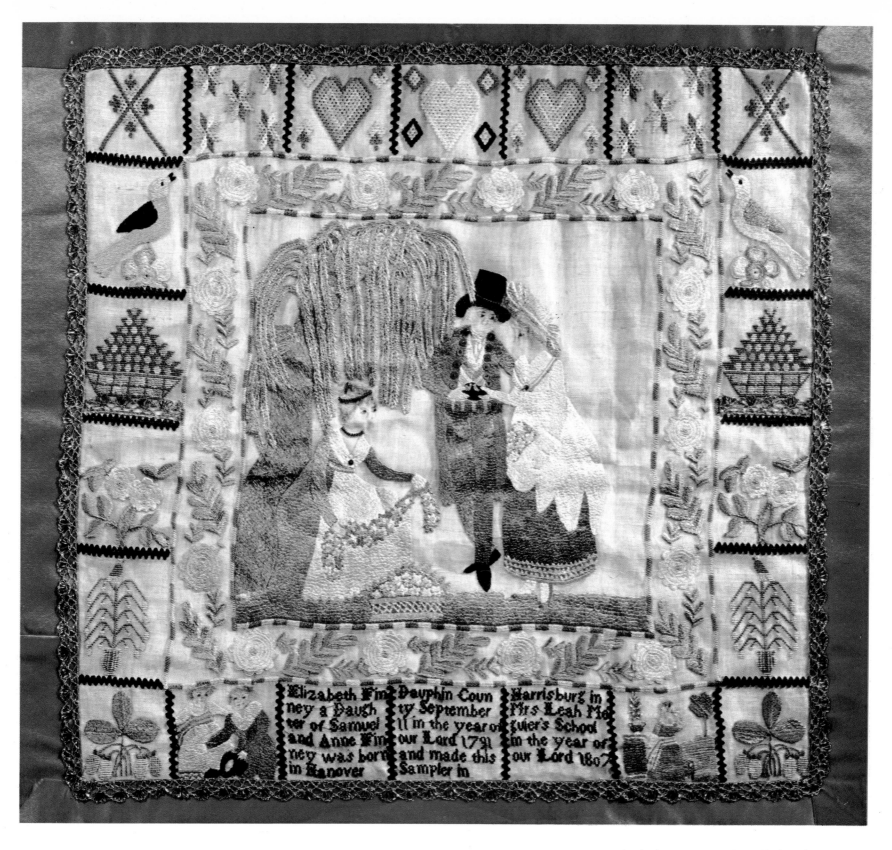

The sampler contains the following embroidered text:

Elizabeth Fin
ney a Daugh
ter of Samuel
and Anne Fin
ney was born
in Hanover

Dauphin Coun
ty September
11 in the year o
our Lord 1791
and made this
Sampler in

Harrisburg in
Mrs Leah Me
guier's School
in the year of
our Lord 1807

130. Elizabeth Finney, sampler, silk thread on muslin, 22 x 20", 1807, Harrisburg, Pa. Worked at Mrs. Leah Meguier's School in Harrisburg. Collection of Mrs. Herbert F. Schiffer.

OPPOSITE: 129. *Valentine*, ink, watercolor and cut paper, 13½ x 11½", c. 1850, found in Connecticut. Collection of Howard and Jean Lipman.

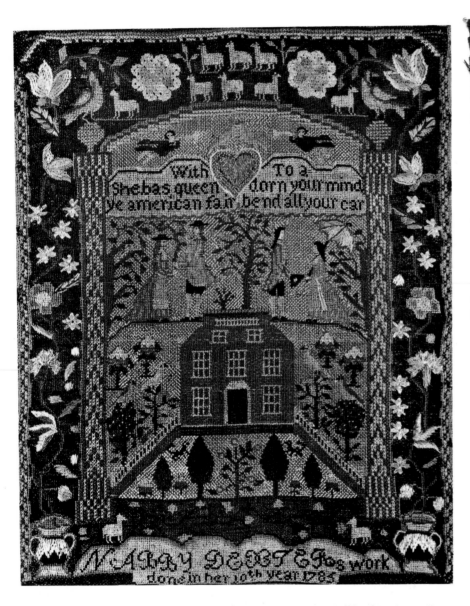

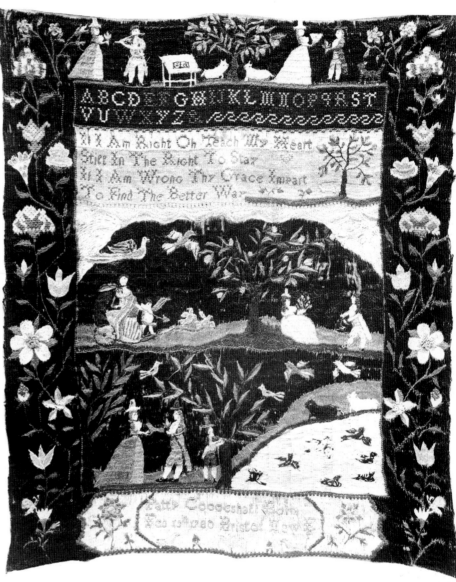

132. Patty Coggeshall, sampler, silk thread on linen, 19½ x 16⅝″, c. 1795, Bristol, R.I. Metropolitan Museum of Art, New York.

131. Nabby Dexter, sampler, silk thread on linen, 13¾ x 11″, 1785, Providence, R.I. Worked at Miss Polly Balch's School in Providence. Collection of Mrs. Gregg Ring.

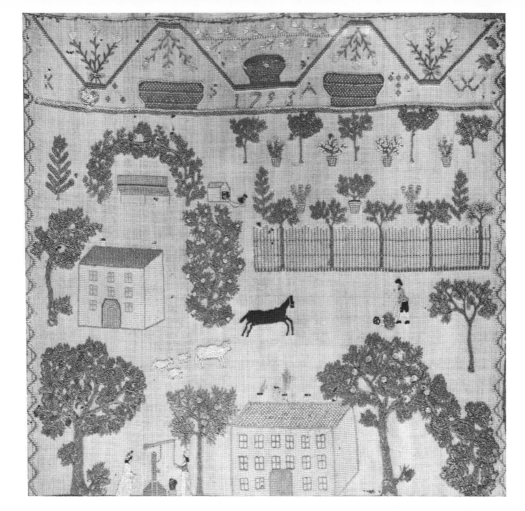

133. Sampler, silk thread on linen, 12 x 11″, 1795, Chester County, Pa. Collection of Theodore H. Kapnek.

134. Martha C. Hooton, sampler, silk thread on linen, 24 x 23″, 1827, Pennsylvania. Collection of Theodore H. Kapnek.

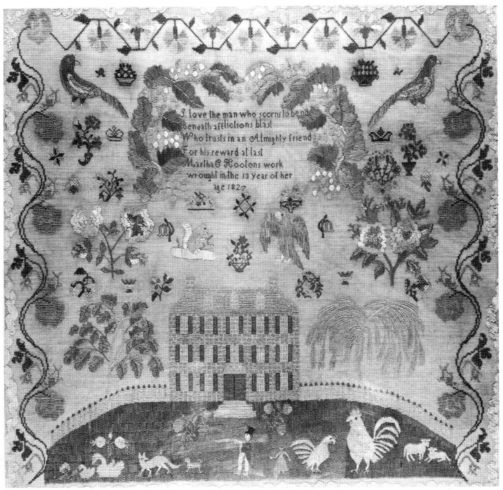

PENMANSHIP, FRACTUR
AND PRESENTATION PIECES

Penmanship

In this age of typewriters, ball-point pens and illegible scrawls, it requires a considerable leap of the imagination to hark back to another era when the ability to write was a mark of culture and penmanship was an art. Eighteenth- and nineteenth-century Americans admired "a fine hand," and schoolboys worked on penmanship exercises with the same diligence their sisters applied to needlework.

In the early years of the nineteenth century a schoolmaster and expert penman, Platt Roger Spencer, originated a script that was to bear his name. The Spencerian method of writing was widely taught in boys' academies and business schools. In the hands of a particularly dexterous and imaginative penman it was transformed into a fanciful pictorial art, executed with fine steel-tipped pens. "Why not learn to write?" asked J. C. Satterlee in a virtuoso display that includes complete alphabets in capital and small letters. Why not, indeed, if one could, with a series of elaborate flourishes and deft crosshatching, sketch a proud lion, a lively boy on pigback or a lowering buffalo of the plains? Animal subjects seemed to hold special appeal for these penmen, but the fine Federal house, executed in blue ink, gave its anonymous author an opportunity to show off broad, bold strokes as well as the delicate cursive forms that are used in the trees. Signed only with initials and a date, this composition is reminiscent of some of the early samplers.

Fractur and family records

Anyone surveying the infinite variety of American folk art cannot help but be struck by the quantity of handsome works created among the German-speaking peoples who settled southeastern Pennsylvania in early colonial times and came to be known, mistakenly, as the Pennsylvania Dutch (from *Deutsch*, meaning German). Their art most nearly approaches the usual definition of folk art: a visual tradition peculiar to a region or ethnic group, rooted in ancient symbols and transmitted, with little or no change, from one generation to another of skilled and specialized craftsmen. America has no "folk," in the European sense, but the Pennsylvania Germans formed a particularly cohesive minority group and were set apart from the mainstream by their strict religious observances, Old World traditions and German language, spoken in churches and schools as well as homes. Thus they tended to preserve the rich heritage of folk art brought from various Germanic regions of Europe, principally the Rhineland and neighboring parts of Holland and Switzerland.

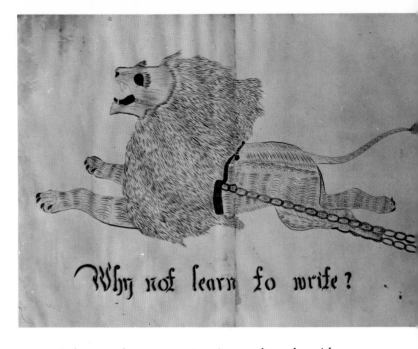

One of the arts the German immigrants brought with them was *fraktur-schriften* (fractur writing), whose ancestry could be traced to *Fraktur*, a sixteenth-century type face which in turn imitated the calligraphy of medieval manuscripts. Long after it had died out in Europe, fractur writing flourished in America, and by the beginning of the nineteenth century it had developed into a splendid decorative folk art. Today the anglicized term "fractur" is often applied to the entire body of Pennsylvania German painting—manuscripts written in fractur script, as well as pictures with little or no text which were done at the same time and in the same style.

In almost every eighteenth-century group of German-speaking Protestants migrating to the religious freedom of William Penn's lands, there was a minister or a schoolmaster who was proficient in fractur writing. To supplement their slender incomes, they and their successors prepared certificates of birth, baptism, marriage and death, which had been required by law in Europe and continued to be made by the tradition-loving Germans in their adopted country. By the nineteenth century, itinerant scribes had begun to monopolize the work, often painting certificates with decorative borders in advance and adding the lettering to order, the inscriptions generally being written in German. Unlike the virtuoso penman who proudly displayed his name in elaborate flourishes, the fractur artist rarely signed his work, continuing the medieval tradition of the anonymous scribe. The earliest fracturs were done by members of the religious community founded at Ephrata Cloister in Lancaster County, Pennsylvania, in 1728. German community schools in Pennsylvania continued to teach manuscript illumination and fractur writing until the establishment of an English school system in the 1850s. This virtually put an end to the

135. J. C. Satterlee, calligraphic picture, *Why not learn to write?*, ink, 27¾ x 79″, 1866, Corry, Pa. Signed and dated. Collection of Herbert W. Hemphill, Jr.

art, and ready-made certificates—designed, printed and sold by fractur artists like Heinrich Otto—took the place of the old hand-illuminated documents.

In the museum of the Bucks County Historical Society there is a schoolmaster's fractur paintbox containing the materials and tools he used for his work. In it are goose-quill pens and cat's-hair brushes, small bottles containing colors that were once liquefied with whiskey, and cherry gum varnish which was occasionally used, diluted with water, to add a shining finish to the colors. The paints—golden yellow, blood red, soft blue and delicate green—were homemade from dyes concocted by the artist according to old recipes. Using pen and ink, he carefully lettered the inscriptions and drew the outlines of the accompanying designs; he then filled in the illuminated initials and design motifs with flat washes of color.

As it developed in America, fractur took many forms. The *Taufschein*, or birth and baptismal certificate, was by far the most common document produced by fractur artists. The certificates were treasured by their owners, who displayed them in the home or kept them in the family Bible and passed them on to succeeding generations; more than half the surviving examples of fractur fall into this category. The next most numerous kind of fractur was the *Vorschrift*, or penmanship example, prepared by a schoolmaster for his pupils to copy. It consisted of an illuminated passage from the Bible or a moral precept, followed by the alphabet and, often, numerals from one to ten. Teachers also illuminated songbooks and primers for classroom use and sometimes made little drawings of birds or flowers as "rewards of merit" for diligent scholars. The many re-

ligious sects that came to Pennsylvania's German counties developed their own distinctive schools of fractur: illustrated here are typical works by members of the Mennonite and Schwenkfelder sects. Their art most often took the form of bookplates and illustrations for hymnals, small drawings called "bookmarks," because they have often been found between the pages of old books, and house blessings, which brightened otherwise austere interiors. Portraits and other decorative work offended these fundamentalist Christians, who shunned all kinds of worldly display; and because of their opposition to infant baptism, they had no use for the baptismal certificates so popular among other German-speaking Pennsylvanians.

As the Germans settled more and more into their new environment, fractur, like other American art forms, became increasingly independent of its European antecedents. In the earliest fracturs the lettering is finely detailed, the colors are soft and subtle, and the ornamental designs subordinated to the inscriptions. In later examples the drawing and lettering are cruder, the colors much brighter. The painted designs become increasingly bolder and in some cases replace the lettering. In the double portrait of George Washington and his wife the inscription is limited to their names, rendered phonetically very much as a heavily accented Pennsylvania German might have pronounced them. Several of the works shown here are purely decorative pieces painted in the fractur style but having no lettering whatever.

Although fractur was an art peculiar to the German-speaking Pennsylvanians, painted and lettered family records of a similar nature were made elsewhere. The Pedrick family record, painted in New England, has much in common with Pennsylvania fracturs. On the other hand, the Woodward register recalls, in both style and imagery, the sentimental mourning pictures created by the young ladies of New England in the early nineteenth century. The Pixler register takes the form of a composite family portrait; it is unusual in its minimal treatment of the inscription and in many other details.

Presentation pieces

On special occasions Pennsylvania Germans gave each other "presentation pieces"—drawings in the fractur style, appropriately inscribed. Sometimes they were made at home, sometimes ordered from a fractur artist. In *Spring Blessing* the arrival of the season is celebrated with a colorful composition and a German verse. In 1818 Elizabeth Fedderly received a painting—possibly a portrait of herself and her family—as a New Year's Day present. The use of English in the inscription indicates that by this time many of the German immigrants had already begun the process of assimilation in the proverbial American melting pot.

136. Calligraphic picture, *Porky, with Rider Up*, ink, 17 x 27″, c. 1865, Pennsylvania. Collection of Mr. and Mrs. Peter H. Tillou.

137. L. W. Frink, calligraphic picture, *The Buffalo of the Plains*, ink, 16 x 22″, 1871, New York. Collection of Barbara Johnson.

138. *Blue House*, ink, 13 x 16″, 1847, found in Richmond, Va. New York State Historical Association, Cooperstown.

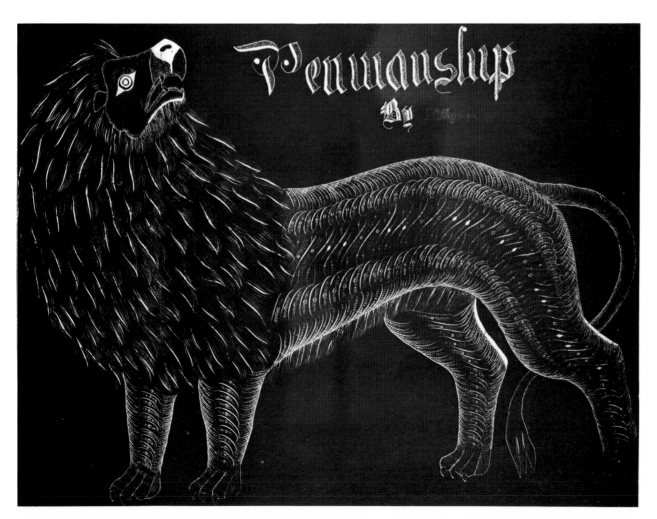

139. F. B. Hoyman, calligraphic picture, *Lion*, ink, approximately 18 x 24″, c. 1865, probably New York or Pennsylvania. Privately owned.

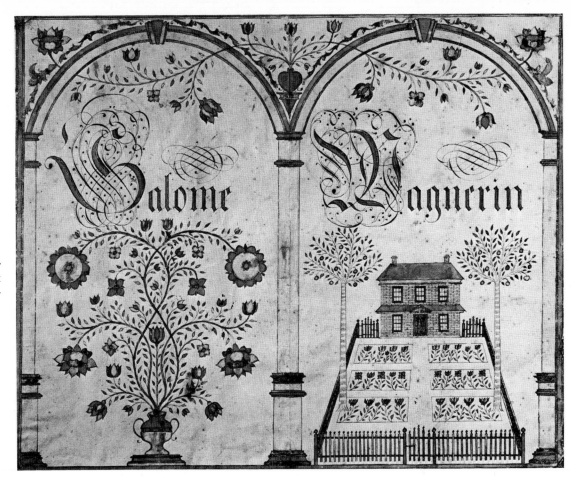

140. Schwenkfelder school, *House Blessing*, ink and watercolor, 13¼ x 16⅜″, 1825–35, Pennsylvania. Collection of Fred Wichmann.

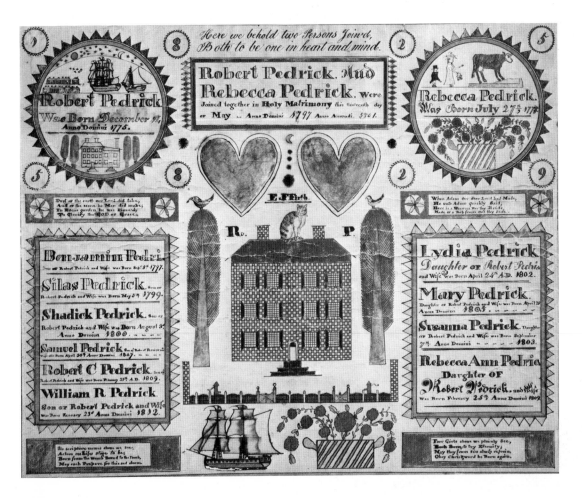

141. E.F. Firth, *Pedrick Family Birth Record*, ink and watercolor, 17¼ x 21⅜″, c. 1812, New England. Henry Ford Museum, Dearborn, Mich.

OPPOSITE: 142. *The Abraham Pixler Family*, ink and watercolor, 10 x 8″, c. 1815, found in Pennsylvania. Metropolitan Museum of Art, New York; Gift of Edgar William and Bernice Chrysler Garbisch.

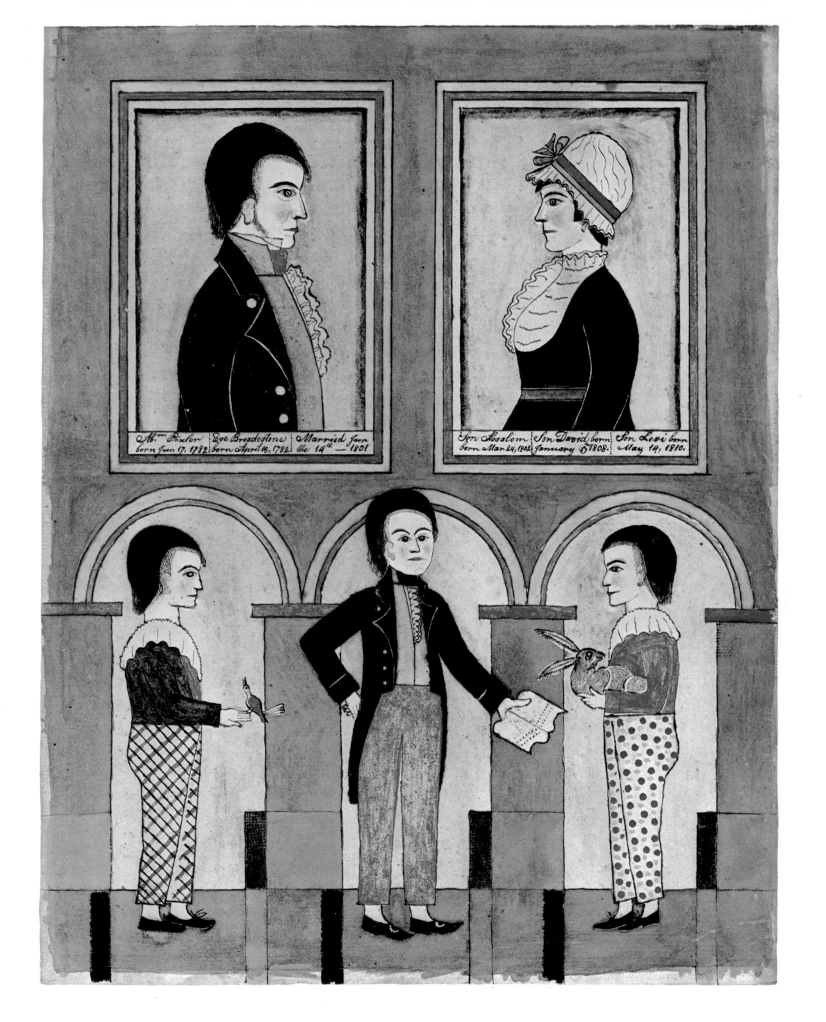

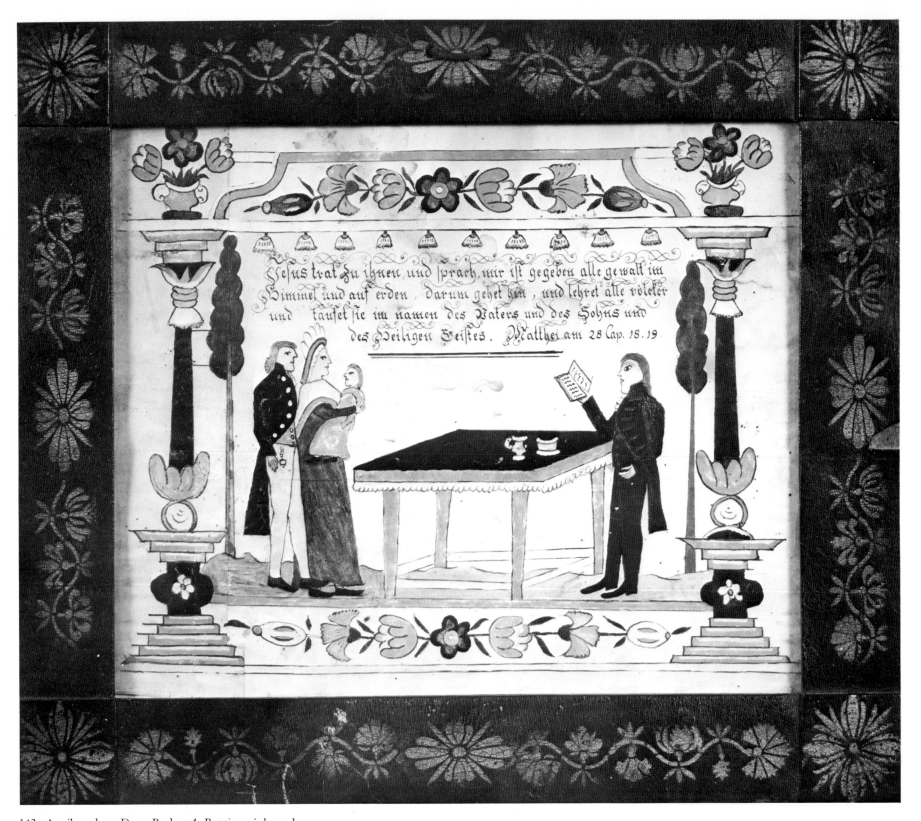

143. Attributed to Durs Rudy, *A Baptism*, ink and
watercolor, 7⅞ x 9 13/16″, c. 1825, Broadheadville,
Pa. In original stenciled frame. Museum of Fine Arts,
Boston; M. and M. Karolik Collection.

OPPOSITE: 146. Fractur drawing, ink and watercolor,
12½ x 15⅝″, c. 1795–1830, eastern Pennsylvania.
Henry Francis du Pont Winterthur Museum, Winter-
thur, Del.

144. Mennonite school, title page of songbook of Heinrich Gottschall, ink and watercolor, 3⅞ x 6¼", 1835, Montgomery or Bucks County, Pa. Collection of Donald A. Shelley.

145. Mennonite school, *The Temptation of Eve*, ink and watercolor, 7½ x 12¾", c. 1820, eastern Pennsylvania. Collection of Scott Francis Brenner.

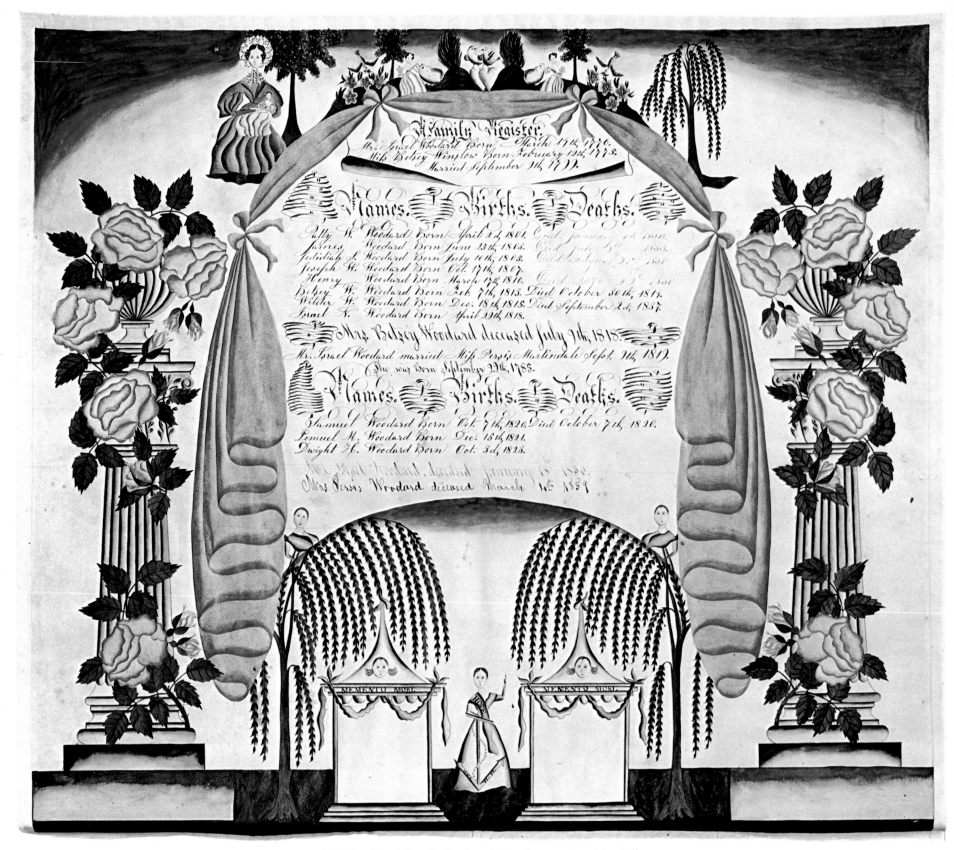

147. *Woodward Family Register*, ink and watercolor, 16 x 18″, c. 1837, New England. Collection of Bertram K. and Nina Fletcher Little.

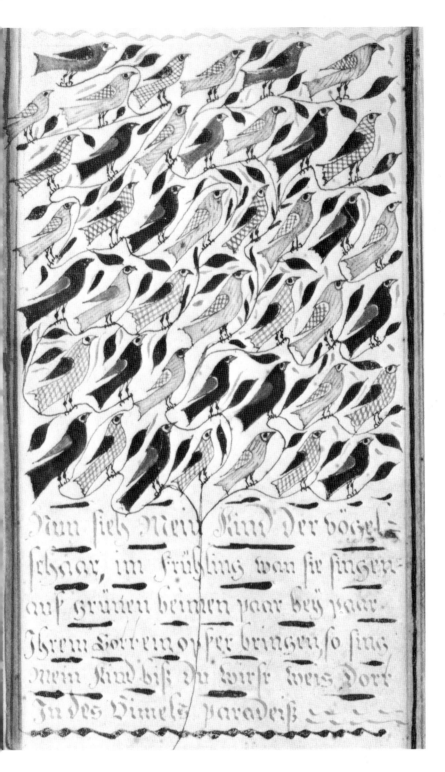

148. Fractur bookmark, ink and watercolor, 6¾ x 4″,
c. 1790–1820, probably eastern Pennsylvania. Henry
Francis du Pont Winterthur Museum, Winterthur, Del.

149. Schwenkfelder school, fractur drawing, paint and
cut paper, 12½ x 7¾″, c. 1800, vicinity of Pennsburg,
Pa. Formerly collection of George Horace Lorimer.

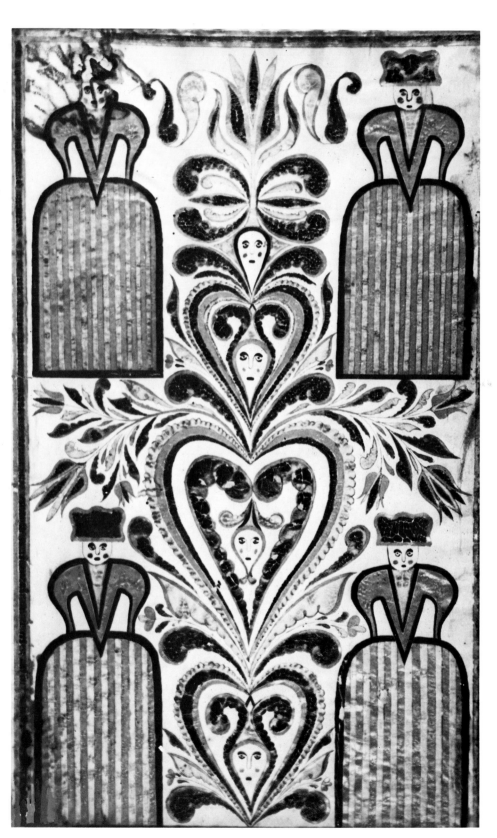

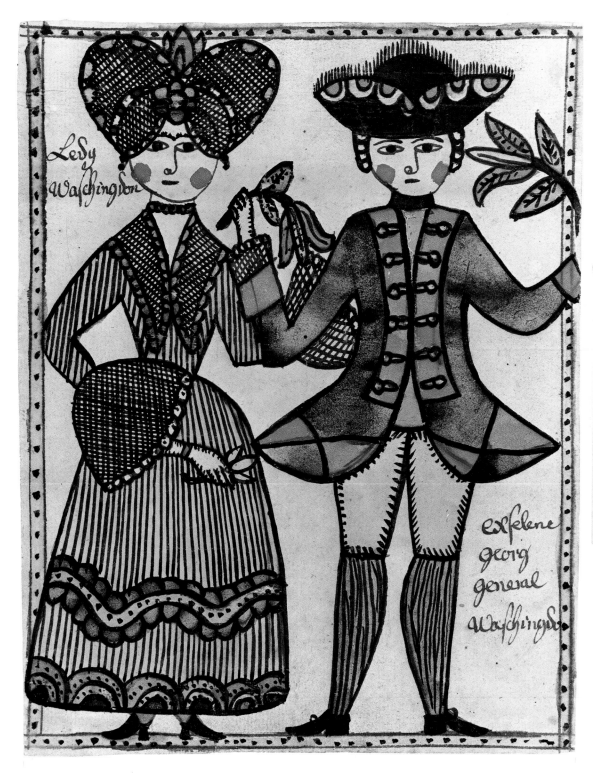

150. *Exselenc Georg General Wasch-ingdon and Ledy Waschingdon,* watercolor, 8 x 6¼", c. 1775–1800, Pennsylvania. Abby Aldrich Rocke-feller Folk Art Collection, Wil-liamsburg, Va.

151. S. B. (unidentified), *Two Soldiers,* watercolor, 6 x 8½", c. 1810, Pennsylvania. Initialed on coattails. Reading Public Museum and Art Gallery, Reading, Pa.

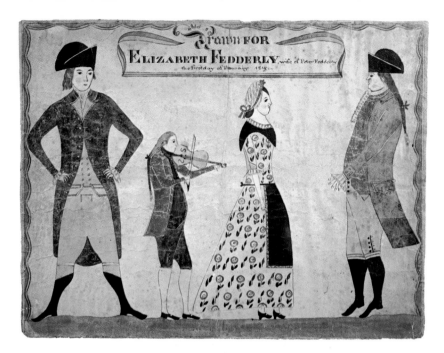

152. *Drawn for Elizabeth Fedderly, wife of Peter Fedderly the first day of January 1818*, ink and watercolor, 14½ x 18½", 1818, Pennsylvania. Collection of Mr. and Mrs. Martin B. Grossman.

153. *Spring Blessing*, ink and watercolor, 7 15/16 x 12 5/16", c. 1785, Pennsylvania. Museum of Fine Arts, Boston; M. and M. Karolik Collection.

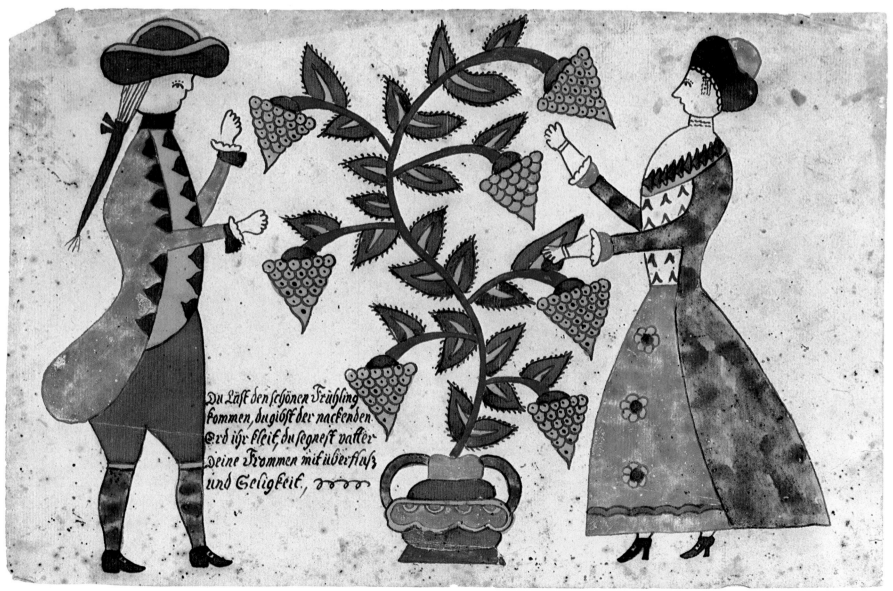

154. Anny Mohler, *Anny's Gift*, watercolor, 12½ x 15 11/16″, c. 1830, Stark County, Ohio. Abby Aldrich Rockefeller Folk Art Collection, Williamsburg, Va.

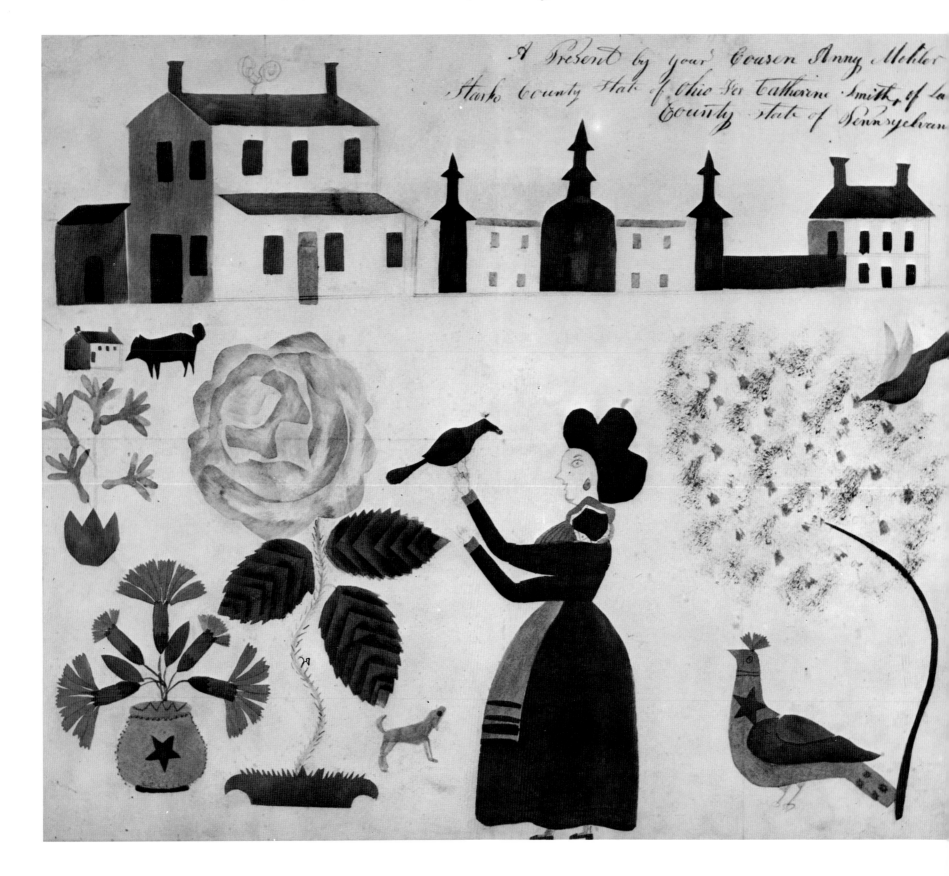

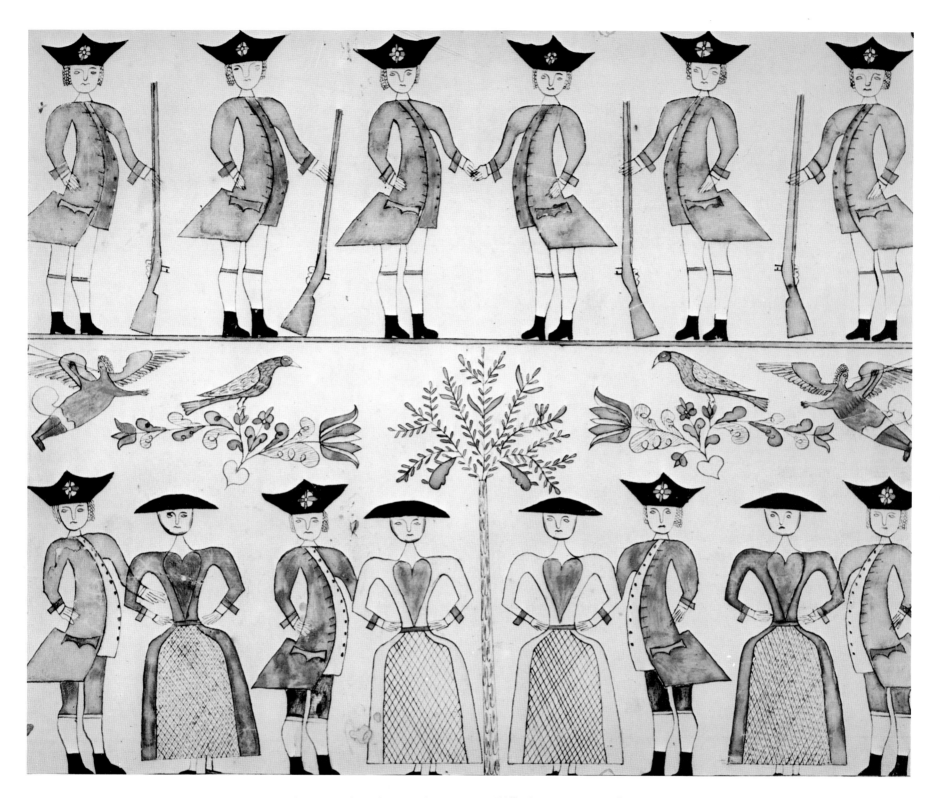

155. Fractur drawing, ink and watercolor, 12⅜ x 15½", 1790–1820, Pennsylvania. May represent a military wedding. Henry Francis du Pont Winterthur Museum, Winterthur, Del.

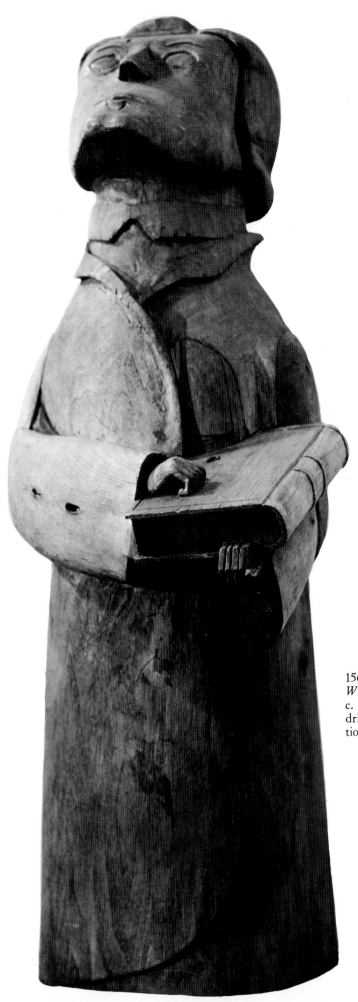

156. Attributed to Corbin, *Henry Ward Beecher*, wood, 21½″ high, c. 1840, Centerville, Ind. Abby Aldrich Rockefeller Folk Art Collection, Williamsburg, Va.

SCULPTURE IN WOOD, METAL, STONE AND BONE

PORTRAITS

Gravestones

Surviving time and weather from generation to generation, these gravestone portraits present the very type of pioneer New Englander: straightforward, hardy and above all confident—no more afraid to face eternity than to face the rigors of life in a raw new world.

Likenesses of men, women and children were made by America's first native sculptors, the stonecutters whose gravestones stand to this day in village burying grounds. Their talents seemed to thrive in a rural atmosphere, for the majority of early likenesses are found in small towns rather than in the urban centers of the time. While interesting early gravestone portraits can be seen in the Atlantic States, and while there are splendid stones that are primarily symbolic, floral or graphic, the highest achievement of this native art is found in New England.

The earliest gravestones, dating from the mid-seventeenth century, were carved with symbols of the passage of time, death and resurrection. Not until the eighteenth century were the features of the beloved dead perpetuated in stone. The first gravestone portraits evolved from the conventionalized winged angel who stood for the deceased on Judgment Day. Thus, on Polly Coombes's stone her sprightly face sports what appears to be a pair of wings. Austin Seely, Jr., is also portrayed with wings and several motifs commonly found on gravestones of this period: the soul is symbolized by a heart, and birds represent the flight of the soul. Pointing hands, which are most often shown lifted toward heaven, indicate the ultimate destination of the soul. Some stonecutters invented their own personal symbolism.. The lily shapes with crosses in the centers, seen on the stone of Lieutenant Moses Willard and his wife, were used by an anonymous carver of Charlestown, New Hampshire, on many stones he made for the inhabitants of that village.

The gravestone portraits range from simple busts to full-

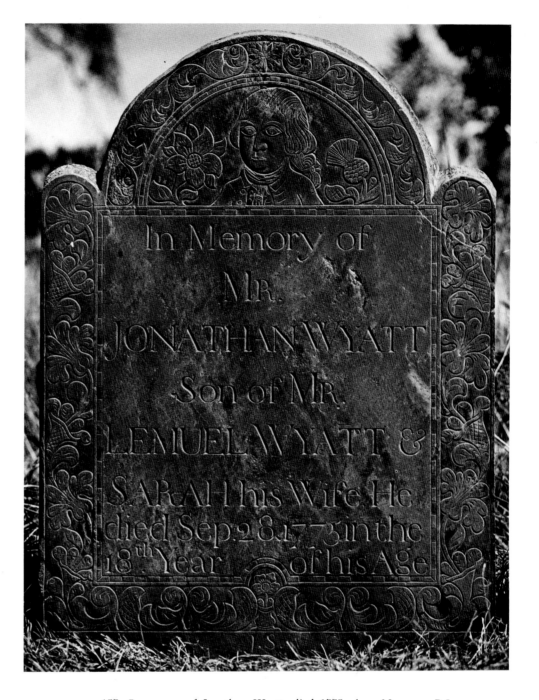

157. Gravestone of Jonathan Wyatt, died 1775, slate, Newport, R.I.

119

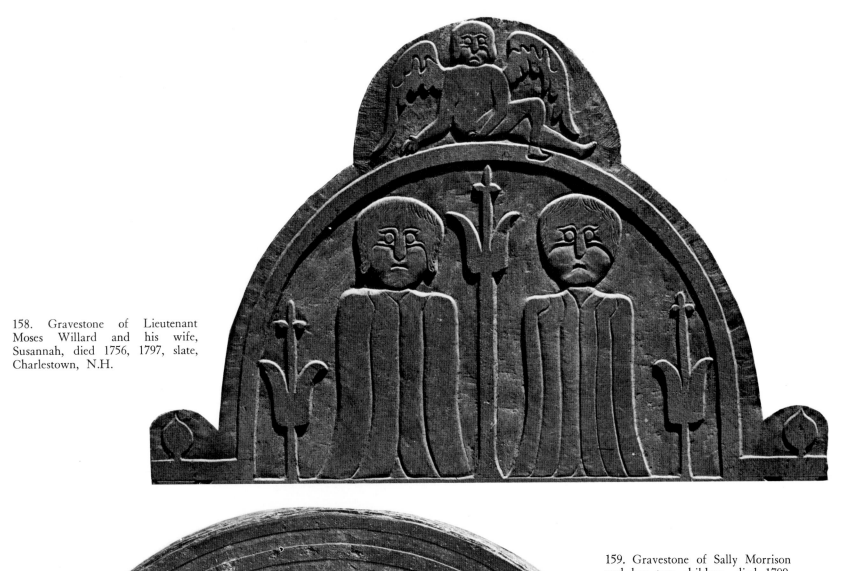

158. Gravestone of Lieutenant Moses Willard and his wife, Susannah, died 1756, 1797, slate, Charlestown, N.H.

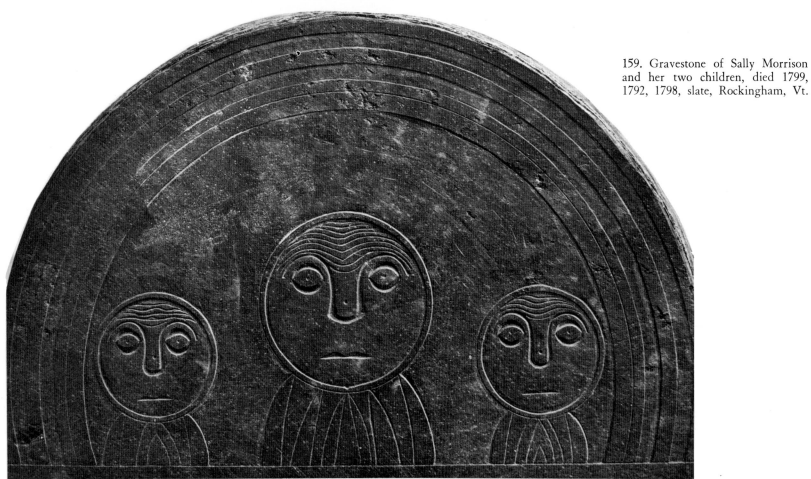

159. Gravestone of Sally Morrison and her two children, died 1799, 1792, 1798, slate, Rockingham, Vt.

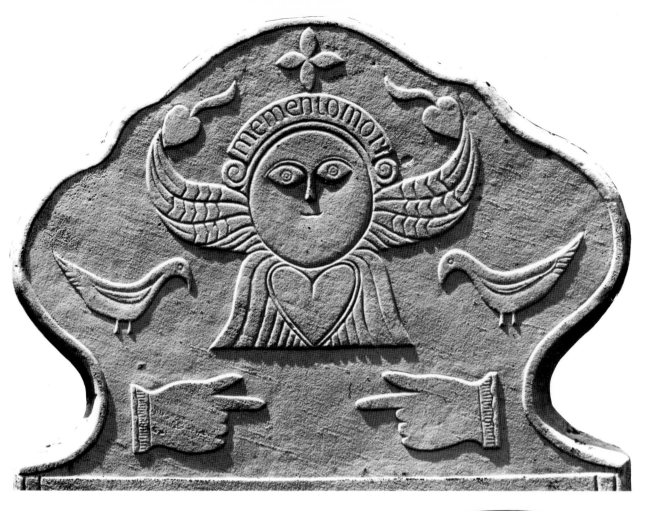

160. Gravestone of Austin Seeley, Jr., died 1796, white marble, Arlington, Vt.

161. Gravestone of Polly Coombes, died 1795, slate, Bellingham, Mass.

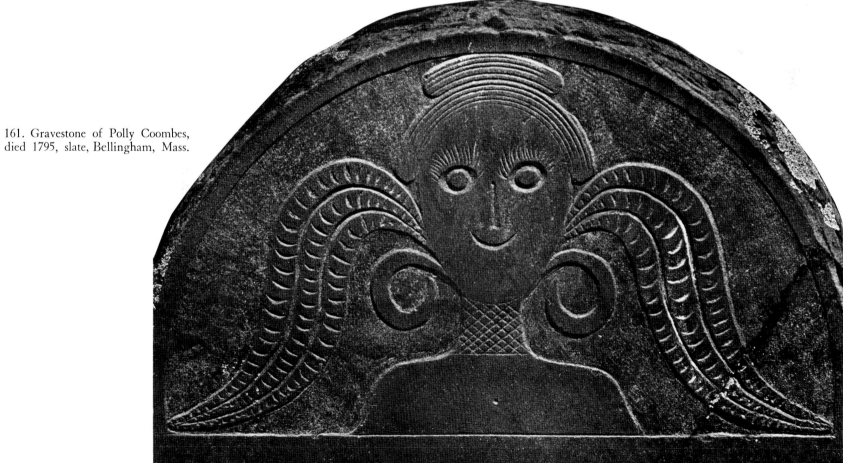

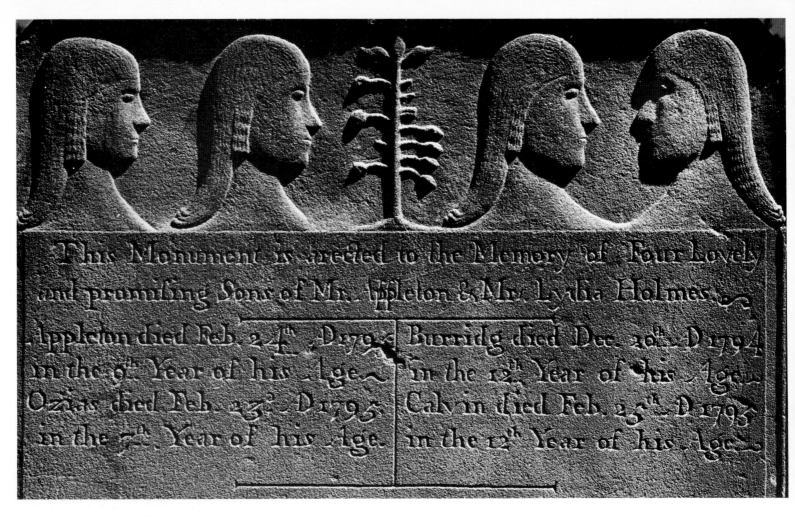

162. Gravestone of the Holmes children, died 1795, 1795, 1794, 1795, red sandstone, East Glastonbury, Conn.

163. Gravestone of Major Lemuel Hide, died 1800, red sandstone, South Hadley, Mass.

length representations, from single subjects to family groups: man and wife, mother and child, and occasionally others, like the "Four Lovely and promising Sons" of the Holmes family—carried away at the same time by one of the epidemics that too frequently ravaged early communities.

The materials used for the gravestones were slate, marble, granite, soapstone, sandstone and fieldstone of every kind, and the material greatly influenced the stonecutter's technique. Slate invited sharply incised contours and two-dimensional pattern, while softer stones lent themselves to rounded, more sculptural relief.

There is great variety in the degree to which the stone-cutter individualized his subject. Details of dress and hair are often quite factual, and since the stones are always dated, they provide an accurate record of the appearance of these early Americans and the fashions of the day. The most striking portraits, however, tend to be conventionalized—timeless images which are particularly appropriate for gravestone effigies.

Woodcarvings

Although sculptured portraits are far less numerous than painted ones, the subjects are the same: family and friends, ordinary fellow citizens and national heroes. The only free-standing portraits of any importance were carved of wood, and in their vigorous, homely style we see country whittling developed to a fine art. Most of the carved portraits had specific functions (see the ship figureheads and cigar-store figures) and were made by trained craftsmen. Others, such as those reproduced in this section, appear to have been purely decorative pieces for the home. The standing figure of George Washington, whose polished walnut finish suggests a certain amount of formal training, was possibly carved by a professional who specialized in carved decorations for furniture, such as the finials and small figures or busts centered on the pediments of secretaries. The other examples are less sophisticated and appear to be amateur works. And as was often the case among the painters, lack of training was more than compensated for by a depth of feeling that is communicated directly and strongly.

An Indiana farmer is said to have carved the portrait of the Reverend Henry Ward Beecher during a visit the abolitionist minister paid to his home. One need not know the details of Beecher's career or the fervor of his anti-slavery crusade to feel what the carver felt: the presence of a deeply religious man who literally draws his strength from the Bible and lifts his eyes, indeed his whole being, to behold his God. The impression of intensity and devotion is as powerful as that made by the carved saints on Romanesque churches and Gothic cathedrals.

164. *Abraham Lincoln*, polychromed wood, 32¾" high, c. 1860, found in Illinois. Collection Howard A. Feldman.

165. *George Washington*, polychromed wood, 18″ high, c. 1850, found in New Bedford, Mass. New York State Historical Association, Cooperstown.

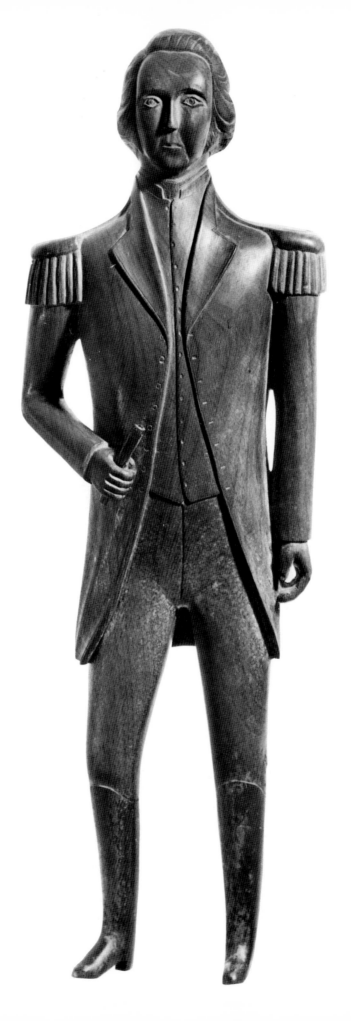

166. *George Washington*, walnut, 24″ high, c. 1825, from a Masonic Lodge in Pennsylvania. Collection Mr. and Mrs. Benjamin Ginsburg.

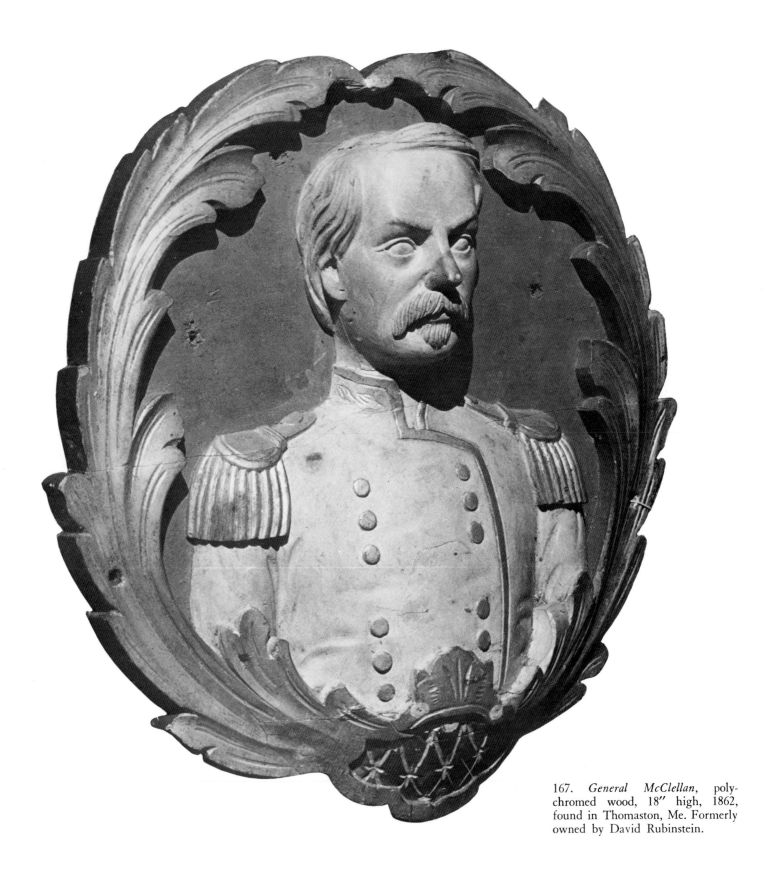

167. *General McClellan*, polychromed wood, 18″ high, 1862, found in Thomaston, Me. Formerly owned by David Rubinstein.

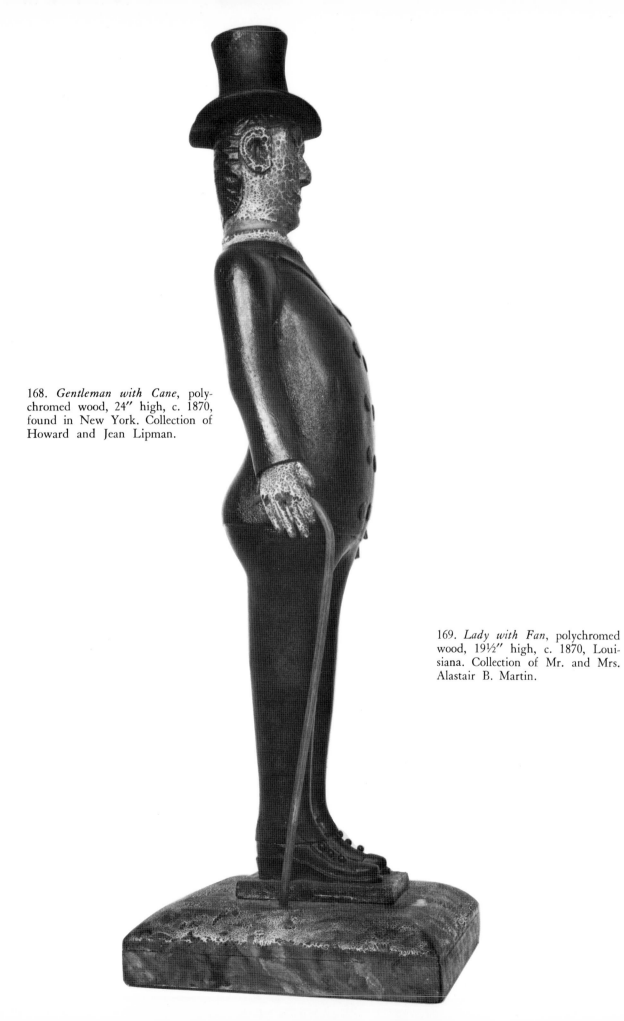

168. *Gentleman with Cane*, polychromed wood, 24″ high, c. 1870, found in New York. Collection of Howard and Jean Lipman.

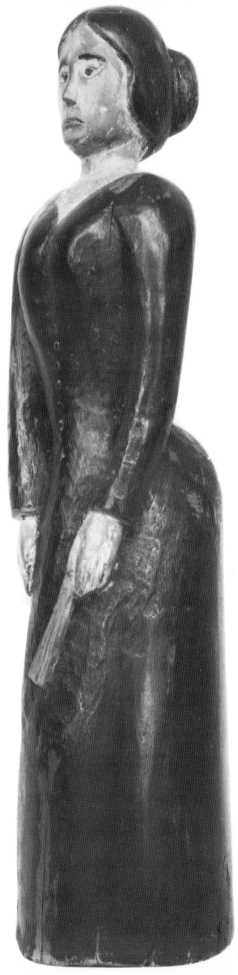

169. *Lady with Fan*, polychromed wood, 19½″ high, c. 1870, Louisiana. Collection of Mr. and Mrs. Alastair B. Martin.

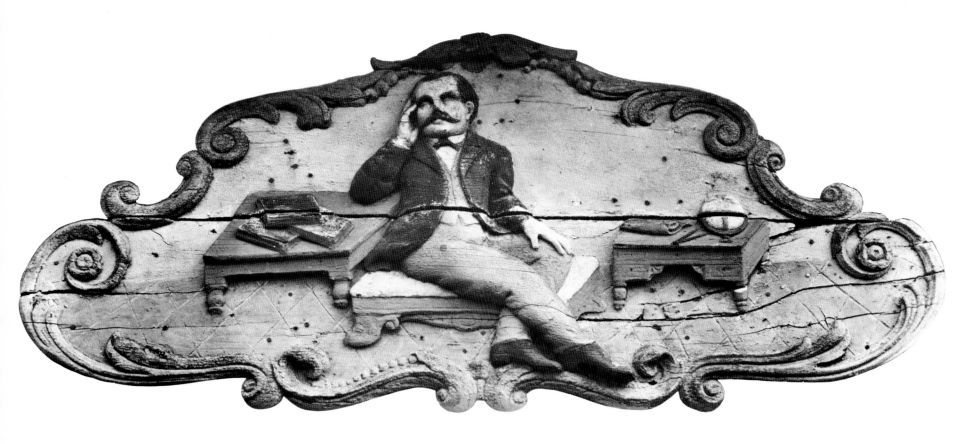

170. Sternboard, *Man at Desk*, polychromed wood,
75″ long, c. 1865, found in Provincetown, Mass.
Formerly collection of Mrs. Edward H. Evans.

SHIP FIGUREHEADS AND STERNBOARDS

Shipping was one of the mainstays of the young American economy, providing contact with the rest of the world and forming the basis of many a personal fortune. Its companion industry, shipbuilding, had a special need for artists, who carved figureheads, sternboards and other accouterments for the seagoing vessel. Nearly every town on the Atlantic seaboard had a shipyard, and there the carvers maintained their busy shops. After the relatively unadorned steamship replaced sailing vessels, many shipcarvers, finding their talents less and less in demand, went on to produce cigar-store figures and other trade signs.

From local newspaper advertisements, United States Navy drafts, customs house entry descriptions and contemporary accounts of all kinds, it is possible to reconstruct the trade of shipcarving. The successful carver often had a shopful of apprentices, to each of whom, on completion of his training, he issued a certificate stating the length of time he had worked and his qualifications as a carver. Old sketchbooks have been found showing that carvers made preliminary sketches to submit to their patrons, the shipbuilders. Sometimes there was lengthy correspondence between builder and carver, discussing the design of the figurehead. The builder sometimes had the lines of the ship's head and the rake of the bow chalked on the shop floor, and the carver then completed the sketches with chalked figureheads for the builder's approval. Figureheads were often made from sketches of living models or from models who actually posed for a carved portrait. The carving was done with chisels of various sizes, sets of which have been preserved. The figurehead and its scroll base have a sculptural unity that create the impression of having been cut from a single block. However, the height of the figureheads, averaging from six to seven feet, made this impossible; they were actually carved in several pieces, with the grain carefully matched and the sections joined with wooden pegs. Arms and other projecting pieces were carved separately and fastened on with dovetail slip joints. Such parts were often conveniently detachable, to be removed during rough weather and put into place on dress occasions, such as entering port. In most cases figureheads were brightly painted in lifelike colors, but those designed for the sleek clipper ships were often painted white with bits of gold leaf applied on the ornamental details, making them sparkle in the sun.

After the figureheads, the chief category of marine decoration was the sternboard, a broad flat surface that was most often decorated with an eagle. It also served, in the examples shown here, as a vehicle for personal portraits—one of the owner's wife or daughter, the other of the owner himself, flatteringly portrayed as a thoughtful gentleman surrounded by books, charts, compass and other scientific devices. There were also numerous inboard decorations, which gained in importance with the advent of steampowered vessels, on which the projecting prow with its figurehead no longer had a place.

Some of the first American shipcarvers learned their trade from English craftsmen who had set up shop in the colonies. Their figureheads were often busts or three-quarter figures swathed in classical draperies, following elegant English models; this neoclassic influence continued well into the 1800s. Side by side with it, a distinctly national style developed: lively, individual, full-length portraits executed with the same spare vigor and simple style that distinguish American folk painting.

Most shipcarvings were made of soft, native pine rather than the oak or other hardwoods used abroad. The ease with which pine could be cut encouraged the American carver's natural inclination to model surfaces in broad planes, paying less attention to elaborate detail than to the large sweep of the silhouette.

Each ship required a different kind of carved decoration, designed to suit the individual tastes of its builder and owner, and adapted to its basic structure and function. The whalers were workhorse vessels, relatively small, deep and strong. Their utilitarian structure—as well, perhaps, as the simple tastes of their owners—discouraged excessive decoration. Figureheads and sternboards were small and plain. The captain of a whaler would often commission a portrait of his wife or daughter—a reminder of hearth and home during the long, arduous voyages. Simple and natural in pose, expression and dress, these sturdy women are portrayed looking stoically out to sea, just as they must have stared out many times from their widow's walks, waiting for their men to come home.

The famous clippers, built for speed, were long, slender ships. Their figureheads were designed as structural extensions of the converging lines of the prow. Leaning buoyantly out over the water, heads thrown back and hair and clothes blown as if facing a brisk wind, these were the most glamorous of American carvings.

Military vessels were by tradition lavishly decorated, as befitted these representatives of American naval power. Eagles and other patriotic motifs were commonly used, and for the figurehead a portrait of a national hero or a personification such as Liberty or Columbia was particularly appropriate. In 1834, when the young nation's most famous vessel, the *Constitution*, required a new figurehead (its third, the others having been damaged beyond repair in

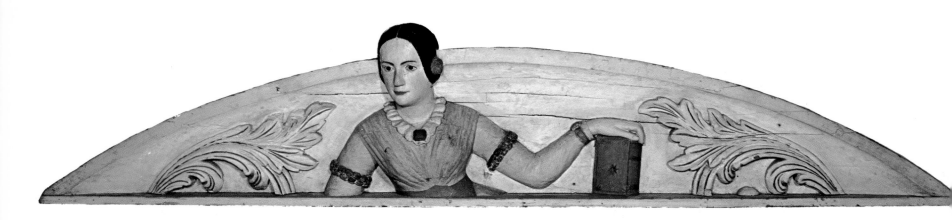

171. Sternboard of the *Eunice H. Adams,* polychromed wood, 84″ long, 1845, Newport, R.I. The *Eunice H. Adams,* built at Bristol, R.I., was used mainly in the whaling trade out of New Bedford. Whaling Museum, New Bedford, Mass.

military engagements), the choice of the subject became a national issue. Not surprisingly, Andrew Jackson, the new and popular President, was chosen: dressed in plain clothes, with hat and cane in one hand and a scroll of the Constitution in the other, this figure evokes the tough spirit of the nation's first populist President.

While many of the folk artists represented in this book remain anonymous, individual carvers of figureheads and their work can often be identified. In fact, scholars have documented some seven hundred carvers. Works by a few of the best known are included here. Samuel McIntire, an architect and carver who decorated many of the fine houses of Salem, is an example of the versatile craftsman who did carvings of various kinds. His sketches for marine decora-

tions still exist, but only one small figurehead (possibly a working model for a larger piece) has been attributed to McIntire. Boston was the home of many famous carvers, among them Laban S. Beecher, creator of the *Constitution*'s Andrew Jackson figurehead. The most elegant of the figureheads reproduced here, her simple dress swirling in classical drapery folds, was carved by Isaac Fowle and placed in front of the family shop in Boston as an advertisement.

John H. Bellamy of Maine, who spent most of his career decorating naval vessels out of the Portsmouth, New Hampshire, shipyard, was famed for his eagles. Here, however, he is represented by a ferocious lion—a visual pun on the cathead, a projection just under the ship's bow to which the cat, or anchor rope, was attached.

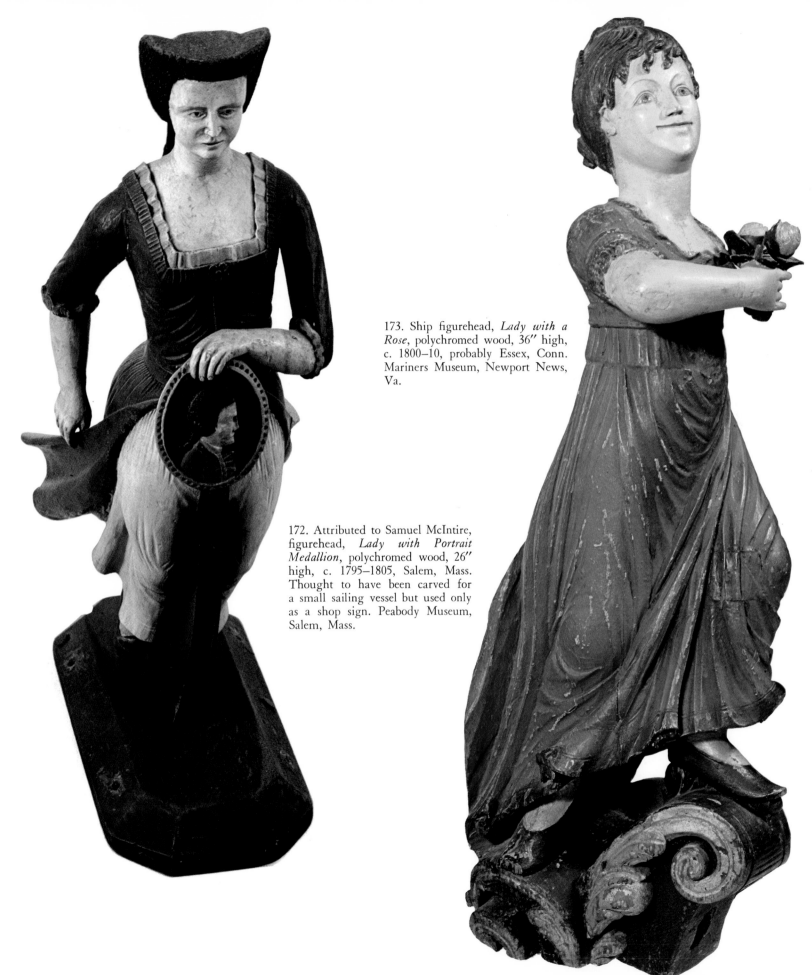

173. Ship figurehead, *Lady with a Rose*, polychromed wood, 36″ high, c. 1800–10, probably Essex, Conn. Mariners Museum, Newport News, Va.

172. Attributed to Samuel McIntire, figurehead, *Lady with Portrait Medallion*, polychromed wood, 26″ high, c. 1795–1805, Salem, Mass. Thought to have been carved for a small sailing vessel but used only as a shop sign. Peabody Museum, Salem, Mass.

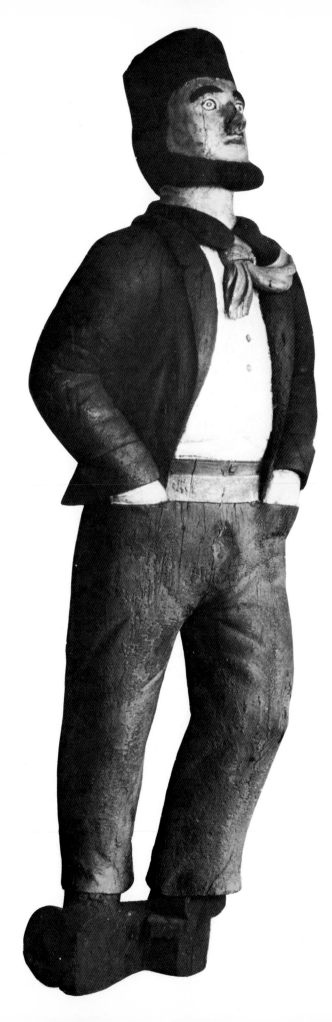

174. Figurehead, *Sailor*, polychromed wood, 69″ high c. 1860, found in Maine. Collection of Mrs. Loyall Sewall.

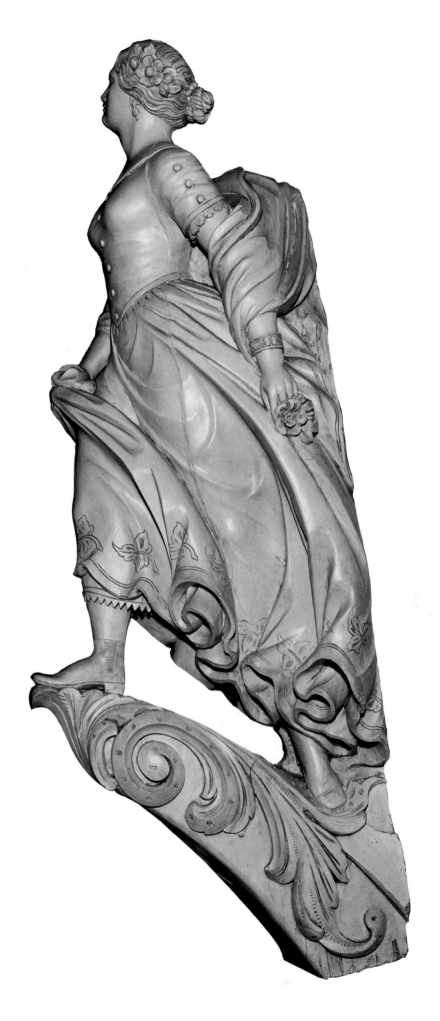

175. Isaac Fowle, figurehead, *Lady with a Scarf*, painted wood, 74″ high, c. 1820, Boston, Mass. Probably a shop sample, since it has only one unweathered coat of white paint. Bostonian Society, Old State House, Boston.

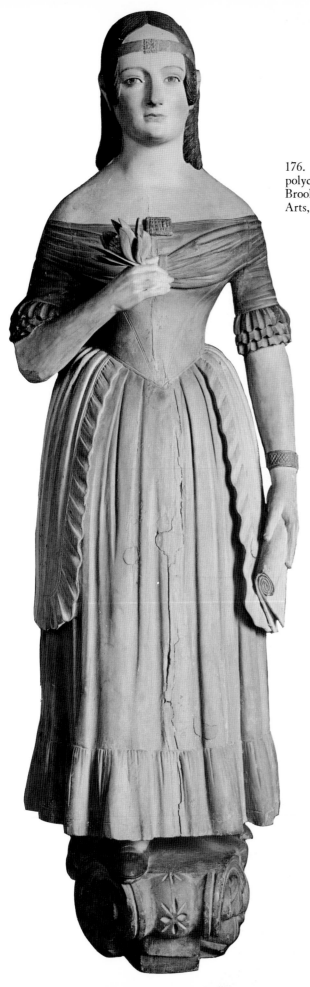

176. Figurehead of ship *Creole*, polychromed wood, 69″ high, 1847, Brooklyn, N.Y. Museum of Fine Arts, Boston.

177. Figurehead of Indian chief from ship *Sachem*, polychromed wood, 79¾″ high, 1875, East Boston, Mass. Probably carved by Hastings and Gleason, Boston. Carnegie Museum, Pittsburgh, Pa.

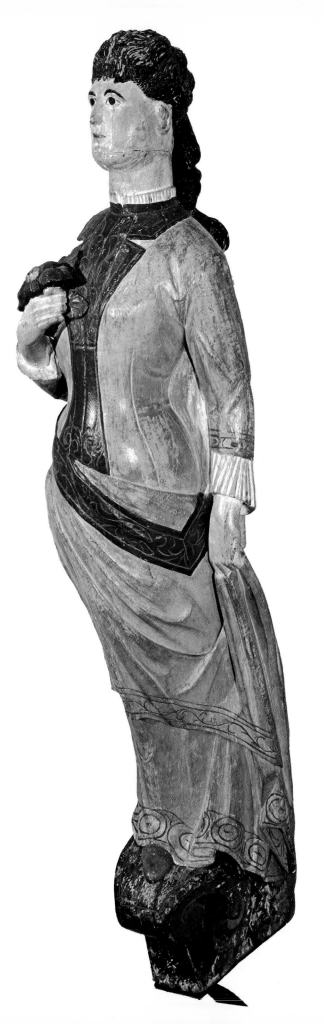

178. Figurehead, *Victorian Lady*, polychromed wood, 63″ high, c. 1875, found in Maine. New York State Historical Association, Cooperstown.

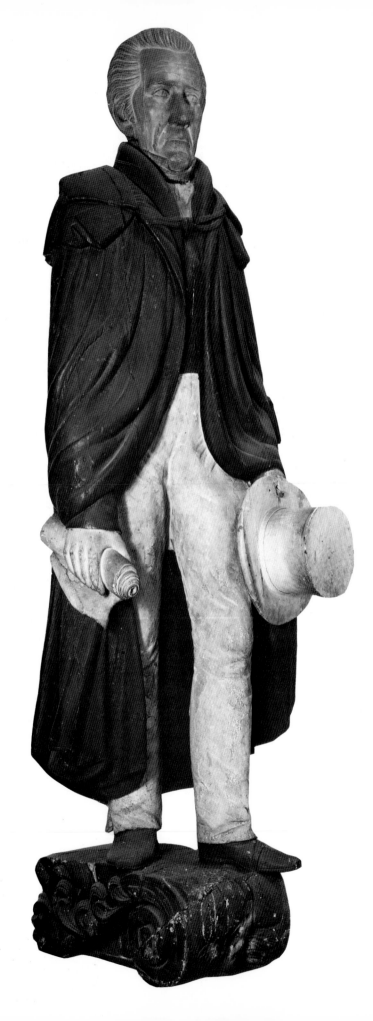

179. Laban S. Beecher, figurehead of Andrew Jackson for the frigate *Constitution*, polychromed wood, 142″ high, 1834, Boston. Shortly after figurehead was mounted, head was sawed off just below the nose by an anti-Jackson agitator; restored in 1835 by Jeremiah Dodge & Son, Shipcarvers. Museum of the City of New York.

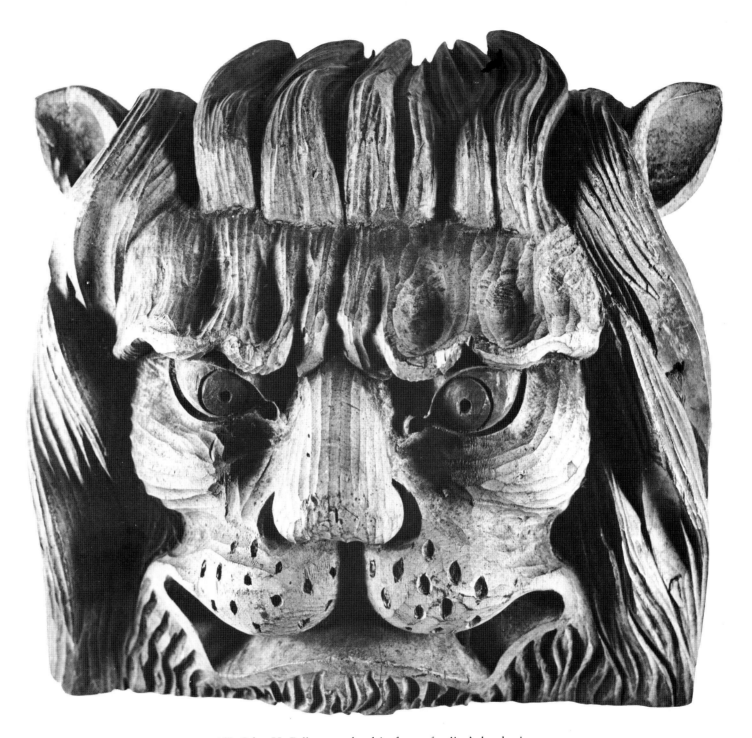

180. John H. Bellamy, cathead in form of a lion's head, pine, 14″ wide, 1859, Portsmouth, N.H. A note pasted to back reads, "This piece was carved by John H. Bellamy at 77 Daniel St, January 1859." Old Sturbridge Village, Sturbridge, Mass.

Anyone lifting his eyes to the horizon of an early American city, village or farm would be certain to see, atop the highest building, a jaunty weathervane. Turning with the wind, it provided an instant weather report as surely as the evening news gives us ours. Whether he was a farmer or a man of the sea, the early American's life and fortune were determined largely by the weather. Thus it is not surprising to find prominent depictions of weathervanes, often in oversized proportions, in many naïve landscape paintings.

Since the weathervane was always seen at a distance, clearly silhouetted against the sky and indicating wind direction at a glance, its design required an emphasis on overall pattern. A comparison between a group of animal weathervanes and animal paintings and drawings of the time reveals how dramatically the weathervane makers enhanced the design characteristics of the profiled creature. The popularity of horse weathervanes may be partly accounted for by the prevalence and importance of this domesticated animal, but it must also have had something to do with the inherent decorative interest of the running horse's silhouette.

During the colonial period the subjects of weathervanes were limited to a few designs—simple arrows, fish, cocks, Indians, serpents and grasshoppers. By the time of Independence, however, this basic repertory was joined by scores of subjects representing special and localized interests of the American people and all the themes that attracted them as a nation. The farmer's attention quite naturally focused on the livestock of his farm, and for barn and henhouse weathervanes he was likely to choose horses, cows, sheep, pigs or fowl. In seacoast villages weathervanes often represented sailors, sea captains, ships, whales, gulls, fish and even fanciful mermaids and sea serpents. On churches everywhere, the cock and the fish—ancient Christian symbols—were popular, as well as angels blowing trumpets. Some regions had their special subjects: in eastern Pennsylvania many barns displayed Indian weathervanes, a tradition that originated in pioneer days when they were used to show that the land had been purchased from the Indians, thus warding off raids by natives who might otherwise assume the land was rightly theirs. From the point of view of design, the Indian was an ideal subject because his arrow doubled as a wind direction indicator. Sometimes the weathervane functioned as a trade sign, featuring an appropriate symbol of the shopkeeper atop his store. The advent of the steam locomotive inspired a whole new category of weathervanes, and locomotives were placed on stations and other railroad service buildings. Among the most widely used weathervanes on public buildings and private houses alike were those that took the form of well-loved American patriotic emblems—the ubiquitous eagle, Columbia, Liberty and Uncle Sam.

Weathervane techniques were as varied as the subjects. The earliest vanes were carved of wood or cut out of sheet metal by local carvers and metalsmiths, most of whom made trade signs and other decorations as well. The wooden vanes were carved with chisels or cut out of flat planks with small saws. They were almost invariably painted for protection against the weather, some in solid colors, usually white, Indian red, or yellow ocher to simulate gilt. Others displayed striking combinations of a few bold colors: on the angel weathervane reproduced here, for example, the flowing black hair against the stark white dress forms an abstract pattern, and the whole is enlivened by a brassy yellow trumpet. Metal vanes, too, could be painted or gilded. Yellow ocher doubled for gold leaf over copper, and a dark color was sometimes used to preserve the surface of sheet-iron silhouettes. The Indian archer shown here is a remarkable example of polychrome decoration on iron. Most metal vanes, however, were left unpainted, unadorned iron creating a bold, black silhouette and copper giving an equally striking appearance, first gleaming brightly in the sun, then weathered to gray green.

Metal vanes were cut and cast and molded in a variety of ways. The simplest technique was to cut a silhouette from a flat sheet of iron, zinc or tin, and artisans in rural districts long continued to make vanes by hand in this way. After 1850, however, the majority of metal weathervanes were mass-produced by large commercial companies such as the J. W. Fiske Works of New York City. These thriving manufacturers issued catalogues illustrating dozens of designs which could be ordered by mail or purchased in hardware stores. Although certain of the manufacturing processes were mechanized, weathervane making remained essentially a hand operation, and all the finishing work on each vane was done by a skilled craftsman.

The two methods used by the manufacturers—casting in iron and molding in sheet copper—permitted a new sculptural approach to the weathervane figure, which became three-dimensional and much more finished in its details than the stark silhouettes of the handmade variety. Manufacturers of cast-iron fences, gates and trellises, as well as weathervanes, used sand molds for casting. Most weathervane companies specialized in copper figures, which were made in the following way: the original pattern was carved of wood—two such models are reproduced here—and a mold or template was cast in iron from the model. Next, a

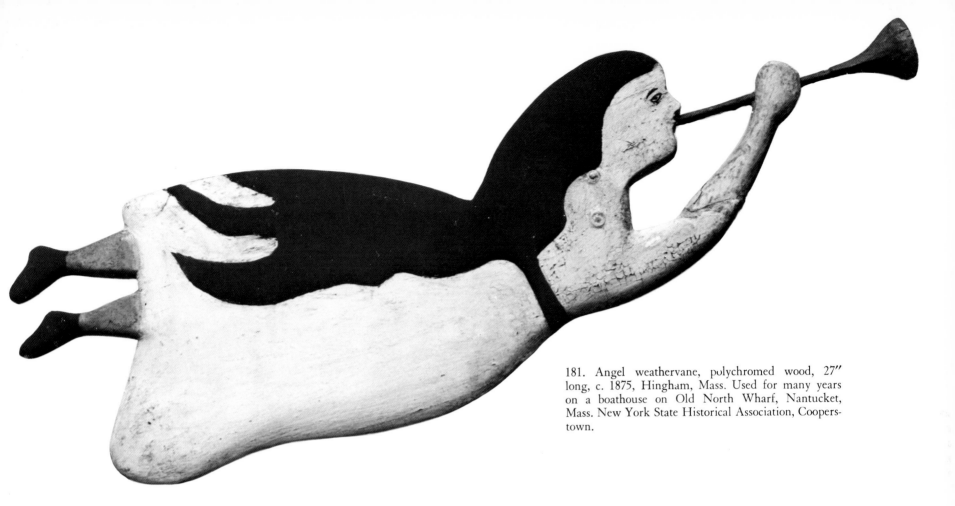

181. Angel weathervane, polychromed wood, 27″ long, c. 1875, Hingham, Mass. Used for many years on a boathouse on Old North Wharf, Nantucket, Mass. New York State Historical Association, Cooperstown.

thin sheet of copper was hammered into the depression of the mold. The two sides of the weathervane, thus fashioned, were soldered together to make a single, hollow form. Some vanes were so large that they had to be made in sections, each requiring a separate mold; some combined hammered sheet-metal parts with sections cast from iron or zinc, the heavier metals adding weight to the finished piece. Details, such as a fish's fins or an animal's tail, were worked by *repoussé*—hammering the sheet copper without a mold to produce a relief surface with a rich, textured effect. In the classically proportioned horse shown here the front of the body was cast in two sections in zinc, the back and parts of the front legs molded in sheet copper, and the tail cut and stamped from sheet copper.

A lively variation of the weathervane is the whirligig, a carved figure with paddlelike arms that revolve gaily in the wind. There has been some discussion as to whether whirligigs were used as weathervanes or as toys. The large figures, such as those shown here, were certainly mounted on rods and used as vanes, which indicated not only wind direction but, according to the speed of the revolving arms, velocity also. Wind toys have been popular through the ages, and it is reasonable to assume that some small whirligigs were actually children's playthings. It has been suggested that they fall into the category of "Sunday toys," used in those early households where Sabbath observance was a serious matter, and play, if permitted at all, was restricted to quiet, gentle toys.

Almost nothing is known about the makers of whirligigs. We can only surmise that they were whittled by amateur carvers for their own pleasure or for neighbors and friends. Military figures seem to have been particularly popular, and the costumes, portrayed in realistic detail and color, provide a reliable guide to dating. All whirligigs are carved in the round, the head and body from a single piece of wood. The arms are separate, joined by a rod that passes through the shoulders of the figure. Sometimes the arms are made to hold paddles; sometimes paddles substitute for arms. Perhaps because they were made by amateurs, whirligigs have an unusually spontaneous, individual quality. They offered the folk sculptor a dimension unavailable to other artists of the time—the challenge of working with a three-dimensional figure that actually moved. These amusing men with flailing arms are especially interesting in connection with present-day kinetic art, and Alexander Calder, inventor of that uniquely American contribution to sculpture, the mobile, was intrigued when he saw whirligigs and animated toys in a folk-art collection.

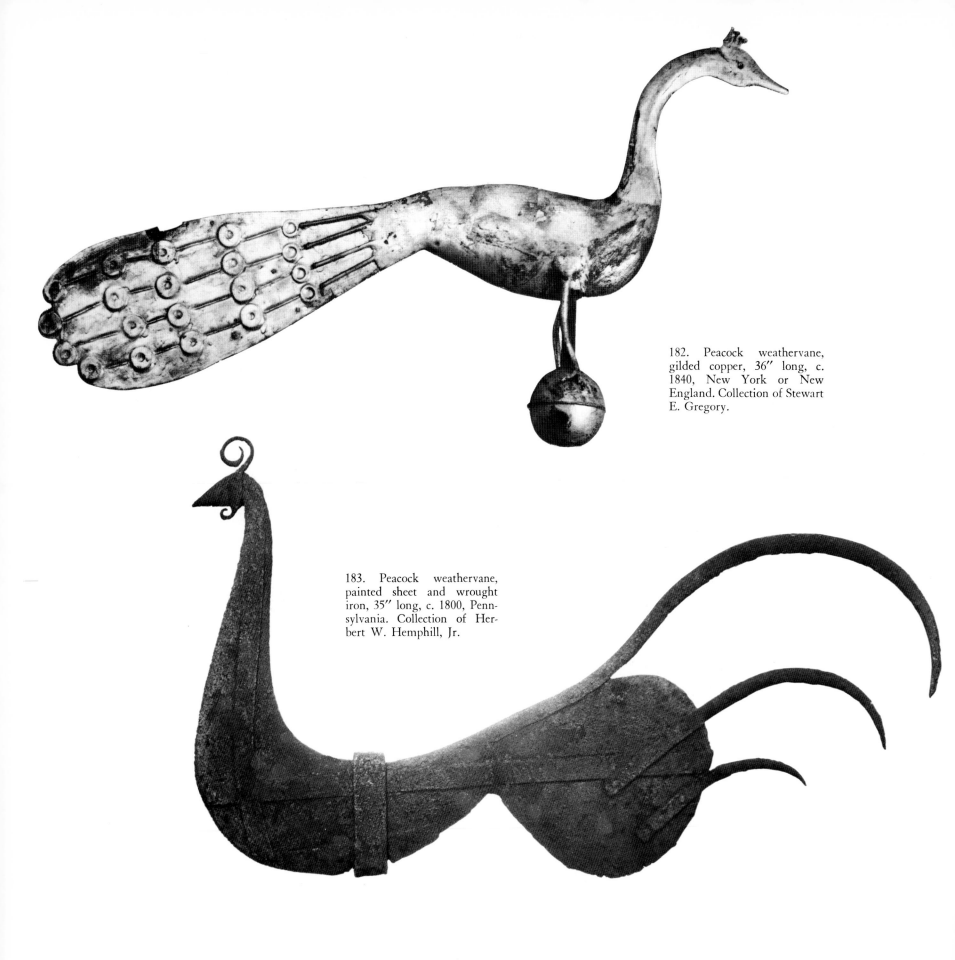

182. Peacock weathervane, gilded copper, 36″ long, c. 1840, New York or New England. Collection of Stewart E. Gregory.

183. Peacock weathervane, painted sheet and wrought iron, 35″ long, c. 1800, Pennsylvania. Collection of Herbert W. Hemphill, Jr.

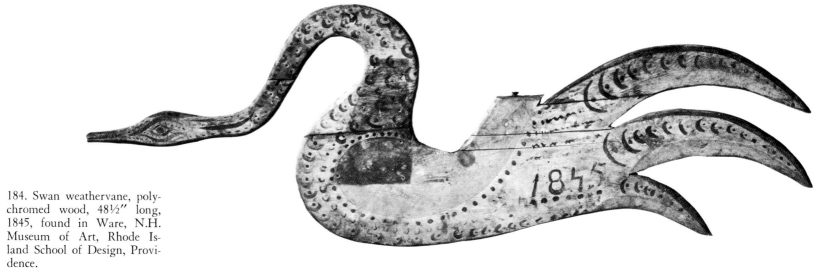

184. Swan weathervane, polychromed wood, 48½″ long, 1845, found in Ware, N.H. Museum of Art, Rhode Island School of Design, Providence.

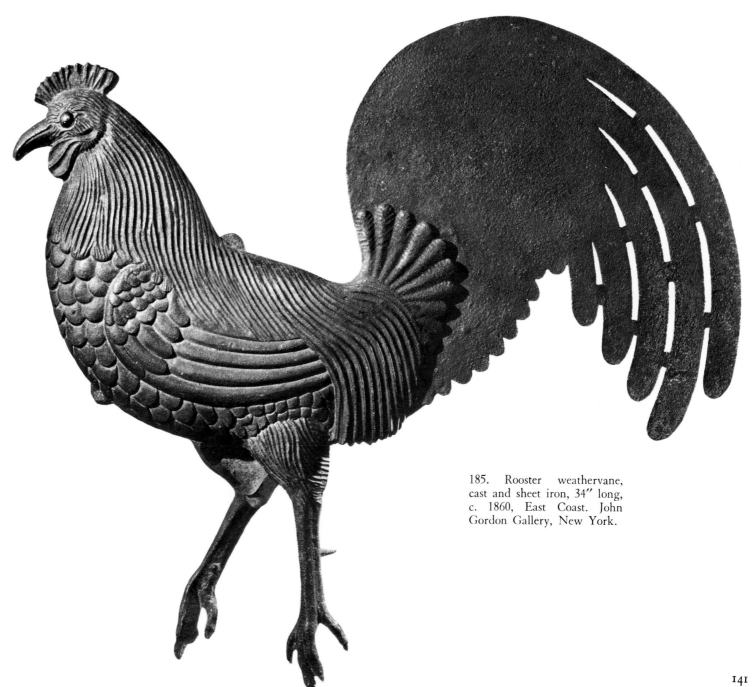

185. Rooster weathervane, cast and sheet iron, 34″ long, c. 1860, East Coast. John Gordon Gallery, New York.

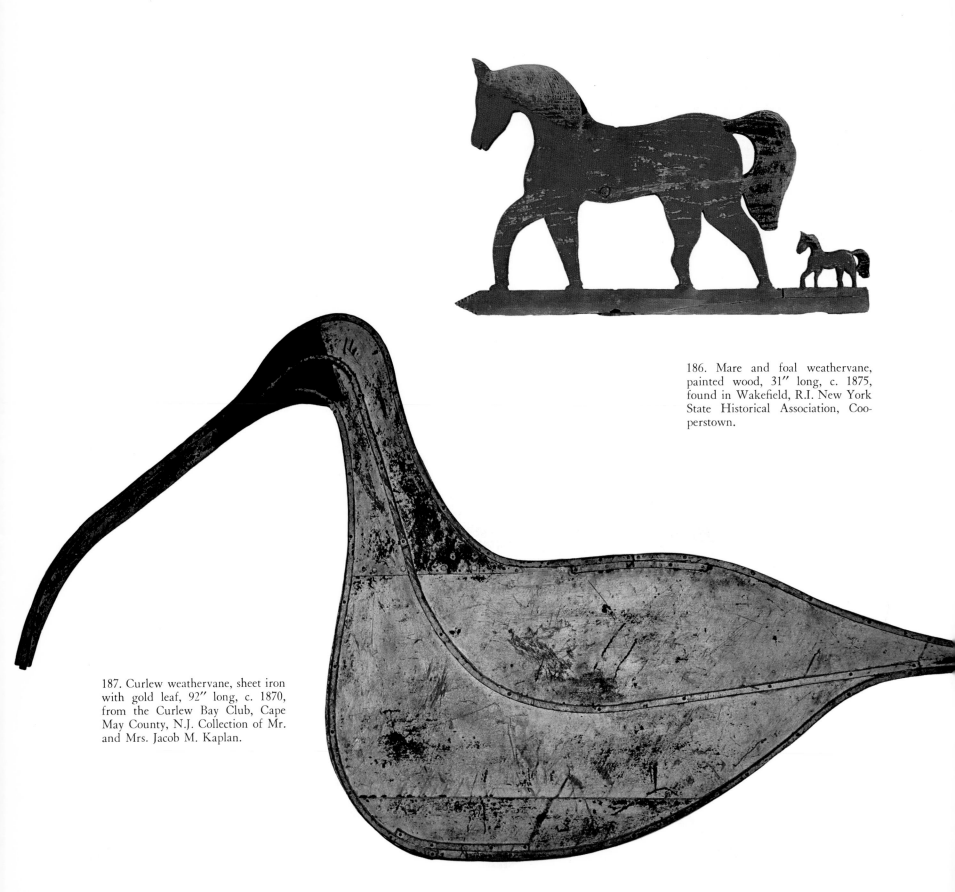

186. Mare and foal weathervane, painted wood, 31″ long, c. 1875, found in Wakefield, R.I. New York State Historical Association, Cooperstown.

187. Curlew weathervane, sheet iron with gold leaf, 92″ long, c. 1870, from the Curlew Bay Club, Cape May County, N.J. Collection of Mr. and Mrs. Jacob M. Kaplan.

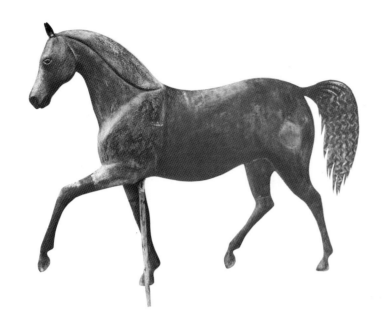

188. Horse weathervane, cast zinc and sheet copper, 30″ long, c. 1860, probably Massachusetts. Collection of Mr. and Mrs. Robert M. Doty.

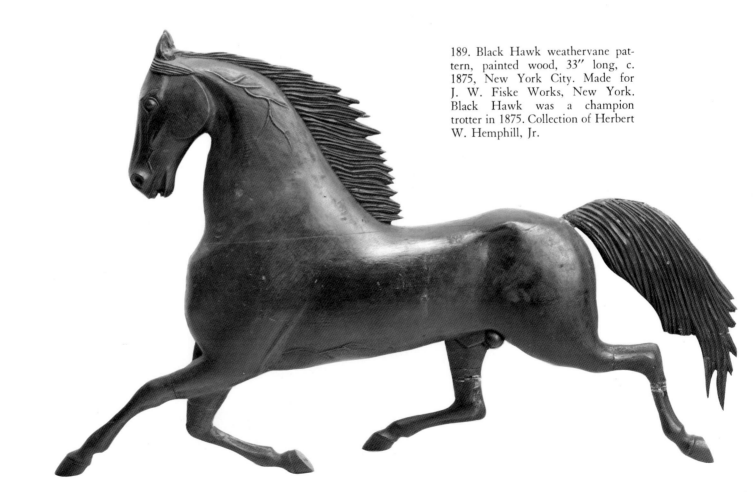

189. Black Hawk weathervane pattern, painted wood, 33″ long, c. 1875, New York City. Made for J. W. Fiske Works, New York. Black Hawk was a champion trotter in 1875. Collection of Herbert W. Hemphill, Jr.

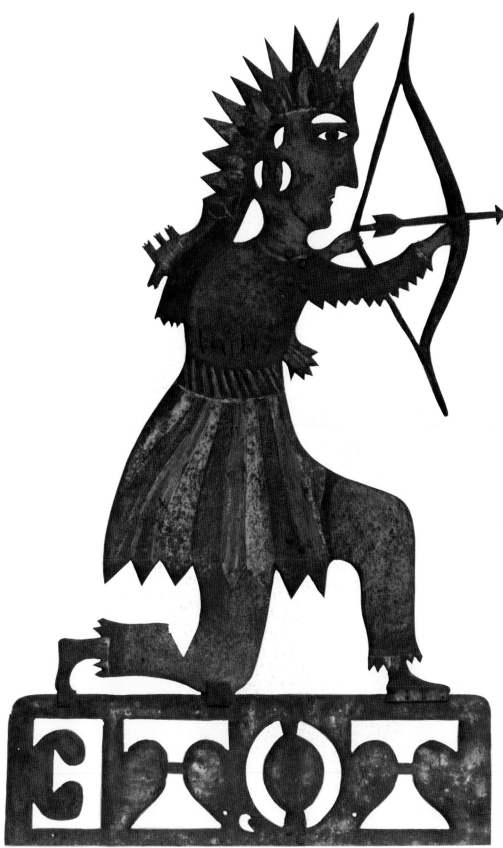

190. Indian archer weathervane, polychromed sheet iron, 51″ high, c. 1810, found in Pennsylvania. Shelburne Museum, Shelburne, Vt.

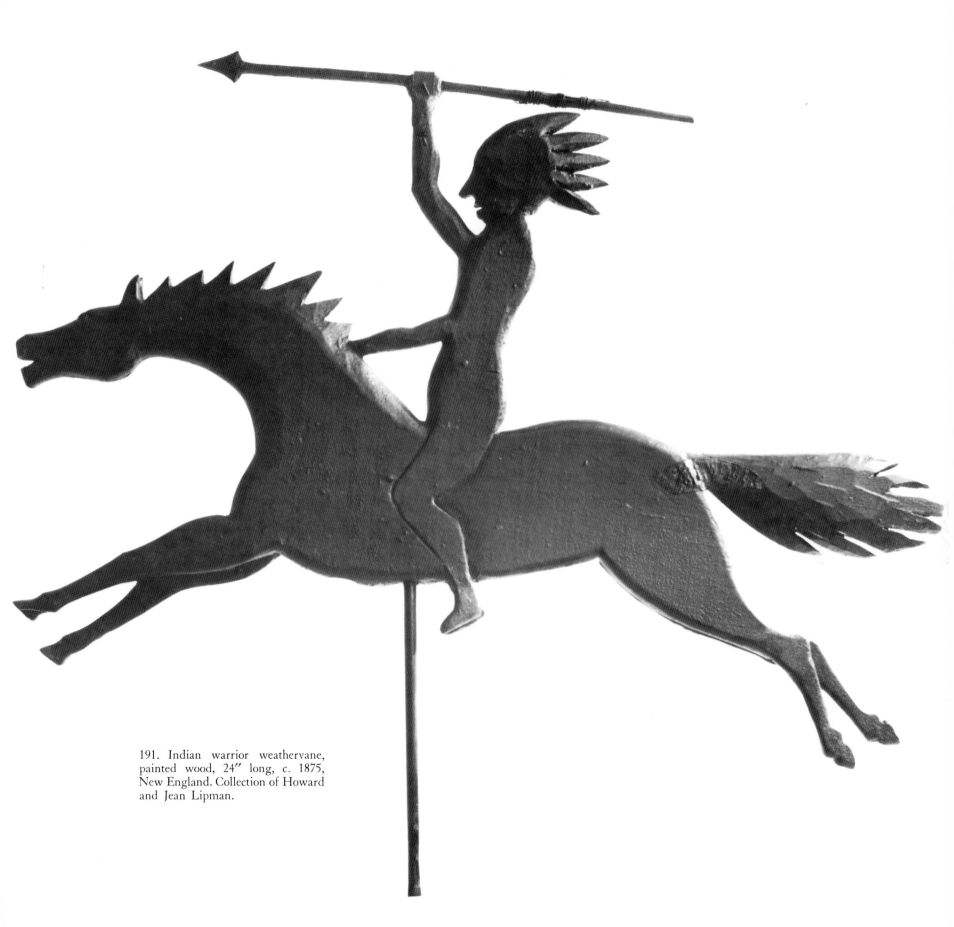

191. Indian warrior weathervane, painted wood, 24″ long, c. 1875, New England. Collection of Howard and Jean Lipman.

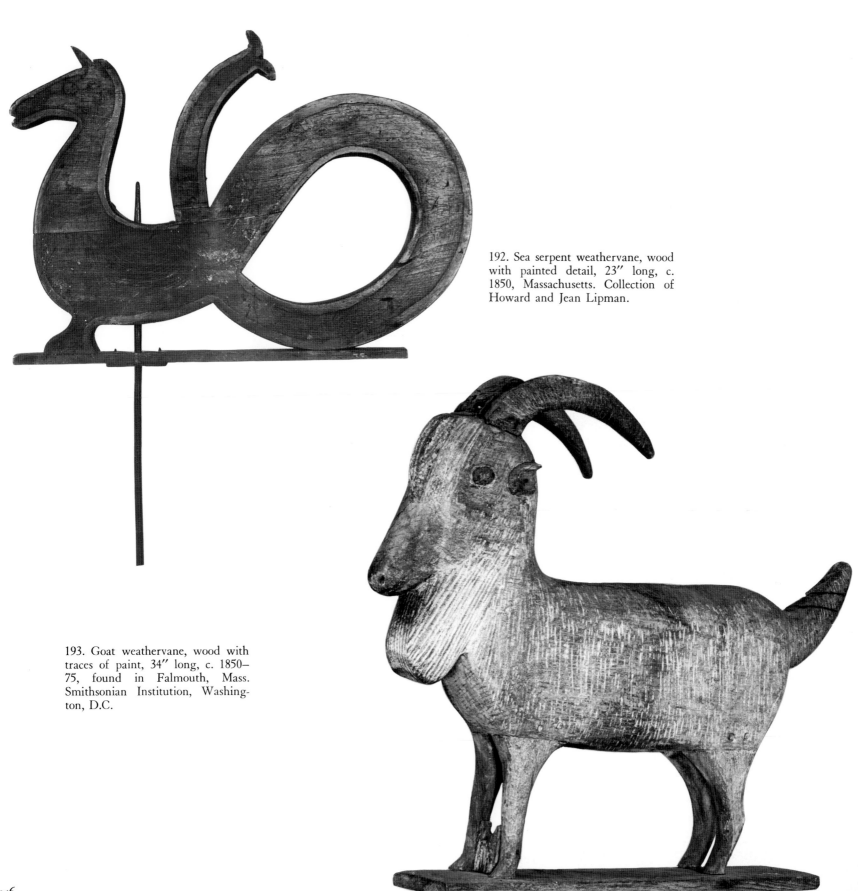

192. Sea serpent weathervane, wood with painted detail, 23″ long, c. 1850, Massachusetts. Collection of Howard and Jean Lipman.

193. Goat weathervane, wood with traces of paint, 34″ long, c. 1850–75, found in Falmouth, Mass. Smithsonian Institution, Washington, D.C.

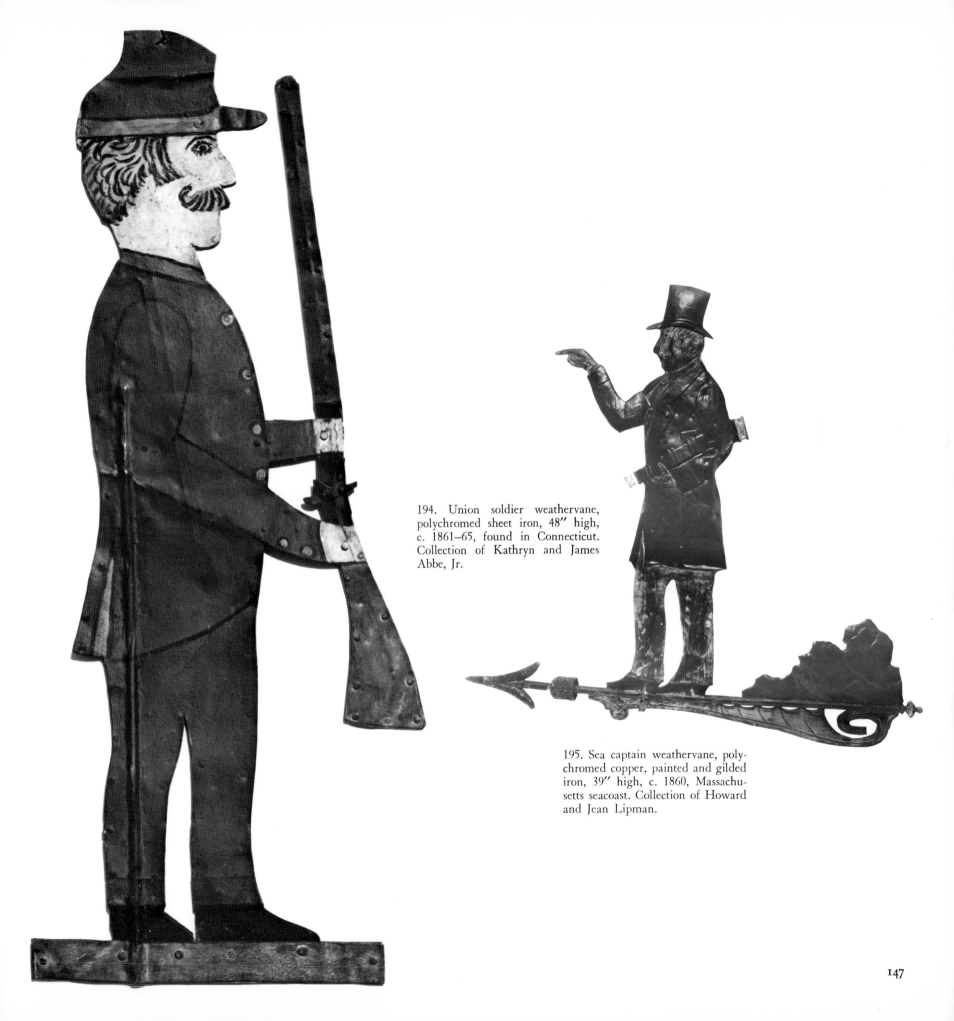

194. Union soldier weathervane, polychromed sheet iron, 48″ high, c. 1861–65, found in Connecticut. Collection of Kathryn and James Abbe, Jr.

195. Sea captain weathervane, polychromed copper, painted and gilded iron, 39″ high, c. 1860, Massachusetts seacoast. Collection of Howard and Jean Lipman.

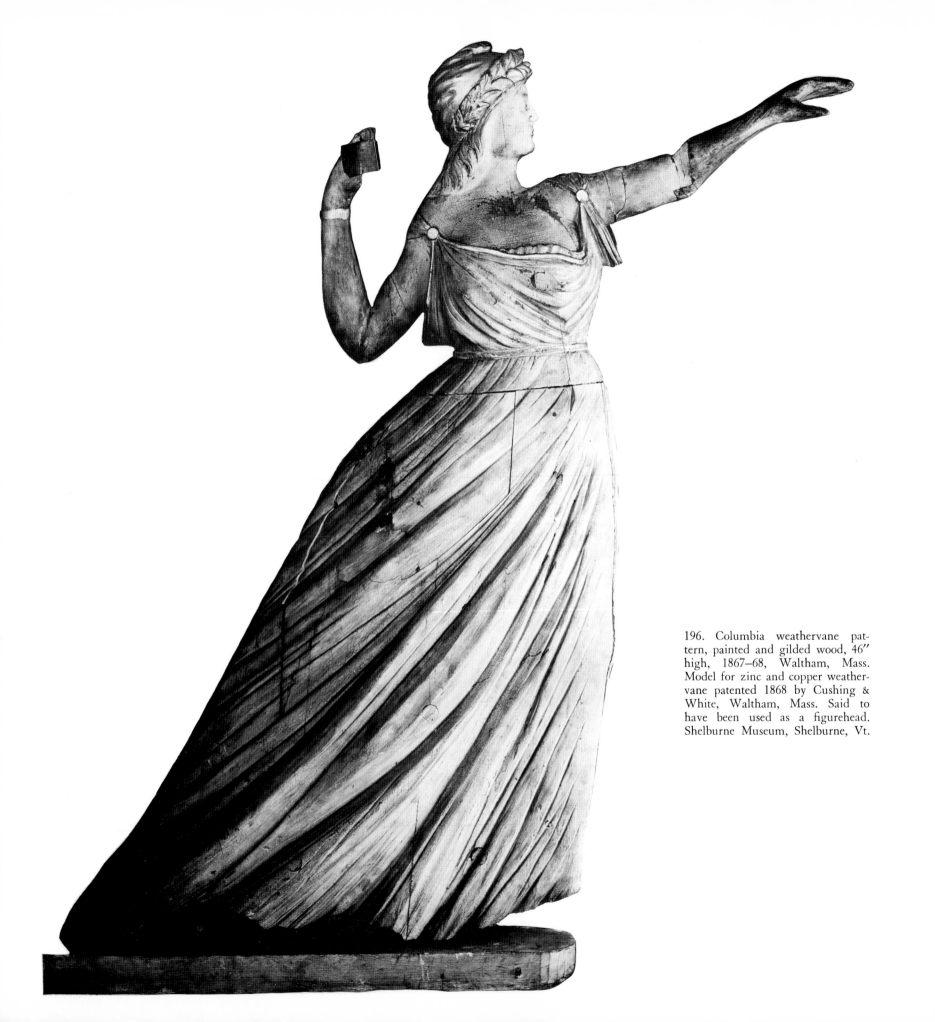

196. Columbia weathervane pattern, painted and gilded wood, 46" high, 1867–68, Waltham, Mass. Model for zinc and copper weathervane patented 1868 by Cushing & White, Waltham, Mass. Said to have been used as a figurehead. Shelburne Museum, Shelburne, Vt.

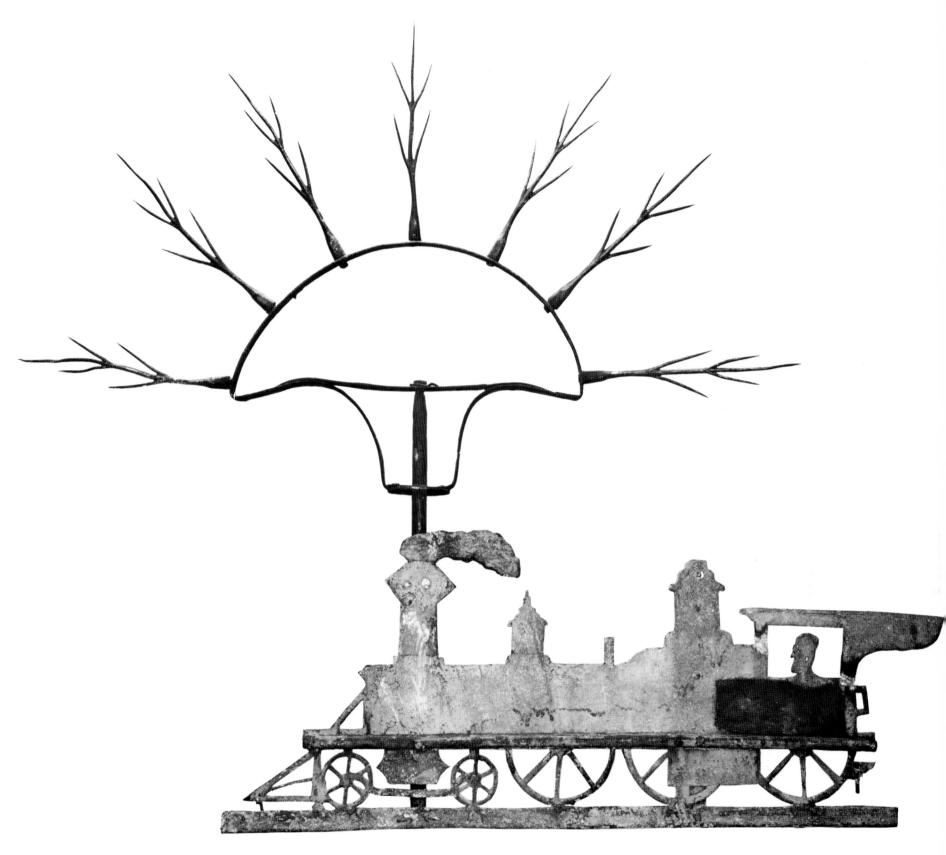

197. Locomotive weathervane, sheet zinc, brass and iron, 34″ long, c. 1840, Rhode Island. Said to have been used on a railroad station; the top element is a lightning rod. Shelburne Museum, Shelburne, Vt.

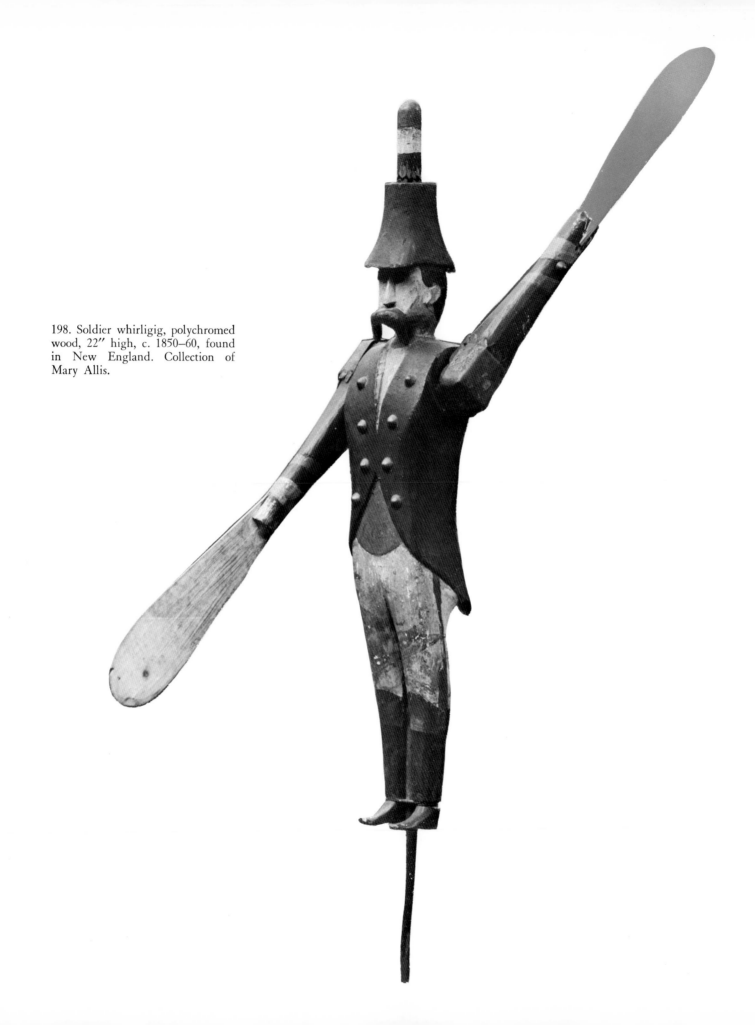

198. Soldier whirligig, polychromed wood, 22″ high, c. 1850–60, found in New England. Collection of Mary Allis.

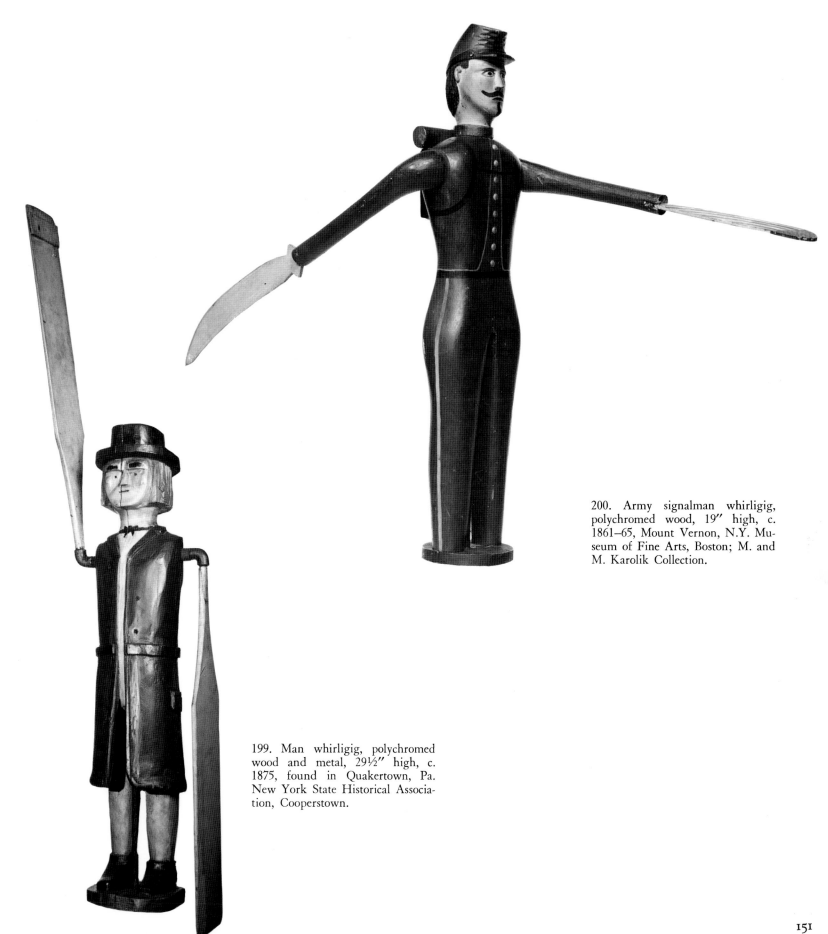

200. Army signalman whirligig, polychromed wood, 19″ high, c. 1861–65, Mount Vernon, N.Y. Museum of Fine Arts, Boston; M. and M. Karolik Collection.

199. Man whirligig, polychromed wood and metal, 29½″ high, c. 1875, found in Quakertown, Pa. New York State Historical Association, Cooperstown.

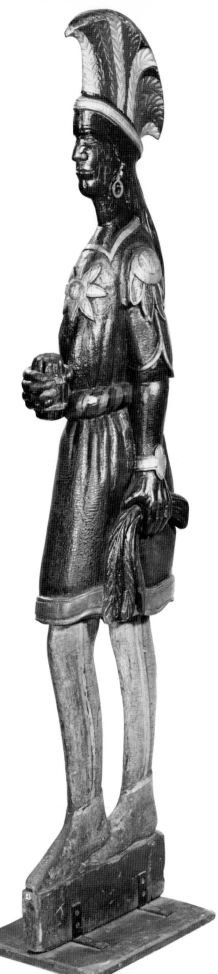

201. Cigar-store Indian, painted and gilded wood, 72¼″ high, 1850–75, found in Virginia. Made from a flat board carved on each side in relief. Virginia Museum of Fine Arts, Richmond.

CIGAR-STORE FIGURES AND OTHER SHOP SIGNS

From the moment Columbus arrived at the Spanish court with ten Indian captives as trophies, the figure of the Indian has held special fascination for the white man. Judging from the large number found in all categories of folk art, the fondness for images of Indians grew even as these original Americans were being dispossessed of their ancient lands. Indeed, the idealization of the "noble savage" as a great chief or beautiful princess tended to help people forget—then as now—the dark side of the story of white men and Indians in America.

The best-known and most picturesque Indian figures in American folk art are the life-size wooden Indians that once stood before tobacco shops as advertisements for cigars, snuff and related products from another native of America, the tobacco leaf. The sign carved in the form of a trade or business symbol has great antiquity and was practical in societies where most people could not read the written word. A successful sign is based on an emblem that is at once eye-catching and immediately associated with the product advertised. The identification of the Indian with tobacco products evolved slowly. It appears to have originated in England in the seventeenth century, although we would scarcely recognize these "Virginians": strange, hybrid figures with Negroid features, feathered headdress and a kilt of tobacco leaves. The makers apparently modeled them after the popular romanticized engravings of Indians of South America and Florida published by Theodore de Bry in the late 1500s and early 1600s. The Indian was not established as a cigar-store symbol in America until the nineteenth century, and his heyday was from the fifties through the eighties.

While many other types of folk art have at one time or another been discarded and forgotten, popular affection for cigar-store figures never entirely died out. Evidence of this interest is found in a number of newspaper articles about cigar-store figures which were published in the last decade of the nineteenth century. These articles are particularly valuable because they are based on conversations with the carvers themselves. One such article, written by Frank Weitenkampf for *The New York Times*, is full of infor-

mation about the "Indian trade" as practiced in New York City. He tells us that the earliest wooden Indians were made by figurehead carvers who, with the decline of the sailing-ship industry, had lost their occupations and turned to the making of shop signs. The price for an Indian ranged from sixteen dollars for a small countertop or window-display model to a hundred and twenty-five for a life-size sidewalk figure. The center of the trade was the Eastern seaboard. The method of the carver was carefully documented in Weitenkampf's article:

> The wood used is generally white pine, which is bought in logs of various lengths at the spar yards. The artist begins by making the roughest kind of an outline—a mere suggestion of what the proportions of the figure are to be. In this he is guided by paper patterns. The log is blocked out with the axe into appropriate spaces for the head, the body down to the waist, the portion from there to the knee, the rest of the legs (which are at once divided), and the feet. The feeling for form in the chopped block is so very elementary as to have complete suggestiveness only for the practiced artist. A hole is now bored in each end of the prepared log about 5 inches deep. Into each hole an iron bolt is placed, the projecting parts of which rest on supports so that the body hangs free. The carver now goes from the general to the particular. The surface of the wood soon becomes chipped up by the chisel and the log generally takes on more definite form. Then when the figure is completely evolved the finishing touches are put in with finer tools. Detached hands and arms are made separately and joined to the body with screws.

No sooner was the Indian established at the entrance of cigar stores than certain tobacconists, seeking novelty, began using other figures to advertise their wares. The parade of carved figures which followed the early vogue for Indians presents a vivid contemporary picture of all the personalities close to the hearts of nineteenth-century Americans. There were everyday folk, soldiers, sailors, fashionable ladies, dancing Negroes; exotic foreigners, some having particular associations with tobacco, such as Turks and Egyptians; characters out of literature and history; patriotic symbols, such as Uncle Sam; and popular heroes of the day. Some figures seem to have been associated with individual brands, an early form of national advertising: the elegant lady holding a tobacco leaf, a squirrel perched on her bonnet, proclaimed the virtues of Squirrel brand cigars.

According to early published accounts, no respectable tobacco dealer would have set up shop without an Indian or figure of some kind. Often it was mounted on a base with wheels so that it could be rolled into the shop each evening for protection from vandals. Some figures doubled as display racks: flat headdresses, especially on small counter

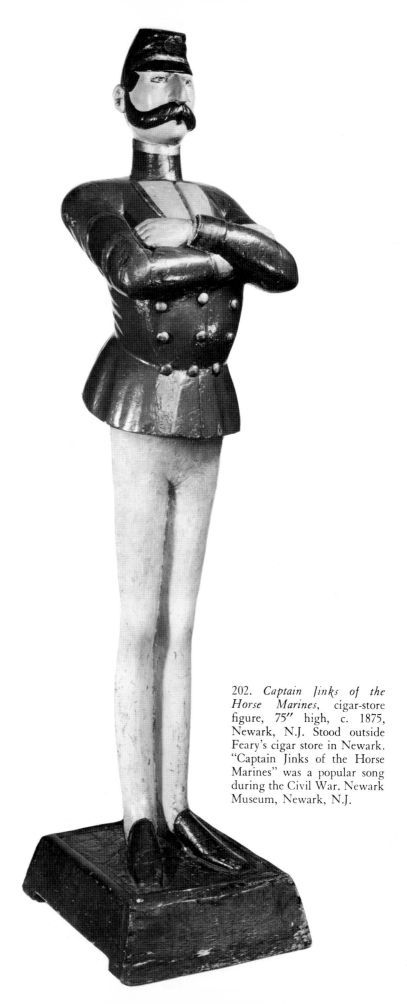

202. *Captain Jinks of the Horse Marines*, cigar-store figure, 75″ high, c. 1875, Newark, N.J. Stood outside Feary's cigar store in Newark. "Captain Jinks of the Horse Marines" was a popular song during the Civil War. Newark Museum, Newark, N.J.

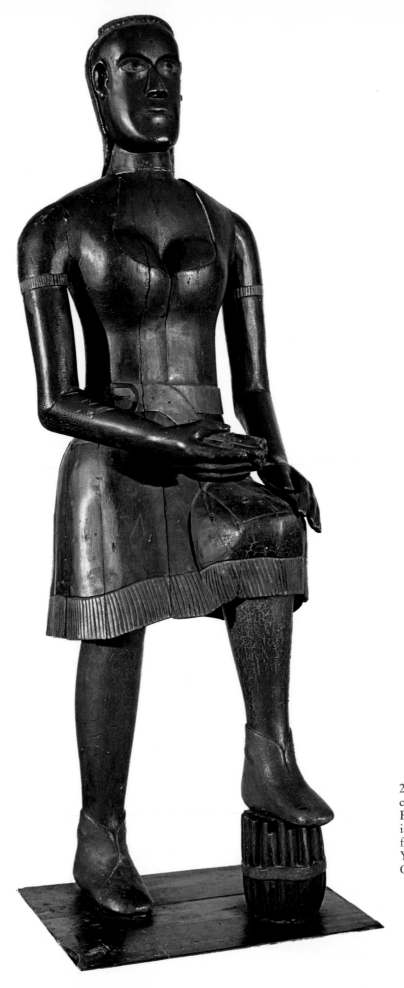

203. Job, cigar-store Indian, poly-chromed wood, 59″ high, c. 1825, Freehold, N.J. Job was a slave who is said to have made this shop sign for a tobacconist in Freehold. New York State Historical Association, Cooperstown.

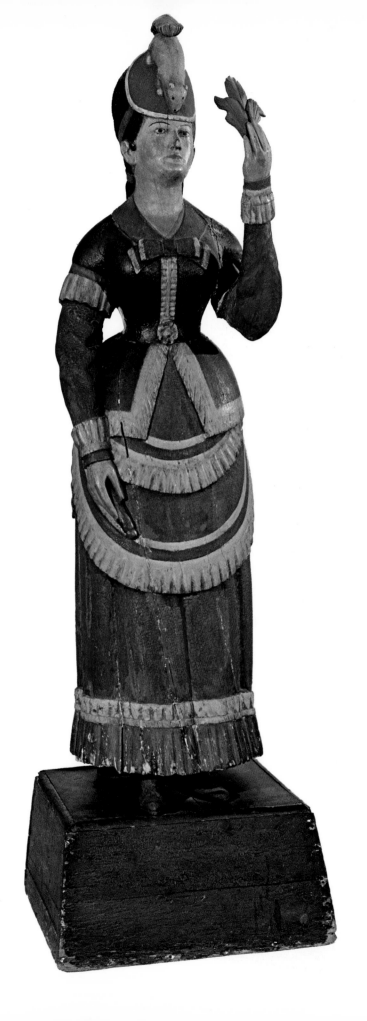

204. Cigar-store figure, polychromed wood, 67½″ high, c. 1875, Calais, Me. Made to advertise Squirrel brand cigars. New York State Historical Association, Cooperstown.

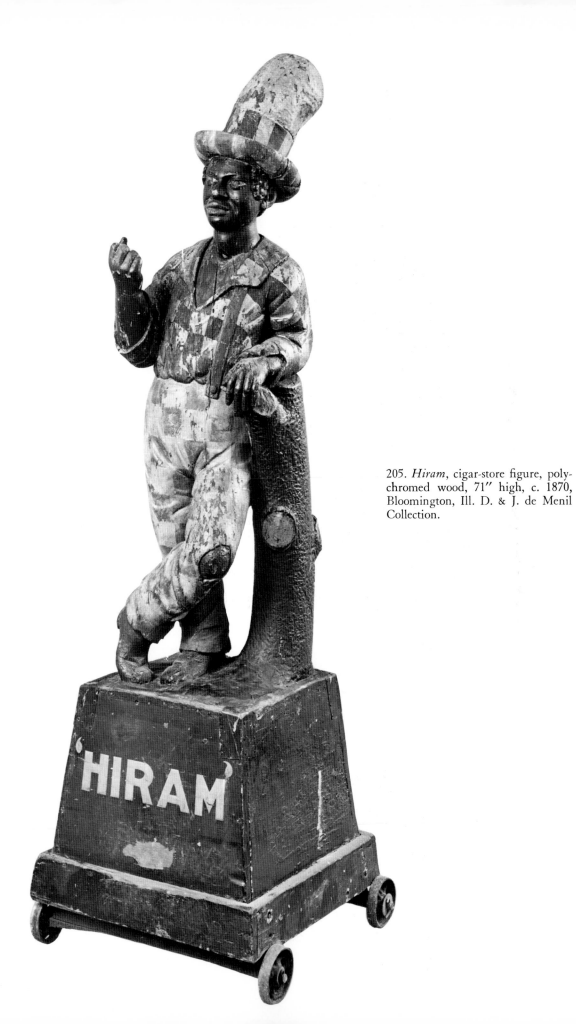

205. *Hiram*, cigar-store figure, polychromed wood, 71″ high, c. 1870, Bloomington, Ill. D. & J. de Menil Collection.

models, could support a cigar box, and some held boxes with holes into which individual cigars could be inserted. The figures were given special care and feeding: many had a small hole in the top of the head into which linseed oil was poured to lubricate the wood and discourage cracking. Ideally, they were repainted every year or two with high-grade paint, sometimes with flashy gold or silver trimming. Some itinerants made a full-time profession of repainting cigar-store figures.

Although the first cigar-store carvers worked in the big cities of the Eastern seaboard, in the same centers that had once supported a vigorous ship-figurehead business, the craft eventually spread to the Midwest. Detroit had a number of carvers, many of them Swiss, German and Scandinavian immigrants who used their Old World skills to meet the demand of American businessmen for advertising figures. One of the best-known—and highest-priced—carvers was Julius Theodore Melchers. A native of Germany who emigrated to the United States in 1852, Melchers became fascinated by Indians. He hired Indians as models and became an avid collector of Indian artifacts. For his figures he used old masts from sailing ships, easily acquired in quantity in those days, and his renown was such that he was able to employ a number of apprentices in his thriving business.

At the opposite pole from Melcher's sophisticated work is the wooden Indian said to have been made by a slave named Job for a tobacconist in Freehold, New Jersey. The African heritage of the carver is apparent, especially in the masklike face. This figure transcends its homely trade-sign function to rank as a great American sculpture.

Tobacco shops were not the only businesses that used sculptured figures as advertisements. As early as the eighteenth century in New England seaports, little carved mariners could be seen hanging above the doorways of ship chandlers and nautical instrument makers; these were undoubtedly carved by the same men who executed figure-heads. One of these figures, and other carvings in the round for a ladies' bootmaker, an apothecary and a tavern, are shown here, as well as a wooden plaque carved in relief for a tool company, a tinsmith's hanging signboard, and a silhouetted gentleman for a tailor's shop.

The day of sculpture as advertising has passed. Hordes of city Indians were banished from the sidewalks as objectionable obstructions to pedestrian traffic, and large tobacco companies turned to other promotional media. Many Indians vanished altogether, and those that survived —like their real-life models—are confined to "reservations," in museums and private collections. Not long ago, however, when a collector sold off a large number of cigar-store figures, some were purchased by tobacco dealers, and today these handsome figures are once again gainfully employed.

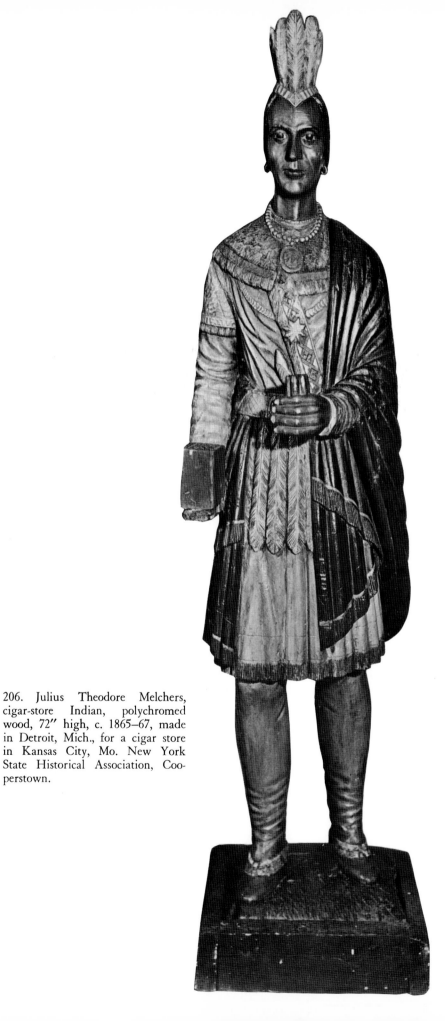

206. Julius Theodore Melchers, cigar-store Indian, polychromed wood, 72″ high, c. 1865–67, made in Detroit, Mich., for a cigar store in Kansas City, Mo. New York State Historical Association, Cooperstown.

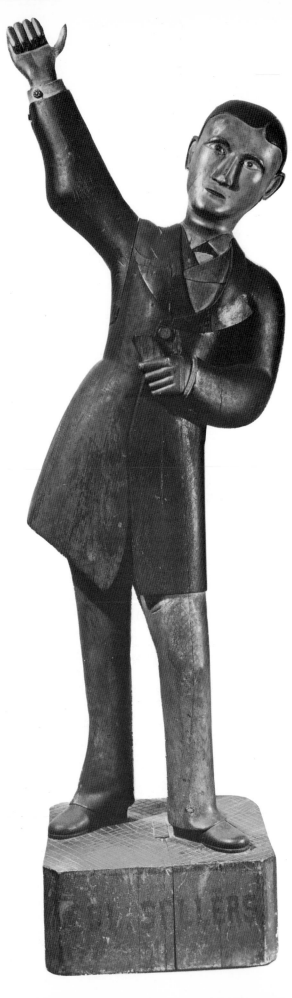

207. *Colonel Sellers*, shop sign, poly-
chromed wood, 59½″ high, c. 1875,
Sellersville, Pa. Used for an apothe-
cary shop in Sellersville, the figure
portrays a character in Mark Twain's
The Gilded Age (1875). New York
State Historical Association, Coo-
perstown.

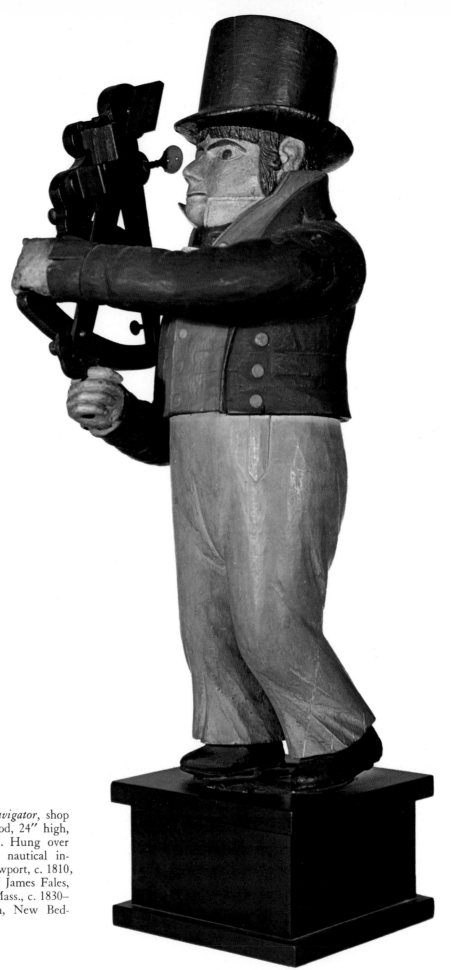

208. Samuel King, *Navigator*, shop sign, polychromed wood, 24" high, c. 1810, Newport, R.I. Hung over door of James Fales, nautical instrument maker in Newport, c. 1810, and then over shop of James Fales, Jr., in New Bedford, Mass., c. 1830–80. Whaling Museum, New Bedford, Mass.

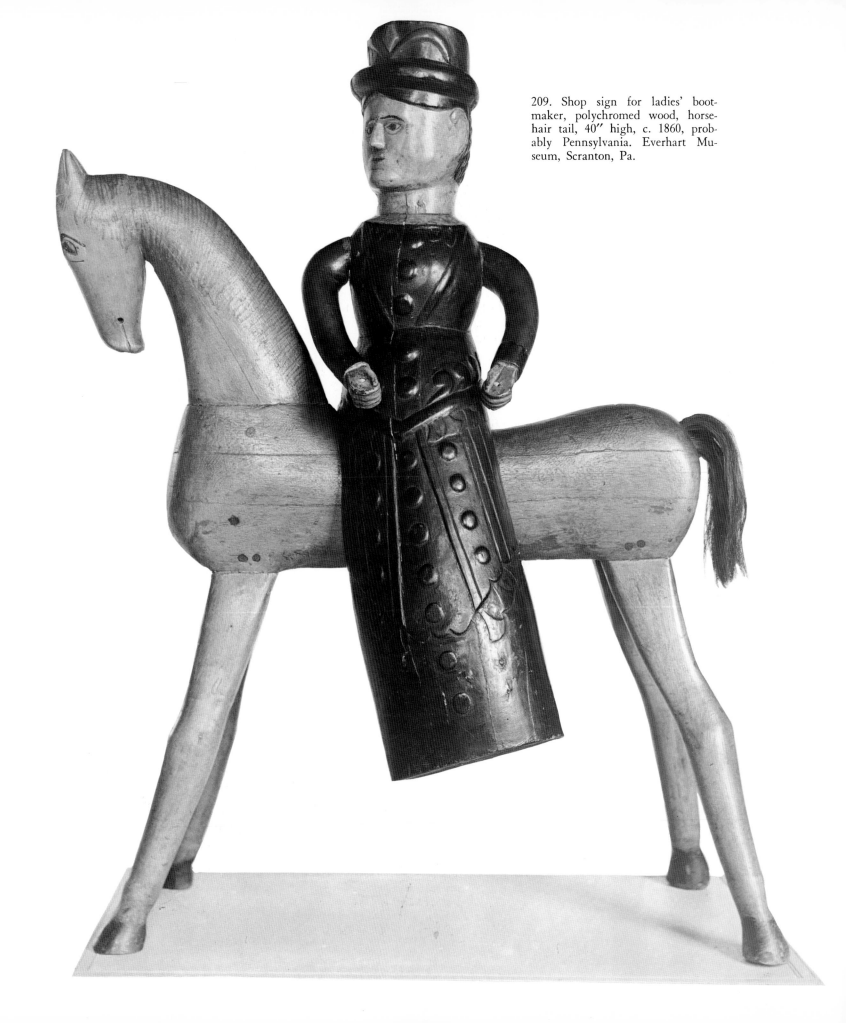

209. Shop sign for ladies' bootmaker, polychromed wood, horsehair tail, 40″ high, c. 1860, probably Pennsylvania. Everhart Museum, Scranton, Pa.

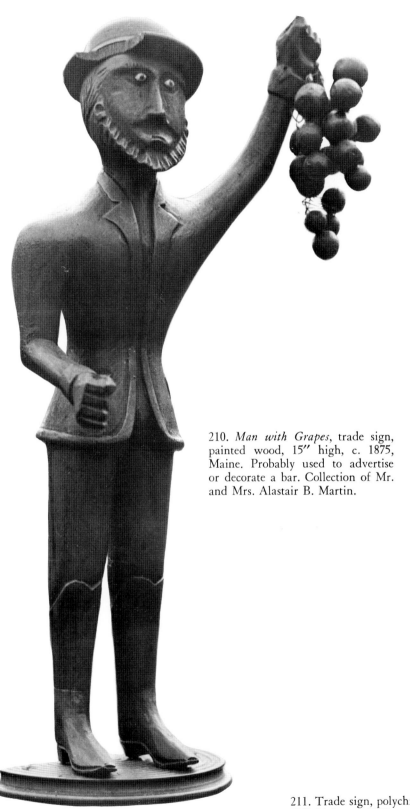

210. *Man with Grapes*, trade sign, painted wood, 15″ high, c. 1875, Maine. Probably used to advertise or decorate a bar. Collection of Mr. and Mrs. Alastair B. Martin.

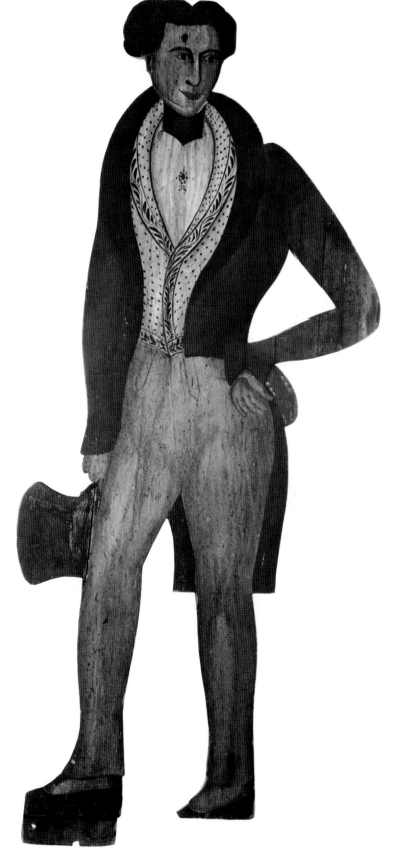

211. Trade sign, polychromed wood, 42″ high, c. 1830, probably New England. Presumably made for a tailor's shop. Connecticut Historical Society, Hartford.

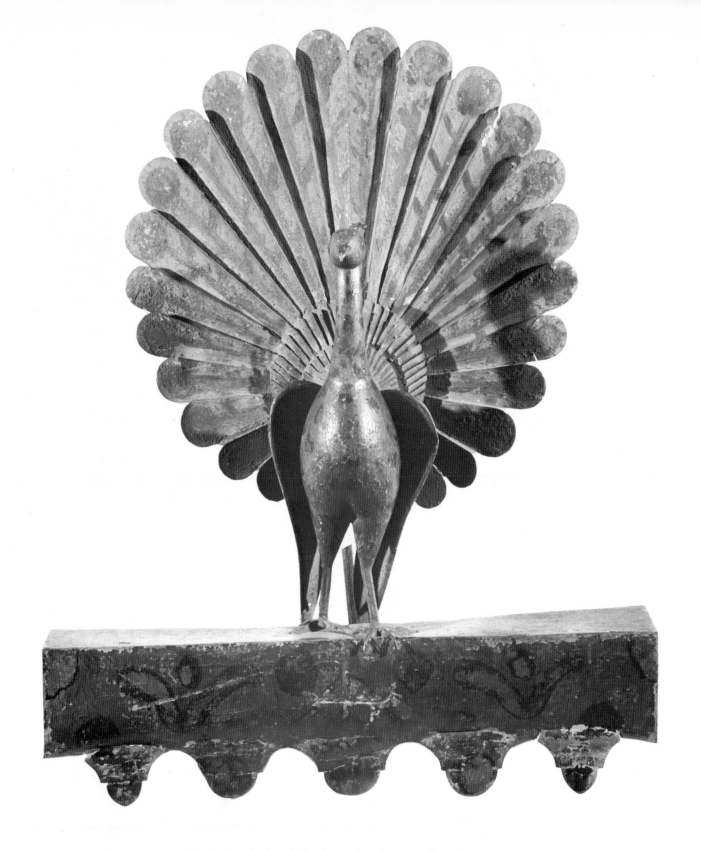

212. Peacock tinsmith's sign, painted zinc, 29″ high, c. 1830, found in Torrington, Conn. Abby Aldrich Rockefeller Folk Art Collection, Williamsburg, Va.

213. Toolmaker's trade sign, walnut, 27½″ wide, c. 1870, probably used by Collins Axe Co. of Collinsville, Conn. New York State Historical Association, Cooperstown.

214. Ship chandler's sign, polychromed wood, 49″ high, c. 1850, probably New England. Collection Rudolf F. Haffenreffer, 3rd.

215. Captain Osgood, Canada goose decoys, polychromed wood, all 24″ long, c. 1849, Salem, Mass. Shelburne Museum, Shelburne, Vt.

Every schoolchild knows that the Indians gave the early settlers corn and tobacco, the canoe and moccasins; few of us, however, realize that the wildfowl decoy was invented by the original Americans long before the white man's arrival. Over countless centuries of studying the habits of their quarry, keen Indian hunters observed that indeed birds of a feather do flock together and that an artificial bird can be used to attract wildfowl within the range of a concealed hunter. The device is so simple that it is difficult to believe that hunters in other lands did not use it, but the most diligent researchers have not found evidence of decoys in the Old World. The common practice in Europe was to trap wildfowl in cages, sometimes using tame birds to attract the prey; the word "decoy," which is of Dutch origin, referred to such cages.

The earliest American Indian bird lures were crudely shaped mud heaps or bunches of dried grass fastened to sticks, which roughly simulated bird forms. These temporary figures were succeeded by the first true decoys: stuffed skins and birds made of bulrushes painted in natural colors. The efficacy of these Indian lures was quickly apparent to the colonists, who soon began to carve their own decoys from wood. Using the decoy in conjunction with their own imported firearms, they became far deadlier hunters than ever the native Indians were.

The subsequent story of decoys is a part of the history of hunting in America, man's use and abuse of a staggering abundance of wildlife. It requires considerable imagination to visualize the New World as it must have been when the first white men arrived. Over an empty continent the great north-south seasonal migrations of birds literally darkened the sky, and the hunter could not only expect more birds than he could possibly shoot but he could predict the arrival of each species with great accuracy, for the birds, guided by a mysterious inner calendar that scientists still do not fully understand, always fly south at the same time each fall and return at the same time each spring. The New World, in short, was a hunter's heaven.

In colonial times men hunted primarily to supplement a meager and monotonous diet, but during the first hundred years of independence wildfowl shooting for sport and especially for profit led to slaughter of such proportions that a number of native species vanished altogether. By the end of the nineteenth century conservationists were urging strict control of hunting, and finally in 1918 Congress passed legislation that put an end to the shooting of wildfowl for commercial purposes. For most people today "decoy" means a lure for ducks or geese, which can

still be legally hunted by sportsmen. However, during the heyday of unrestricted shooting, when any game was fair game, decoys were carved in the likeness of every species, and from that period we have a sculptured anthology as various and as splendid as American bird life itself.

The form of the decoy was determined by the habits of the species it represented and the preferred method of hunting. Small shore birds, who feed along the beaches, require "stickups," decoys that stand on sharp sticks planted in the sand or among grasses. The large waterfowl, such as ducks and geese, are usually attracted by floating decoys, although stickups can be used in certain situations. Some of the simplest decoys—and the most striking from the point of view of design—were flat profiles, used as stickups. Judging from the large number that were made, they must have been as effective as the more naturalistic, three-dimensional types.

Many hunters carved their own decoys, most often during the bleak winter lull between autumn and spring migrations. Decoys were also made by carpenters, sea captains, anyone with a talent for whittling, and eventually there were professional decoy makers whose products were eagerly sought by hunters. Decoy making is one of the few forms of folk-art expression that has survived the machine age. Although factories now produce decoys in quantity, the home-carved varieties have remained more popular with discriminating sportsmen throughout the country. Decoy making continues as a modern craft based very closely on the methods of earlier generations, which originated in colonial times and were perfected about the time of the Civil War.

The material preferred by decoy makers was well-aged white pine or cedar, although occasionally a thrifty hunter would pick up a piece of driftwood and fashion it into a decoy. To make a three-dimensional, floating decoy the carver began by cutting the wood for the body into the required length. He then placed the body on a chopping block and hewed it roughly into the desired shape with a carpenter's hatchet—often he cut several bodies at the same time. The hewn body was then placed in a vise and finished with a long narrow-blade drawknife. Great attention was given to the head, which was sawed, rather than hewn, out of a small piece of wood, usually according to a pattern or template, and then finished like the body; the final touches were whittled with a jackknife. The head was then attached to the body with long spikes and supplementary nailing.

Sandpapering to remove all tool marks, priming to preserve the wood and painting in natural colors completed

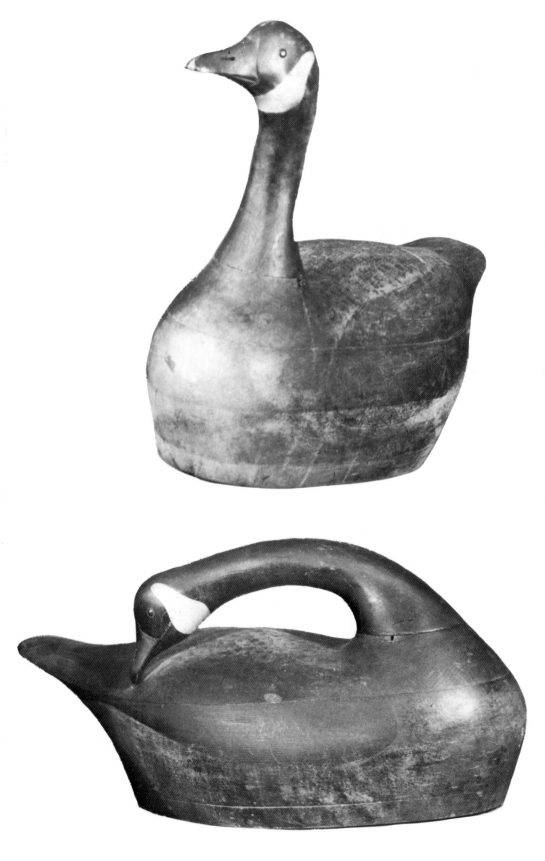

the decoy maker's work. Although carving methods are virtually the same today as a hundred years ago, the old decoys are readily distinguished by their painting. Whereas today's craftsmen pride themselves on realistic feather painting, the nineteenth-century decoy maker would have agreed with Mies van der Rohe that "less is more." The epitome of the suggestive rather than literal approach to decoy painting is found in the work of Lothrop T. Holmes. Using a limited palette of neutral colors, he painted the magnificent merganser drake and hen, shown here, in clear, stylized patterns that have the elegance of Oriental brushwork.

The most interesting decoys from the point of view of folk art date from the nineteenth century and come from the Eastern seaboard, especially New England and New Jersey. Each of the numerous river estuaries and salt marshes along the Atlantic coast presented its special challenge to the hunter and decoy maker, leading to an astonishing variety of regional decoys. Those who hunted in the cold, rough waters of Maine needed seaworthy decoys like the heavy sea loon carved by the lighthouse keeper Albert Orme. To add buoyancy, decoy bodies were sometimes hollowed out, as is the case with Captain Osgood's Canada geese. Purely local traditions arose: Long Island decoy makers sometimes used what the modern art critic would call an assemblage technique, adding roots, tree knots, string, nails and other "found objects" to the carved birds. The egret made of wood and twine, with a pointed stick for its beak, manages to capture the essence if not the actual appearance of its subject.

The stylized quality of the Long Island egret is typical of all decoys worthy of consideration as folk art. Made with the simplest of tools, the decoys shown here were executed with the nonrealistic approach on the part of the maker that characterizes all art—ancient or modern—in which design predominates. The decoy maker reduced forms and painted surfaces to their essentials in order to create an instantaneous and concentrated impression of his quarry. This abstraction was entirely deliberate, but it was a practical, not esthetic, decision on the part of the carver, who had discovered that conventionalized symbols attracted birds far more effectively than literal copies of nature.

216. Lothrop T. Holmes, pair of merganser decoys, polychromed wood, 17″ and 16¼″ long, c. 1860, Kingston, Mass. Both stamped with maker's name. Collection of Robin B. Martin.

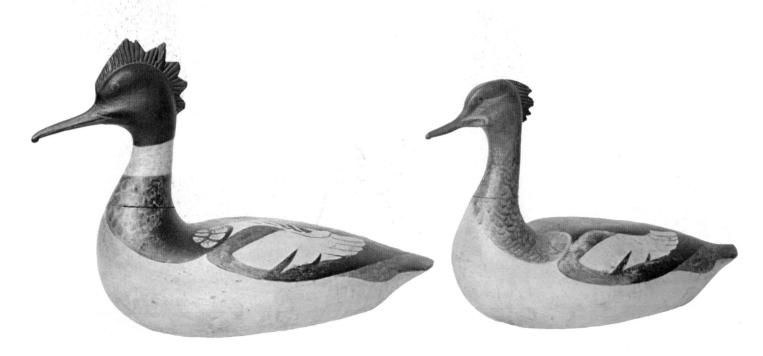

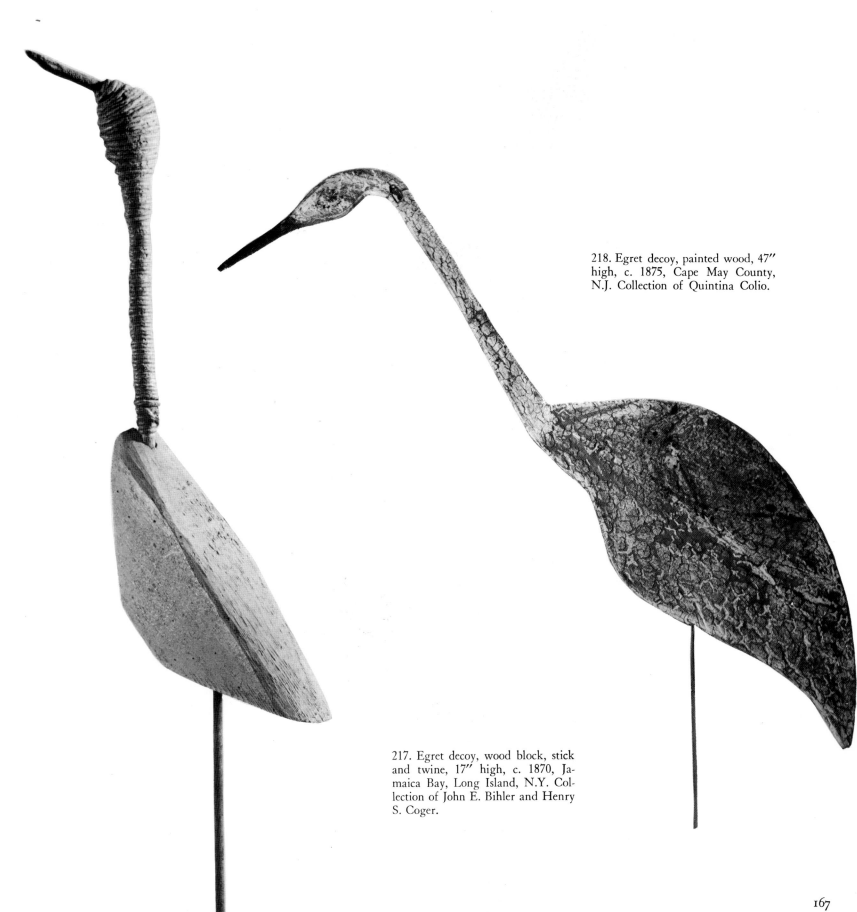

218. Egret decoy, painted wood, 47″ high, c. 1875, Cape May County, N.J. Collection of Quintina Colio.

217. Egret decoy, wood block, stick and twine, 17″ high, c. 1870, Jamaica Bay, Long Island, N.Y. Collection of John E. Bihler and Henry S. Coger.

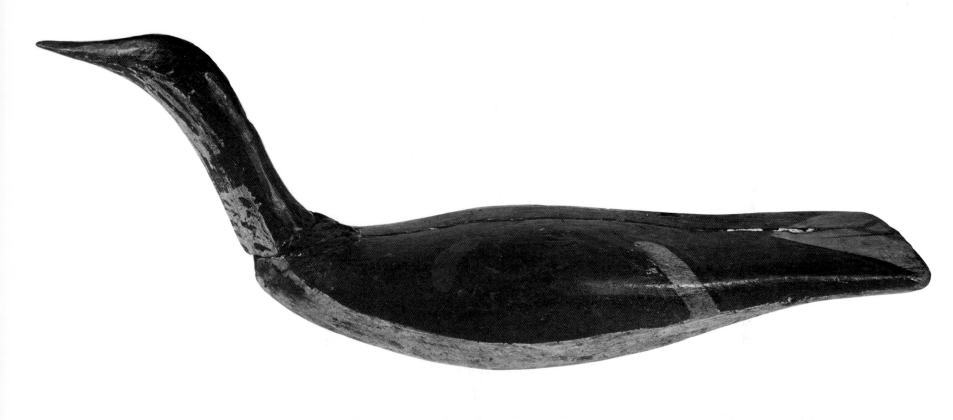

219. Loon decoy, painted wood, 26″ long, c. 1875, probably Maine. One of a pair. Shelburne Museum, Shelburne, Vt.

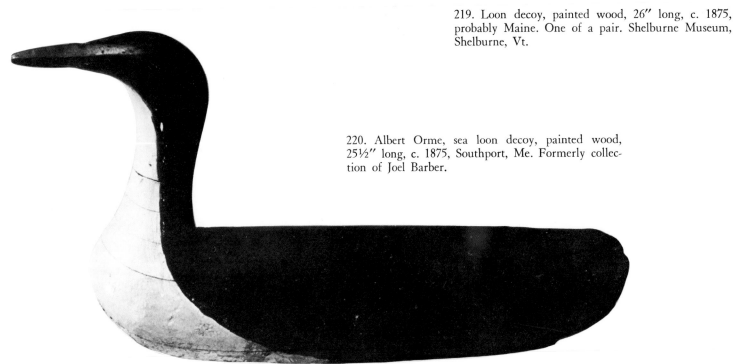

220. Albert Orme, sea loon decoy, painted wood, 25½″ long, c. 1875, Southport, Me. Formerly collection of Joel Barber.

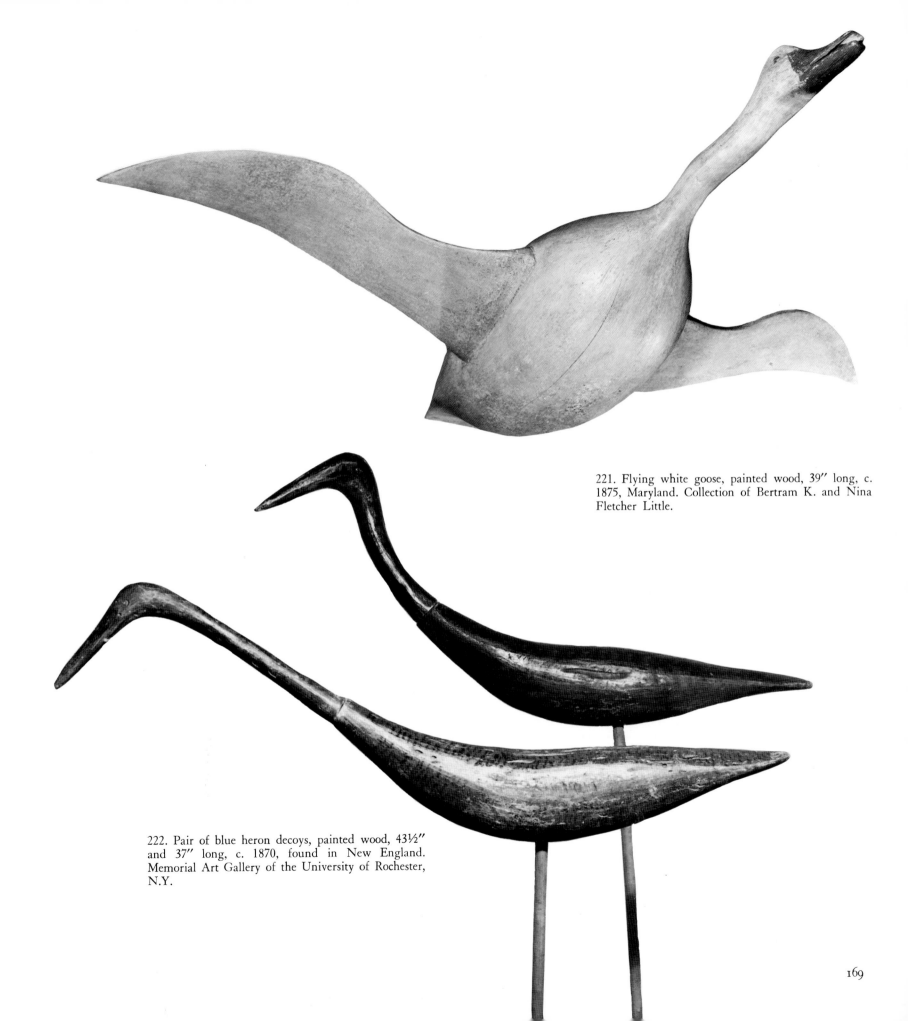

221. Flying white goose, painted wood, 39″ long, c. 1875, Maryland. Collection of Bertram K. and Nina Fletcher Little.

222. Pair of blue heron decoys, painted wood, 43½″ and 37″ long, c. 1870, found in New England. Memorial Art Gallery of the University of Rochester, N.Y.

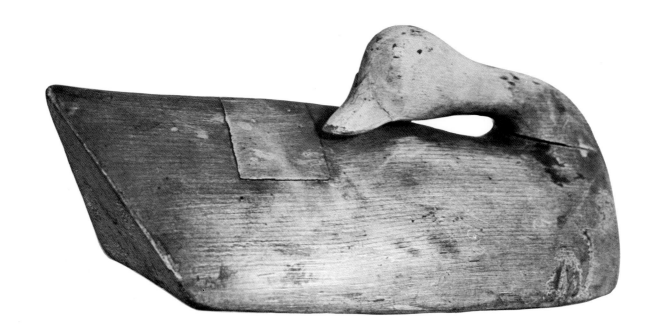

223. Sleeping cygnet decoy, wood, 14″ long, c. 1860–70, found on Long Island, N.Y. Collection of Mr. and Mrs. Jacob M. Kaplan.

224. Black duck decoy, painted wood, 21½″ long, c. 1860, Marshfield, Mass. Collection of George Ross Starr, Jr.

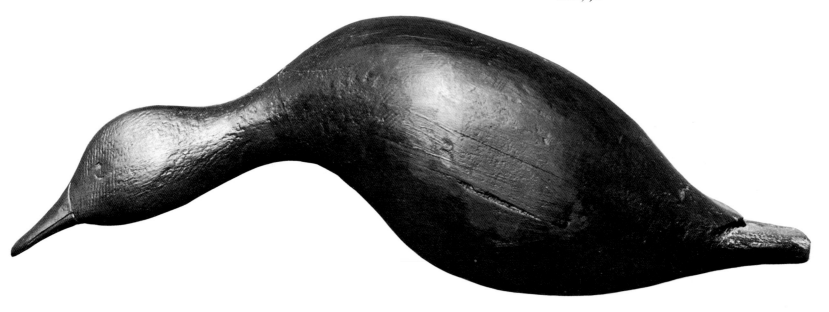

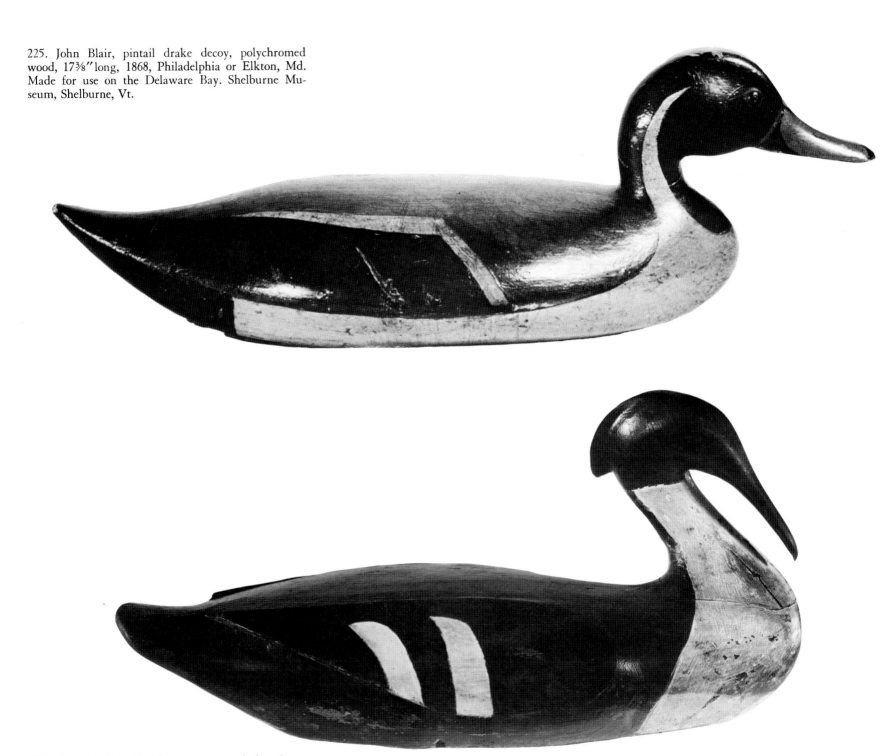

225. John Blair, pintail drake decoy, polychromed wood, 17⅜″ long, 1868, Philadelphia or Elkton, Md. Made for use on the Delaware Bay. Shelburne Museum, Shelburne, Vt.

226. Captain Ben Smith, merganser drake decoy, painted wood, 17⅛″ long, c. 1850, Monhegan Island, Me. Museum of Fine Arts, Boston; M. and M. Karolik Collection.

Anyone who has ever stared numbly at shelf after shelf of identical plastic toys in the local Kiddyland may find it hard to believe that the lovingly made, highly original creations reproduced here were ever made or used as playthings. Lucky indeed were the children who owned these toys, yet they, their parents and the toymakers certainly never looked upon them as art.

Early limners often portrayed their subjects with their generic attributes—toys in the case of children—and these portraits of children and family groups provide a fascinating record of the appearance and approximate period of use of early toys. Most American toys worthy of consideration as folk art come from New England or Pennsylvania. The Pennsylvania carvers drew their skills and inspiration from a tradition of toymaking that can be traced to the German-speaking lands of Europe. Toys were a pleasant and undoubtedly profitable sideline for the local carpenter, cabinetmaker, shipcarver, cobbler, tinsmith and potter. Knowing that children love best those simple toys that leave the most to the imagination, these craftsmen chiefly followed sturdy, uncomplicated designs, and unconsciously they achieved an almost abstract, highly individual style.

The kinds of interesting folk toys produced during the eighteenth and nineteenth centuries make a long list. Most of the earliest were made from wood; there were carved and painted dolls, hobbyhorses and animals in infinite variety. To heighten the child's delight, the element of motion was added, sometimes quite simply with wheels, as in the case of the painted soldier on horseback from

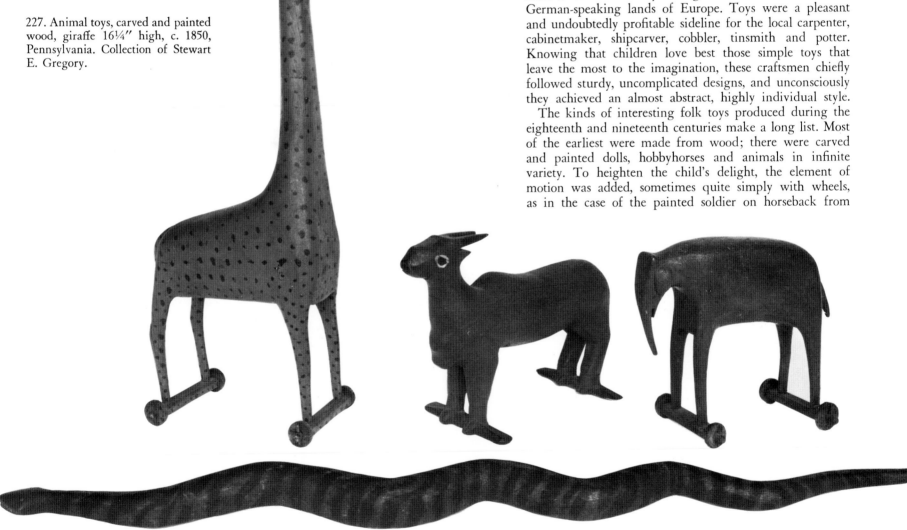

227. Animal toys, carved and painted wood, giraffe 16¼″ high, c. 1850, Pennsylvania. Collection of Stewart E. Gregory.

York County, Pennsylvania. The lower jaw of the toy whale shown here is made to snap shut, a feature that intensifies the behemoth's already fierce expression. The tin Indian maid of striking silhouette has jointed limbs and body, and can be manipulated into a variety of attitudes. Other animated toys were more complex: the gentleman in the balancing act has his exact center of gravity in every position insured by weighted balls; the puppetlike doll dances when wiggled on a string; and the highly abstract version of that all-American fowl, the turkey, can be made to peck most realistically by raising and lowering the ball that weights the jointed head and tail. Most intricate of all were entire animated tableaux, such as the marching soldiers, their Union uniforms readily identifiable, who step smartly in formation when the ratchet mechanism is operated by hand.

While wood was by far the most common material used by toymakers, by mid-nineteenth century tin toys were gaining in popularity, the beginning of a wave of die-stamped, mass-produced playthings that eventually displaced the handmade variety and the special talents that produced them. Unusual even in a selection of early toys such as this one is the little scrimshaw acrobat. Using whalebone or whale's teeth, the crews of New England whaleboats carved an astonishing variety of decorative and useful objects such as this. Some hardy sailor, homesick for his small son or daughter, must have whiled away part of the long voyage making this special gift to be presented upon his return home.

The faithful dog and familiar barnyard friends like the pig and the turkey were, of course, favorite subjects, but there were more exotic fauna in the toymakers' repertory. These creatures were unusual in both subject matter and appearance. How many early nineteenth-century toymakers could actually have seen a giraffe, an elephant or a kangaroo? It is possible that the pull-toy animals in the group photograph were made by a carver who also created Noah's Arks, such as the one we illustrate. The ark, with its paired animals, was a favorite "Sunday toy"—reserved for the Sabbath, when boisterous play was considered a violation of the Lord's Commandment, "Remember the Sabbath day, to keep it holy." Children in religious households had to be satisfied with toys having a Scriptural or educational value that made them a permissible form of Sunday amusement.

The carvings of animals from faraway lands have particular charm. Their creators, like the painters of composite scenes shown elsewhere in this book, seem to have been most inventive when liberated from the confines of observed reality. Speaking of her own Noah's Ark toy, a Miss Willson, born in 1795, summed up its outstanding quality in words that apply to all the best of American folk art: "It was made with the mind as well as the hands."

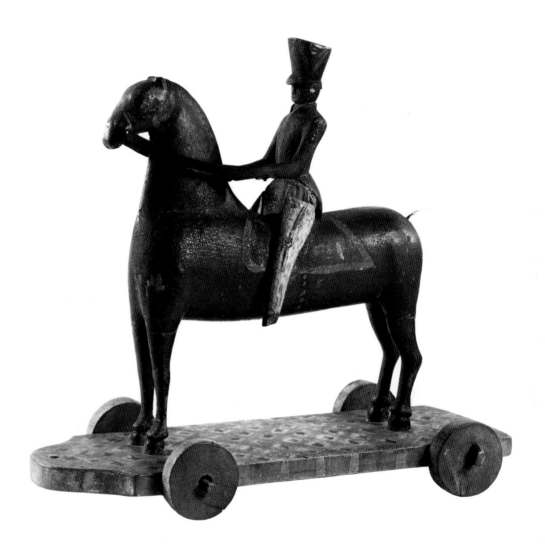

228. Soldier on horseback toy, polychromed wood, 13½″ high, c. 1825–50, Pennsylvania. Historical Society of York County, York, Pa.

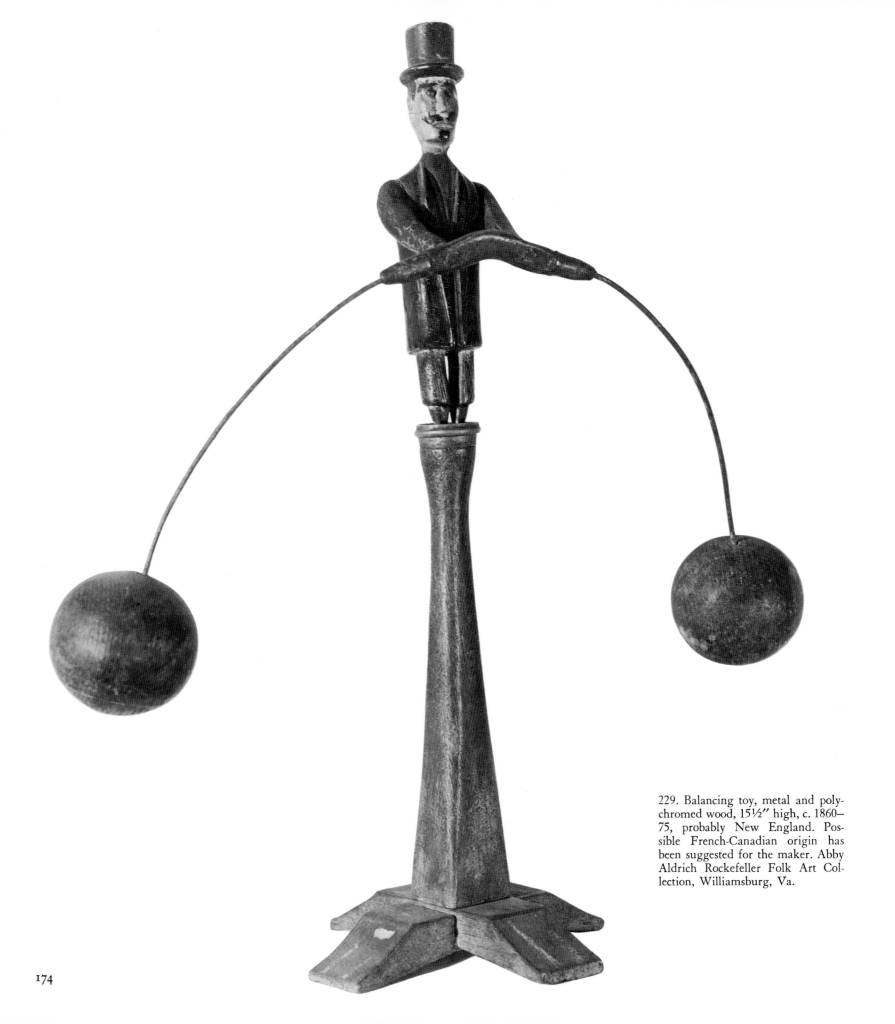

229. Balancing toy, metal and polychromed wood, 15½″ high, c. 1860–75, probably New England. Possible French-Canadian origin has been suggested for the maker. Abby Aldrich Rockefeller Folk Art Collection, Williamsburg, Va.

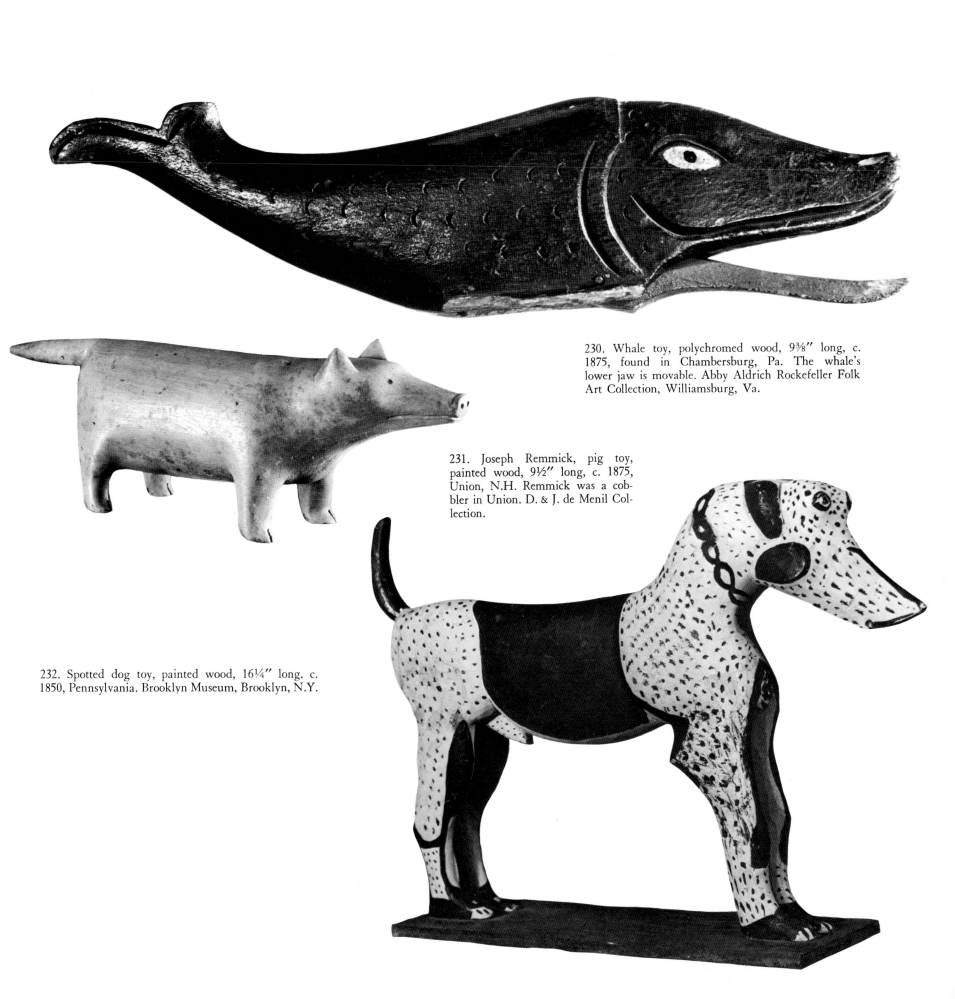

230. Whale toy, polychromed wood, 9⅜″ long, c. 1875, found in Chambersburg, Pa. The whale's lower jaw is movable. Abby Aldrich Rockefeller Folk Art Collection, Williamsburg, Va.

231. Joseph Remmick, pig toy, painted wood, 9½″ long, c. 1875, Union, N.H. Remmick was a cobbler in Union. D. & J. de Menil Collection.

232. Spotted dog toy, painted wood, 16¼″ long. c. 1850, Pennsylvania. Brooklyn Museum, Brooklyn, N.Y.

233. Kangaroo toy, painted wood, 47½″ long, c. 1840, Lebanon County, Pa. Collection of Mr. and Mrs. John Gordon.

234. Scrimshaw acrobat toy, whale ivory, 5½″ high, c. 1850, found in New Bedford, Mass. Whaling Museum, New Bedford, Mass.

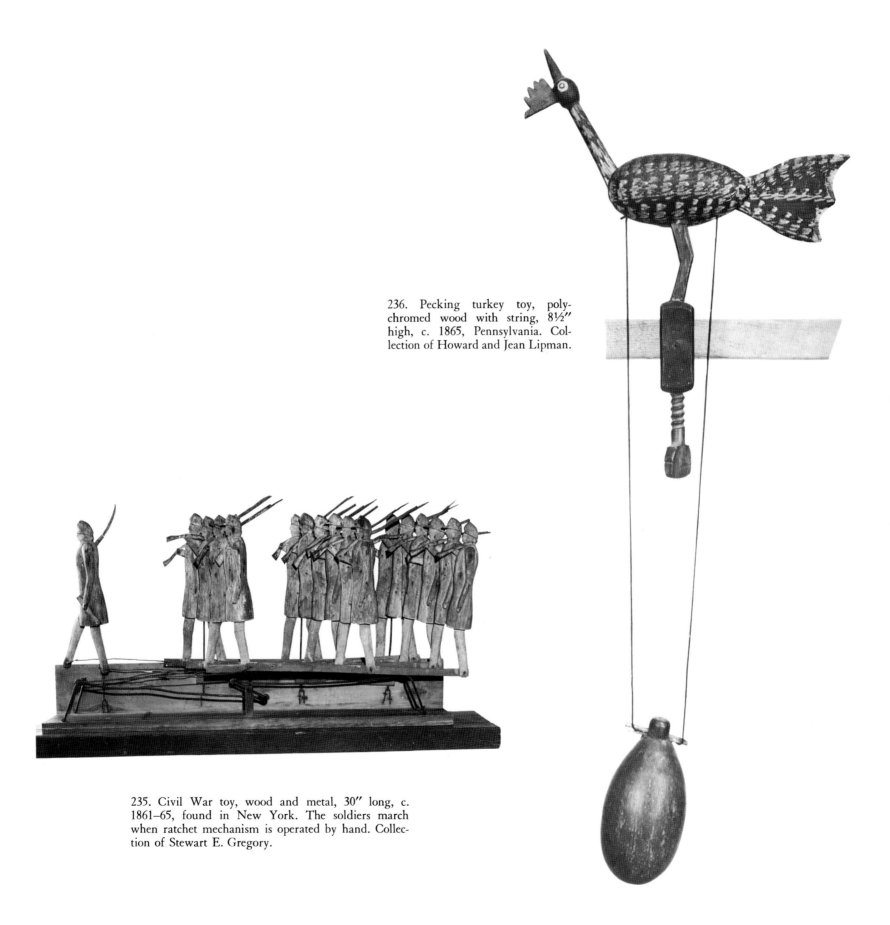

236. Pecking turkey toy, polychromed wood with string, 8½" high, c. 1865, Pennsylvania. Collection of Howard and Jean Lipman.

235. Civil War toy, wood and metal, 30" long, c. 1861–65, found in New York. The soldiers march when ratchet mechanism is operated by hand. Collection of Stewart E. Gregory.

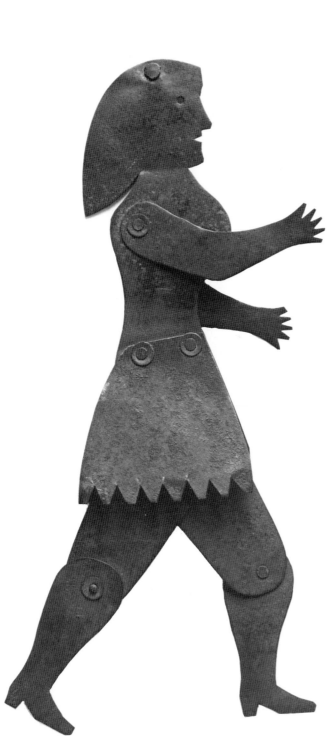

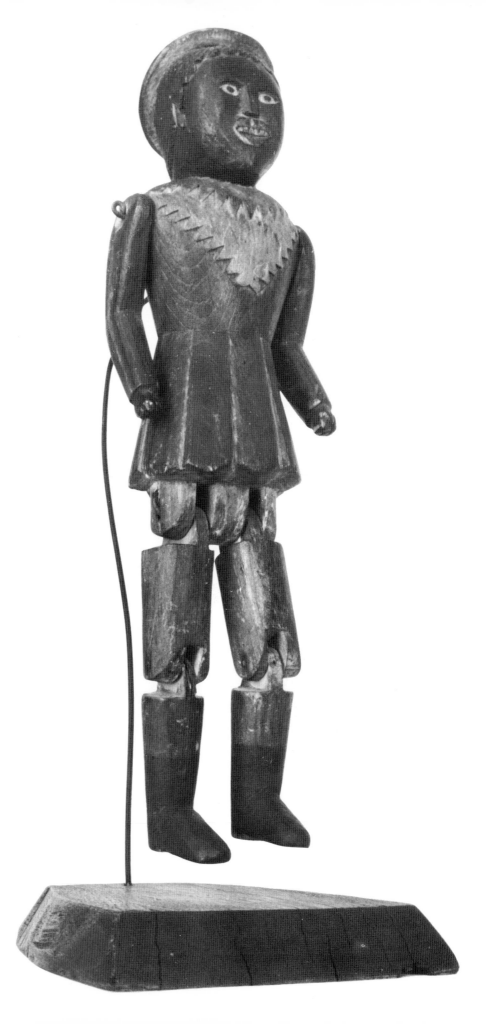

237. Jointed Indian doll, sheet tin,
13½″ high, c. 1850, Lebanon, Pa.
Formerly collection of Mary Allis.

238. Dancing doll, painted wood
with metal, 10″ high, c. 1850, prob-
ably the South. Collection of Mr.
and Mrs. Alastair B. Martin.

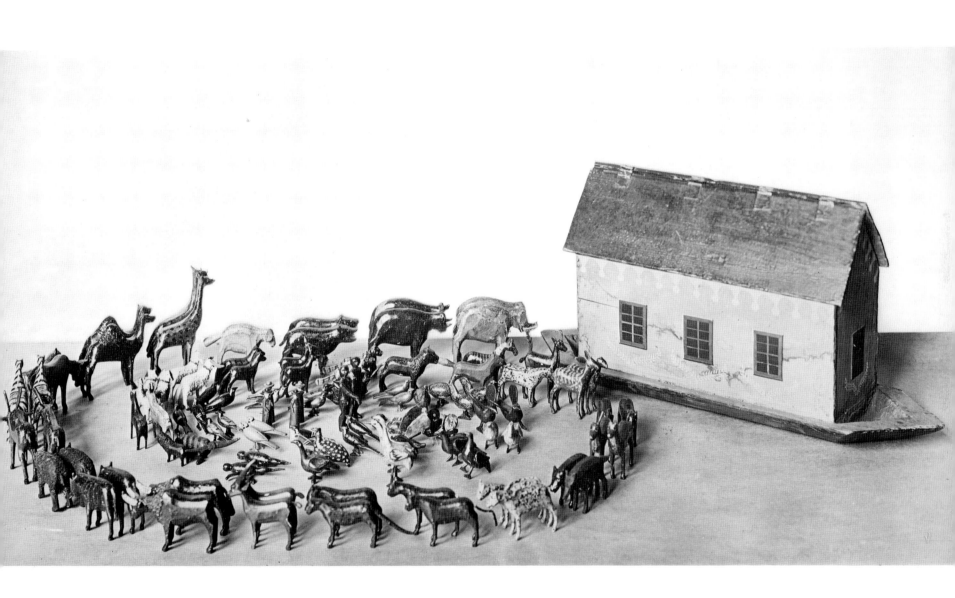

239. Noah's Ark, polychromed wood, ark 16″ long, c. 1810, Salem, Mass. Essex Institute, Salem, Mass.

HOUSEHOLD ORNAMENTS

In keeping with the down-to-earth practicality of the early Americans, their sculpture was primarily designed for use. Yet in addition to the gravestones, figureheads, trade signs, decoys, weathervanes and toys such as those shown in the preceding pages, a number of sculptured ornaments were made simply for the pleasure that came from producing and looking at them. The same families that decorated their walls with portraits and landscapes, stenciled their floors and placed a rooster weathervane atop the barn might well have had a chalkware cat on the mantel. If the household was in Nantucket or New Bedford or some other town that drew its livelihood from whaling, a scrimshaw piece surely adorned the parlor.

Woodcarvings

When a housewife wanted a special ornament to brighten her home, she most often turned to the same talented whittler who provided her friends and neighbors with wooden toys, signs and weathervanes. He might be the local carpenter or cabinetmaker, or he might be one of the itinerant peddlers who traveled from town to town, selling small carvings or executing work on the spot to the customer's specifications. One of the most talented of such carvers was Wilhelm Schimmel, maker of one of the eagles shown here. Schimmel was a picturesque itinerant who, according to tradition, came from southern Germany to Pennsylvania and from the late 1860s to 1890 wandered about the Cumberland Valley whittling toy birds, animals and human figures for village farmers' children, as well as mantel ornaments for their elders. Thus he earned a meager livelihood, or at least his board and lodging and the rum he is said to have loved too well. During one prosperous period he reportedly traveled with a horse and buggy filled with carvings for sale, but mostly he carved as he went, and his customers probably enjoyed watching lively barnyard animals and fierce eagles emerge from a chunk of pine as much as they subsequently delighted in owning the finished sculpture. Schimmel's only tools were a sharp jackknife, bits of glass to smooth away the knife marks, and a few paintbrushes, with which he produced a variety of boldly carved and strikingly painted animals, from small toys to monumental eagles. The farm folk of Pennsylvania, where Schimmel worked, seemed particularly to favor his carvings of domesticated animals.

Patriotic homes displayed eagles and portraits of national heroes, such as those reproduced earlier. In the prosperous and sophisticated cities, carved decorations were used inside and outside the house. The sinuous mermaid, painted in pink flesh color with sea-green tail and dark

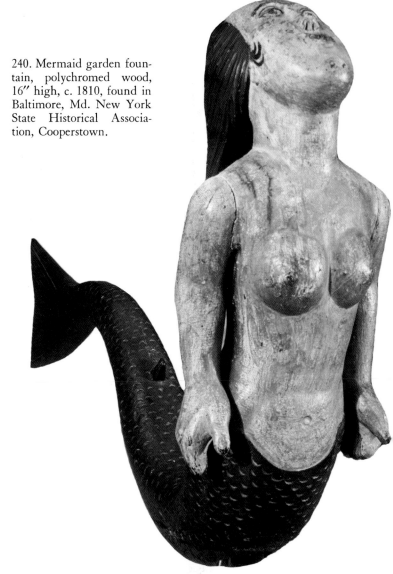

240. Mermaid garden fountain, polychromed wood, 16″ high, c. 1810, found in Baltimore, Md. New York State Historical Association, Cooperstown.

green hair and eyes, served as a fountain in a Baltimore garden. Possibly the work of a figurehead carver, the mermaid had a metal tube running up the body to the mouth, allowing her to spout water, which must have risen and fallen in a curve, repeating in reverse the sweeping lines of her tail.

Scrimshaw

It has been said that art is a creative response to boredom, and anyone wishing proof of this theory might consider the art of scrimshaw. This art form was developed by the crews of New England whaleboats which roamed from the North Atlantic to the Indian Ocean in search of the great sperm whale and its precious oil. The more intensely it was hunted, the more elusive the whale became. By mid-

nineteenth century it was often three to five years before a vessel was filled with oil and could return home, and sometimes months passed without sighting a single whale. It was to relieve the monotony of these long and tedious voyages that sailors, using the jawbones and teeth of whales, carved and incised countless varieties of useful and decorative objects for their own amusement and as gifts for stay-at-home families and friends. The term scrimshaw, like the art itself, appears to have been the invention of the whalemen. Its origin has never been satisfactorily explained, and it is found in many variations, such as "skimshontering," "squimshon" or "skrimshander," which Melville used in *Moby Dick*.

When a youth shipped out on a whaler, he was introduced to scrimshaw by the other members of the crew. All whalers had a cooper to tend to the making of the oil barrels and a carpenter to perform the never-ending repair and maintenance jobs aboard a sailing ship. These trained craftsmen, skilled at working with their hands, often provided tools and scrimshaw instruction for the rest of the crew. Scrimshawing was a social pastime aboard ship, the sailors' equivalent of a quilting bee. Especially on Sunday— for the Lord's day of rest from daily chores was strictly observed by most whalemen—the sailors would gather round with jackknives, saws and chisels to work the huge teeth of the sperm whale.

Sometimes the tooth, which averaged six inches in length, was fashioned into jewelry, cane handles or such household items as piecrust cutters or clothespins. More rarely a decorative sculpture in the round, like the remarkable *Proposal* shown here, was made. In most cases the carver chose to preserve the tooth intact, polishing its slightly grooved surface with sandpaper or sharkskin and incising on it a scene that struck his fancy. Sometimes he dreamed of home and portrayed an elegant lady of fashion, or a family in its fine parlor. Sometimes he recorded incidents of the voyage for the folks at home. One of the teeth shown here depicts what the whalemen, with wry Yankee humor, called the "Nantucket sleigh ride": the awful moment—which could stretch to an hour or more— when the harpooned whale, in a frenzied effort to free himself, pulled the small harpoon boat and its crew across the waters at breakneck speed. Occasionally, as in this scene, the whale succeeded in capsizing the boat and escaping.

The design was sometimes sketched freehand, but more often an original drawing or an engraving from a book or magazine was transferred to the surface of the tooth. This could be done in two ways: the drawing was placed on the tooth and a pin used to punch through the paper, leaving an outline of the drawing as a series of tiny pinpricks on the tooth; or pinholes were pricked in the drawing itself, which was placed on the tooth and rubbed with a pencil, leaving marks through the holes. The lines were then carefully incised with a sailmaker's needle or awl, and accented with color. Lampblack, prepared by the sailors themselves, was the most common pigment, but sometimes bottled colors, purchased ashore, were used. After the pigment was applied and worked into the design, the tooth was rubbed with a cloth to remove the excess.

Scrimshaw flourished and declined along with the whaling industry. Although it has never died out altogether, it was during the second and third quarters of the nineteenth century that the masterpieces of scrimshaw were produced aboard whaling vessels. It is in many ways a quintessential folk art: virtually all its practitioners are anonymous; all were amateurs, with no formal art training; and all worked primarily for their own amusement. Their creations were made for private use, never for profit. Treasured for years in the homes of whalemen's friends and relatives, scrimshaw carvings were trophies of long and perilous voyages, and they survive as testaments to the enormous skill and native sense of design possessed by these rugged seafarers.

Pottery and chalkware

Pottery household ornaments were popular in Europe in the eighteenth and nineteenth centuries and were exported to America in quantity both before and after the Revolution. American potters as well were quick to meet local demand, turning out subjects that had particular appeal to their public.

In the second half of the nineteenth century, chalkware ornaments began to rival the pottery products in popularity. The technique for making these figures was so simple and cheap that they could be sold for as little as fifteen cents each, and they averaged no more than half a dollar for the most elaborate items. Actually, the material used was plaster of Paris, but to the public it was "chalk"—no doubt because when rubbed it left a mark exactly like that made by a piece of chalk.

To make a figure of a cat, for instance, a thin plaster mixture—water and a gypsum compound somewhat different from modern plaster of Paris—was poured into a two-part mold held together by string or clamps. It set rapidly on the inner surface of the mold, and any excess was then poured off, leaving a hollow figure. Once the plaster hardened, the mold was opened, the seam smoothed out and the surface painted. Any number of cats could be made from the same mold, and if the original mold broke or wore out, a new one could be formed simply by pouring plaster around one of the finished cats.

It is believed that chalkware was first made by Italian immigrants, for there is a long tradition of plaster ornamentation in Italy; and in many nineteenth-century American cities the Italian peddler balancing a tray of chalk

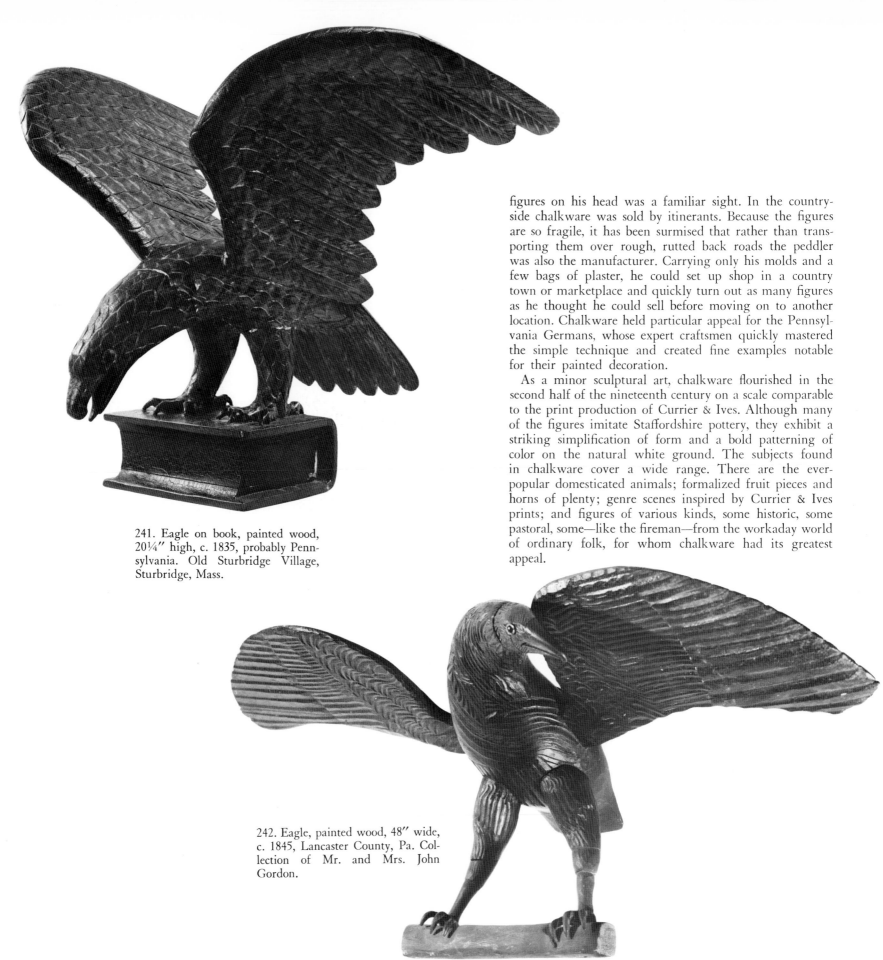

figures on his head was a familiar sight. In the country-side chalkware was sold by itinerants. Because the figures are so fragile, it has been surmised that rather than transporting them over rough, rutted back roads the peddler was also the manufacturer. Carrying only his molds and a few bags of plaster, he could set up shop in a country town or marketplace and quickly turn out as many figures as he thought he could sell before moving on to another location. Chalkware held particular appeal for the Pennsylvania Germans, whose expert craftsmen quickly mastered the simple technique and created fine examples notable for their painted decoration.

As a minor sculptural art, chalkware flourished in the second half of the nineteenth century on a scale comparable to the print production of Currier & Ives. Although many of the figures imitate Staffordshire pottery, they exhibit a striking simplification of form and a bold patterning of color on the natural white ground. The subjects found in chalkware cover a wide range. There are the ever-popular domesticated animals; formalized fruit pieces and horns of plenty; genre scenes inspired by Currier & Ives prints; and figures of various kinds, some historic, some pastoral, some—like the fireman—from the workaday world of ordinary folk, for whom chalkware had its greatest appeal.

241. Eagle on book, painted wood, 20¼″ high, c. 1835, probably Pennsylvania. Old Sturbridge Village, Sturbridge, Mass.

242. Eagle, painted wood, 48″ wide, c. 1845, Lancaster County, Pa. Collection of Mr. and Mrs. John Gordon.

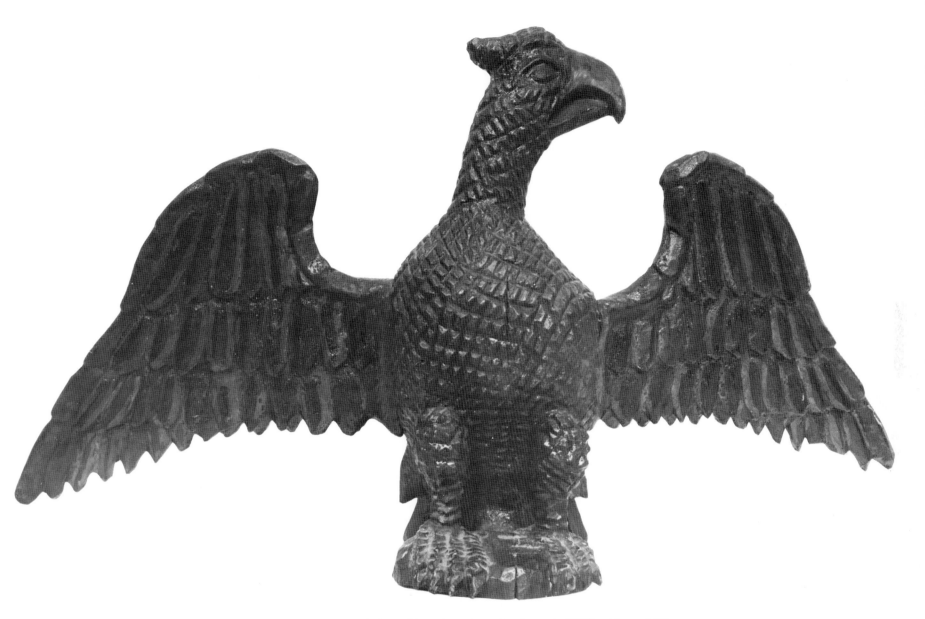

243. Wilhelm Schimmel, eagle, painted wood, 33½″ wide, c. 1870, Cumberland Valley, Pa. Collection of Mr. and Mrs. Alastair B. Martin.

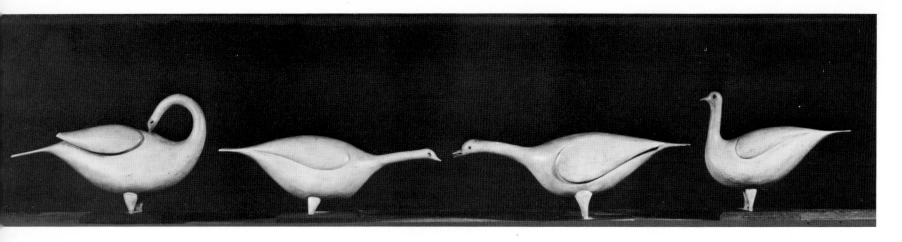

244. Geese, painted wood, 3¾″ to 5¼″ high, c. 1875, found in New England. Collection of Bertram K. and Nina Fletcher Little.

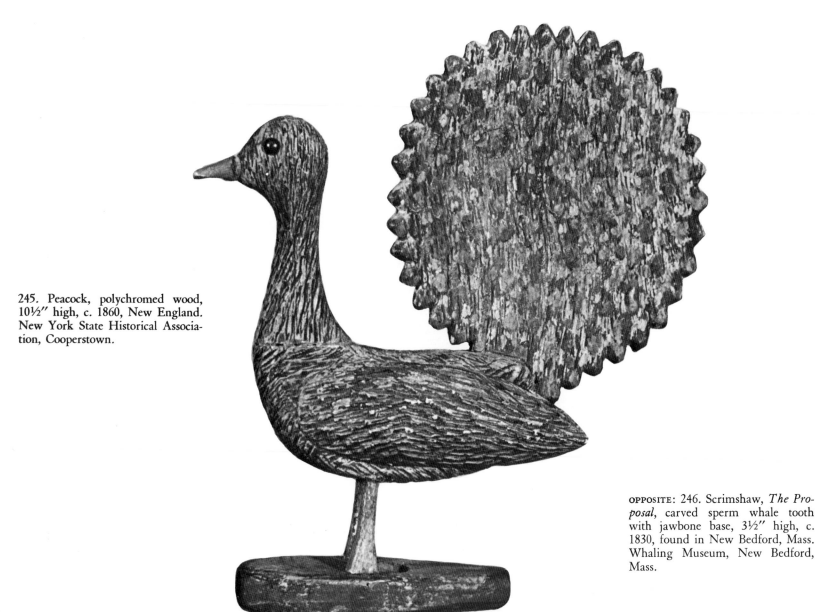

245. Peacock, polychromed wood, 10½″ high, c. 1860, New England. New York State Historical Association, Cooperstown.

OPPOSITE: 246. Scrimshaw, *The Proposal*, carved sperm whale tooth with jawbone base, 3½″ high, c. 1830, found in New Bedford, Mass. Whaling Museum, New Bedford, Mass.

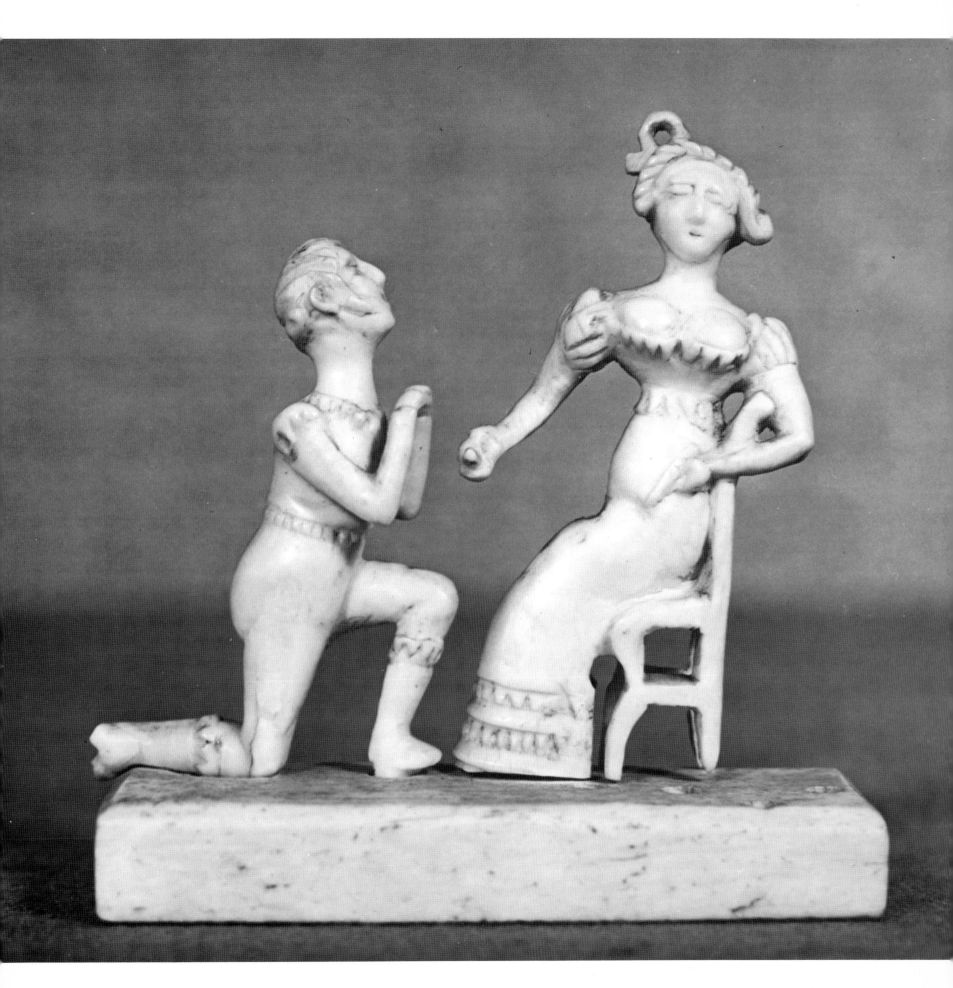

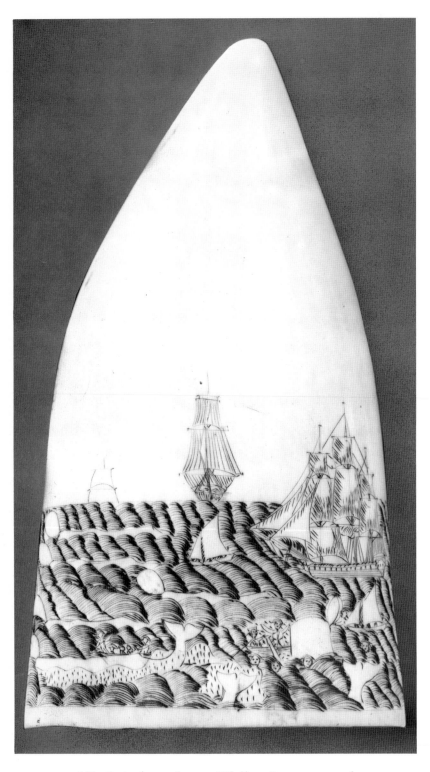

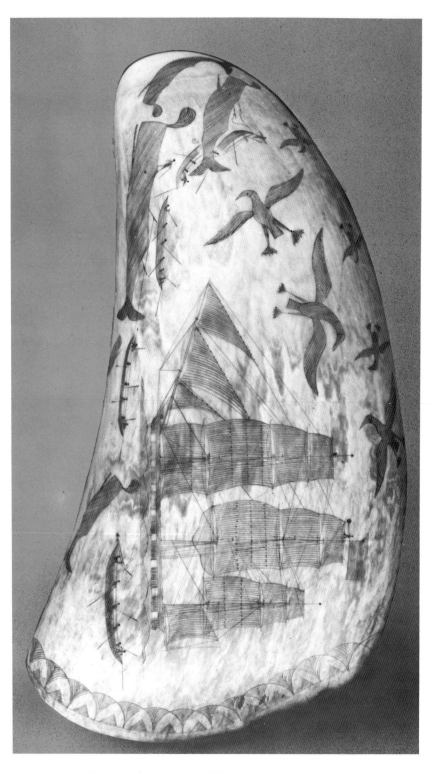

247. Scrimshaw, *Sperm Whaling Scene*, engraved
whale's tooth, 5¼″ high, c. 1835, found in New Eng-
land. Collection of Barbara Johnson.

248. Scrimshaw, *Sperm Whaling in the South Pacific*,
engraved whale's tooth, 7¼″ long, c. 1825, found
in Nantucket, Mass. Collection of Barbara Johnson.

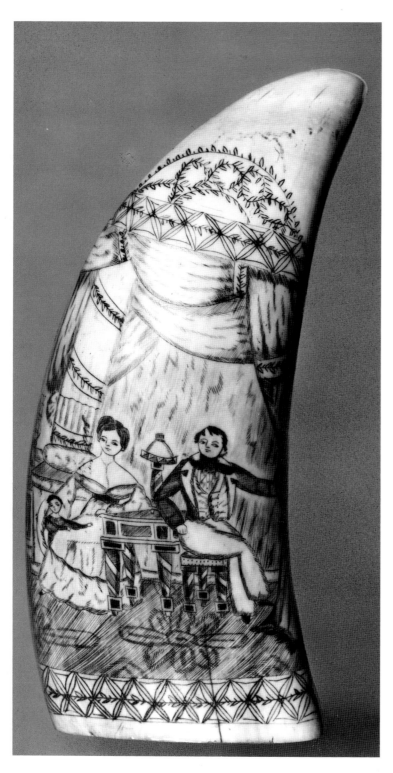

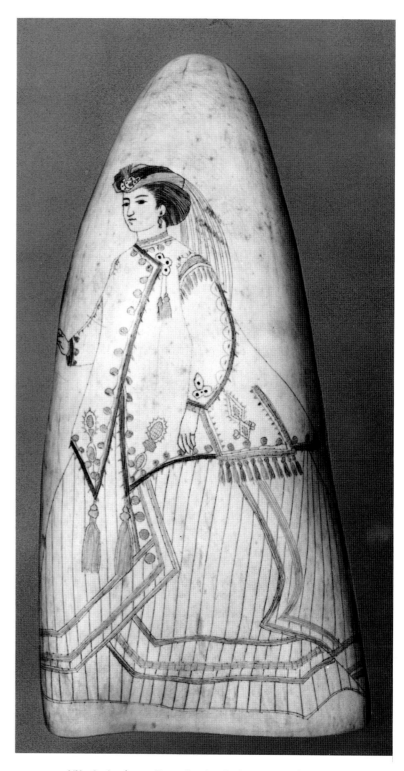

249. Scrimshaw, *The Family in the Parlor*, engraved whale's tooth, 6″ high, c. 1840, probably New England. Smithsonian Institution, Washington, D.C.

250. Scrimshaw, *Portrait of a Lady*, engraved whale's tooth, 6¼″ high, c. 1870, probably New England. Smithsonian Institution, Washington, D.C.

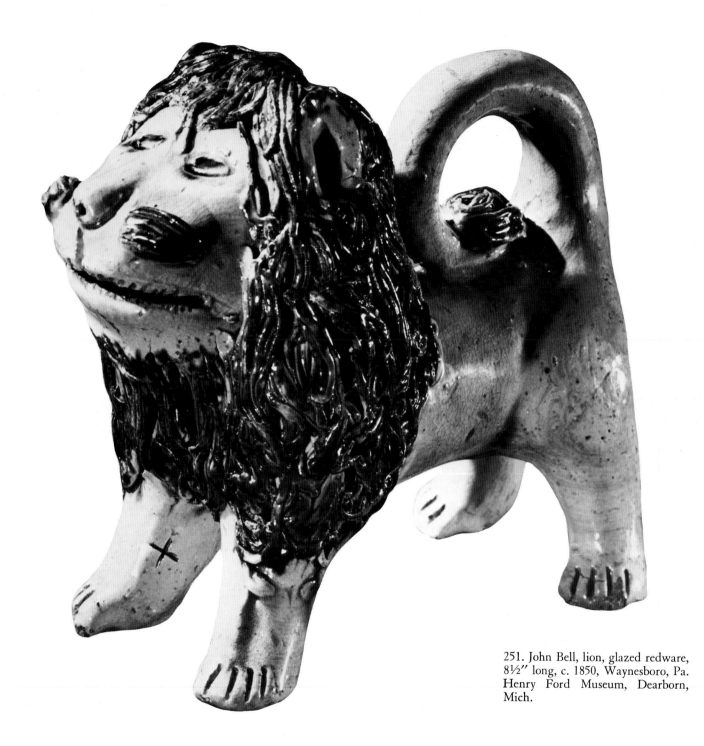

251. John Bell, lion, glazed redware, 8½″ long, c. 1850, Waynesboro, Pa. Henry Ford Museum, Dearborn, Mich.

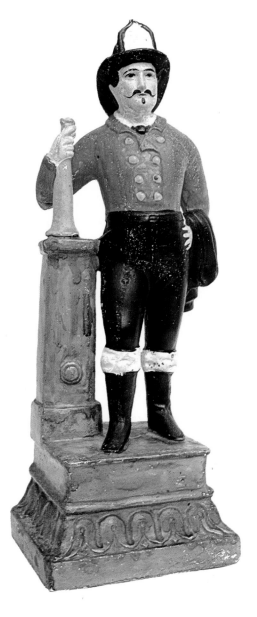

253. Fireman, painted chalkware, 14⅜″ high, c. 1870, Pennsylvania. Collection of Mrs. Wilbur L. Arthur.

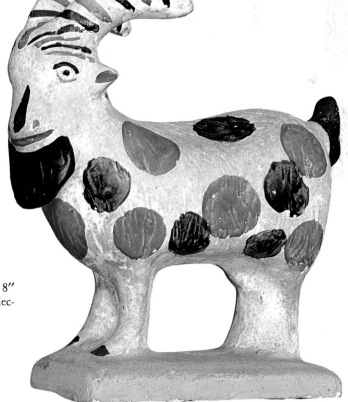

254. Goat, painted chalkware, 8″ high, c. 1850, Pennsylvania. Collection of Howard A. Feldman.

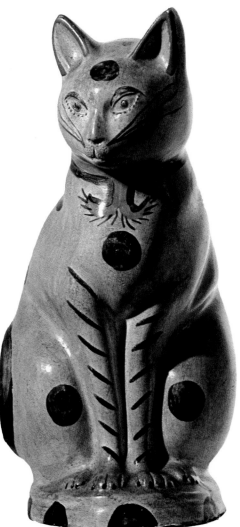

252. Cat, painted chalkware, 17½″ high, c. 1850, Pennsylvania. Museum of American Folk Art, New York.

DECORATION FOR HOME AND HIGHWAY

OVERMANTELS, FIREBOARDS, CORNICES

Perhaps the most picturesque of all American folk artists were the itinerant decorators, who rode from town to town painting walls and floors, signs, even a portrait here and there, in exchange for bed and board and a bit of pay. They did not consider themselves artists in our sense of the word; rather, they were skilled craftsmen—like carpenters or blacksmiths—executing work to the customer's order. With their rapid work methods and the primitive tools they carried in their saddlebags, they were the originators and disseminators of a simple, practical kind of country decoration.

Overmantels

The parlor was the most formal room of the house, and its focal point was the fireplace. The custom of placing a painted scene over the fireplace, like most American traditions of household decoration, came from England. The scene was usually executed on a paneled wall that covered the chimney; occasionally a painted canvas was set into the woodwork. In New England the overmantel usually consisted of one or several wide boards held in place by moldings and forming an integral part of the architectural structure of the fireplace wall, as can be seen in the photograph of the Waid-Tinker house in Old Lyme, Connecticut. This townscape—very likely a local scene—was probably the work of Jared Jessup, a native of Long Island who decorated houses up and down the Connecticut River Valley, from Old Lyme to Deerfield, Massachusetts. Jessup also specialized in freehand imitations of wallpaper patterns and is believed to have worked with several assistants. According to local tradition, he was arrested as a British spy during the War of 1812 and was never seen again—a tale typical of those told by small-town inhabitants about these somewhat mysterious itinerants

who arrived, stayed until local commissions were exhausted and then pushed on to parts unknown. The overmantel in Old Lyme suffered the fate of so many of the itinerant decorators' labors; today it is painted over, having been damaged beyond repair by a fire in the 1940s.

Identifying house decorators by name has required the same detective work by researchers and art historians that has led to the reconstruction of the careers of many other folk artists. The wall decorations now attributed to Jessup were first identified by his signature on the back of a closet door in a Connecticut house; there, one after the other, from 1792 to 1867, each painter who had worked on the house had written his name, leaving a permanent genealogy of the walls' decorations, even after they were papered over at the turn of the century. The attribution of almost one hundred New England murals to a prominent nineteenth-century American, Rufus Porter, a prolific inventor and journalist, began with the discovery of the signature "R. Porter" on the walls of a house in Westwood, Massachusetts. Many works are still waiting to be identified, and some, such as the *Situation of America* overmantel, present interesting questions. This panel, taken from a house on Long Island, is probably a view of the New York harbor in the mid-nineteenth century; but the boat, which looks more like a junk than a steamship, the pagodalike cupola of the central building and the curious proportions of the doorways on all the houses suggest puzzling and as yet unexplained Oriental influences.

Landscapes were clearly the most popular subjects for overmantel decorations, especially those features dear to the heart of the New Englander: a town with its clusters of neat houses and church spires, a fine homestead, a distant view of rolling hills or cultivated fields, a river or seaport with the handsome vessels that made Yankee ship-

255. Cornice board, stencil and freehand painting on wood, 44½″ long, 1844, City Island, N.Y. Formerly owned by Ginsburg & Levy, New York.

builders and sailors famous the world over. Winthrop Chandler's sweeping view of a large port city is more ambitious than most and is said to be a view of London. For his view of the great and distant city, this provincial limner took English and Italian architectural elements, no doubt copied from engravings, and combined them with the familiar New England townscape.

Occasionally a still-life or decorative subject was chosen for the overmantel. Rufus Hathaway's stylized pair of peacocks was probably inspired by a wallpaper pattern. Hathaway, incidentally, was not a professional decorator, his father-in-law having decided that a doctor would make a more suitable husband for his daughter. So Rufus became Dr. Hathaway, but continued to execute portraits and an occasional decoration for his neighbors in Duxbury, Massachusetts.

Fireboards

During the summer season, when fires were not needed, a fireboard served the practical purpose of sealing off the fireplace, keeping out dirt, soot and chimney swallows. Constructed of wide boards held together by sturdy battens on the back, the fireboard was always custom-made for its particular fireplace opening, and it was often painted by the same decorators who worked on the overmantels, walls and floors of the house. Sometimes, as in the New England fireboard featuring a lion, canvas was mounted on a wood panel and then painted. The fireboard stood on a wood base or was attached to the fireplace frame by a turnbuckle. Sometimes it was notched out at the bottom so that it fitted over the andirons, which were left in place and so served as supports.

The eighteenth-century custom of placing a vase of cut flowers or boughs in an unused fireplace accounts for the popularity of floral still-life subjects on fireboards. The fireboard from West Sutton, Massachusetts, is an example. Apparently its owner wanted to retain the appearance of an open fireplace, and the artist obligingly attempted a *trompe*

l'oeil rendering. Landscapes in *trompe l'oeil* frames were also popular, and one unusual fireboard, shown here, is a stylized wooden relief. Found in a Connecticut parish house, it combines a tasseled catafalque, church spires, and a suggestion of a church interior with a painted landscape barely glimpsed through tall, narrow windows.

As decorative pieces meant to be seen clearly at some distance, from various angles in the room, fireboards tend to have simple compositions with broad, heavily painted outlines and strong, flat colors. Some are very sophisticated, like the Mount Vernon fireboard; others are very naïve, like the one with a large pot of flowers and tiny horse.

Cornices

Window treatments in early·American houses varied from straight curtains with fabric loops hung on slender wooden rods, to elegant swags like those seen in some overmantels and portrait paintings, to Venetian blinds topped by wooden cornices, which concealed the blinds when they were raised. In the second quarter of the nineteenth century cornices with stenciled decorations came into fashion, many produced by the same workshops that turned out stencil-decorated furniture.

Cornices like those shown here were sold as sets, with matching ornamental motifs and an assortment of precisely painted landscape views. A typical set of landscape stencils, many of which still exist, had cutouts of individual trees, hills, fences, coaches, wagons, animals, flocks of birds; complicated subjects, such as houses and steamboats, might require two or three separate stencils. Using these, the artist could compose a variety of lively scenes. Once he had combined the stenciled elements, he finished the details of water, sky and foliage by hand.

These cornices were made in New York, and they include the familiar windmills, steamboats and scenic hills of the Hudson River Valley. Stenciled in bronze powders against a dark green background, they must have been the crowning decorative touch in a nineteenth-century parlor.

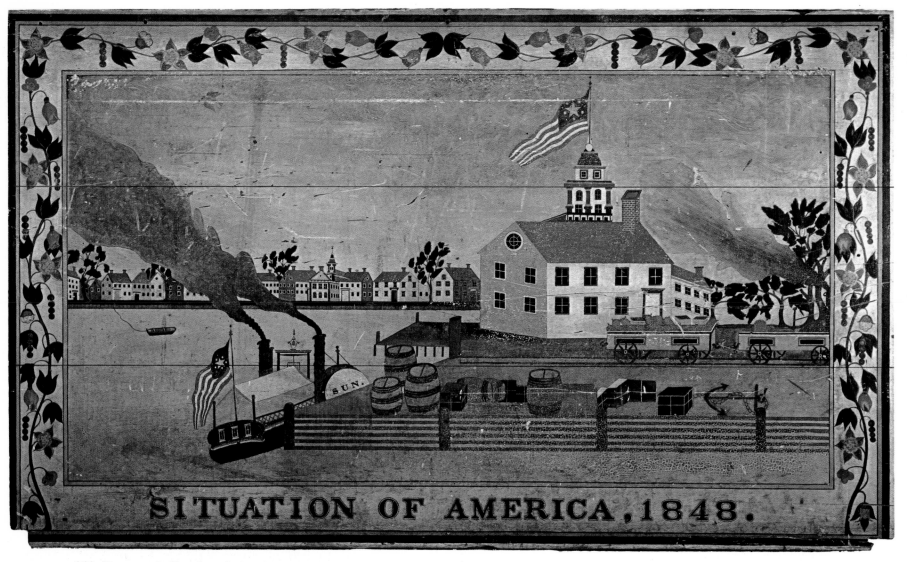

SITUATION OF AMERICA, 1848.

256. Overmantel, *Situation of America, 1848*, oil on wood, 34 x 57″, 1848, from the Squire Phillips house, Brookhaven, Long Island, N.Y. The paddlewheeler *Sun*, built in 1836, dismantled in 1861, had New York City as its home port. View most likely from Brooklyn across East River, showing dome of City Hall and spire of Trinity Church. Collection John H. Martin.

OPPOSITE: 257. Overmantel, oil on wood, 40 x 64″, c. 1808, from the parlor of the Edmond and Deliverance Crowell house in Vineyard Haven, Martha's Vineyard, Mass. Smithsonian Institution, Washington, D. C.

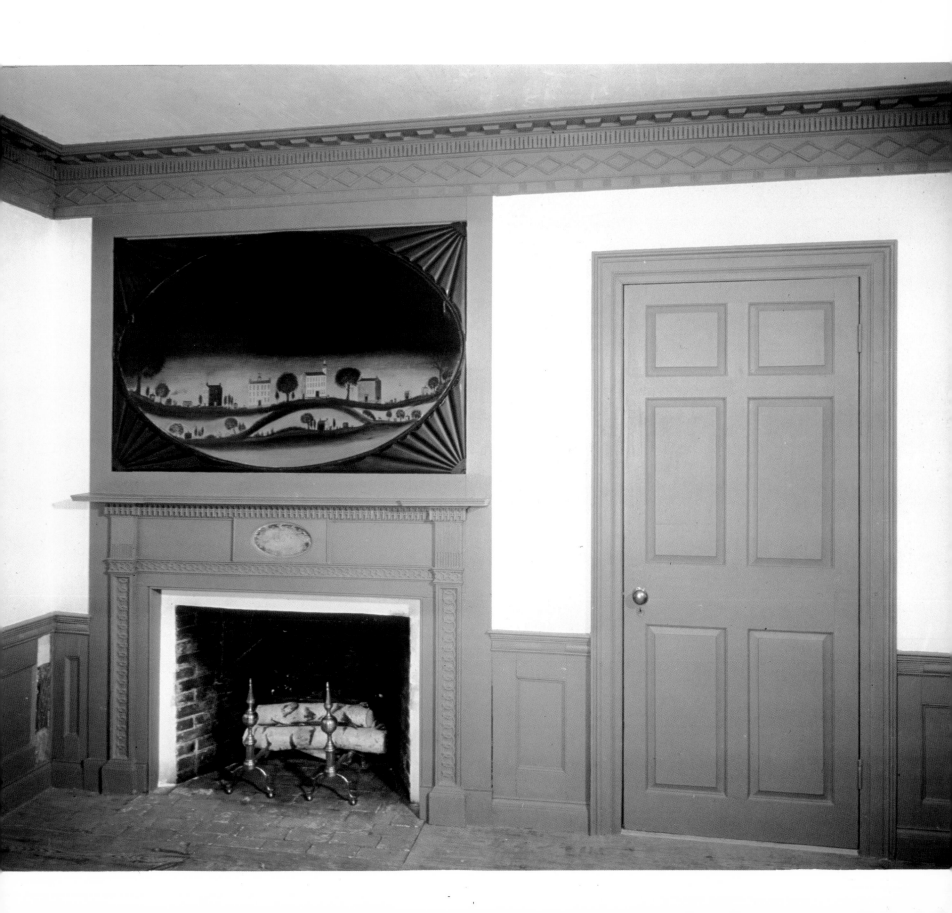

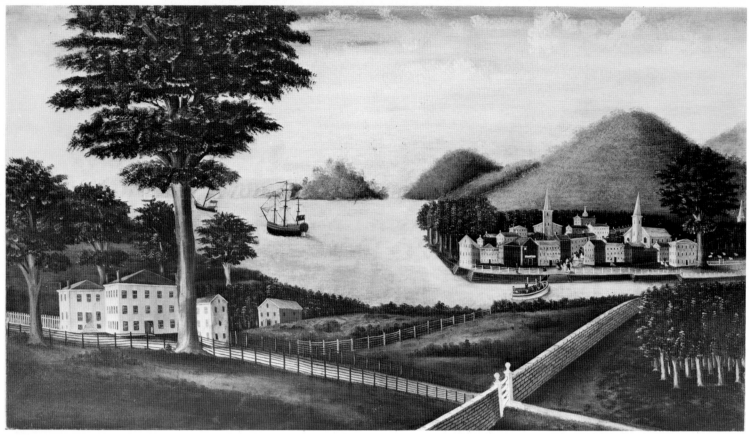

258. Van Cortland, overmantel, oil on wood, 28 x 48″, c. 1775–80, from the Gardiner-Gilman house, Exeter, N.H. Thought to depict town of Exeter seen from the other side of the Exeter River. Amon Carter Museum of Western Art, Fort Worth, Tex.

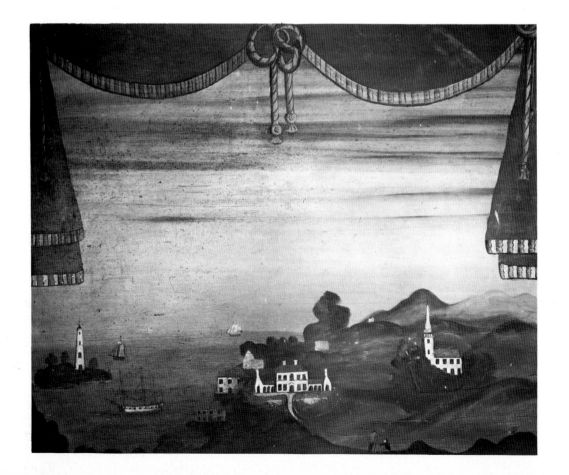

259. Overmantel, oil on wood, 41 x 49″, c. 1820, Palmer house, Canterbury, Conn. Owned by Mrs. Isabel O'Brien.

OPPOSITE: 261. Winthrop Chandler, overmantel, oil on wood, 27 x 45″, c. 1780, from the John Chandler house, Petersham, Mass. Collection of Mr. and Mrs. J. Robert Moore.

260. Rufus Hathaway, overmantel, oil on wood, 30 x 57", c. 1800, Duxbury, Mass. Part of wood-work in the John Peterson house, Duxbury, now demolished. Collection of Mr. and Mrs. Robert C. Vose, Jr.

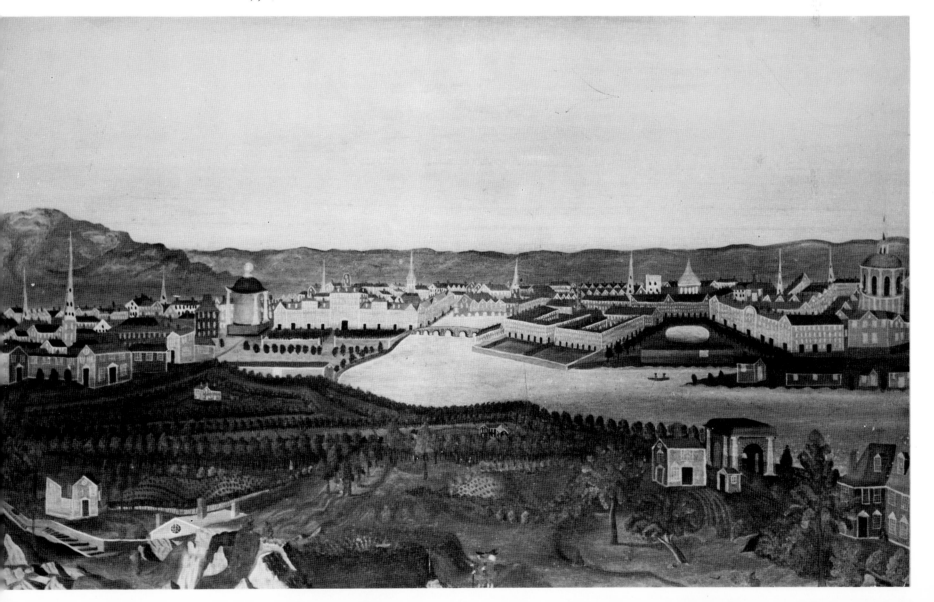

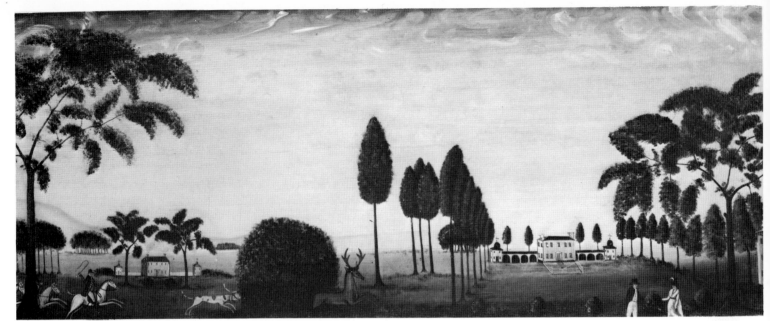

262. Overmantel, *Hunting Scene*, oil on wood, 27¼ x 67⅜″, c. 1800, probably the South. Henry Francis du Pont Winterthur Museum, Winterthur, Del.

263. Attributed to Jared Jessup, overmantel, *Amen Street*, oil on wood, about 48″ wide, c. 1800, Waid-Tinker house, Old Lyme, Conn. Attribution based on similarity to several overmantel paintings on plaster. This overmantel and the walls of the room were damaged by fire in the 1940s and have been painted over.

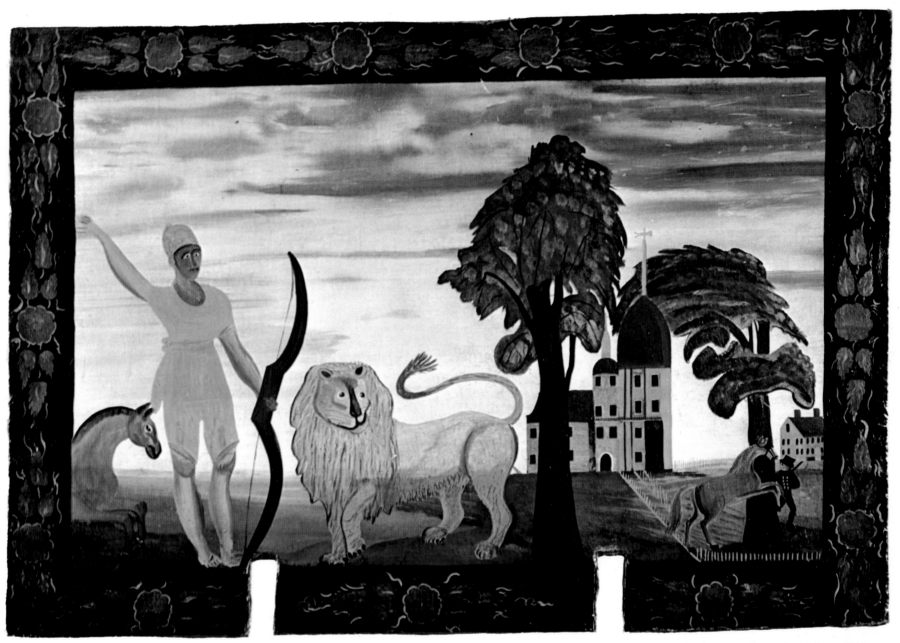

264. Fireboard, oil on canvas, mounted on wood panel, 32¾ x 48½″, c. 1825, New England. New York State Historical Association, Cooperstown.

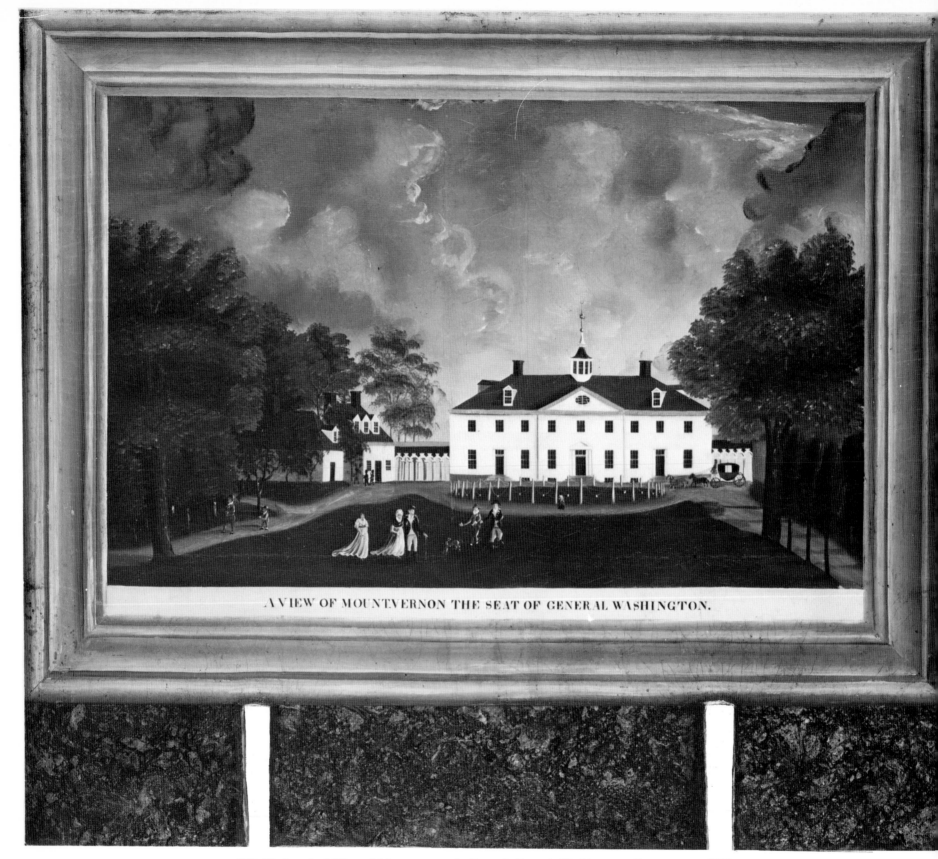

A VIEW OF MOUNT.VERNON THE SEAT OF GENERAL WASHINGTON.

265. Fireboard, *A View of Mountvernon the Seat of General Washington*, oil on canvas, 37⅝ x 43⅜", c. 1800, found in Baltimore, Md. *Trompe l'oeil* frame and stone hearth below are painted on the canvas; slots are to accommodate andirons. National Gallery of Art, Washington, D.C.; Gift of Edgar William and Bernice Chrysler Garbisch.

266. Fireboard, *Minot's Light*, oil on canvas, 37 x 49″, c. 1860, Massachusetts. *Trompe l'oeil* frame is a part of the canvas. Collection of Bertram K. and Nina Fletcher Little.

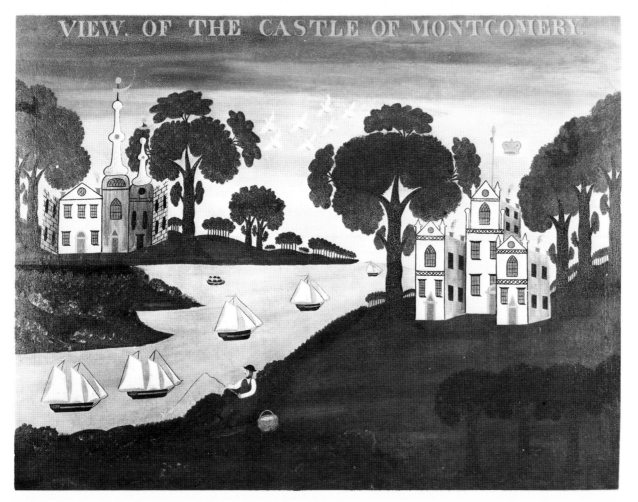

267. Fireboard, *View of the Castle of Montgomery*, oil on canvas, 44¼ x 55¾″, c. 1815, from the Wofford house near Woodruff, S.C. Said to have been painted by the architect of the house, built about 1815. New York State Historical Association, Cooperstown.

199

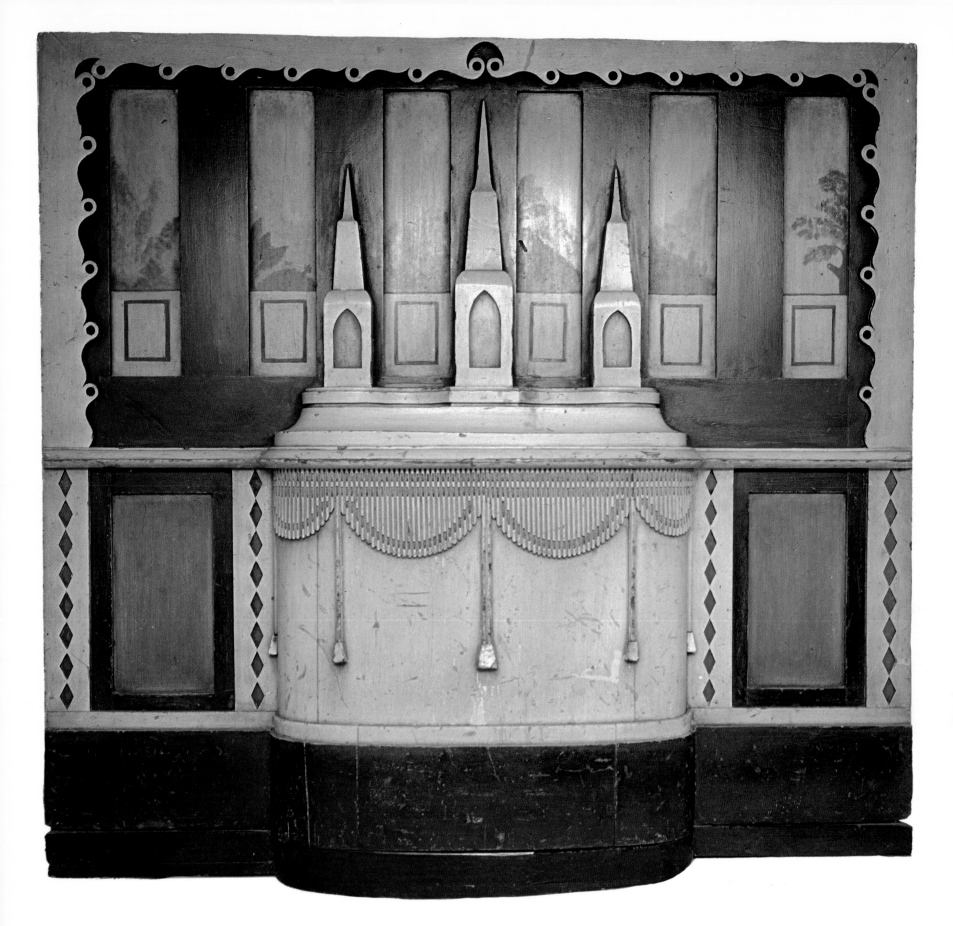

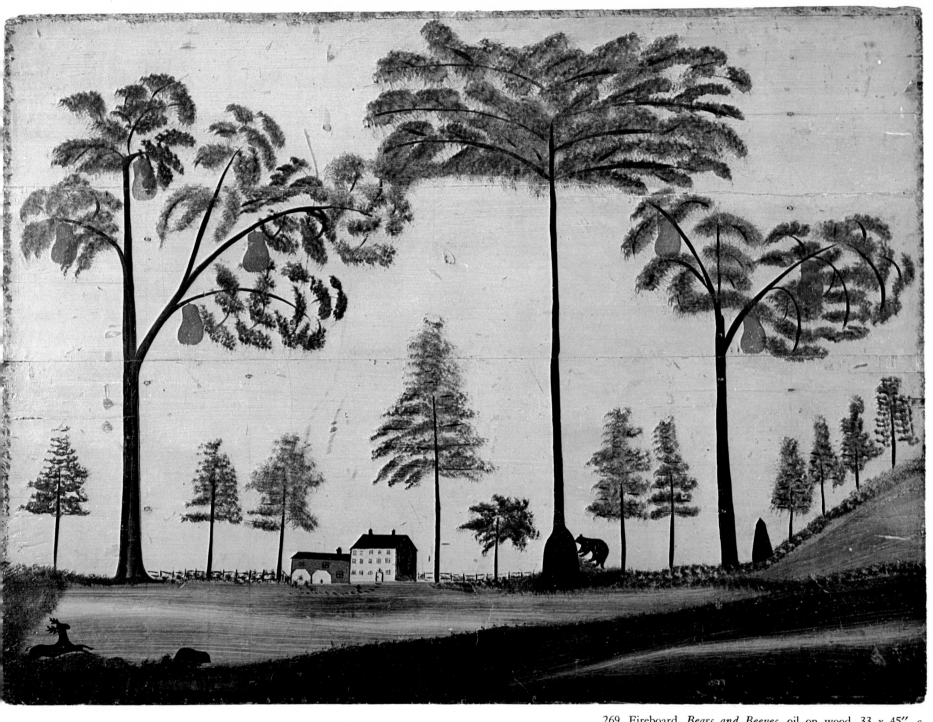

269. Fireboard, *Bears and Beeves*, oil on wood, 33 x 45″, c. 1800, New England, probably New Hampshire. New York State Historical Association, Cooperstown.

OPPOSITE: 268. Fireboard, carved and polychromed wood, 46½″ wide, c. 1840, Connecticut. Collection of Howard and Jean Lipman.

270. Fireboard, oil on wood, 34¾ x 50½″, c. 1800–25, from the Lucy Waters Phelps house, West Sutton, Mass. Abby Aldrich Rockefeller Folk Art Collection, Williamsburg, Va.

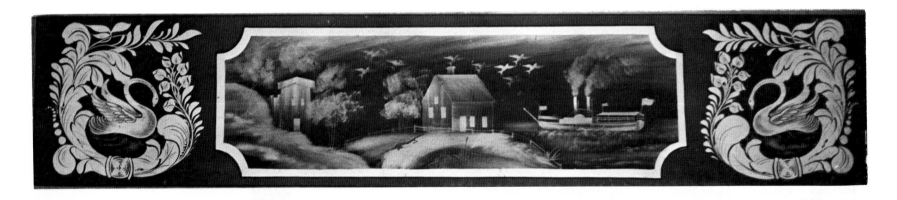

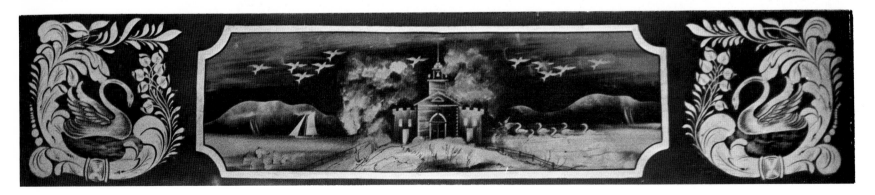

ABOVE, and OPPOSITE, TOP: 271, 272 273. Cornice boards, stencil and freehand painting on wood, 47⅛″ long, 1830–40, Hudson River Valley, N.Y. Hudson River Museum, Yonkers, N.Y.

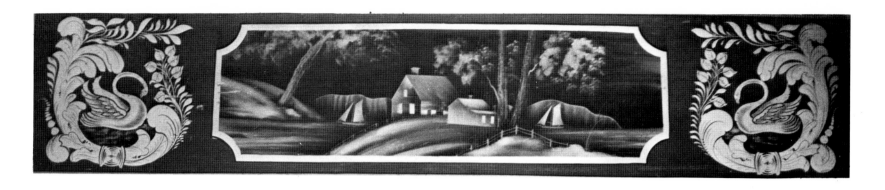

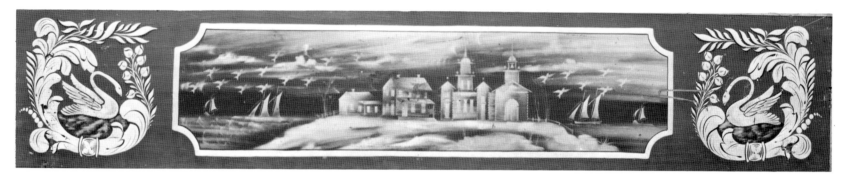

274. Cornice board, stencil and freehand painting on wood, 52½″ long, 1830–40, New York. Collection of Bertram K. and Nina Fletcher Little.

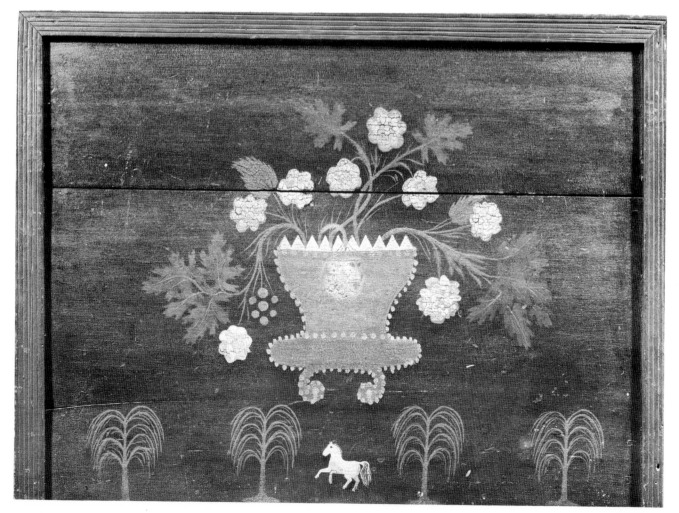

275. Fireboard, oil on wood, 24½ x 34½″, c. 1830–40, New England. Collection of Stewart E. Gregory.

WALLS AND FLOORS

Stenciled walls

The great vogue for patterned wallpapers, which were imported from Europe and later manufactured in America, almost exactly coincided with the period of prosperity that followed the Revolution. However, wallpaper was a luxury beyond the means of many rural folk, who nevertheless longed for the kind of color and design that enlivened the walls of well-to-do mansions. As substitutes for the costly wallpapers, itinerant decorators developed the art of stenciling and painting freehand in simple repeat motifs. Many portraits and scenes of daily life show interiors with painted patterns on the walls, and sometimes the floors as well. Houses decorated in this way have been found in New England, New York and as far west as Kentucky, Ohio and Texas, indicating the far-ranging activities of the itinerant decorators.

Stencils were used in making expensive hand-painted wallpapers, and it did not take long for ingenious Yankee craftsmen to get the idea of cutting their own stencils and using them to paint designs directly on plaster walls. The intricate patterns of the wallpapers proved too complicated and difficult to copy, so they invented their own distinctive repertory of simple motifs, which proved to be more interesting as folk art than the freehand repeat patterns preferred by some decorators. All the conventions of wallpaper placement were followed, with friezes, borders and simulated pilasters breaking wall surfaces into interesting spaces, and the most elaborate designs reserved for the space over the mantel. Stylized leaf and flower forms were repeated in numerous combinations, with borders of foliage, swags and bells, ribbons or geometric figures. There was a certain symbolism attached to some of the motifs: hearts and bells suggested joy, the eagle was a popular American symbol of liberty, the pineapple was a traditional emblem of hospitality, and the willow—always seen in mourning pictures—stood for immortality.

The stenciled parlors shown here follow the decorative scheme most commonly used for the "best" room of the house. On side walls relatively small motifs are arranged in repeat patterns, separated by vertical bands. Large, bold designs—peacocks and pineapples, eagles above a large stylized tree, large urns of flowers—focus attention on the overmantel. Decorative friezes trim the tops of the walls, and borders run just above the baseboards, both serving as unifying elements. The chimney wall is tied into the overall design of the room rather than being set apart as a dominant architectural unit with a painted overmantel. Dining rooms, hallways and bedrooms were also stenciled, although the private rooms were generally done in simple, overall patterns.

The colors of stenciled walls were as bold and clear as the designs. Reds, greens, yellows and black, in various combinations, were applied on white, pink, yellow, gray, light green or light blue painted plaster or—as in several examples shown here—on painted wood sheathing. In stenciling, the paint was always laid on flat, never shaded. The decorators cut their own stencils and made their own pigments from local materials—yellow, green and red earth clays or brick dust—which they powdered and mixed with skim milk; lampblack was sometimes diluted with rum and water. The base coat on the walls was a simple whitewash, sometimes tinted with color.

One of the most prolific stencil decorators was Moses Eaton, whose work kit was discovered intact in the attic of his father's home in Dublin, New Hampshire. It contained several stiff, round stencil brushes and seventy-eight stencils which made forty complete designs. The stencils were cut from heavy paper stiffened with oil and paint; a beveled edge insured a sharp outline on each painted motif. Traces of red, green and yellow paint still remain on the edges of the stencils, giving an idea of the colors—faded now but originally strong and clear—used by Eaton, who stenciled hundreds of houses in Massachusetts, New Hampshire and Maine in the early decades of the nineteenth century.

Scenic murals

In the early nineteenth century, French wallpaper manufacturers introduced a vogue for scenic landscapes, which were sold in sets designed to cover an entire room and depicted such exotic subjects as Captain Cook's voyage around the world or such European sights as "Monuments of Paris" or "The Bay of Naples." About 1825 an ingenious Jack-of-all-trades, Rufus Porter, began to popularize a rapid, cheap method of painting scenic murals directly on plaster walls in a simple, fresh style.

Porter was one of the most remarkable figures in nineteenth-century America, the very type of the adventurous, inventive Yankee. Three generations of Porters had preceded him at the family homestead in West Boxford, Massachusetts, but young Rufus did not fancy the farmer's life and left home for Maine, where he became, in rapid succession, a shoemaker's apprentice, a fiddler and drummer, a house, sign and drum painter, a schoolteacher and dancing master. About 1815, still in his early twenties, he took to the open road, traveling throughout New England and as far south as Virginia as a silhouette cutter, portrait painter and wall decorator. On the side he invented numerous labor-, time- and space-saving devices, originating, among scores of other things, the elevated railroad and an "aerial locomotive." In his later years he became a journalist, founding and editing the *New York Mechanic* and *Scientific American*, which is still published.

As an itinerant painter, Porter had ample opportunity to observe the techniques and production of the wall stencilers, and he conceived the idea of using stencils to facilitate the painting of landscape scenes. Ever anxious to teach the public, he published numerous instruction books and articles on all branches of painting, and in the first volume of *Scientific American*, published in 1846, he gave a thorough description of his mural techniques. He stated that the four walls of a parlor could be completely painted in watercolors in less than five hours, at a total cost of ten dollars. This rapid technique was made possible by reducing to the simplest possible terms the subject matter, drawing and coloring. In addition to freehand painting, architectural features were rendered with stencils, complicated subjects like steamboats were done with transfers, and foliage was rapidly stamped with a cork stopper or stippled with a brush. Porter most often used full color, but he also painted murals in monochrome gray, plum and gray-green.

The subject of Porter's landscapes was always the familiar New England countryside. "There can be no scenery found in the world," wrote this enthusiastic native son, "which presents a more gay and lively appearance in a painting, than an American farm on a swell of land, and with various fields well arranged." He never attempted to reproduce an actual locale—rather, he made composite scenes, using elements drawn from close observation of his surroundings. In the murals reproduced here Porter followed his own prescription for laying out the scenes:

> As a general rule, a water scene,—a view of the ocean or a lake,—should occupy some part of the walls. . . . Other parts, especially over a fire-place, will require more elevated scenes, high swells of land, with villages or prominent and elegant buildings. . . . Small spaces . . . may be generally occupied by trees and shrubbery rising from the foreground, and without much regard to the distance.

Porter was one of the most prolific of America's itinerant decorators. Nearly one hundred houses have been found in Maine, New Hampshire and Massachusetts with decorations by him or by a number of decorators who apparently received instruction from Porter or worked with him. About 1830 one of his followers, Orison Wood, painted the handsomely stylized landscape that still adorns the stairhall of a Maine tavern. The stairhall of a house in East Springfield, New York, was painted at almost the same time by William Price, an itinerant decorator whose style was more flowing and naturalistic than that of the Porter group. In the parlor of a simple cottage in Fitchburg, Massachusetts, there is an unusual combination of subjects. The overmantel is decorated with a still life—large urns of flowers and books framed by an elaborate tasseled swag—

276. Parlor, stenciling on plaster, 1824, Josiah Sage house, Sandisfield, Mass. Owner, Mr. and Mrs. Robert W. Rushmore.

while the side walls are painted with landscapes. The artist, J. H. Warner, was obviously proud of his work, for he signed and dated a large scroll strategically placed at the center of the overmantel composition.

Stenciled floors

In colonial days the floors of many New England houses were simply sprinkled with sand, and designs were swept in with a broom as part of the daily housekeeping routine. In more prosperous homes this rude but practical floor covering was replaced by the painted floorcloth, a heavy sailcloth stiffened with starch and decorated with bold geometric repeat patterns; sometimes the floors themselves were painted freehand in similar fashion. After the Revolution the decorators who traveled the countryside applying stencil painting to walls began to use the same technique on floors. This painted decoration imitated and

277. Moses Eaton, overmantel, stenciling on plaster, c. 1825, Thompson house, Kennebunk, Me. House demolished c. 1935.

substituted for expensive rugs and floorcloths, just as wall stenciling took the place of wallpaper.

Floors are even more vulnerable than walls, and comparatively few decorated floors survive today. The Edward Durant house in Newton, Massachusetts, is exceptional in that it has not one but several floors stenciled in bold, clear patterns and rich colors—Indian red, yellow ocher, verdigris green, black and white—and all in fine condition. In two rooms the same pattern is used, but in one room it runs diagonally instead of at right angles to the walls.

By the time Rufus Porter died in 1884, his craft, too, had passed into history. By mid-century, American manufacturers had developed machinery that could mass-produce patterned wallpapers. Stenciled walls and floors and scenic murals, invented as decorations for the farmhouses and taverns of everyday folk who could not afford high-priced wallpapers and carpets, were in turn replaced by less expensive products. The itinerant decorators, like portrait painters superseded by the camera or figurehead carvers put out of work by the demise of the clipper ship, succumbed to "progress" and sought other outlets for their considerable talents.

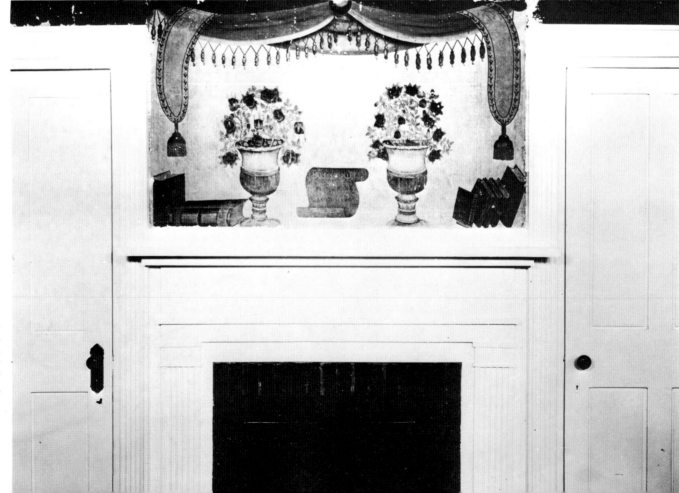

278. J. H. Warner, overmantel, painting on plaster, 1840, Fitchburg, Mass. Scroll in center inscribed, "Painted by J. H. Warner, Aug. 1840." Owned by Mr. and Mrs. Raymond R. Howard.

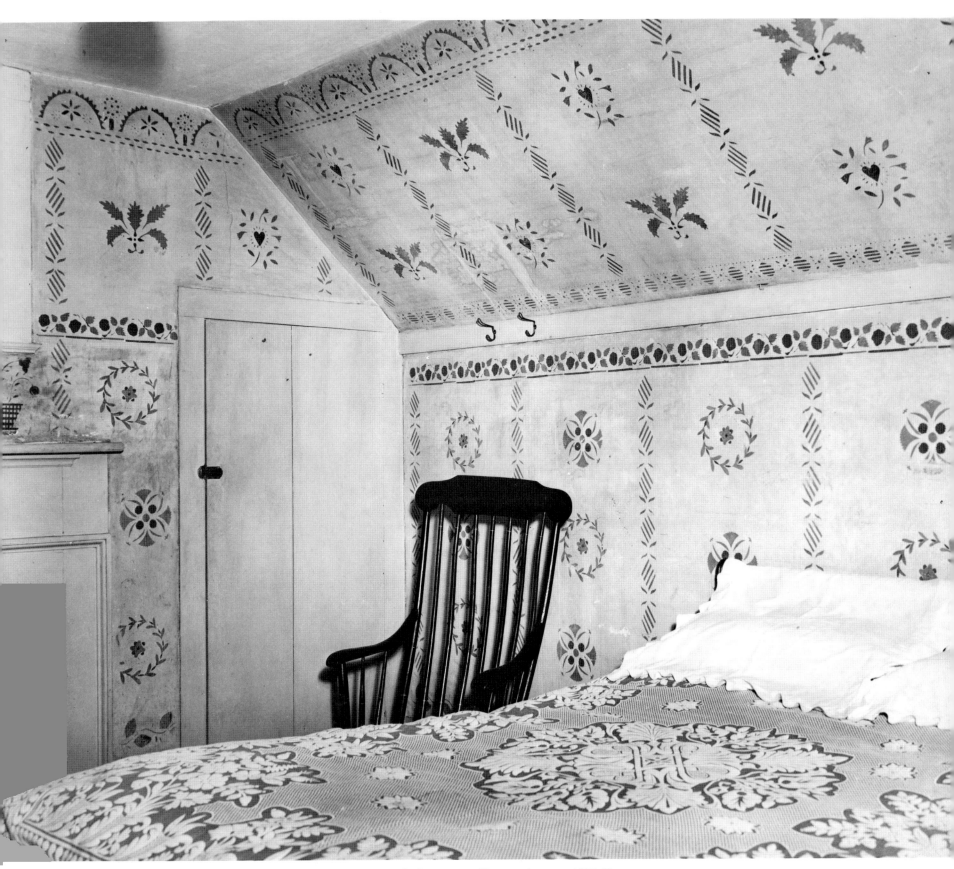

279. Moses Eaton, bedroom, stenciling on plaster, c. 1825, Temple, N.H. Owned by Mr. and Mrs. Wilfred Colburn Weston.

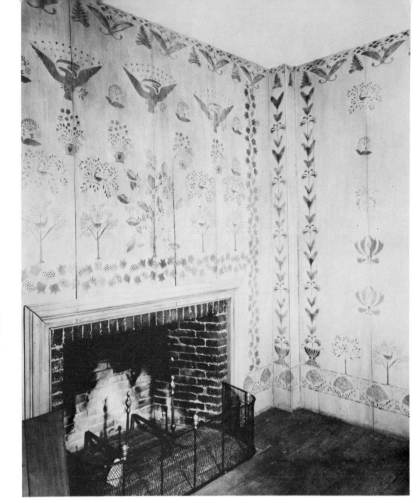

280. Parlor, stenciling on wood sheathing, c. 1825, Columbus, N.Y. Some of the designs resemble those of Moses Eaton. Shelburne Museum, Shelburne, Vt.

281. Bedroom, stenciling on wood sheathing, c. 1830, Joshua Lasalle house, Windham, Conn. American Museum in Britain, Bath, England.

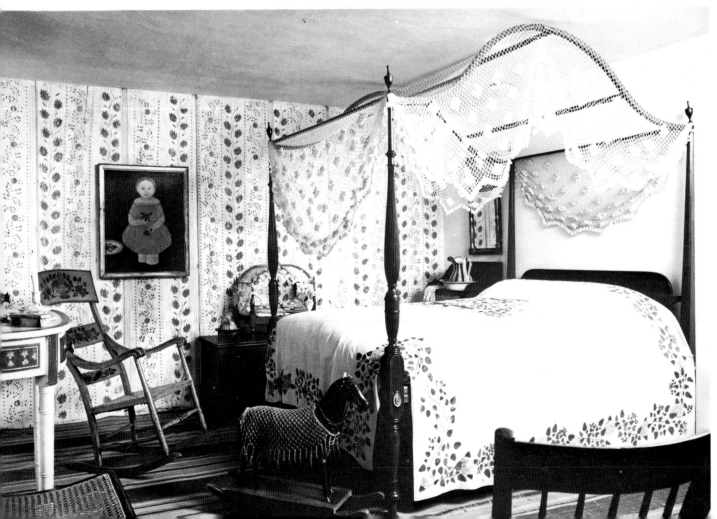

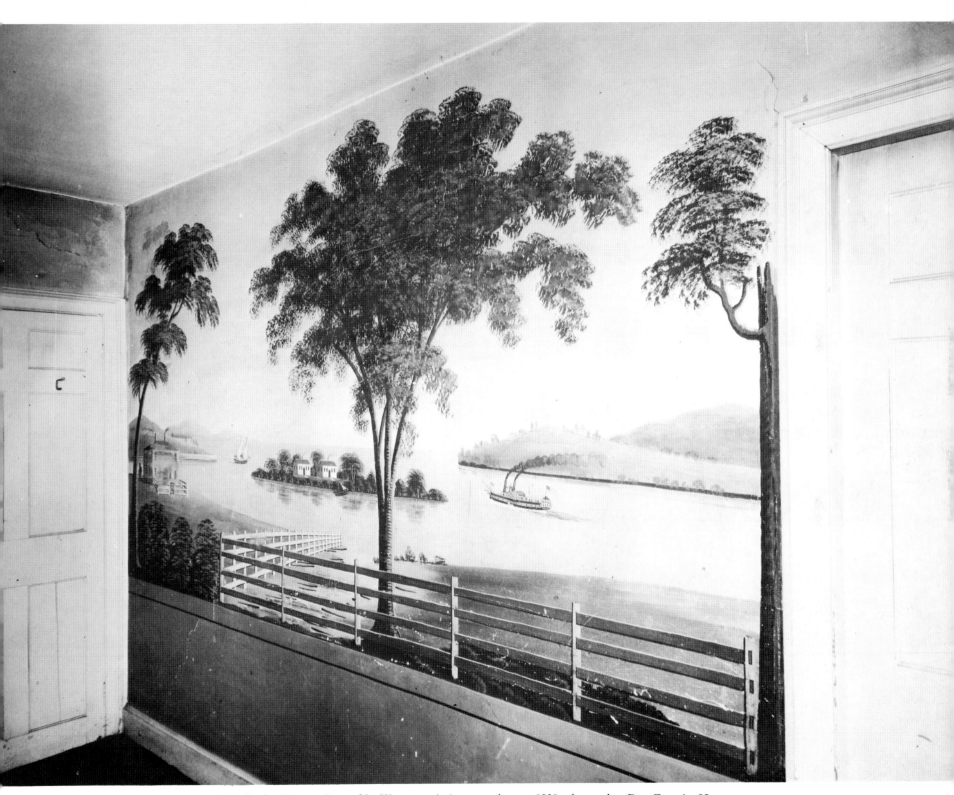

282. Rufus Porter, *Steamship Victory*, painting on plaster, 1838, from the Dr. Francis Howe house, Westwood, Mass. House demolished in 1965, walls removed. Collection of Benjamin M. Hildebrant.

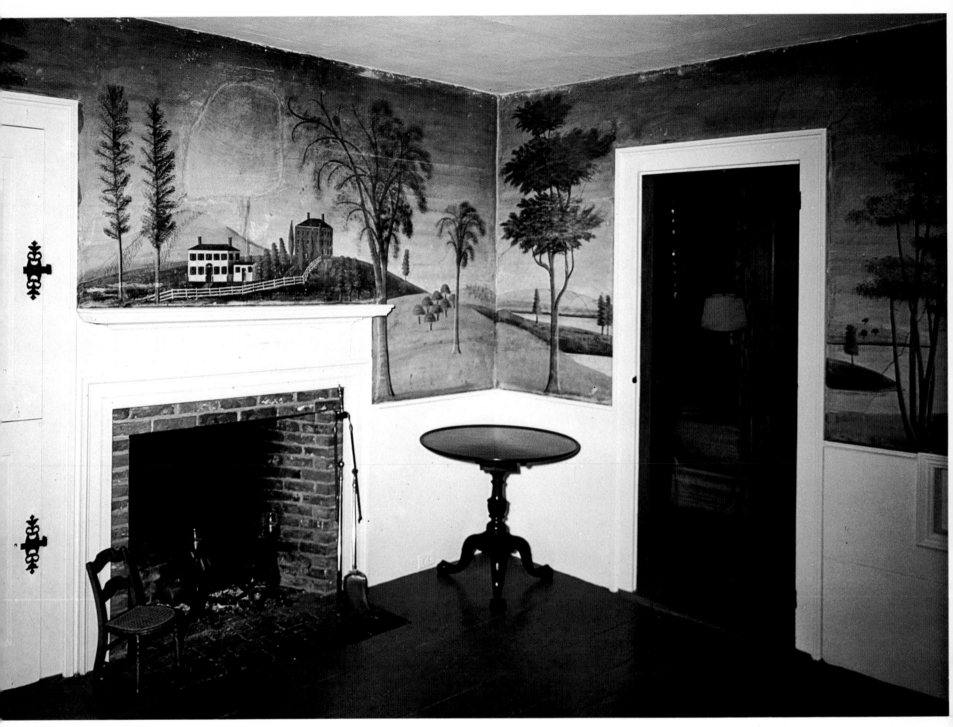

283. Rufus Porter, dining room, painting on plaster, c. 1825–30, Holsaert house, Hancock, N.H.
Owned by Aurel Brockway Sidway.

284. William Price, stairhall, painting on plaster, 1831, from the Ezra Carroll house, East Spring-field, N.Y. Signed and dated. Henry Francis du Pont Winterthur Museum, Winterthur, Del.

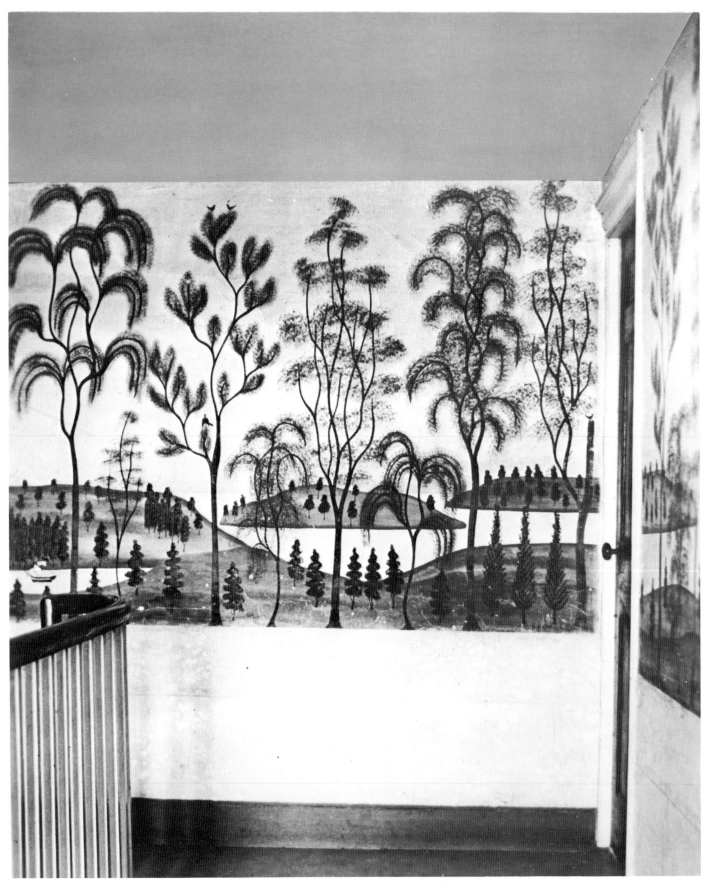

285. Orison Wood, stairhall, painting on plaster, c. 1830, Old Cushman Tavern, Webster Corner, Lisbon, Me. Owned by Mrs. Minot Morse.

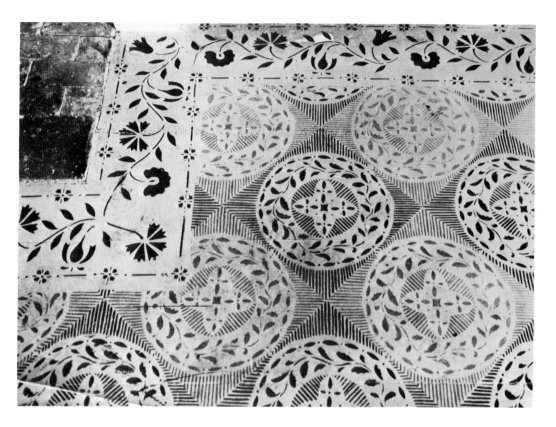

286, 287, 288. Floors, stenciling on wood, each design unit about 12″ square, c. 1825, Edward Durant house, Newton, Mass. Owned by estate of Arthur S. Dewing.

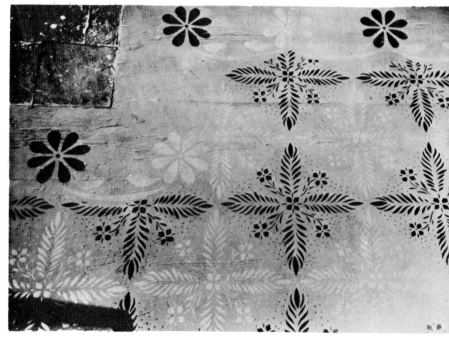

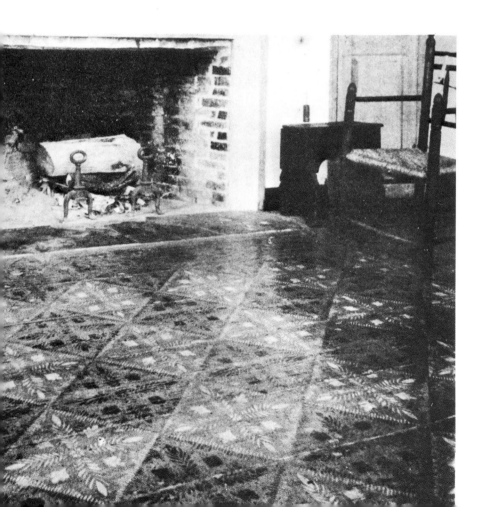

On the exteriors of their houses and public buildings early Americans exhibited the same taste for bright colors and bold, original decoration that they expressed indoors in stenciled walls and floors, painted murals, overmantels and fireboards, and decorated furniture.

Woodcarvings

We know from written accounts, and from the work of old woodcarvers still active in the early years of this century, that carved ornaments and three-dimensional wood figures were often used as architectural decoration in New England. However, harsh winters have done their damage to the soft native pine, and few examples survive.

In California the climate is kinder, and the great redwood tree provides a virtually weatherproof medium. In the coastal town of Mendocino, on top of the local Masonic Temple, a life-size sculpture of Father Time has stood for more than a century, carved from a single, huge redwood log by Erick Albertson, a local blacksmith. Father Time, the maiden whose hair he braids, the broken pillar, hourglass, dove, and sprig of acacia in the maiden's hand, all have significance in Masonic ritual and pertain to immortality. Albertson, believed to have been a Swedish immigrant who lived in the East before coming to California, was the first Master of the Mendocino Masonic Lodge. He supervised the building of the temple and provided ornamental carving for the upstairs room as well as the sculpture group for the spire.

Even the humble barnyard gate could become a work of art. In mid-century a Waterbury, Connecticut, farmer with the imposing name of Hobart Victory Welton constructed an ingenious gate out of iron and wooden farm implements and surmounted it with a still-life carving of the bountiful harvest produced with the help of these simple tools. Another farmer in Jefferson County, New York, had a wooden gate that was the ultimate in patriotic decoration: a red, white and blue American flag with thirty-eight stars, indicating that it was made in 1872 or thereabouts.

Decorated barns

The most characteristic landmark of the Pennsylvania German countryside is the great red barn decorated with "hex signs." These barns are most plentiful in Berks, Lebanon, Montgomery and Lehigh counties, and some are well over a hundred years old. Legend has it that the geometric designs on white circular medallions, many of them five to six feet in diameter, were painted to fend off evil spirits—to protect the barn from lightning and the livestock from witches. It has also been said that false arches were painted above the windows so that witches trying to fly in would be confused about the exact placement of the opening, bump their heads and depart. Picturesque as it is, the hex story has little foundation in fact. Like so many of the decorative motifs used by the descendants of German-speaking immigrants to Pennsylvania, the barn decorations are of European origin, and they may well derive from ancient magical emblems. However, by the time the farmers of southeastern Pennsylvania began painting these symbols on their barns—in the 1840s—they were intended merely as decorations, and their symbolic origins had been largely forgotten. A more direct ancestor of the Pennsylvania barn is the decorated frame house typical of Switzerland and Germany. Since the Pennsylvania Germans could not ornament their native stone houses with painted designs, they maintained the tradition of their ancestors by transferring the decoration from the house to the barn.

At first farmers painted their barns themselves, but soon the ubiquitous itinerants entered the scene, specializing in barn decoration. Often the route of a specific painter can be traced through his patterns, which reappear on one barn after another. One old-time painter reported that he used stencils for his designs, but more often they were marked out with chalk and string, or with a large wooden compass, and then painted.

The barns were almost always dark red, and the colors used for the designs were yellow and blue, occasionally red and green, on a white ground. The earliest circular design was the six-lobed symbol, which represented an open tulip. The star on the barns was a conventionalized pomegranate, the flower of Solomon's temple, which was symbolic of prosperity and fertility. Occasionally, geometrically constructed heart designs are found.

The number of circular decorations on the face of the barn varied from two to seven, and frequently the gable ends were decorated as well. The structural lines of the barns were usually bordered with broad white bands, which also defined the door and window trim; supplementary false arches were often painted over doors and windows. By such simple devices as these, the Pennsylvania barn was transformed into one huge geometrical design.

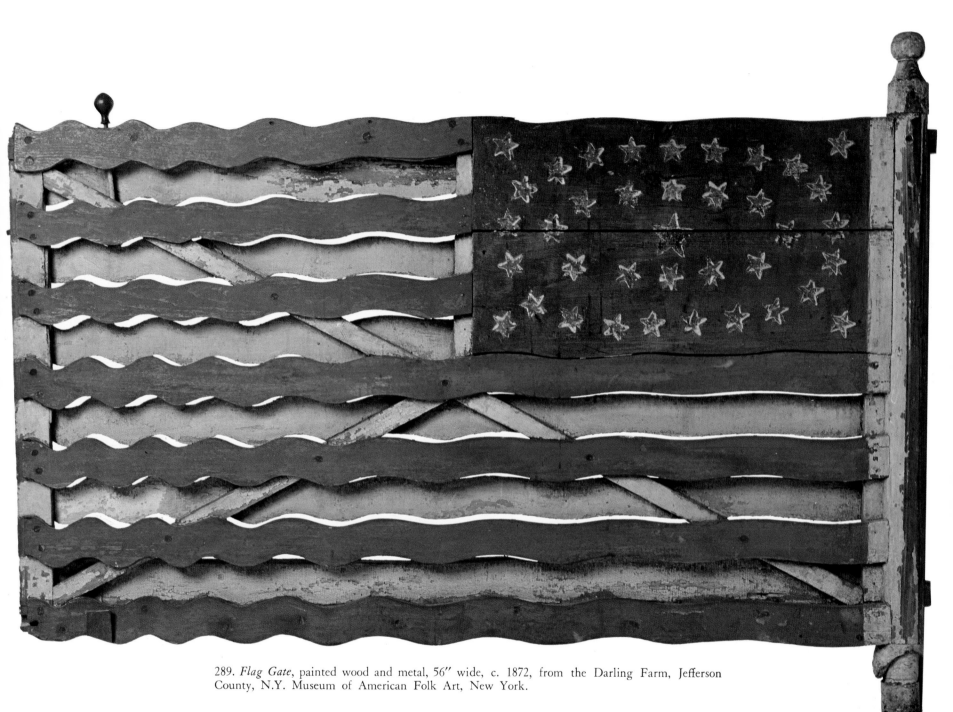

289. *Flag Gate*, painted wood and metal, 56″ wide, c. 1872, from the Darling Farm, Jefferson County, N.Y. Museum of American Folk Art, New York.

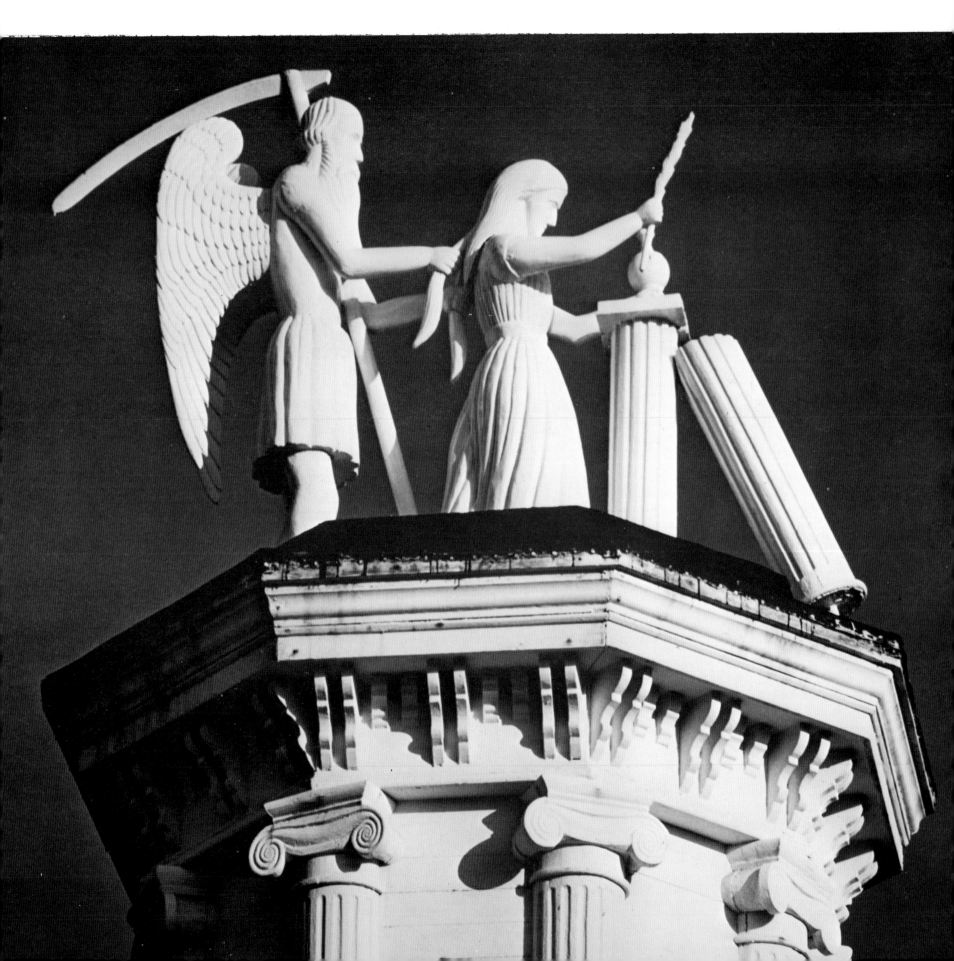

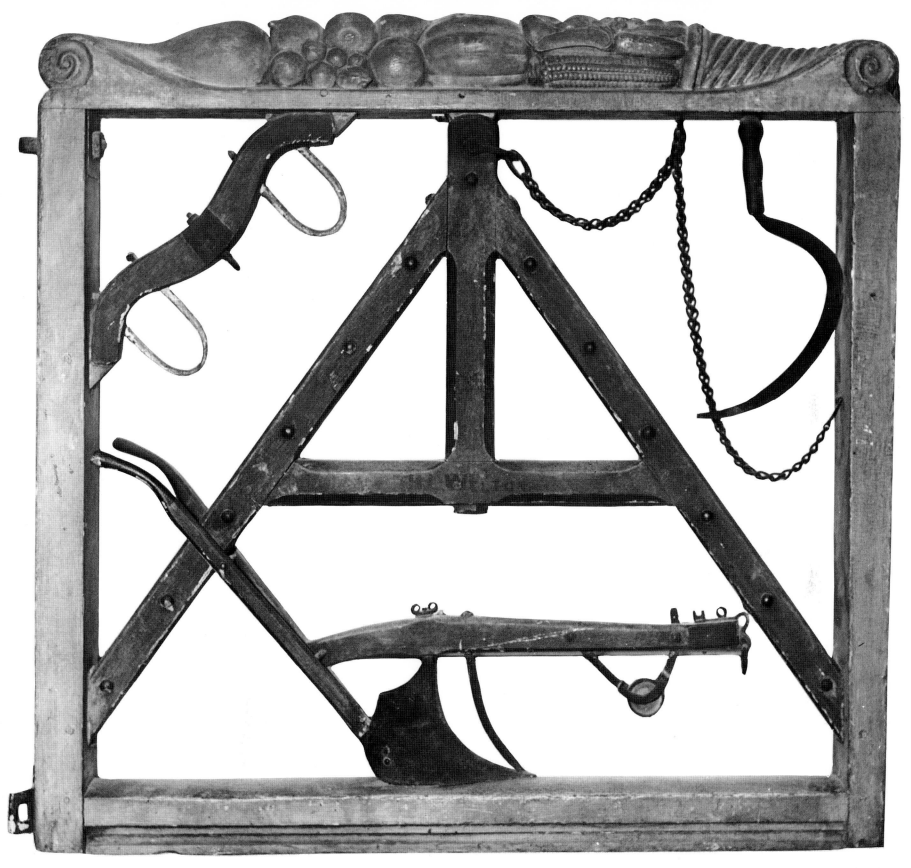

291. Hobart Victory Welton, *Welton Gate*, wood and iron, 41⅜″ wide, c. 1850, Waterbury, Conn. Mattatuck Historical Society, Waterbury, Conn.

OPPOSITE: 290. Erick Albertson, *Father Time*, painted wood, life size, c. 1870, Masonic Temple, Mendocino, Calif.

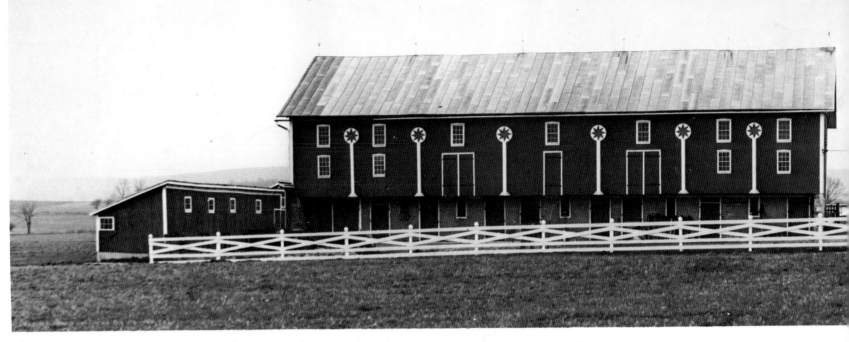

292. Painted barn decoration, c. 1875, John O. Mayer farm between Rehersberg and Freytown, Berks County, Pa.

293. Painted barn decoration, 1870, near New Smithville, Berks County, Pa.

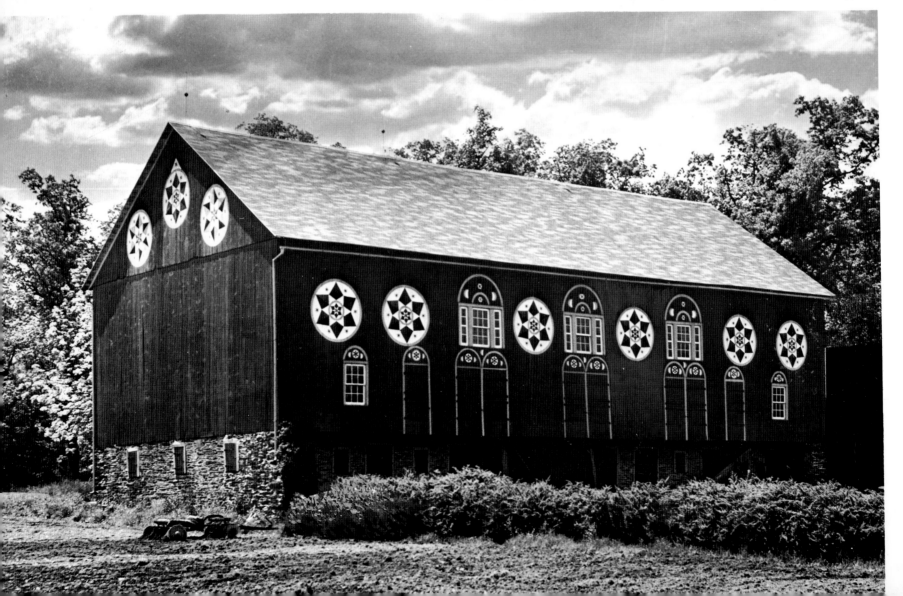

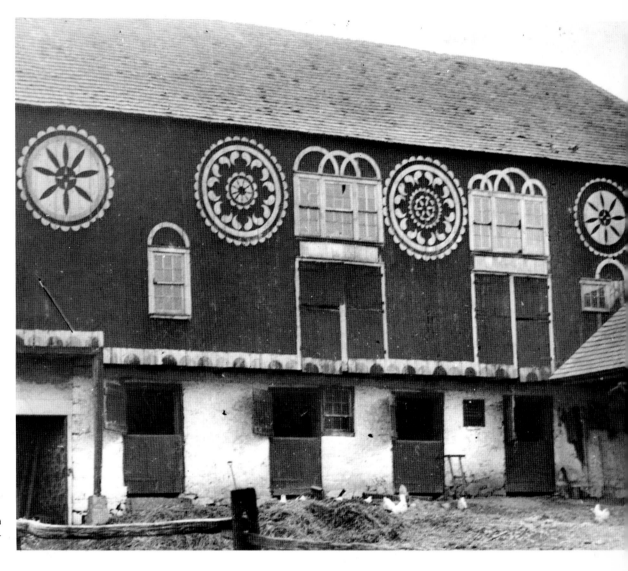

294. Noah Weiss, painted barn decoration, 1862, near Steinsberg, Lehigh County, Pa.

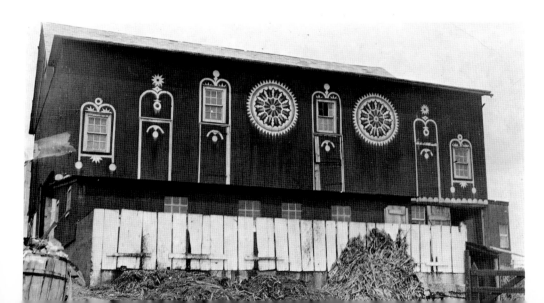

295. Painted barn decoration, c. 1870, on Lumneytown Pike near Pennsburg, Montgomery County, Pa.

Artists were not the only itinerants who rode the turn-pikes of the newly independent United States. Craftsmen with every sort of talent for hire—potters, tinkers, carpenters, weavers—brought needed services to scattered homesteads; the famous Yankee peddlers formed a primitive distribution system for the products of New England's busy workshops; and there were even itinerant doctors, dentists, teachers and preachers. Serving the needs of these, and many other Americans who seemed constantly to be on the move, was the tavern, a combined drinking establishment, restaurant and inn—the focal point of the busy life of the highway.

As early as 1645 the town of Salem required that taverns display signs for the convenience of travelers. In the same year the Rhode Island courts ordered all tavern keepers to "cause to be sett out a convenient Sign at ye most conspicuous place of ye said house, thereby to give notice to strangers it is a house of public entertainment. . . ."

Painted tavern signs, like carved cigar-store and shop signs, constitute one of the earliest forms of American advertising, and the painters who decorated them might be considered our first commercial artists. The signs were usually made with pictures on both sides and hung from a tall post at right angles to the road, so as to attract travelers coming from either direction. Very often the painted panel was framed by a pair of turned wooden posts and surmounted by a crest, as can be seen in the sign from the D. Beemer Inn. Sometimes the sign hung from sturdy leather straps, but E. Fitts, Jr., who ran an inn and general store near Shelburne, Massachusetts, had an elaborate wrought-iron frame for his sign.

Tavern signs were often painted by the same itinerant artists who decorated houses and painted portraits. They no doubt welcomed the opportunity for a break in their journeys at a pleasant inn and were happy to paint or repaint a sign in return for lodging and a convivial evening or two in the barroom. Coach painters formed another large pool of artistic talent which provided tavern and trade signs in addition to painting and gilding coaches, carriages, wagons and sleighs. Some artists signed their names in letters as large and bold as the tavern's name, clearly an advertisement for themselves as well as their patrons.

The earliest tavern signs most often represented British characters or emblems, but after the Revolution these were replaced by American patriotic symbols. In numerous signs representing the crowned royal lion, the crown was painted out, leaving a realistic rather than symbolic beast, which continued to be a popular image for signs through the nineteenth century. Perhaps William Rice intended a

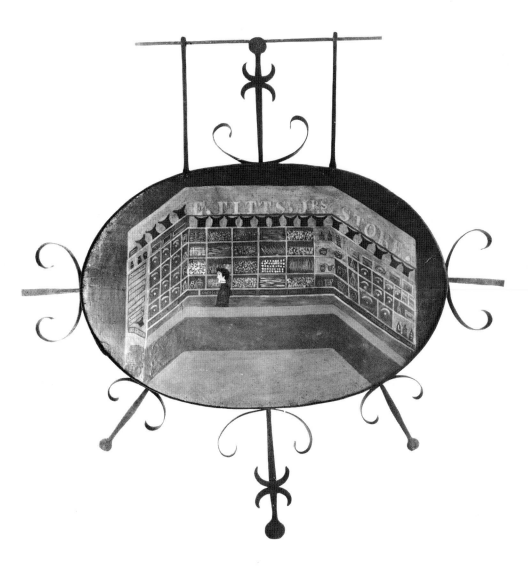

296. Shop and inn sign, *E. Fitts, Jrs. Store*, painted wood, wrought-iron framework, 46″ wide, 1832, vicinity of Shelburne, Mass. One side advertised E. Fitts's store, the other side, which is dated, his inn. Collection of Howard and Jean Lipman.

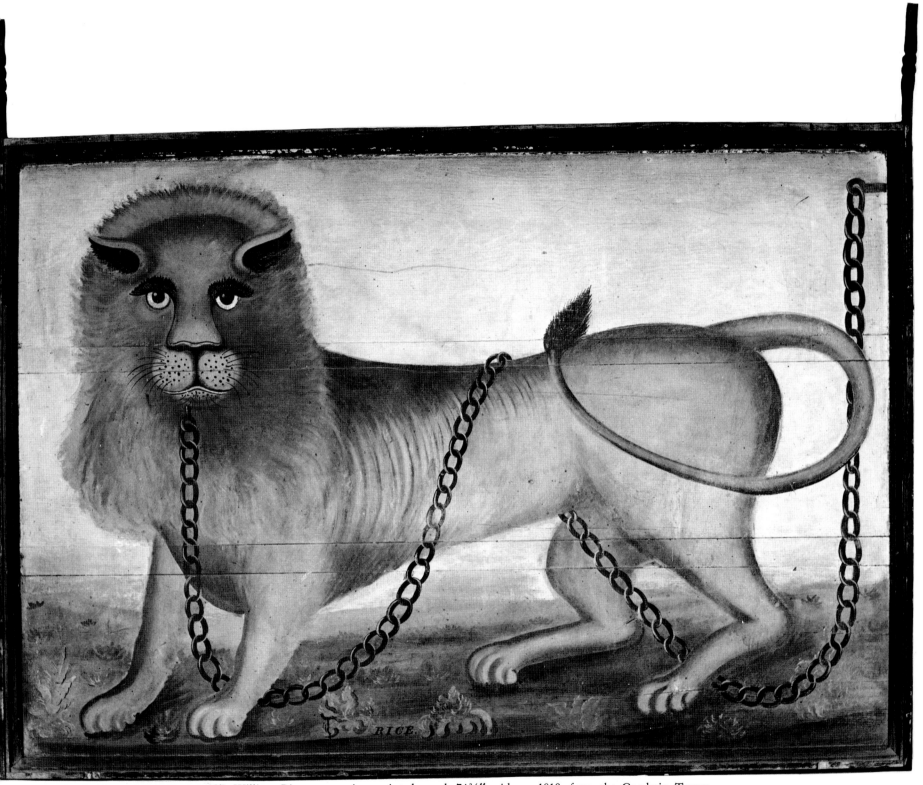

297. William Rice, tavern sign, painted wood, 74¾″ wide, c. 1818, from the Goodwin Tavern, Albany Avenue, Hartford, Conn. Signed. Wadsworth Atheneum, Hartford, Conn.

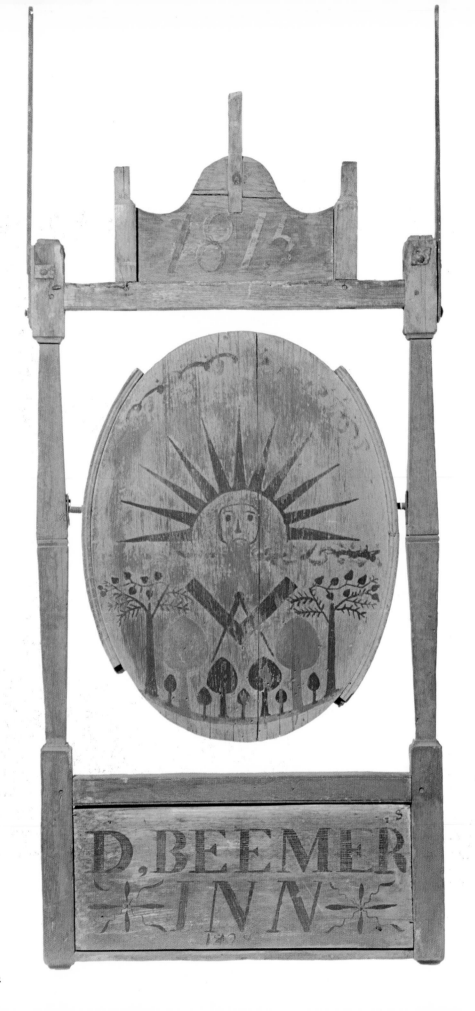

veiled political commentary on the demise of British rule when he painted a placid lion in chains for a Hartford, Connecticut, tavern.

To whet the appetites of weary wayfarers, artists selected a scene of merriment, as on the sign for J. Carter's Inn, which depicts a soldier and a gentleman traveler exchanging toasts across a tavern table set on a gaily patterned floor. The other side of this sign shows a man and his wife being driven in a carriage to the door of the inn. Masonic symbols often appear on the signs, giving notice that the owner was a Mason and would welcome brothers of the order. One of the most unusual of all nineteenth-century tavern signs is the one cut from marble, probably by the local stonecutter, and banded in wrought iron for a hotel in Ashfield, Massachusetts. Judging from the symbols carved at the bottom of the sign, the owner, John Williams, Jr., was a Mason.

Some tavern keepers fancied carved decorations as well. The proprietor of the Angel Tavern in Guilford, New York, obviously could not resist the opportunity presented by his establishment's name and ordered a saucy Angel Gabriel to hang over the doorway, summoning revelers to a last carouse before the grim accounting of Judgment Day—or the morning after.

298. Inn sign, *D. Beemer Inn*, painted wood, 51″ high, dated 1815 and 1828. Presumably 1815 is the date the inn was established, 1828 the date the sign was painted. Smithsonian Institution, Washington, D.C.

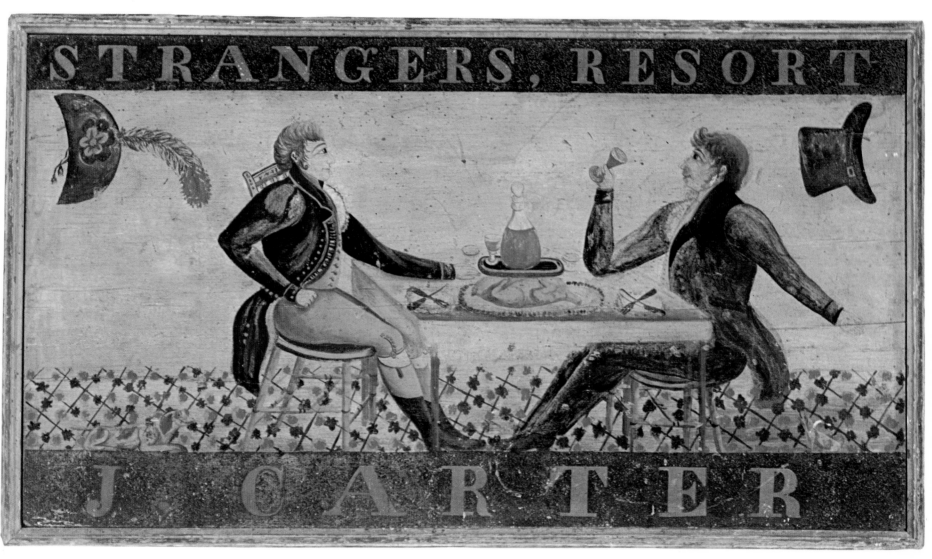

299. Inn sign, *Strangers, Resort*, painted wood, 42″ wide, 1815, from J. Carter's Inn, Clinton, Conn. Connecticut Historical Society, Hartford.

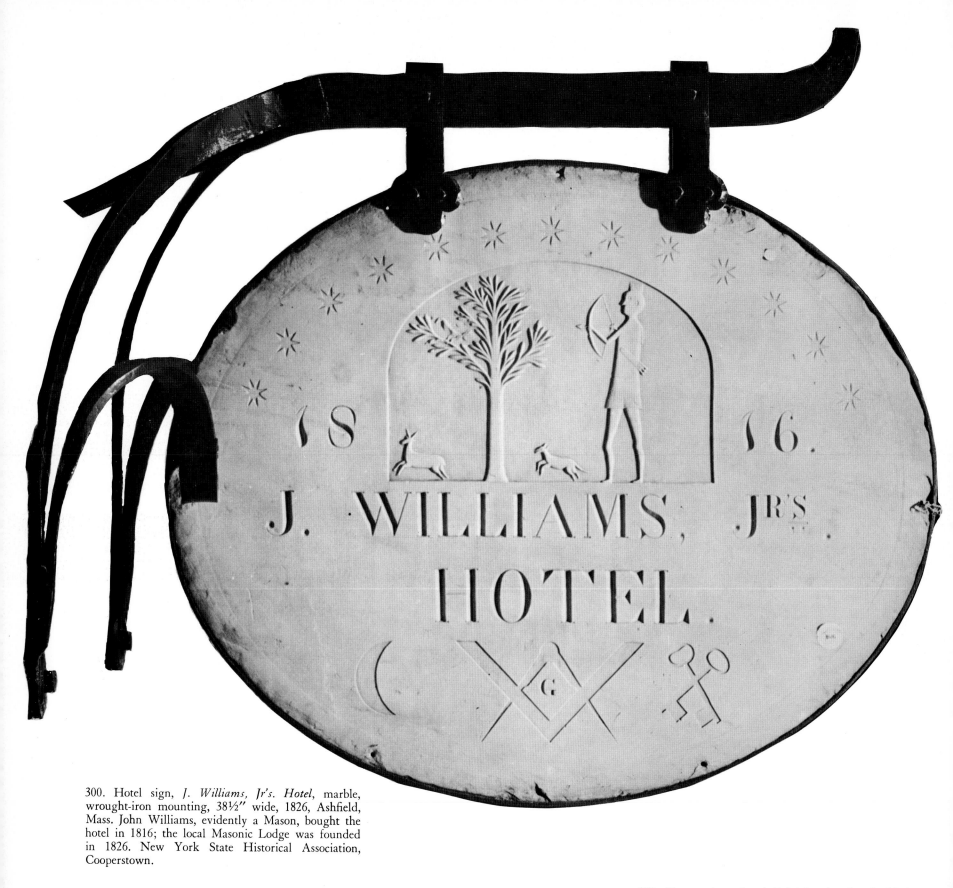

300. Hotel sign, *J. Williams, Jr's. Hotel*, marble, wrought-iron mounting, 38½″ wide, 1826, Ashfield, Mass. John Williams, evidently a Mason, bought the hotel in 1816; the local Masonic Lodge was founded in 1826. New York State Historical Association, Cooperstown.

OPPOSITE: 301. Tavern sign, *Angel Gabriel,* painted and gilded wood, 46½″ wide, c. 1825, from the Angel Tavern, Guilford, N.Y. Collection of Mr. and Mrs. Jacob M. Kaplan.

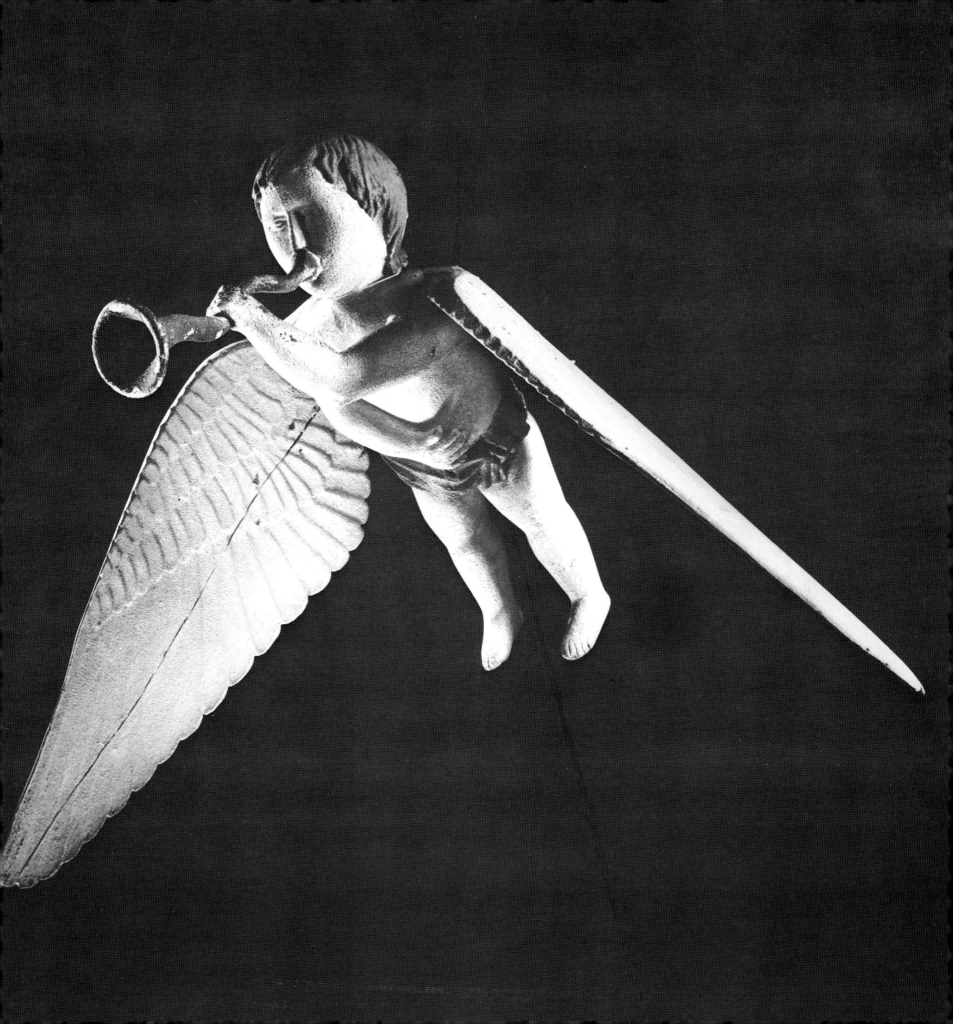

FURNISHINGS

FURNITURE

The country people who hired an itinerant decorator to stencil their walls and floors—and sometimes to paint the family portraits in the bargain—also furnished their houses with boldly decorated chests, chairs and tables like those shown on these pages. For the most part, these pieces are the basic ones used in the early household: chests for storage—the low ones often doubling as seats—tables, beds, chairs. The forms are simple and functional, the construction sturdy. From the point of view of folk art, this furniture is interesting because of its great variety of painted decoration, which constitutes, in effect, a résumé of many of the styles and techniques documented earlier in this book. At a glance one can see that the motifs on some of the Pennsylvania furniture are the same as those used by fractur artists in their illuminated birth and baptismal certificates. There are decorations that recall fireboards, tavern signs and Rufus Porter's murals. Stencils were widely used to decorate furniture, just as they were used by still-life painters. There is even an example of the kind of painting schoolgirls learned in young ladies' seminaries. And many pieces, with their exuberant swirls and flourishes or brilliant colors, show the folk artist at his freest and most inventive.

From the beginning the colonists had to make their own household furnishings and equipment, and by the time of the Revolution furniture making was one of America's leading industries. In the workshops of Boston, New York, Philadelphia and other cities, skilled cabinetmakers created sophisticated adaptations of the great English styles. These polished mahogany pieces with elaborate carvings and inlays were purchased by the rich merchants and ship owners of the Eastern seaboard and by the landed gentry of the South. But the average American had to be satisfied with simple pine or maple furniture made at home or purchased from the local carpenter or joiner. Imported styles—Hepplewhite, Sheraton, Empire—eventually found their way into rural areas and influenced the shapes of

furniture, as can be seen in the small Sheraton table from Connecticut. And just as painted decoration was used to dress up domestic interiors, so it was a means of disguising and enlivening the humble native woods of country-made furniture.

The Pennsylvania Germans had a rich heritage of Old World design and craftsmanship, as well as folk customs. Families were expected to provide a dowry for their marriageable daughters, just as they had for centuries in Europe. The magnificent *Schrank*, or wardrobe, was probably a gift from a prosperous Pennsylvania German farmer to his daughter on the occasion of her betrothal. It was made in sections so that it could be taken apart and moved easily. The young bride took it to her new home to hold her dowry of precious linens—many she herself had probably embroidered. Most girls, however, received a simpler, if no less beautifully decorated, dower chest. The young owner's name and the date on which the chest was presented were often lettered on it in elaborate German script; as in fractur documents, the lettering is an integral part of the total design.

The decorative motifs, like those used by the Pennsylvania Germans in all their art forms, derived from early Germanic folk art and originally had symbolic significance, although from the mid-eighteenth century on they were valued more for their decorative qualities. The tulip appears everywhere, a reminder of the tulipomania that swept Europe, and particularly Holland, in the seventeenth century, when bulbs were eagerly collected and growers competed in developing ever more splendid new varieties. From then on the flower remained a favorite motif in the decorative arts of Holland and the adjacent Rhineland, the home of many of America's German immigrants. The tulip was also considered a variation of the holy lily, and its three petals stood for the Trinity. The mermaid had religious meaning, symbolizing the dual nature of Christ— half human, half divine. Lions, griffins and crowns were

borrowed from medieval heraldry, while the pomegranate came by way of the Persian damasks that began to be copied in Germany during the late Middle Ages. Some of the motifs were particularly appropriate for dower chests: unicorns, those legendary beasts which in medieval times were considered the guardians of virginity; doves, as symbols of conjugal bliss; the tree-of-life; hearts, standing for love and joy. An even more ancient, pagan tradition is reflected in the popular red and golden yellow used on dower chests, for these colors were sacred to Donar, the Teutonic god of marriage and the home.

In view of the similarity between fractur and the painted dower chests, it is not surprising to learn that fractur artists and itinerant decorators sometimes painted chests as well. Chests from the different German counties of Pennsylvania exhibit distinctive traits, and the origin of a chest can often be determined by its characteristic details. Lancaster County chests recall an Old World design in which an architectural framework of arches and columns encloses the painted decoration. The columns are typically painted in two colors, the sunken arched panels a light cream as a background for the brightly colored motifs. It is unusual to find the human figure, but on the center panel of the Lancaster County chest shown here a man appears in profile; he may represent the bridegroom. Montgomery and Lehigh counties are best known for their geometric designs; Berks County is associated with unicorns, horsemen and flower patterns. Mahantango Valley craftsmen specialized in small, highly stylized motifs, many obviously imitated from fractur drawings, painted against a strong, flat background color. Centre County, somewhat removed from the original German settlements, presents free adaptations of traditional motifs. One Centre County chest mixes memories of the Old World decorative tradition with patriotic symbols of the new nation. Dominating the central panel is a large American eagle, boldly painted in black and holding a vermilion scroll where, instead of a patriotic motto, the artist carefully lettered the owner's name, in keeping with German tradition. The eagle clutches stylized tulips, in place of the usual olive branch and arrows, and is surrounded by geometric symbols very like those later used by Pennsylvania German farmers to decorate their barns.

Decorated chests abounded in New England as well; in fact, the earliest American furniture decorated with painted designs was made in Connecticut in the late seventeenth and early eighteenth centuries. Some very early Connecticut chests—from the Guilford–Saybrook area—had delicately painted, quite sophisticated decoration related in style to British painted designs and crewelwork. This tradition is continued, in a simpler and stronger linear style, in some of the later Connecticut chests such as the one with thistle, flowers and vases on a red ground, shown here. The blanket chest ornamented with feathery trees was actually made in the eighteenth century, but did not receive its present decoration until much later, about 1825. The marked similarity between these trees and those in Rufus Porter's murals suggests that the owner of this chest may have lived in a community visited by Porter or one of his pupils and may have taken the opportunity to have the old blanket chest rejuvenated in the latest fashion. Indeed, by the mid-eighteenth century many itinerant house, coach and sign painters had begun to add furniture decoration to their long list of services.

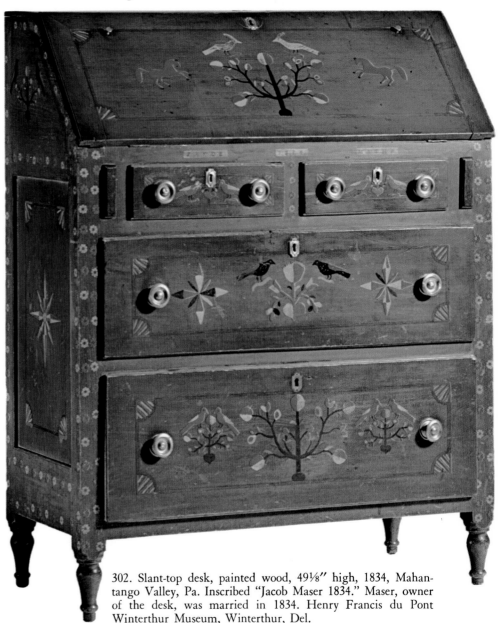

302. Slant-top desk, painted wood, 49⅛" high, 1834, Mahantango Valley, Pa. Inscribed "Jacob Maser 1834." Maser, owner of the desk, was married in 1834. Henry Francis du Pont Winterthur Museum, Winterthur, Del.

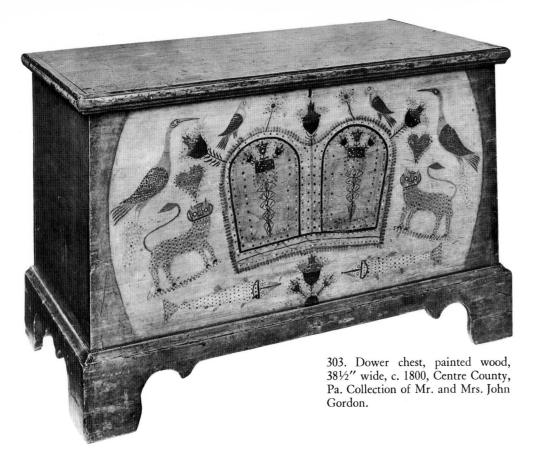

303. Dower chest, painted wood, 38½″ wide, c. 1800, Centre County, Pa. Collection of Mr. and Mrs. John Gordon.

Freehand painting was commonly used on many kinds of New England furniture. The arrow-back windsor chair with a lioness striding across its back was part of a set in which each chair was painted with a different species of jungle beast. The eagle appears frequently, as on the comb back of the windsor rocker, of which the seat is carved in imitation of rush. The rocking chair, incidentally, was an American invention, introduced around the middle of the eighteenth century. It became very popular and was made in various forms. Some people even had local carpenters cut down the legs of their old chairs and fit them with wooden rockers.

The other rocking chair shown here is an example of fine early stenciled decoration. Stencils were adopted by furniture makers early in the nineteenth century when the Empire style, with elaborate gilt and inlaid metal decorations, became popular here. Country craftsmen lacked the skills required for such intricate work but found that stencils could be used to produce a similar effect. At first, designs were very complicated: a single motif like a pineapple might require as many as seven separate stencils. Sometimes gold leaf or gold powder was used for the painting, but in time less expensive bronze and other metallic powders took their place on all but the most elaborate pieces. To stencil a chair, the decorator began by sizing the already primed wood surface with a thin coat of varnish and turpentine. When this was almost dry, he

carefully laid the paper stencil on the surface and, using a small velvet pad, or "pounce," brushed the powder through the opening of the stencil. Once the powders had dried, a sealer coat of varnish was applied. Individual fruits and flowers had the crisp, sharp outlines that only a stencil could produce, but a skilled hand could achieve subtle modulations of brightness and shading just as in freehand painting. As the demand for stenciled furniture increased, manufacturers resorted to short cuts: designs were simplified, the number of stencils was drastically reduced, the application of the powders became less detailed and the finished designs flatter.

The type of stenciled chair shown here is popularly referred to as a Hitchcock chair, after the man who, in the 1820s, developed a system for mass-producing stencil-decorated furniture. Quantities of chairs bearing Lambert Hitchcock's label were produced at his Connecticut factory, while dozens of smaller workshops in New England, New York, New Jersey and as far west as Ohio adopted similar techniques of production, each using its own designs— some original, some imitated from competitors. The chest from Cambridge, New York, was probably a sampler of its decorator's stencil designs, displaying a neatly symmetrical arrangement of baskets of fruit, lyres, birds, pineapples, heads of wheat, acorns and clusters of hearts. These are the most common motifs in nineteenth-century American stencil work, found in abundance in young ladies' theorem paintings, decorated furniture, boxes, picture frames and trays. The Pennsylvania stenciled chest is as striking as it is atypical: the designs are painted in gilt and are an unusual combination of American eagles and heraldic lions, as well as paired birds and floral motifs somewhat reminiscent of earlier Pennsylvania German dower chests.

For particularly skillful students in New England ladies' seminaries, furniture offered yet another medium in which they could show off their artistic accomplishments. The small drop-leaf table shown here is decorated with the kind of still-life and genre scenes that schoolgirls practiced in their watercolor painting classes. On top of the table a young matron sits in a bucolic landscape, surrounded by five lovely daughters; each leaf of the table displays the familiar basket of flowers, more flowers cover the drawer, and mossy ropes entwine the legs.

In many instances, especially where the painted ornament seems most perfectly correlated with the structural design of a piece, one surmises that the maker and the decorator were one and the same. Surely such is the case with the country-made Sheraton table, its delicate form cleverly painted to give a *trompe l'oeil* impression of wood grain and of the elaborate inlays and veneers found on its sophisticated city cousins. This piece might be considered a sampler of the many graining techniques commonly used

to imitate costly furniture. Often what began as a fairly realistic simulation of actual wood grain rushed headlong into exuberant design. One cannot help but feel that a man like Thomas Matteson—whose blanket chest with the make-believe top drawers is shown here—was simply carried away by the bright colors and sensuous quality of his paints. Matteson painted on a dry surface, probably using coarse brushes, but other decorators used sponges and even feathers to apply paint in interesting patterns. The decoration on one of the clocks shown here has been called "paw printed," and it does look as if a small animal's paw had been dipped in paint and had then "walked" across the entire surface; it is not certain just what instrument was

actually used to achieve this effect—perhaps a bit of sponge, crumpled cloth or newspaper.

Some of the most dramatic results were achieved by a technique akin to finger painting. First the piece of furniture was given a base coat—often yellow—and allowed to dry thoroughly. Next a contrasting color was brushed evenly over the entire area to be decorated, and while still wet, the paint was manipulated to create bold, free-form patterns such as those on two of the New England blanket chests shown here. Sometimes it appears that the decorator actually used his fingers or the heel of his hand. Simple materials were also used in free, experimental ways: newspaper pulled across the wet painted surface produced

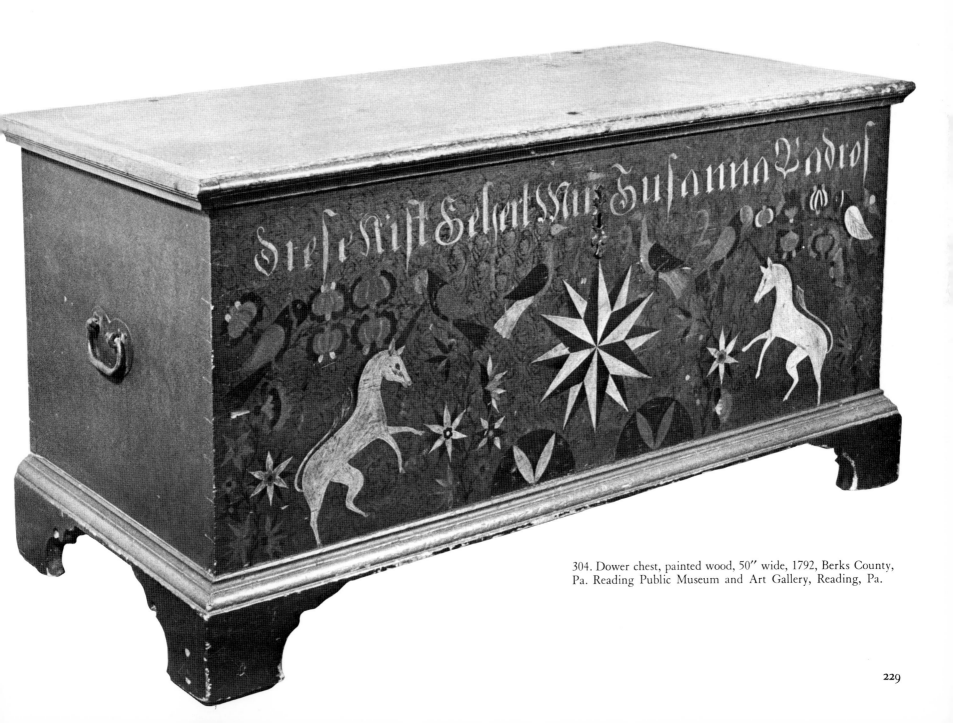

304. Dower chest, painted wood, 50″ wide, 1792, Berks County, Pa. Reading Public Museum and Art Gallery, Reading, Pa.

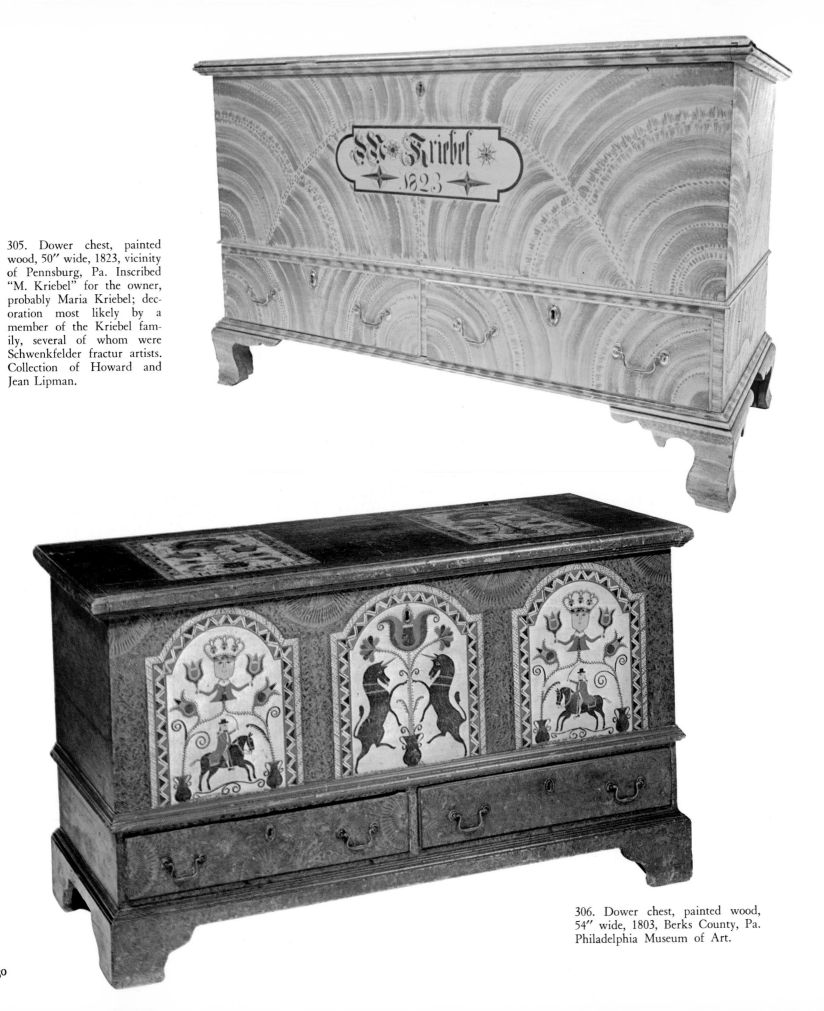

305. Dower chest, painted wood, 50″ wide, 1823, vicinity of Pennsburg, Pa. Inscribed "M. Kriebel" for the owner, probably Maria Kriebel; decoration most likely by a member of the Kriebel family, several of whom were Schwenkfelder fractur artists. Collection of Howard and Jean Lipman.

306. Dower chest, painted wood, 54″ wide, 1803, Berks County, Pa. Philadelphia Museum of Art.

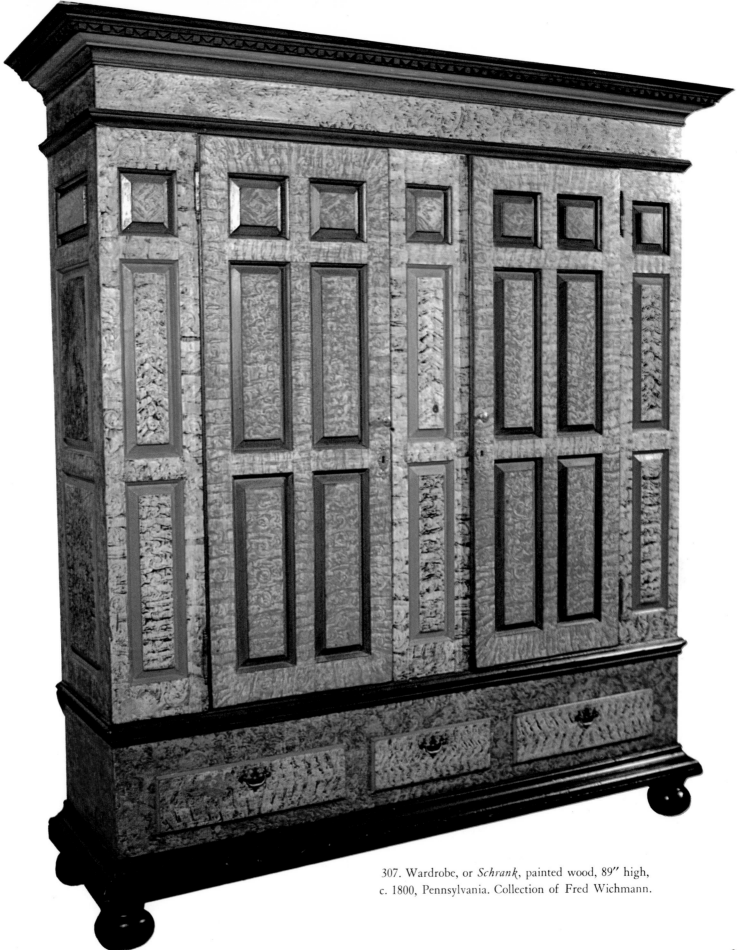

307. Wardrobe, or *Schrank*, painted wood, 89″ high,
c. 1800, Pennsylvania. Collection of Fred Wichmann.

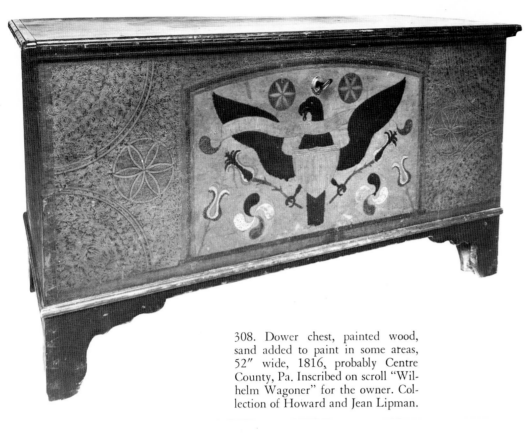

a rippled effect; a roll of putty pushed with a circular movement created fan- or wheel-like designs; a dry corncob could be held at one end and twisted to make a circular pattern. Sponges, combs, dry brushes and swabs of folded paper or cloth could be used in certain areas to wipe away paint, partially or completely exposing the contrasting base coat. A cork, the end of a putty roll or the butt of a brush was used to stamp out small circular designs. A lighted candle passed just close enough to blacken but not to burn a coat of barely wet paint produced a smoky, mottled effect. The top coat of paint could also be mixed with other materials—linseed oil, vinegar or solvent—causing it to separate in curious, random patterns.

These nineteenth-century furniture decorators displayed the uninhibited use of unconventional materials and the fascination with pure design that are characteristic of American folk artists. In the speed and freedom of their paint manipulation, they were surprisingly akin to the abstract expressionists of the 1950s. Both groups of artists— a century apart in time—were "action painters" in the literal sense of the term.

308. Dower chest, painted wood, sand added to paint in some areas, 52″ wide, 1816, probably Centre County, Pa. Inscribed on scroll "Wilhelm Wagoner" for the owner. Collection of Howard and Jean Lipman.

309. Dower chest, painted wood, 52½″ wide, c. 1780, Lancaster County, Pa. Metropolitan Museum of Art, New York.

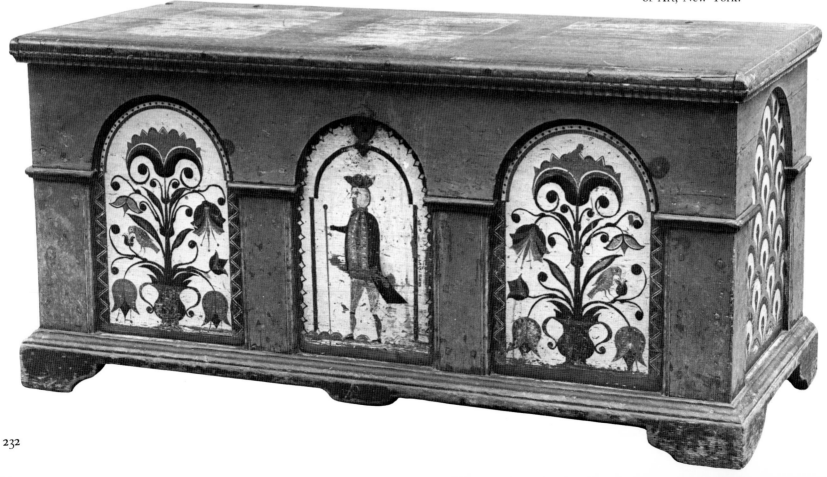

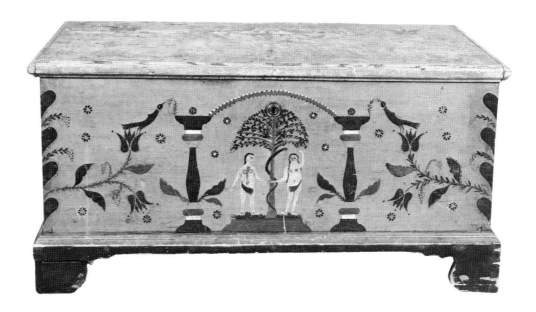

310. Dower chest, painted wood, 50″ wide, 1775–1800, Pennsylvania. Henry Francis du Pont Winterthur Museum, Winterthur, Del.

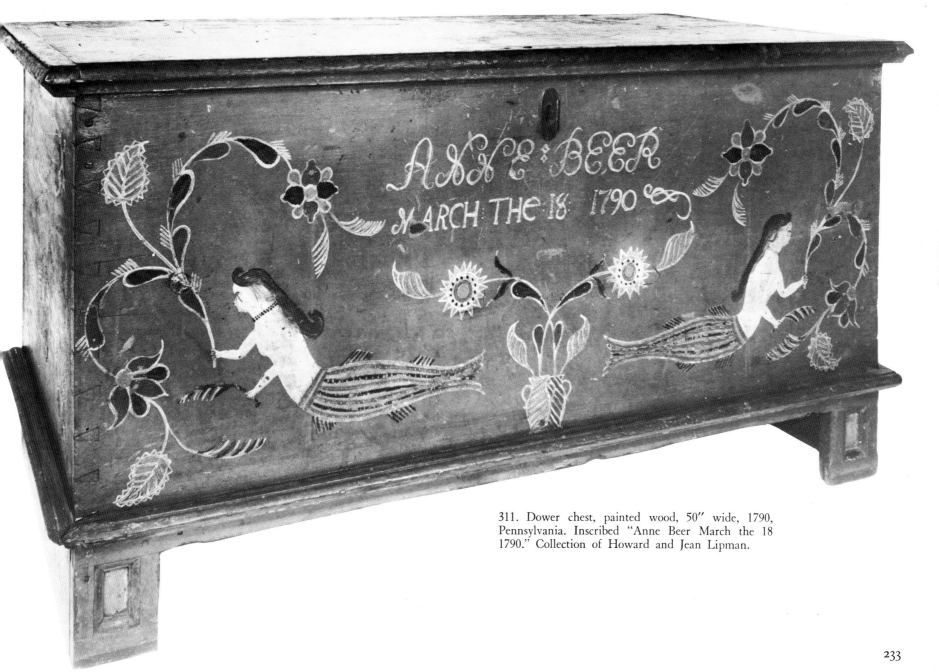

311. Dower chest, painted wood, 50″ wide, 1790, Pennsylvania. Inscribed "Anne Beer March the 18 1790." Collection of Howard and Jean Lipman.

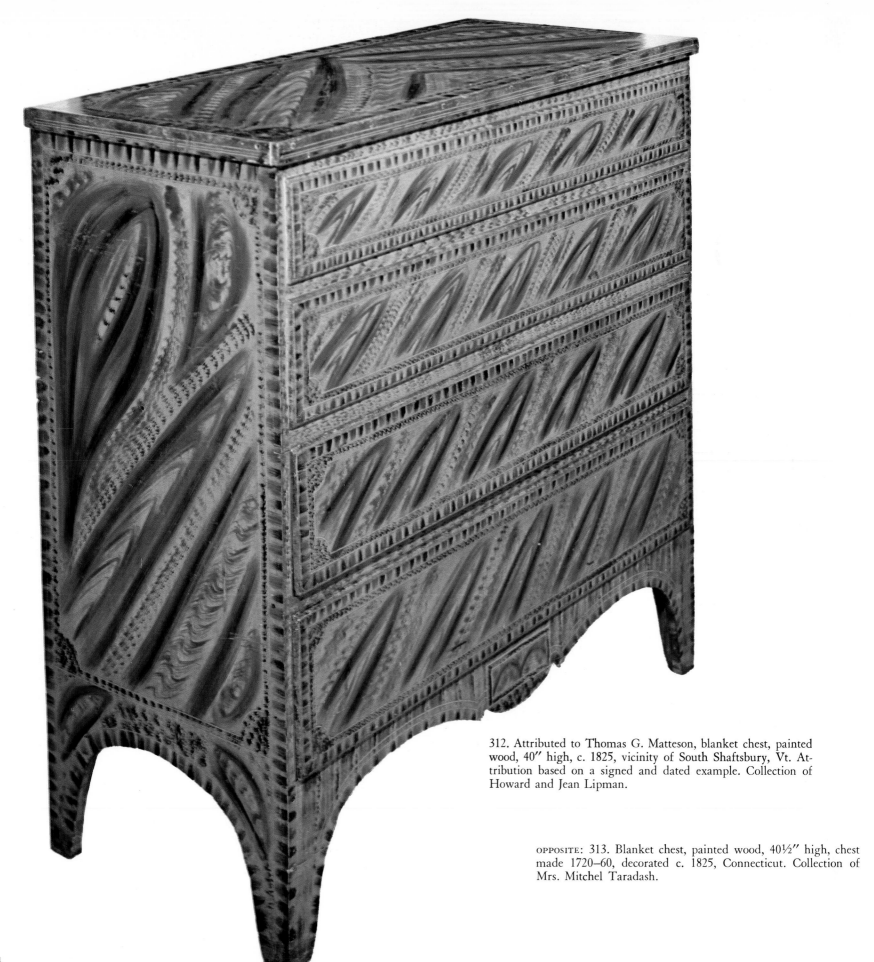

312. Attributed to Thomas G. Matteson, blanket chest, painted wood, 40″ high, c. 1825, vicinity of South Shaftsbury, Vt. Attribution based on a signed and dated example. Collection of Howard and Jean Lipman.

OPPOSITE: 313. Blanket chest, painted wood, 40½″ high, chest made 1720–60, decorated c. 1825, Connecticut. Collection of Mrs. Mitchel Taradash.

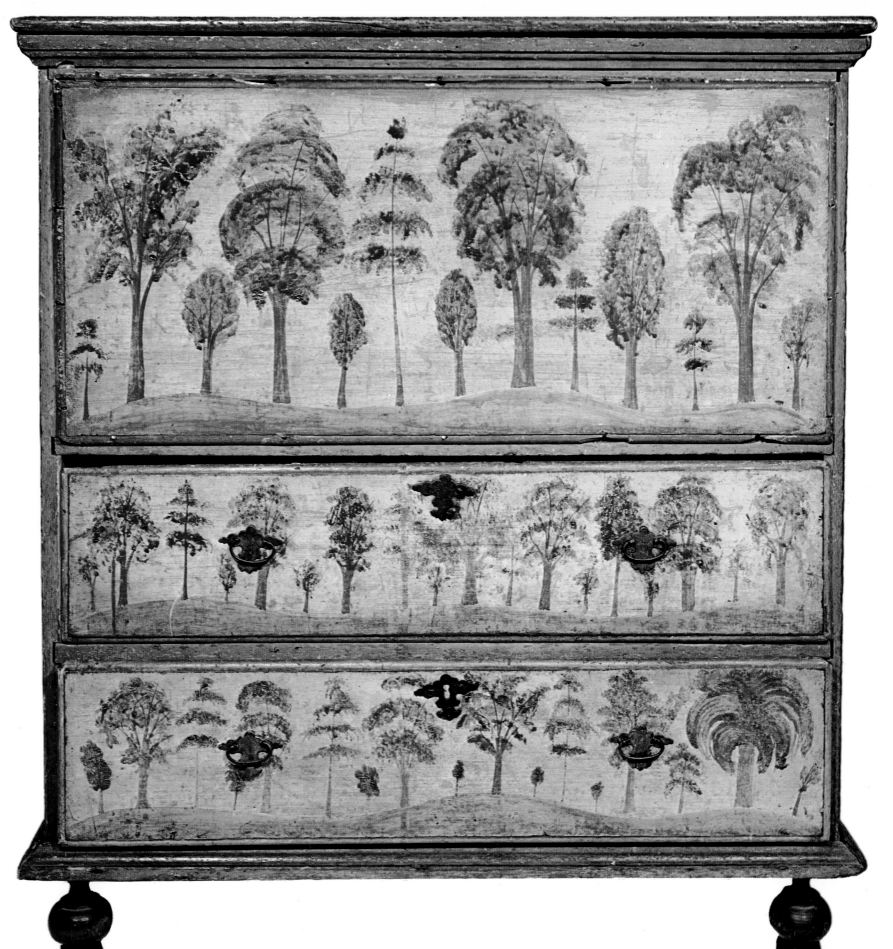

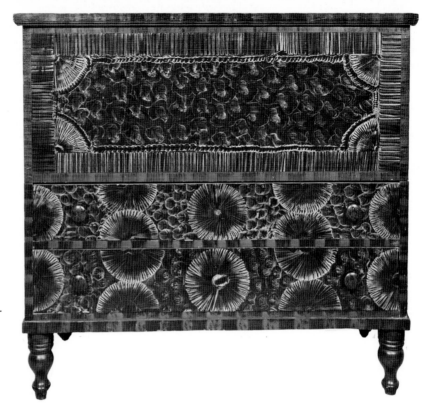

314. Blanket chest, painted wood, 39″ high, c. 1825–35, Mass. Collection of Howard and Jean Lipman.

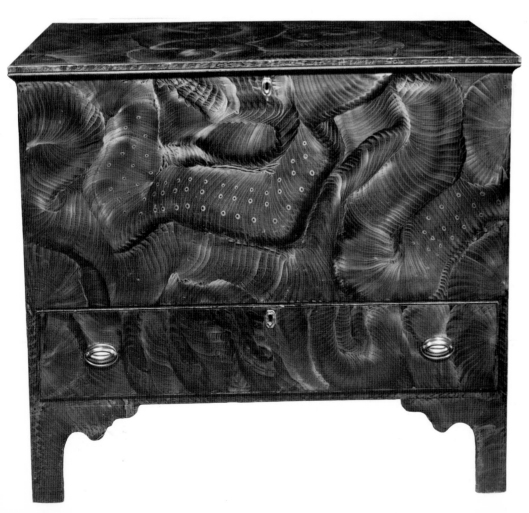

315. Blanket chest, painted wood, 34″ high, c. 1825–40, New England. Collection of Howard and Jean Lipman.

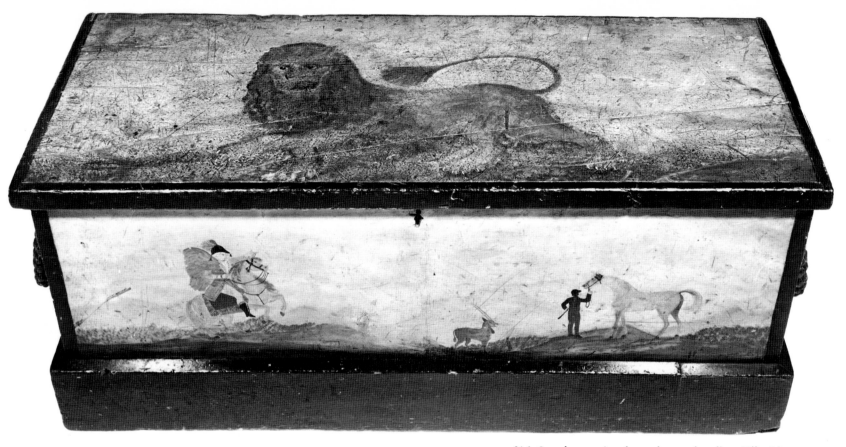

316. Sea chest, painted wood, rope handles, 43″ wide, c. 1825, New England. Collection of Howard and Jean Lipman.

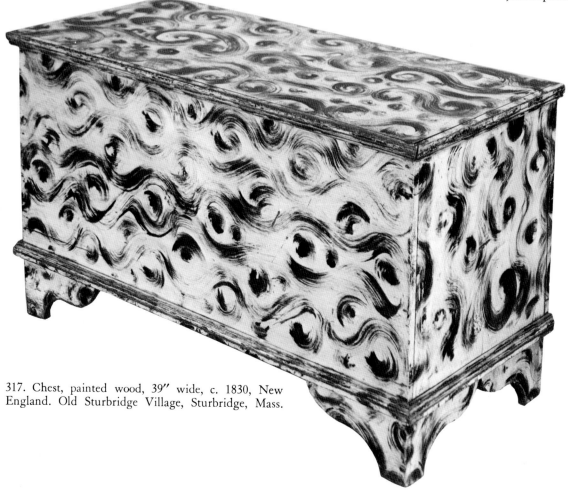

317. Chest, painted wood, 39″ wide, c. 1830, New England. Old Sturbridge Village, Sturbridge, Mass.

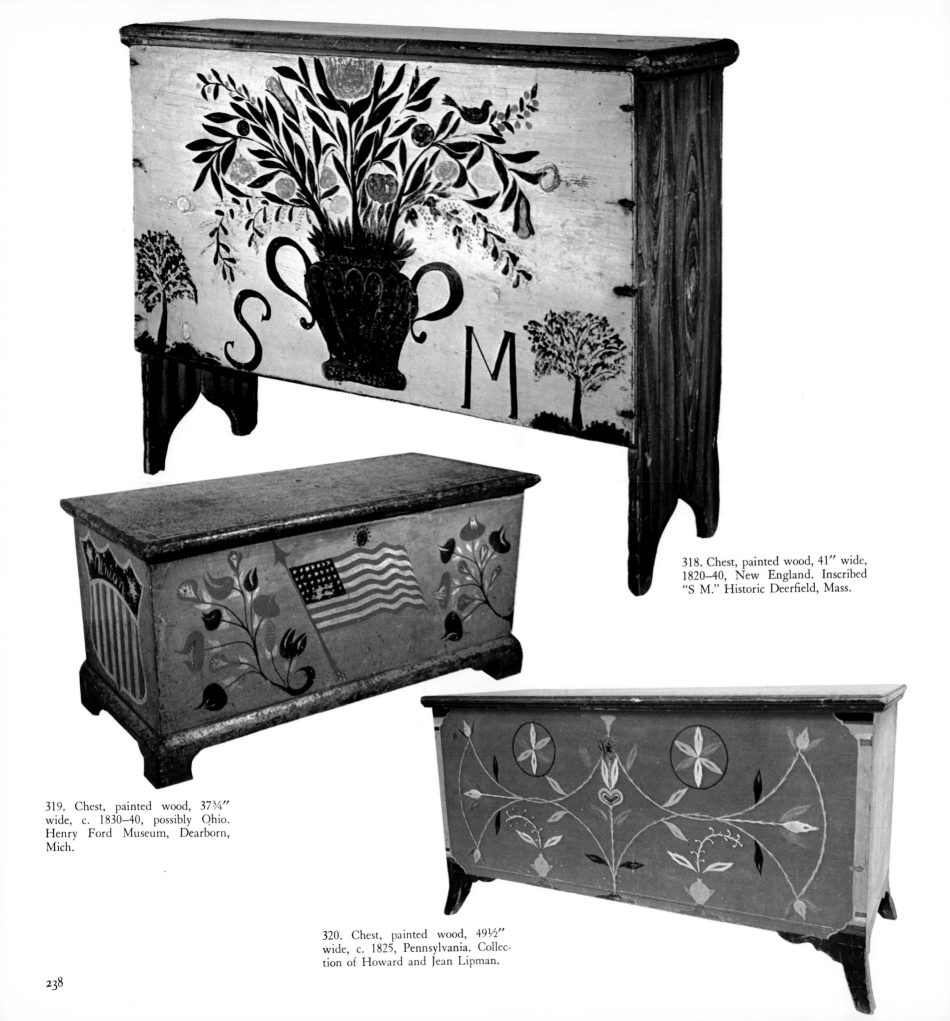

318. Chest, painted wood, 41″ wide, 1820–40, New England. Inscribed "S M." Historic Deerfield, Mass.

319. Chest, painted wood, 37¾″ wide, c. 1830–40, possibly Ohio. Henry Ford Museum, Dearborn, Mich.

320. Chest, painted wood, 49½″ wide, c. 1825, Pennsylvania. Collection of Howard and Jean Lipman.

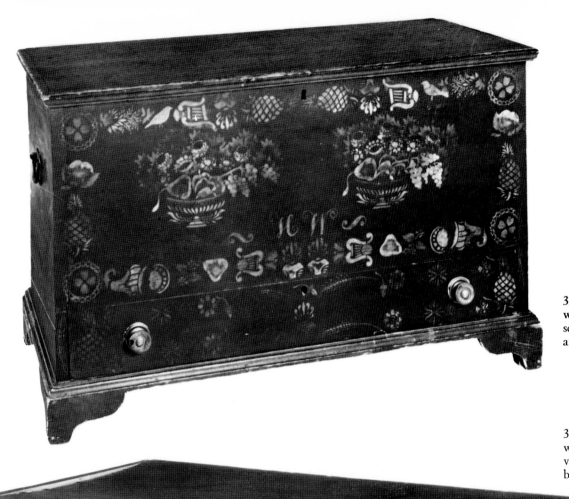

321. Chest, stenciled wood, 39½″ wide, c. 1800, Cambridge, N.Y. Inscribed "H W." Collection of Mr. and Mrs. Thomas H. Schwartz.

322. Chest, painted and stenciled wood, 30″ wide, c. 1830, Pennsylvania. Henry Ford Museum, Dearborn, Mich.

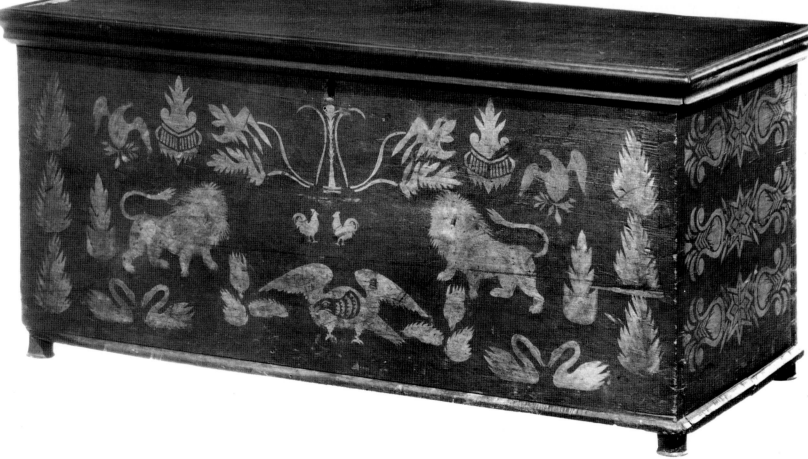

323. Tall clock, painted wood case, 87″ high, c. 1840, found in New Jersey. The name of the clockmaker, L. W. Lewis, is inscribed on the dial. Collection of Howard and Jean Lipman.

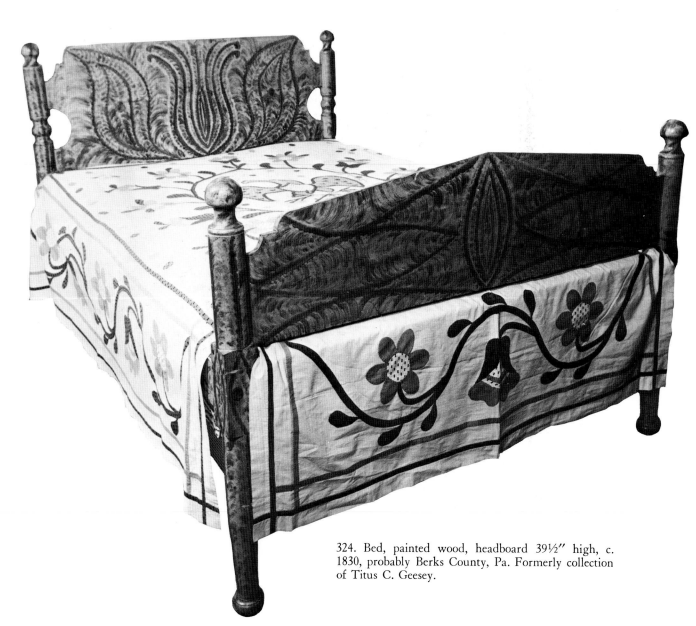

324. Bed, painted wood, headboard 39½″ high, c. 1830, probably Berks County, Pa. Formerly collection of Titus C. Geesey.

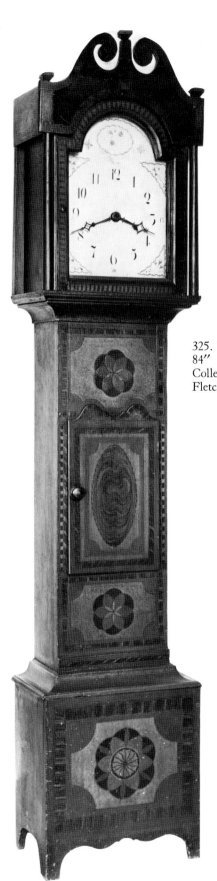

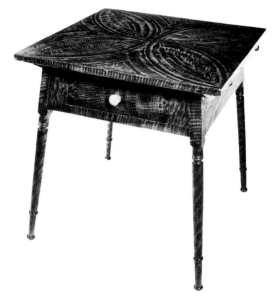

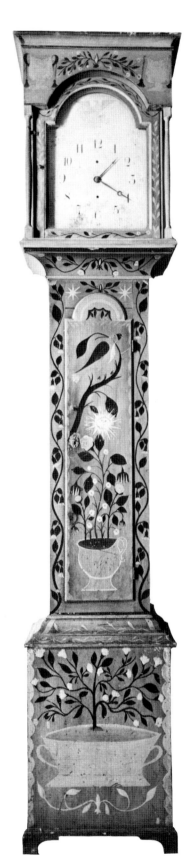

325. Tall clock, painted wood case, 84″ high, 1810–20, Connecticut. Collection of Bertram K. and Nina Fletcher Little.

326. Dough-board table, painted wood, pressed-glass knob, 30″ high, c. 1830, probably Berks County, Pa. Top lifts off to reverse for rolling dough. Collection of Howard and Jean Lipman.

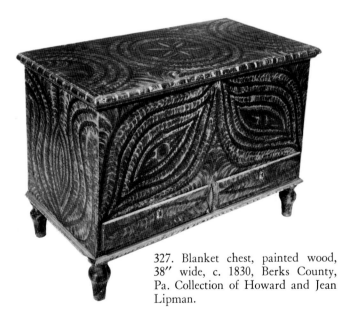

327. Blanket chest, painted wood, 38″ wide, c. 1830, Berks County, Pa. Collection of Howard and Jean Lipman.

328. Tall clock, painted wood case, 92″ high, c. 1830, Mahantango Valley, Pa. Philadelphia Museum of Art; Titus C. Geesey Collection.

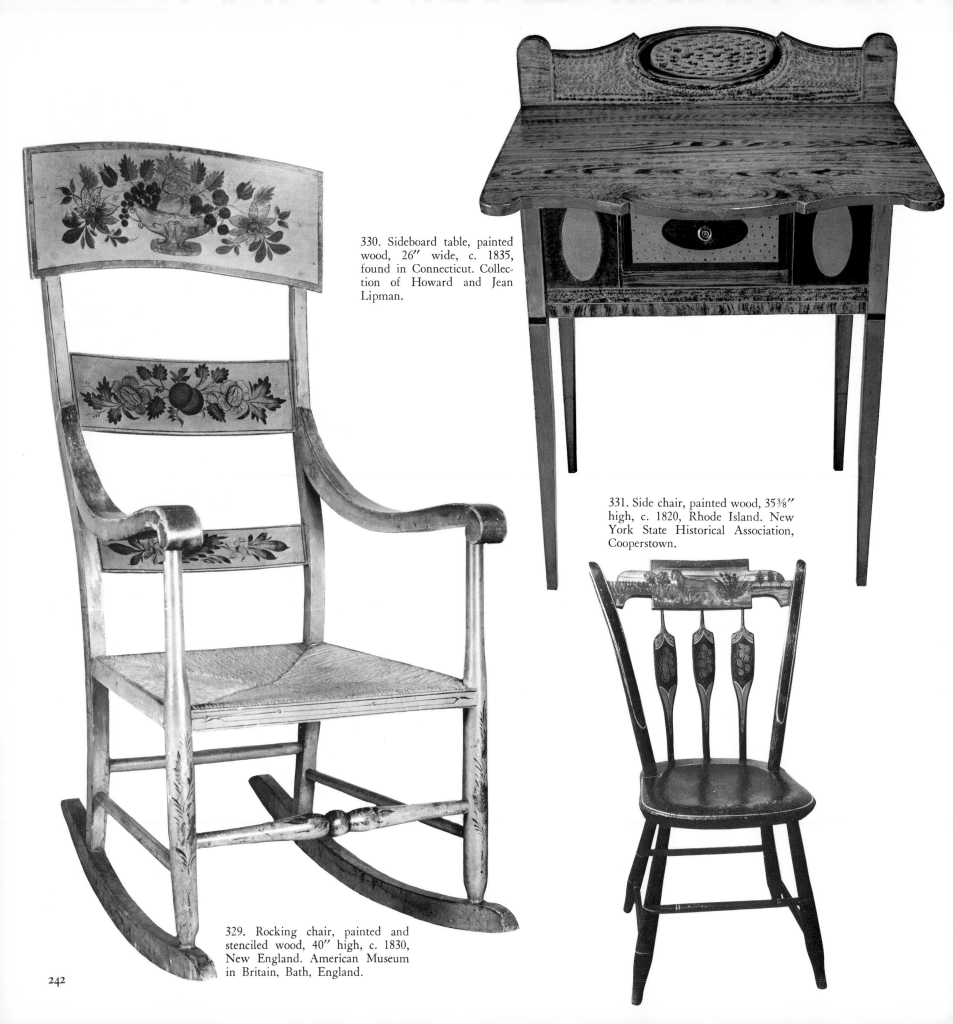

330. Sideboard table, painted wood, 26″ wide, c. 1835, found in Connecticut. Collection of Howard and Jean Lipman.

331. Side chair, painted wood, 35⅜″ high, c. 1820, Rhode Island. New York State Historical Association, Cooperstown.

329. Rocking chair, painted and stenciled wood, 40″ high, c. 1830, New England. American Museum in Britain, Bath, England.

242

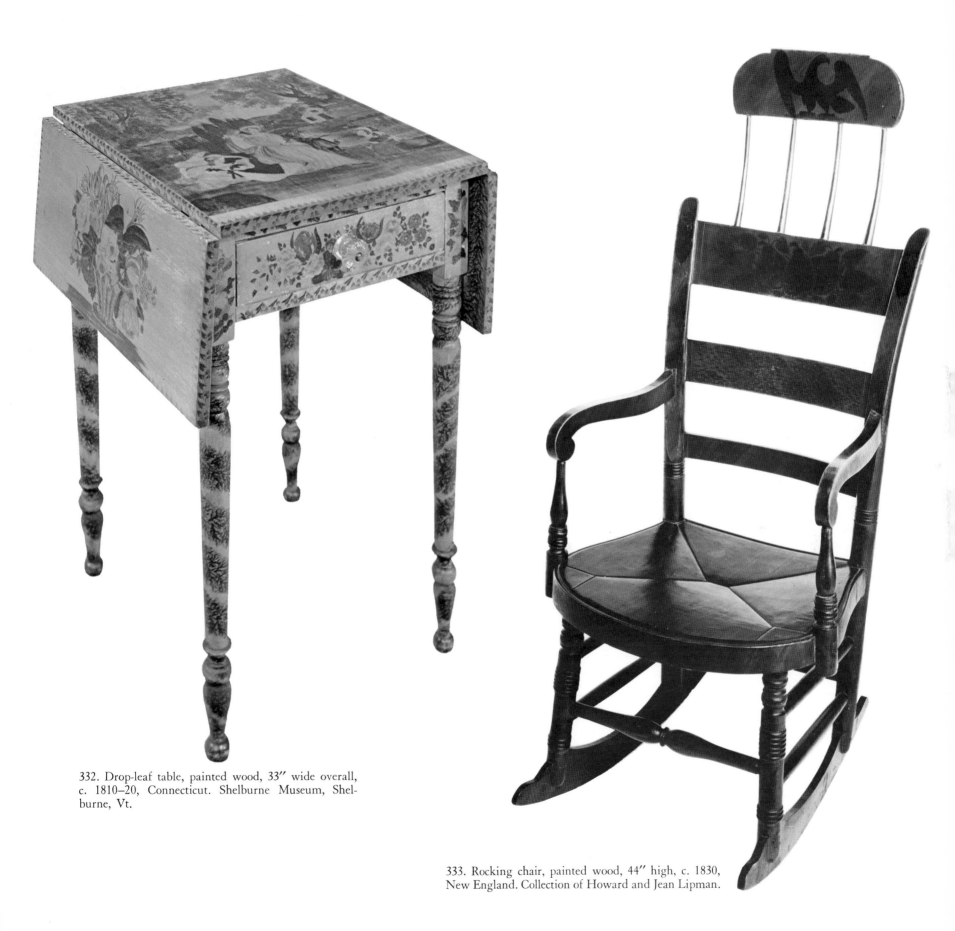

332. Drop-leaf table, painted wood, 33″ wide overall, c. 1810–20, Connecticut. Shelburne Museum, Shelburne, Vt.

333. Rocking chair, painted wood, 44″ high, c. 1830, New England. Collection of Howard and Jean Lipman.

243

Decorated boxes, picture and mirror frames

The early American household was filled with boxes of all kinds in which candles, salt, knives, documents, books, trinkets and other personal belongings were stowed away for neatness and safekeeping. Decorated wooden boxes were made in large quantity in Pennsylvania and New England, and they display the same regional characteristics seen in the dower and blanket chests shown earlier.

The bride's box, like the dower chest, represents one of the many Old World customs perpetuated by the Pennsylvania Germans. A gift from the bridegroom to the bride, it was intended to hold the more fragile items of her trousseau. The boxes, from one to two feet long, were made of thin wood bent around an oval base with a lid that fits down over the framework of the box. The bride's box shown here presents a fine figure of a gentleman—perhaps the groom—who looks as though he had stepped out of a fractur drawing, a reminder that many bride's boxes, like the dower chests, were painted by itinerant fractur artists.

New England whalemen produced inlaid boxes, using whales' teeth and exotic woods collected during their far-ranging voyages. They also made rounded boxes from baleen, decorating the lids with incised and colored designs and pictorial scenes. Baleen, found in the mouth of a certain type of whale and popularly known as whalebone, was not bone at all but a substance of hornlike consistency and almost black color that was easily bent when heated.

Painted and stenciled decorations similar to those found on chests and boxes were also applied to frames for pictures and mirrors. When a family commissioned a portrait or a family record, a frame was usually ordered as well, sometimes from the artist himself, sometimes from a local furniture maker.

Utensils in wood, iron and bone

The early American kitchen was a treasure room for decorative objects of daily use, and nowhere was this more evident than in Pennsylvania German homes. There, characteristic floral and geometric motifs were painted on everything from small buckets to troughs where dough was covered and left to rise before baking. Every *hausfrau* had a favorite set of molds for baking such traditional holiday favorites as springerle and marzipan. Carved from hardwood so as to withstand the heat of the oven, springerle boards are divided into squares to indicate the cutting lines for the small individual cakes, whereas marzipan boards were usually designed for a single large cake. In both types of cake the dough is rolled very thin and pressed onto the board so that, when cooked, the finished cake is stamped

334. Box, carved and painted wood, 7¾″ long, c. 1830, New England. Inscribed "Rebecca. E. Lord." Collection of Bertram K. and Nina Fletcher Little.

with the design in low relief. Since the dough rises very little, the details of the design remain sharp. The cakes can be kept for months and are so hard that one grandmother of German descent was heard to remark every year that it would be just as easy to eat the board as the cakes themselves—yet she would not dream of letting Christmas pass without cooking a batch.

Pie, then as now, was an American favorite, and every good cook owned a piecrust cutter. These handy implements had a small wheel attached to a handle and were used to cut thin pastry strips for lattice-top pies; when laid on its side, the wheel could be used to flute the edges of the pie or to crimp top and bottom crusts together. Some had an added feature: a sharp tine for testing or pricking holes in the crust. Of all utilitarian scrimshaw objects, probably the most numerous were piecrust cutters, also known as pie crimpers or jagging wheels. Obviously, this simple tool was more than an exercise in skill and imagination: for the homesick sailor it must also have been a tantalizing reminder of the delights of home cooking.

The steel piecrust cutter shown here came from the forge of a particularly gifted Pennsylvania metalworker. A major contribution of Pennsylvania German blacksmiths and carpenters was the Conestoga wagon. These brightly painted covered wagons with sturdy ironclad wheels and decorative ironwork hauled most of the nation's freight and eventually developed into the prairie schooner that carried America's restless population all the way to the Pacific. The iron axe socket shown here once hung on a Conestoga wagon, and it is a fine example of a humble utilitarian object transformed into a striking sculptural design.

The most endearing—and sometimes overlooked—aspect of folk art is its humor, nowhere more apparent than in the devil bootjack or the anthropomorphic woolwinder shown here. The sailor who made the scrimshaw dipper must have chuckled when he carved the headless torso that connects the coconut-shell bowl and handle. And the nameless convict who painted the bellows indulged in an extravagant flight of fancy when he pictured himself as "American artist" in foppish attire, nonchalantly striking a pose with his palette and paintbrushes.

Tinware

Tinplate was a practical material for making pots, pans, trays, pails and all kinds of kitchen utensils, as well as lanterns and candelabra. The earliest American tinware was made in the 1700s in and around Berlin, Connecticut. At first it was undecorated, but by the time of the Revolution tin was being japanned, a technique by which colored decoration was applied over a black ground in imitation of Oriental lacquerware. Independence gave impetus to many new industries, long suppressed by the British, and Pennsylvania manufacturers began rolling tin-

335. Portable desk, painted wood, 16½″ long, c. 1825, Lancaster County, Pa. Collection of Mr. and Mrs. Samuel L. Meulendyke.

336. Knife box, painted wood, 12″ long, c. 1860, found in Connecticut. Collection of Howard and Jean Lipman.

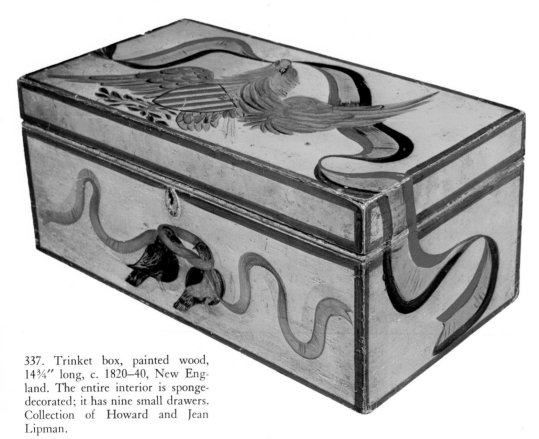

337. Trinket box, painted wood, 14¾″ long, c. 1820–40, New England. The entire interior is sponge-decorated; it has nine small drawers. Collection of Howard and Jean Lipman.

plate, using native iron and tin imported from Cornish mines. Soon tinshops, mostly family affairs, could be found all along the Eastern seaboard as far north as Maine. In the early decades of the nineteenth century tinsmiths began producing great quantities of painted and stenciled wares which they sold directly or had peddled across the countryside by hired itinerants. A single tinsmith could supply half a dozen peddlers, who often traveled more than a thousand miles on each trip. Some tinsmiths turned itinerant themselves, setting up shop for a few months each year at the farthest point of the peddlers' routes—often in the South—and making enough tinware to resupply the peddlers for their return journey north. Country tinsmiths—often called whitesmiths, as opposed to blacksmiths who worked over a sooty furnace—most often decorated their wares with brushstroke painting, which all apprentices learned. Sometimes the tinsmith's wife and daughters did the painting. The colors used were white, yellow, blue and vermilion on various grounds. Both the crooked-spout coffeepot and the cookie box shown here have a vermilion ground; yellow, cream, blue or green were sometimes used as background colors; and the most common of all was black. With these bold colors and the splashy patterns of birds, flowers and other motifs typical of Pennsylvania German decoration, the painted tinware from Pennsylvania best exemplifies the folk-art tradition.

A masterpiece of the New England tinsmith's art is the chandelier from Massachusetts—a soaring ensemble of crimped candleholders and cone-shaped snuffers on dramatically curved arms, with an even dozen cutout tin turkey reflectors clustered around the turned maple post. When the candles are lighted, the rising heat causes each turkey to turn slowly, and the huge chandelier—more than four feet in diameter—comes alive, a multimedia composition of form, light and motion.

Pottery

To supply housewives with everyday dishes, potteries sprang up wherever there was clay of suitable quality and wood to fire the kilns. From the enormous quantity of ceramics made throughout the United States during the first century of independence, two basic types are outstanding as folk art: the Pennsylvania German sgraffito and slip-decorated plates, and the blue-decorated stoneware, much of which came from New York State. A sponge-decorated earthenware pitcher from Massachusetts and an example of the grotesque whiskey jugs made in quantity by African slaves in Georgia and the Carolinas complete this selection.

Potters were among the many skilled German craftsmen who immigrated to Pennsylvania. Their most creative efforts can be seen on decorated pie plates which were often

commissioned as gifts, with an appropriate inscription and sometimes the date and name of the recipient. Sgraffito (from the Italian word for "scratch") is an age-old technique of pottery decoration in which a clay "slip" of one color is superimposed on a barely wet clay body of another color, and a design is produced by scratching through the outer coating. The Pennsylvania potters used a cream-colored slip made from clay found only in New Jersey; when incised with a sharp wooden tool, the native red Pennsylvania clay was revealed. A number of outstanding Pennsylvania potters have been identified, and examples of their work are shown here. On his horseman plate Johannes Neesz lettered in German, "I have been riding over hill and dale and everywhere have found pretty girls"—a droll comment typical of those found on such plates.

Slip decoration was another ancient technique that required a deft hand and a keen sense of calligraphic design. The design was traced with liquid slip poured from a special cup fitted with a number of goose quills. As the potter moved the slip cup across the surface of the vessel, he carefully regulated the flow through the quills, using a single quill for fine lines and lettering, and several quills to make bold, heavy lines.

Stoneware—heavy, durable, nonporous and acid-resistant—was the most practical material for butter, pickle and preserve crocks, as well as jugs and all kinds of containers for liquids. Stoneware was manufactured in New York State, at the famous potteries in Bennington, Vermont, and scattered kilns in New Jersey, Massachusetts, Ohio and Illinois—some of the western ones having been set up by pioneering potters from New York. Stoneware clay came from New Jersey, was gray or tan in color and, unlike the red clay used for much American pottery, it became hard and glossy when fired at high temperatures. To increase its watertightness, stoneware was given a salt glaze during the firing. When common salt was thrown into a hot kiln, it vaporized into a gas, settled on the vessels and bonded chemically with the clay, producing a transparent, pleasantly pebbly glaze. Besides its hardness, salt glaze had the great advantage of being nontoxic, unlike the tin and lead glazes commonly used at the time.

The shapes of these functional stoneware vessels have a classic simplicity. They were thrown on a wheel and came in a full range of sizes, from one to as many as twenty-five or thirty gallons. It required enormous skill to fashion the larger vessels, which were often made by a master potter who traveled a regular annual circuit from one pottery to another. This may account for similar decorations on stoneware from different manufacturers. Master potters were usually master decorators as well, and some of the most exciting designs appear on the larger vessels that were their specialty.

The characteristic blue color of the decoration was pro-

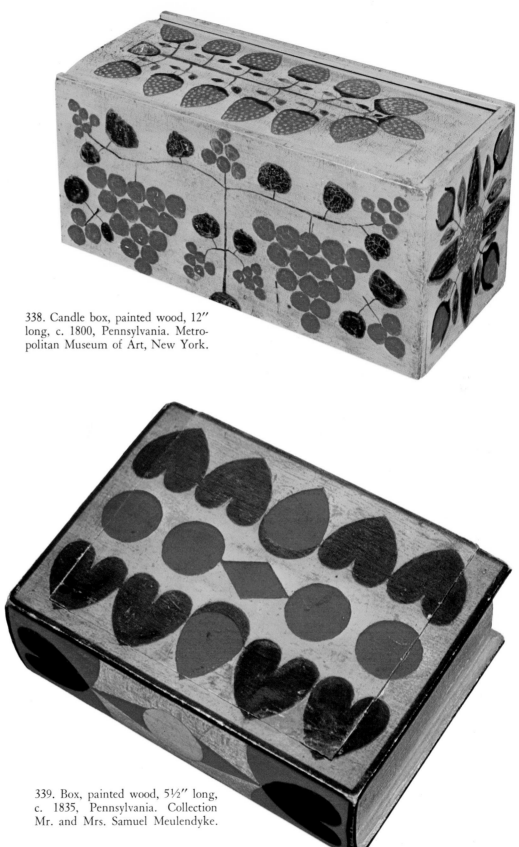

338. Candle box, painted wood, 12″ long, c. 1800, Pennsylvania. Metropolitan Museum of Art, New York.

339. Box, painted wood, 5½″ long, c. 1835, Pennsylvania. Collection Mr. and Mrs. Samuel Meulendyke.

duced by adding cobalt powder to the slip, which was then applied with a slip cup or a brush, or both, and sometimes a design was incised in the wet clay and filled in with color. The manufacturer's name was usually stamped on the vessel or stenciled in the same blue slip, and there might be a painted numeral, indicating the capacity. Most of the decorations have a free, informal quality, as if dashed off by the potter for pleasure. A more formal piece, like the churn with a circus horse and acrobat, recalls the elaborate calligraphic pictures that were something of a fad in the latter half of the nineteenth century. It is known that some New York potters were inspired by the famous handwriting manual developed by their fellow New Yorker, Platt Roger Spencer.

Fabrics

In her hooked rugs, tablecloths and bedcovers, the American woman not only performed incredible feats of needlework but exhibited a brilliant sense of color and design that has brought her the tardy recognition of today's graphic designers and abstract painters.

Winters were cold and fabrics in short supply in the New World. To make warm bedcovers, thrifty housewives saved scraps of worn-out garments, sewed them together in pleasing patterns, attached the top to a backing of sturdy material with a thin padding of cotton and wool in between, and joined the three layers with tiny stitches to produce the quilting. The "patchwork" quilt was an early form of recycling, raised to the level of an art; collectively, early-American quilts form a "museum without walls" of old fabrics—chintzes, percales, muslins, calicoes, sometimes silks and velvets, in every conceivable color and printed design. Sometimes fabrics were saved for a generation before they were used, and thus a single quilt might incorporate textiles of different periods. Sometimes a woman spent years on a single quilt, piecing into it fabrics with highly personal associations: a scrap of Mamma's wedding dress, a bit of calico brought from the Orient by Uncle Jared in his clipper ship, those curtains she put up when she was first married, and so on. Some quilts were souvenirs of important public events: in 1858 Austin Ernest, a local politician in Paris, Illinois, organized a rally for the new Republican party's Presidential candidate, Abraham Lincoln. Mrs. Ernest, perhaps sensing that they had been visited by one of the immortals, saved the material used to decorate the stand from which Lincoln spoke and made it into a quilt.

Mrs. Ernest's quilt is an example of the pieced type of patchwork quilt, so called because it is made up of fabric precut into small geometric shapes and pieced together in larger blocks, which in turn were sewn together to make a bedcover eight to nine feet long and about eight feet wide.

Pieced quilts generally have overall geometric designs based on the repetition of a single pattern. The success of the quilt depended on the maker's choice of colors and their juxtaposition within the total design. Some of the most striking pieced quilts produce a bold, optical effect not unlike the canvases of today's op artists.

The other technique commonly used in patchwork bedcovers is appliqué: each element of the design is cut out, its edges carefully turned, as in making a hem, and stitched to a plain backing with a fine hemming stitch or a buttonhole stitch. Some of the most elaborate bedcovers, such as the early village scene by Sarah Furman Warner of Greenfield Hill, Connecticut, are appliquéd. Appliqué quilts were also made in blocks: in some, identical motifs are repeated throughout; in others, called album quilts, no two blocks are the same. Album quilts, also known as friendship quilts, were often group efforts, each block made by a different woman and assembled into a quilt intended as a gift for a special occasion: an engagement, a young man's twenty-first birthday (in which case it was known as a freedom quilt), a farewell to the local minister when he left for another church. The Thirty-two Birds quilt shown here was a fund-raising project by the women of a Maryland family, who made it during the Civil War and sold it to aid Confederate soldiers.

Many pieced and appliqué quilts were made according to patterns or motifs that sprang up in infinite variety throughout the country, their colorful names a reflection of momentous historical events, local pride, native flora and fauna, popular literature, the Bible, frontier life and simple country humor. Thus we have Lincoln's Platform, Rocky Road to Kansas, North Carolina Rose, Turkey Tracks, Caesar's Crown, Log Cabin, Courthouse Square, Drunkard's Path, to name but a few. Some patterns had their origins in Europe: the Princess Feather was said to have come from Northumberland, England, inspired by the sweeping plumes of the Cavaliers; Pennsylvania quilts often feature the tulip, one of the most common motifs in the distinctive design repertory imported from the German-speaking lands of Europe.

Patterns were passed down from mother to daughter and circulated from one household to another. Although some regional and group traditions can be identified—the Amish, for example, tended to use strong, vibrant colors in their quilts—most motifs traveled far and wide across the country as its inhabitants moved on to populate each new frontier area. Subtle variations were invented, each with a new name. Thus when the eight-pointed Star of Le Moyne had two of its points replaced by a stem and leaves, it became a Cactus Rose, illustrated here in a combination pieced and appliqué quilt from Pennsylvania. Star of Le Moyne, incidentally, was named for the two Frenchmen who colonized Louisiana, and the name itself, as well as

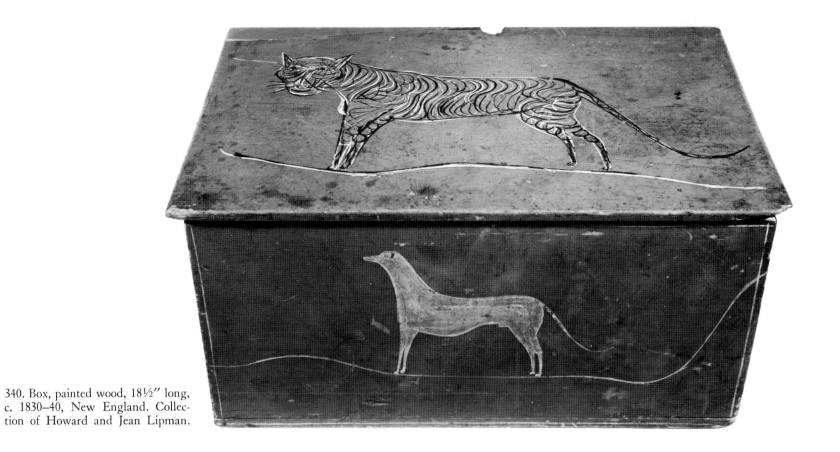

340. Box, painted wood, 18½″ long, c. 1830–40, New England. Collection of Howard and Jean Lipman.

341. Lectern box, carved and painted wood, 19½″ long, c. 1860–75, New England. Inscribed "P. F. Coist"; book "opened" to poem "The Book of Liberty." Collection of Stewart E. Gregory.

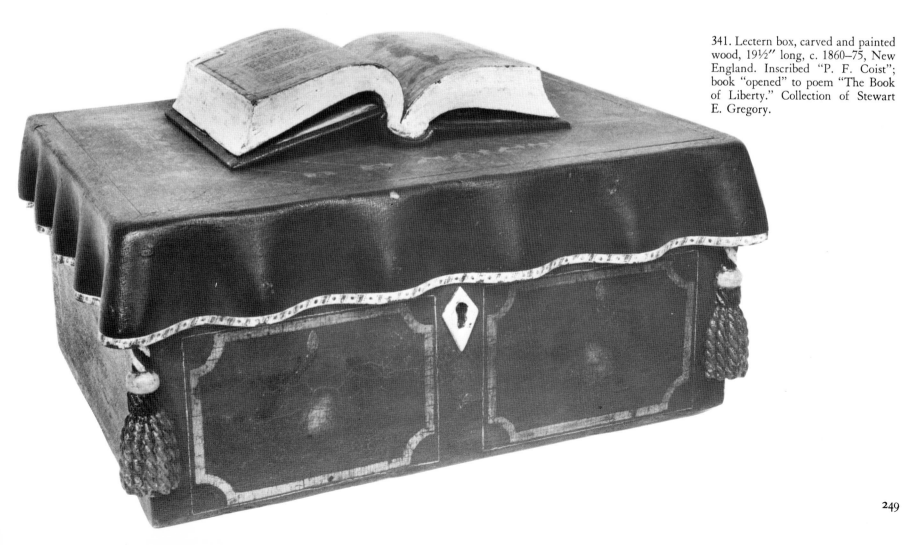

342. Scrimshaw ditty box, engraved baleen, 6¾″ long, c. 1850, New England. Collection of William Pearson.

the pattern, was transformed as it spread across the land, becoming in the northern states an anglicized Lemon Star.

Particularly talented women originated their own designs or created pictorial quilts like several of those shown here. The wedding quilt uses a traditional House pattern to which scenes of daily life are added, and in the large central panel the simple house is transformed into a village church with the preacher waiting in the doorway for the wedding party. The maker of the Land and Sea quilt employed a technique known as *broderie perse* in the central panel, which is occupied by a large appliqué cut from imported English chintz of Oriental design. The border presents lively vignettes of life on the farm and highway and a procession of ships awash on a sea of gaily printed fabric. The woman who designed the Bird of Paradise bride's coverlet must have been as skilled with scissors as with the needle. Her magnificent assemblage of appliquéd birds, flowers, animals and human figures recalls the paper cutouts shown earlier in this book.

Quilting added an extra dimension in warmth as well as in appearance, and quilting designs were sometimes as intricate as the pieced or appliqué top. In the Eagle's Nest quilt, the bold appliqué design is complemented by elaborate quilting done in wavy lines and circular patterns that resemble hex signs: the three-dimensional effect of the quilting is further enhanced by padded cherries and five tiny padded eggs. Elaborate quilting patterns, such as wheels or feathers, were often cut from mill-net, an open-mesh fabric rather like cheesecloth, stiffened with glue or starch. These patterns were pinned to the quilt top and traced with pencil, chalk or dry soap. Quilting was done on a large rectangular wooden frame over which the quilt could be pulled taut and gradually rolled up as the work progressed.

From the farms of New England to the scattered homesteads of the Midwestern prairies and beyond, generations of women found quilt making a welcome occupation. Looking back on her life on the farm, one Midwestern grandmother commented, "I would have lost my mind if I had not had my quilts to do!" If the piecing together of the design was individual therapy, a form of nineteenth-century group therapy was provided by the quilting bee, when the quilting was done by a group of women who turned the work into an excuse for a gay social event. A well-known painting, shown earlier, captures the merriment of such an occasion when all the neighbors crowded into the parlor, the men talking politics and business, the children playing and the women gossiping over the quilting frame. The bee was a popular winter pastime, a day-long affair that culminated in a great dinner and perhaps some song and dance.

Among the bedspreads illustrated here are examples of other popular decorative techniques, such as embroidery and stenciling. Stenciling was also extensively used on

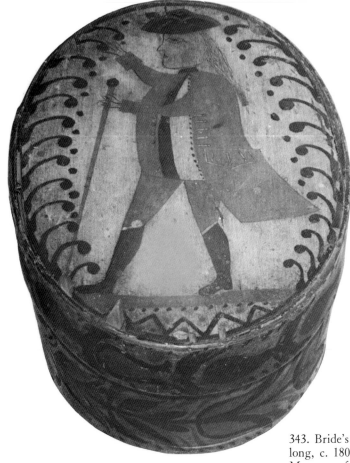

343. Bride's box, painted wood, 16″ long, c. 1800, Pennsylvania. Mercer Museum of the Bucks County Historical Society, Doylestown, Pa.

other household linens, such as tablecloths. The appliqué and embroidery table cover, simulating a fully set table with plates, silverware and a centerpiece of fruit, is a unique creation by a member of the Schwenkfelder religious sect of Pennsylvania Germans.

Floors needed covering too, and here again American women provided their families with handsome homemade products. The bold, geometric rug found in Maine is a subtle combination of light blue, rusty yellow and dark green multi-ply yarns that were sewn onto a linen foundation with short running stitches and then clipped to produce a soft pile. This type of yarn-sewn rug was superseded in the early nineteenth century by the more durable hooked rug, another example of artful recycling. Worn-out clothes—most often wool—were cut into long strips that were then drawn with a metal hook, from back to front, through a coarse foundation such as linen or burlap. Each strip was looped on the surface of the rug, then carried along flat on the reverse side and pulled through again to form another loop, and so on. The looped fabric could be left as it was or clipped, sometimes at different heights, producing a sculptured effect.

It is fitting to end this book (on page 279) with the carpet completed in 1835 by Zeruah Higley Guernsey, a young woman of Castleton, Vermont. Zeruah sheared the wool from her father's sheep; spun it into yarn; dyed it herself with homemade dyes, many of them concocted from native plants, barks and berries; and, using a chain stitch, embroidered it on coarse homespun squares, each in a different design. It was a full two years before the squares were sewn together and the rug completed, in time for her marriage, which is anticipated in the central scene. The Caswell carpet—so called because Zeruah Guernsey was subsequently widowed and remarried to a Mr. Caswell—might be called the Bayeux Tapestry of American needlework, so extraordinary is its craft and so brilliant its design. Each of its eighty-odd individual squares is a miniature masterpiece of American folk art.

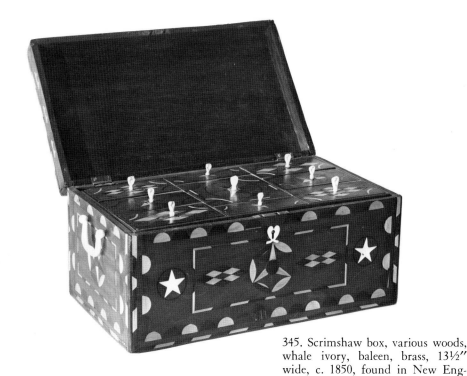

345. Scrimshaw box, various woods, whale ivory, baleen, brass, 13½″ wide, c. 1850, found in New England. Collection of Barbara Johnson.

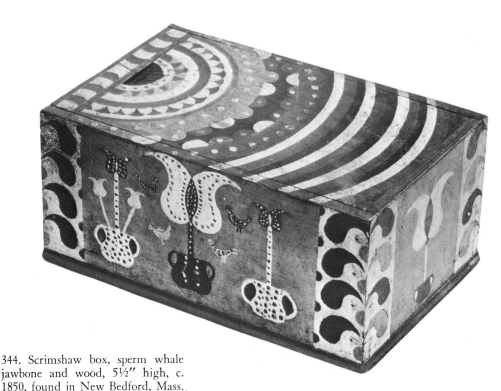

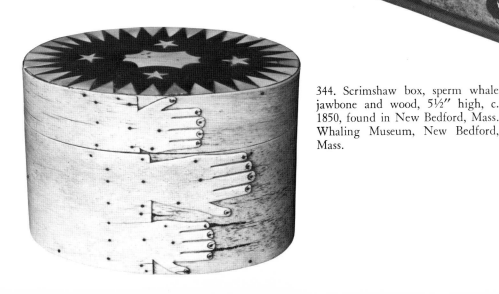

344. Scrimshaw box, sperm whale jawbone and wood, 5½″ high, c. 1850, found in New Bedford, Mass. Whaling Museum, New Bedford, Mass.

346. Candle box, painted wood, 16″ long, c. 1825, Pennsylvania. Formerly collection of Randolph R. Urich.

347. Picture frame, stenciled wood, 6¾ x 5¼″, c. 1825, New England. Collection of Bertram K. and Nina Fletcher Little.

348. Anson Clark, picture frame, stenciled wood, 13¾ x 11⅞″, c. 1825, West Stockbridge, Mass. Collection of Bertram K. and Nina Fletcher Little.

349. Box, painted and stenciled wood, 18⅛″ wide, c. 1830, probably New England. Collection of Herbert W. Hemphill, Jr.

350. Picture frame, painted wood, 5 x 3⅞″, c. 1835, found in New York. Gerald Kornblau Gallery, New York.

351. Mirror, painted and stenciled wood, brass ring, 12 x 9″, c. 1830, probably New England or New York. Collection of Howard and Jean Lipman.

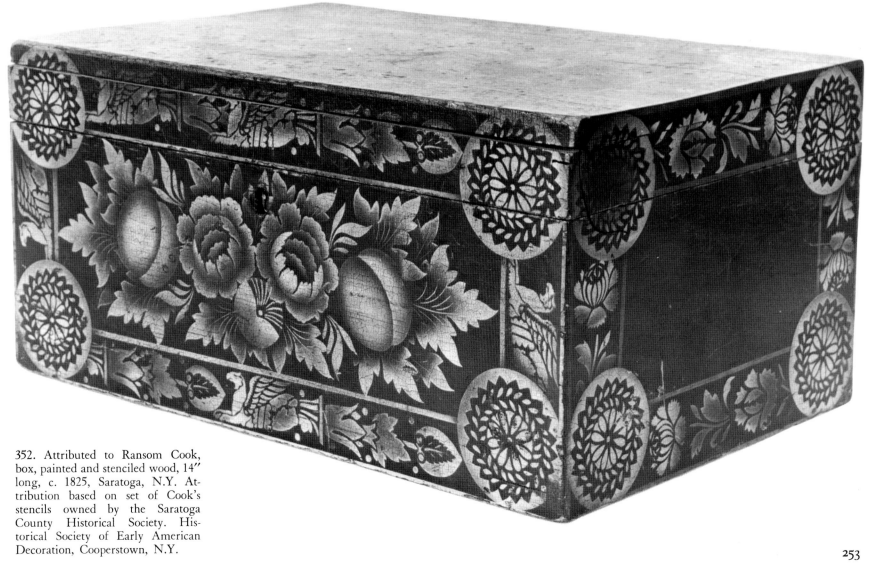

352. Attributed to Ransom Cook, box, painted and stenciled wood, 14″ long, c. 1825, Saratoga, N.Y. Attribution based on set of Cook's stencils owned by the Saratoga County Historical Society. Historical Society of Early American Decoration, Cooperstown, N.Y.

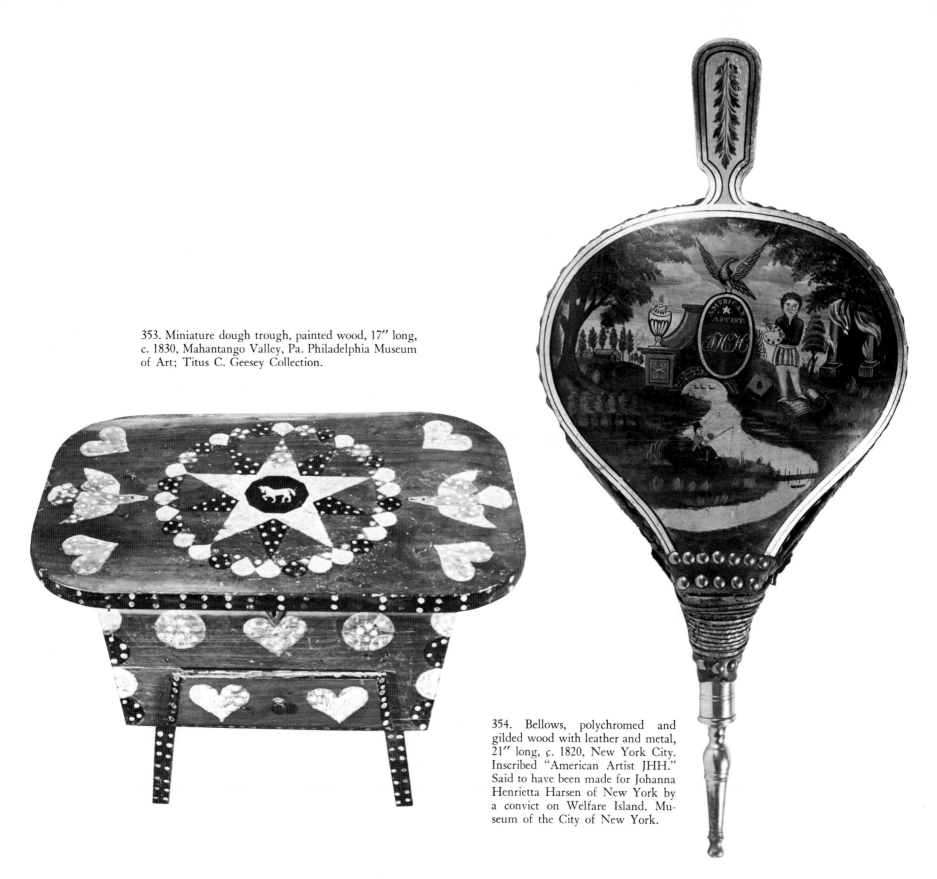

353. Miniature dough trough, painted wood, 17″ long, c. 1830, Mahantango Valley, Pa. Philadelphia Museum of Art; Titus C. Geesey Collection.

354. Bellows, polychromed and gilded wood with leather and metal, 21″ long, c. 1820, New York City. Inscribed "American Artist JHH." Said to have been made for Johanna Henrietta Harsen of New York by a convict on Welfare Island. Museum of the City of New York.

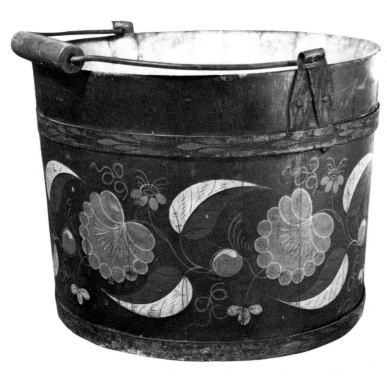

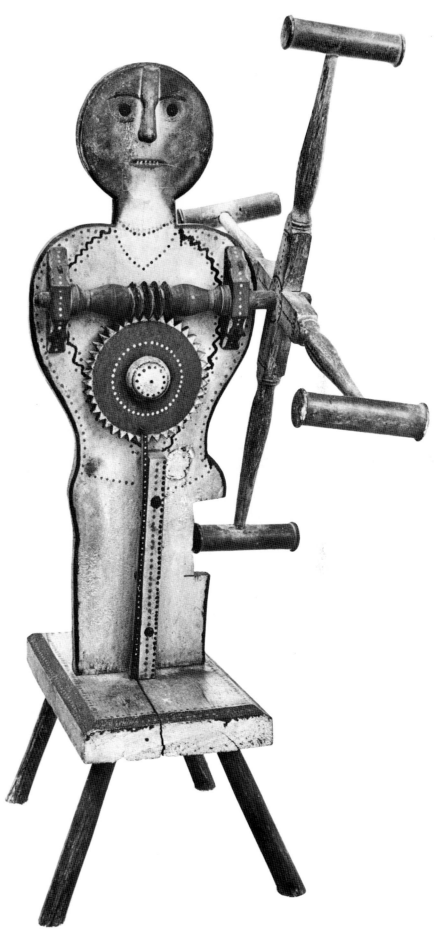

355. Bucket, painted wood with metal fittings, 10″ high, c. 1825, Pennsylvania. Formerly collection of Titus C. Geesey.

356. Woolwinder, painted wood, 39″ high, c. 1875, Connecticut. Collection of Howard and Jean Lipman.

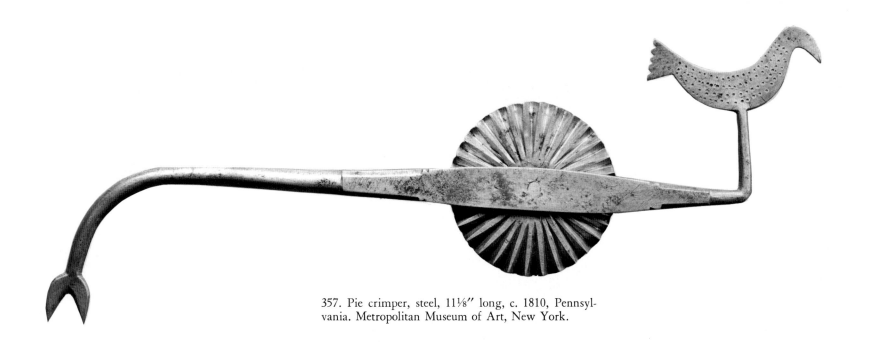

357. Pie crimper, steel, 11⅛″ long, c. 1810, Pennsylvania. Metropolitan Museum of Art, New York.

358. Scrimshaw pie crimper, whale ivory, 6″ long, c.
1850, New Bedford, Mass. Whaling Museum, New
Bedford, Mass.

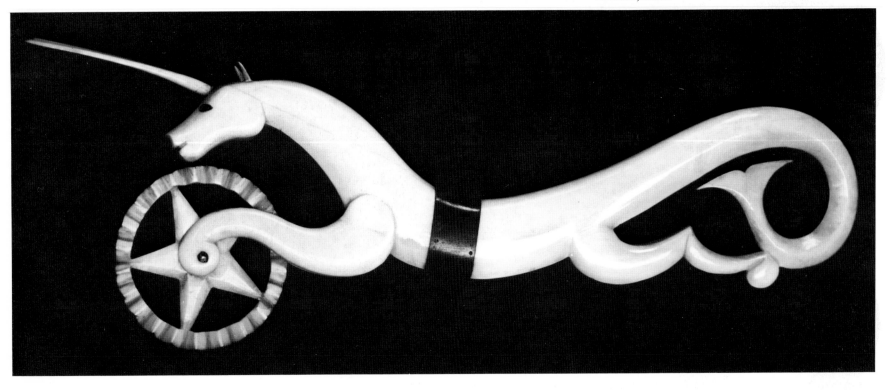

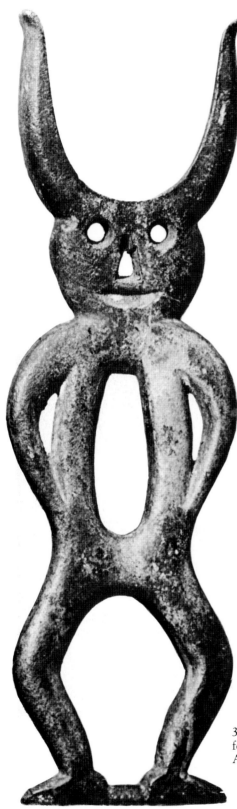

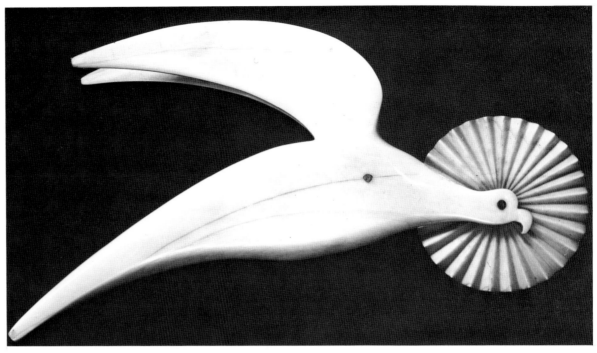

360. Scrimshaw pie crimper, whale ivory, 6″ long, c. 1850, New Bedford, Mass. Whaling Museum, New Bedford, Mass.

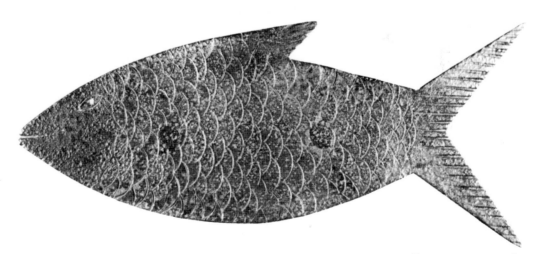

361. Axe socket, incised iron, 8¼″ long, c. 1800, York County, Pa. Cincinnati Art Museum, Cincinnati, Ohio.

359. Bootjack, painted cast iron, 10½″ high, 1850–75, found in Massachusetts. Abby Aldrich Rockefeller Folk Art Collection, Williamsburg, Va.

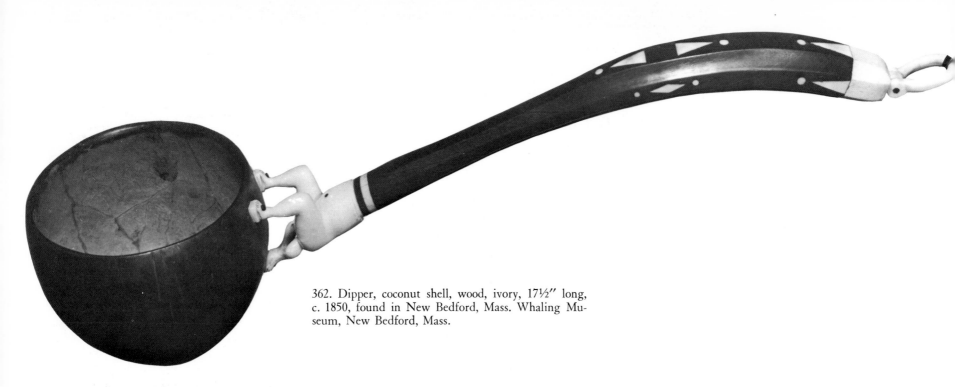

362. Dipper, coconut shell, wood, ivory, 17½″ long, c. 1850, found in New Bedford, Mass. Whaling Museum, New Bedford, Mass.

363. Cakeboard, *Fire Engine Superior*, carved wood, 14½″ long, c. 1800, Pennsylvania. New-York Historical Society, New York.

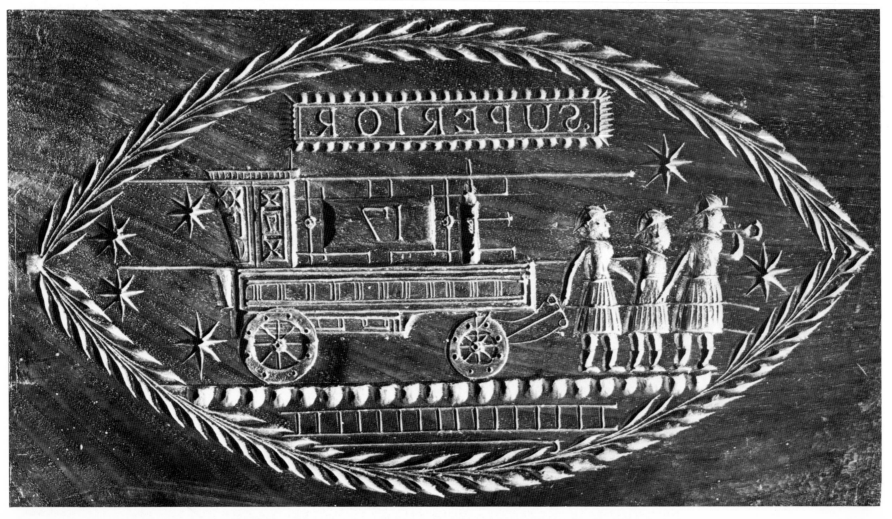

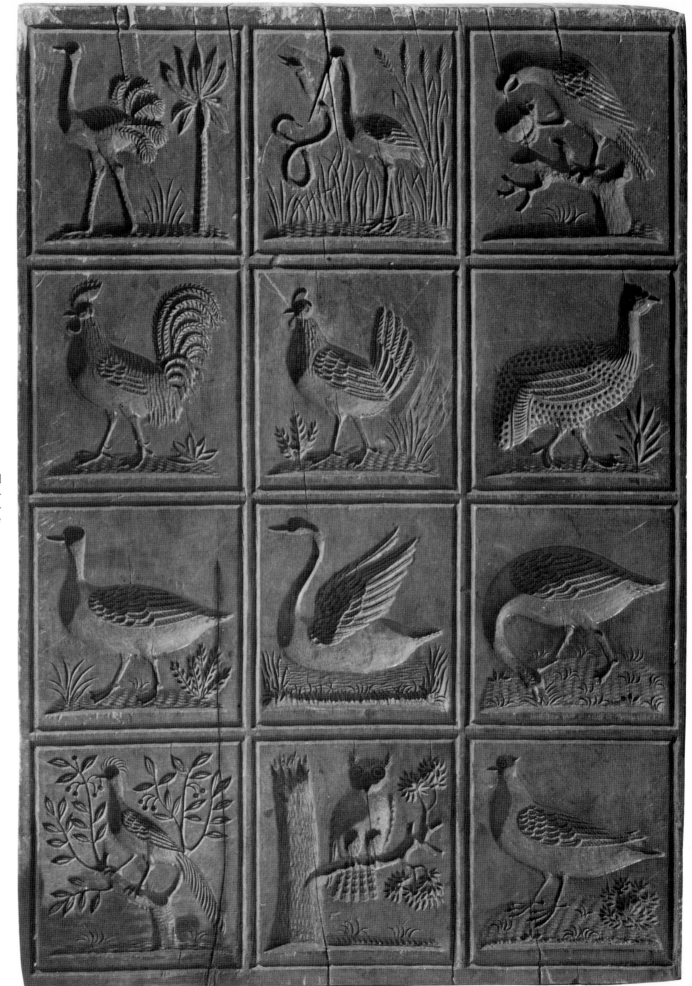

364. Springerle mold, carved wood, 8″ high, 1843, Pennsylvania. Philadelphia Museum of Art; Titus C. Geesey Collection.

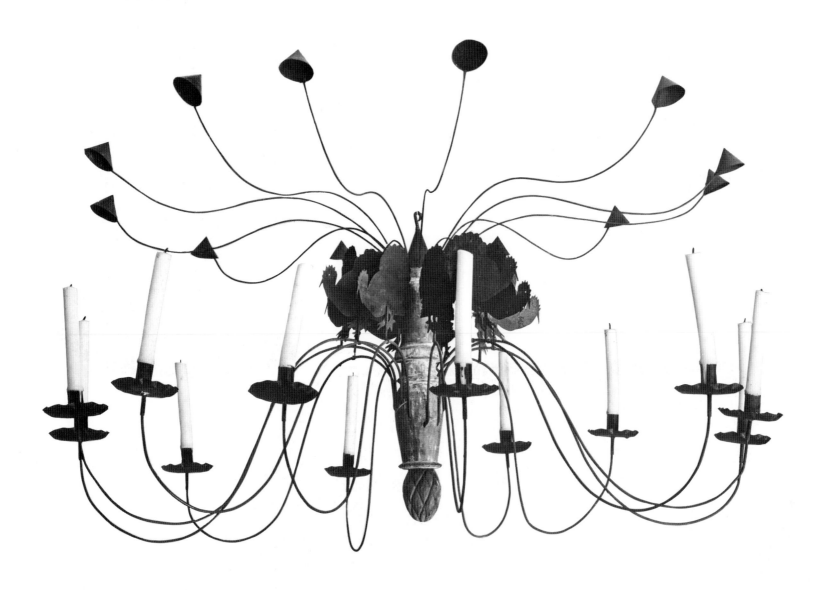

365. Chandelier, tin, wood, iron, 48″ wide, c. 1800, found in Massachusetts. Collection of Mr. and Mrs. John Gordon.

366. Cookie box, painted tin, 10″ wide, c. 1825, Pennsylvania. Collection of Marie G. Ljungquist.

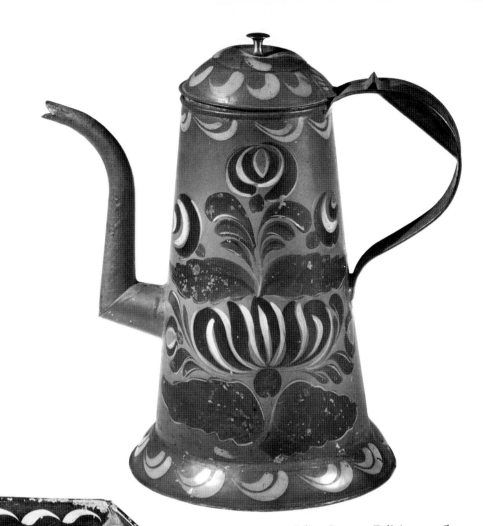

367. James Fulivier, coffeepot, painted tin, 10½″ high, c. 1825, Pennsylvania. Signed on bottom "James Fulivier 75 cts is the price of this"; also inscribed "Jared H. Young." Henry Ford Museum, Dearborn, Mich.

368. Tray, painted and stenciled tin, 8½ x 12″, c. 1825, Pennsylvania. Reading Public Museum and Art Gallery, Reading, Pa.

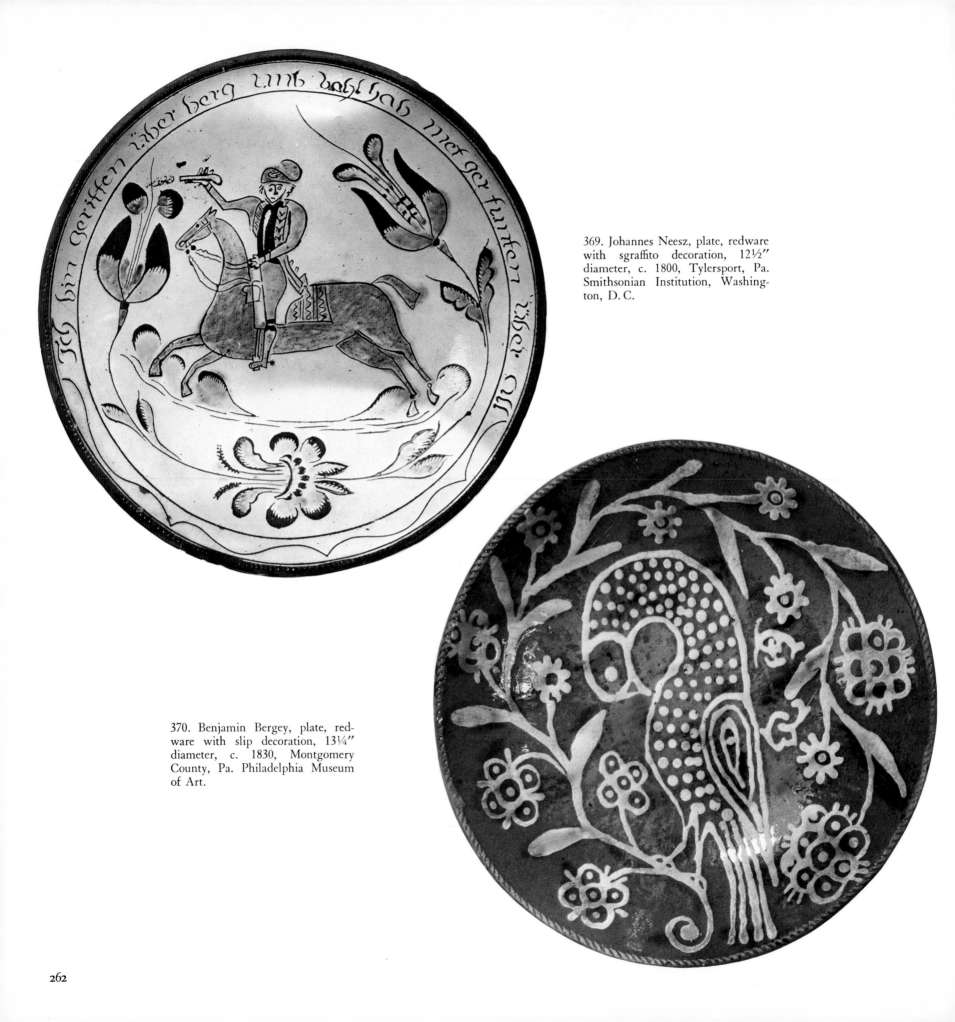

369. Johannes Neesz, plate, redware with sgraffito decoration, 12½″ diameter, c. 1800, Tylersport, Pa. Smithsonian Institution, Washington, D. C.

370. Benjamin Bergey, plate, redware with slip decoration, 13¼″ diameter, c. 1830, Montgomery County, Pa. Philadelphia Museum of Art.

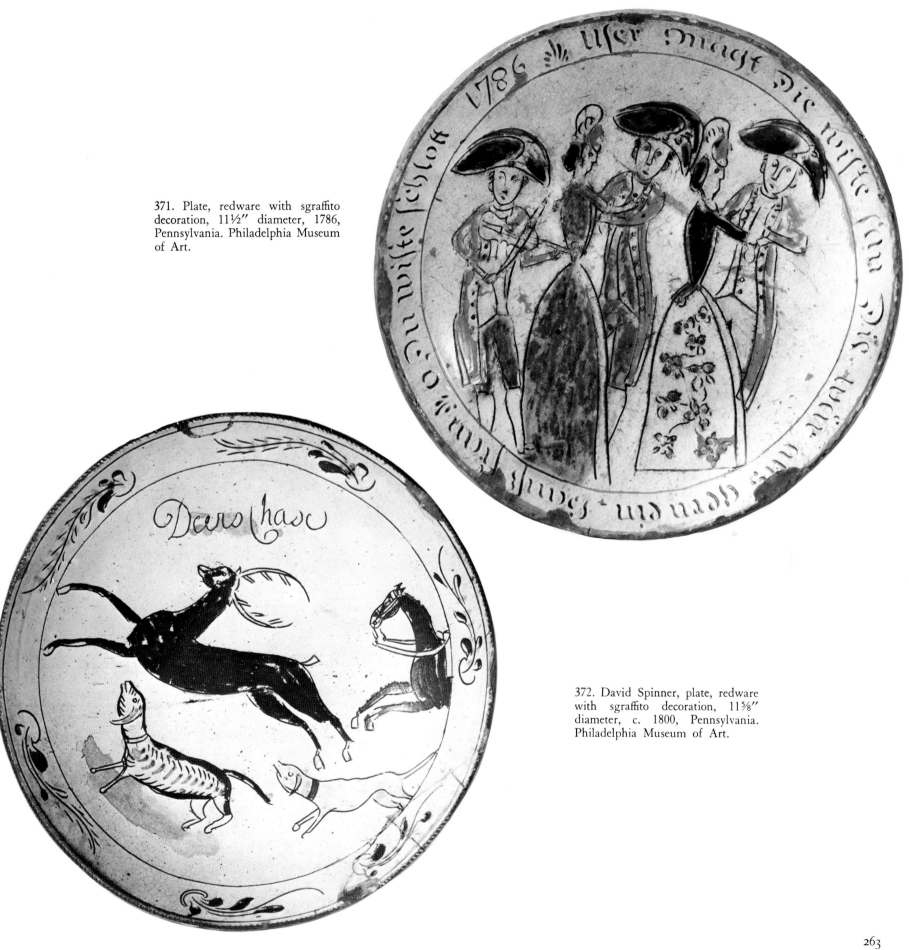

371. Plate, redware with sgraffito decoration, 11½″ diameter, 1786, Pennsylvania. Philadelphia Museum of Art.

372. David Spinner, plate, redware with sgraffito decoration, 11⅝″ diameter, c. 1800, Pennsylvania. Philadelphia Museum of Art.

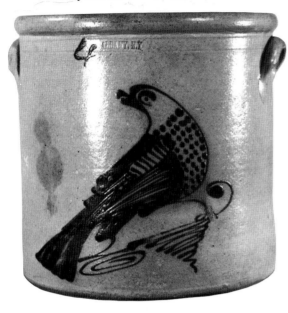

373. Crock, salt-glazed stoneware, cobalt decoration, 11½″ high, c. 1840, stamped "Albany, N.Y." New York State Historical Association, Cooperstown.

374. Cask, salt-glazed stoneware with incised and cobalt decoration, 12″ high, 1825, probably Clark Pottery, Athens, N.Y. Inscribed "Mr Oliver Gridley Newburgh July 9th 1825." Collection of John P. Remensnyder.

375. Churn, salt-glazed stoneware with incised and cobalt decoration, 13″ high, c. 1850–75, probably New York or New England. Inscribed "James Alexander." Henry Ford Museum, Dearborn, Mich.

376. Jug, salt-glazed stoneware, cobalt decoration, 10¾″ high, c. 1830, northern New York. New York State Historical Association, Cooperstown.

377. Jug, salt-glazed stoneware, cobalt decoration, 23″ high, 1850–59, Bennington, Vt. Stamped "J & E Norton Bennington Vt"; inscribed "James A. Gregg." Gregg was a thrower at the pottery. Bennington Museum, Bennington, Vt.

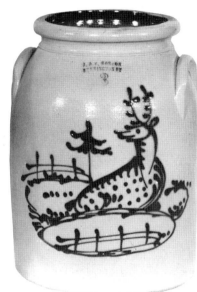

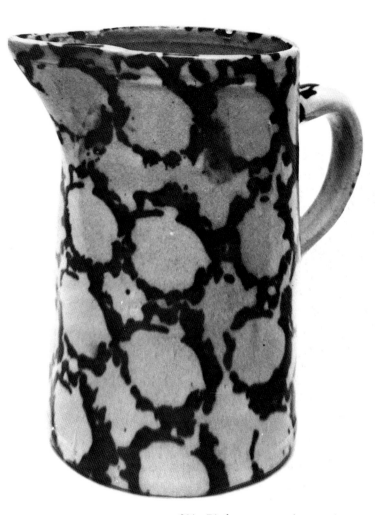

381. Pitcher, sponge-decorated pottery, 9″ high, c. 1875, Cape Cod, Mass. Collection of Howard and Jean Lipman.

378. Crock, salt-glazed stoneware, cobalt decoration, 13¼″ high, 1850–59, Bennington, Vt. Stamped "J & E Norton Bennington Vt." Bennington Museum, Bennington, Vt.

LEFT: 379. Whiskey jug, redware with glazed detail, 6″ high, c. 1860, Georgia or the Carolinas. Collection of Mr. and Mrs. Peter H. Tillou.

RIGHT: 380. Crock, salt-glazed stoneware, cobalt decoration, 13½″ high, c. 1840, Lyons, N.Y. Stamped "F [or J] Harrington Lyons." New York State Historical Association, Cooperstown.

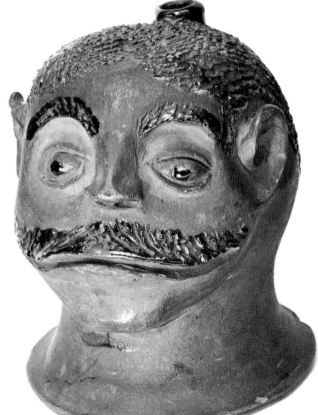

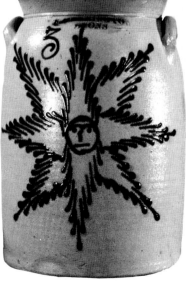

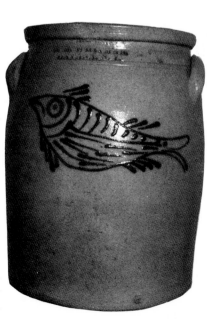

382. Crock, salt-glazed stoneware, cobalt decoration, 9″ high, c. 1840, Havana, N.Y. Stamped "— — Whitman Havana, N.Y." New York State Historical Association, Cooperstown.

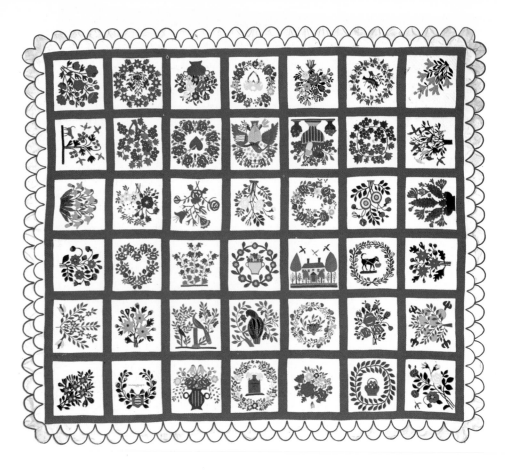

383. Anna Putney Farrington, album quilt, appliqué, cotton, 100 x 98″, 1857, Katonah, N.Y. Collection of Cora Ginsburg.

385. Thirty-two Birds quilt, appliqué, calico, 101 x 98″, c. 1865, Maryland. Shelburne Museum, Shelburne, Vt.

384. Quilt, appliqué, cotton, 100 x 88½″, c. 1850, Pennsylvania. Privately owned.

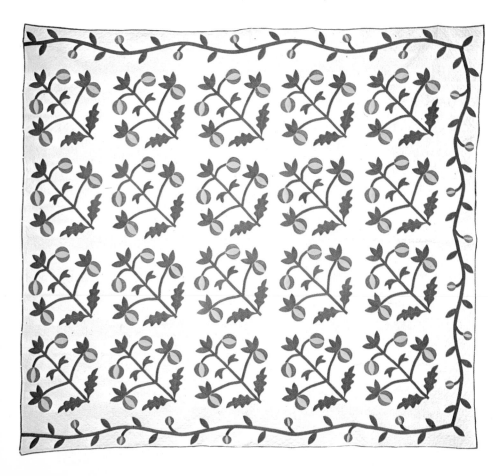

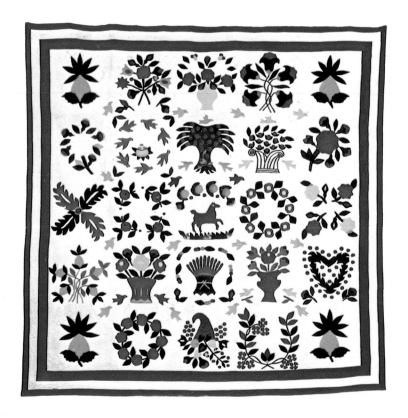

OPPOSITE: 386. Sarah Furman Warner, Greenfield Hill coverlet, appliqué and embroidery, cotton, 105 x 84″, c. 1800–15, Greenfield Hill, Conn. Henry Ford Museum, Dearborn, Mich.

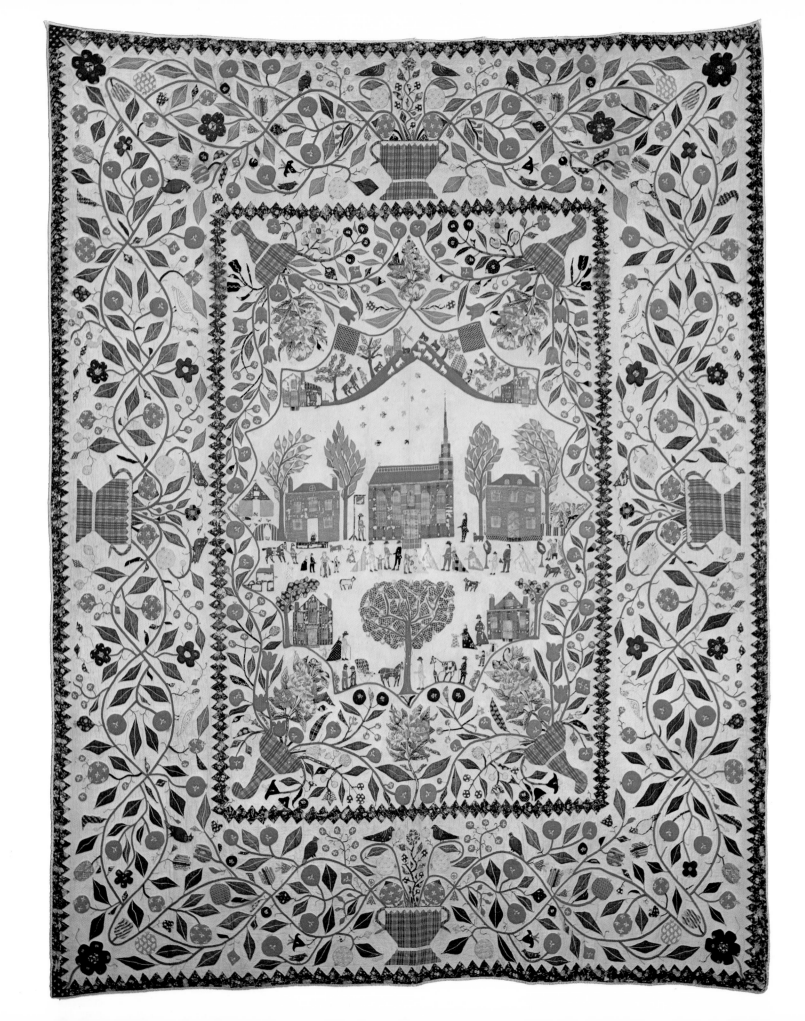

387. Mary Van Voorhis, Eagle's Nest quilt, appliqué, cotton, 104 x 82″, c. 1850, Pennsylvania. San Antonio Museum Association, San Antonio, Tex.

388. Premella Goodall, coverlet, embroidery, wool yarn on wool, 98½ x 88″, c. 1790, Buffalo, N.Y. Henry Ford Museum, Dearborn, Mich.

389. Summer coverlet, appliqué, cotton on muslin, 86 x 86″, c. 1830, Pennsylvania. Henry Ford Museum, Dearborn, Mich.

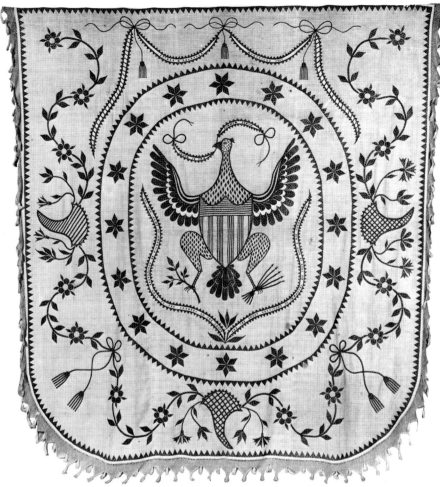

391. Esther S. Bradford, coverlet, appliqué and embroidery, cotton on linen, 94 x 81½", 1807, Montville, Conn. Henry Ford Museum, Dearborn, Mich.

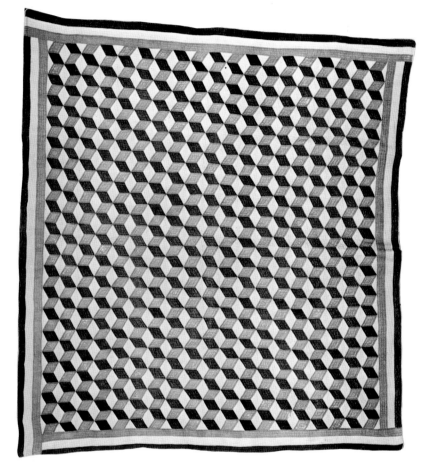

390. Mrs. Austin Ernest, Blocks quilt, pieced, cotton and linen, 88 x 82", c. 1858, Illinois. Made from material used to decorate stand from which Lincoln spoke in Paris, Ill., in 1858; Mr. Ernest was on reception committee for Lincoln. Chicago Historical Society.

392. Elizabeth Ann Cline, Steeplechase quilt, pieced, percale and calico, 81 x 69", 1865, Denver, Colo. Denver Art Museum.

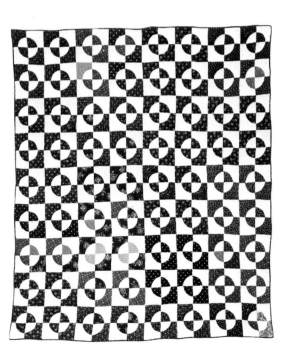

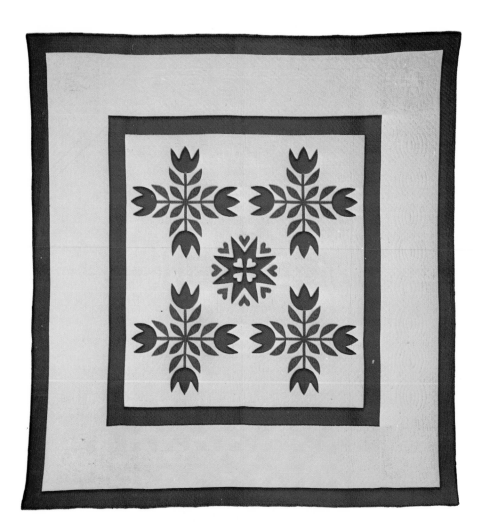

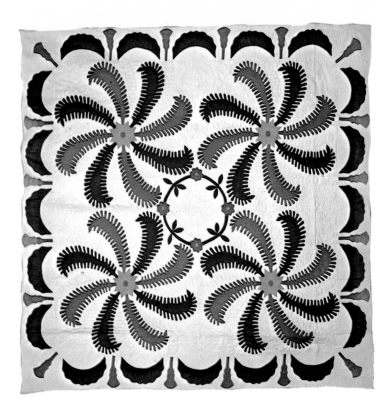

394. Princess Feather quilt, appliqué, cotton on muslin, 94 x 83", c. 1825–50, possibly Pennsylvania. Shelburne Museum, Shelburne, Vt.

393. Tulip quilt, appliqué, cotton, 89½ x 85¼", c. 1875, Pennsylvania. Collection of Mr. and Mrs. Leonard Balish.

395. Cactus Rose quilt, pieced and appliqué, cotton, 84 x 83", c. 1875, Pennsylvania. Rhea Goodman, Quilt Gallery, New York.

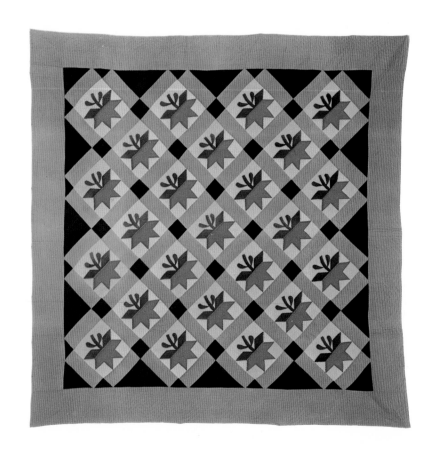

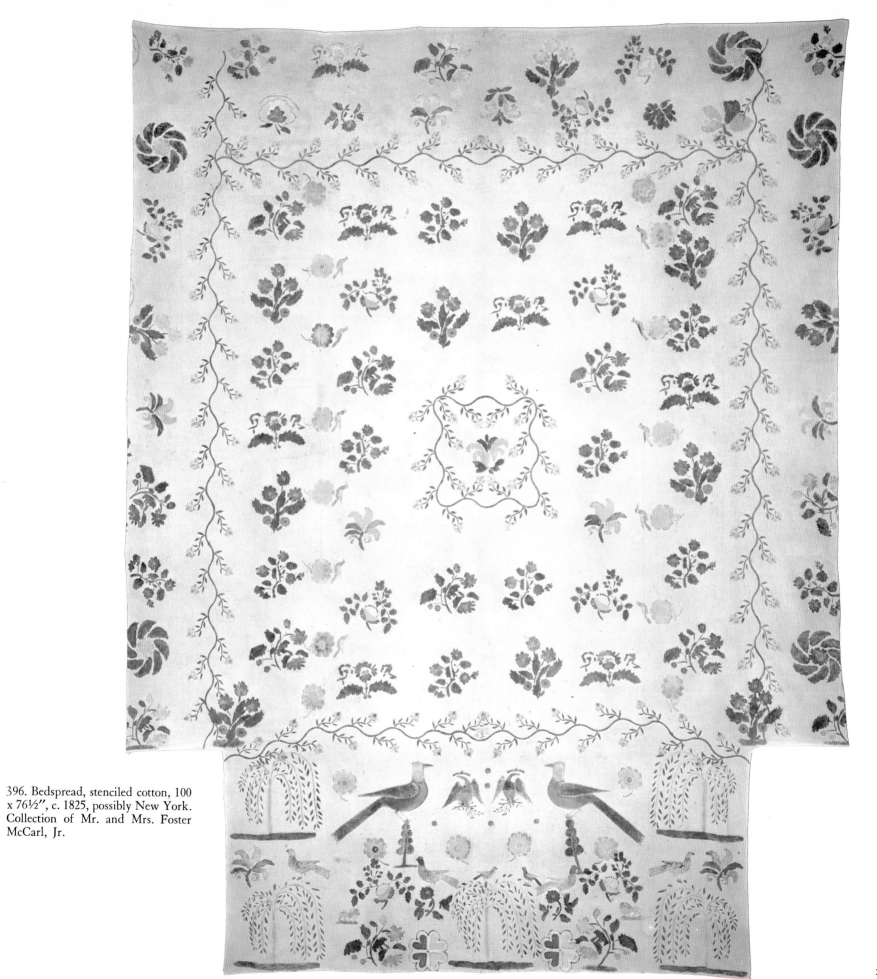

396. Bedspread, stenciled cotton, 100 x 76½″, c. 1825, possibly New York. Collection of Mr. and Mrs. Foster McCarl, Jr.

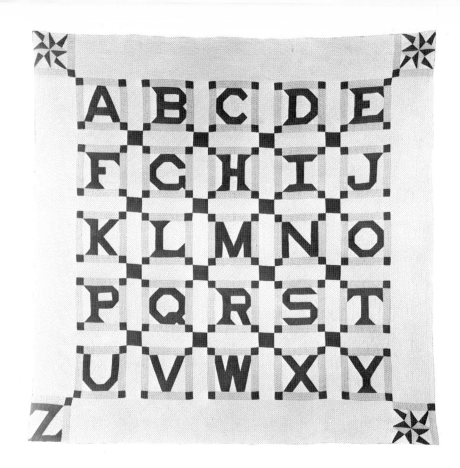

397. Alphabet quilt, pieced and appliqué, cotton, 80½ x 80", c. 1875, found in Berks County, Pa. Collection of Mr. and Mrs. Peter P. Nitze.

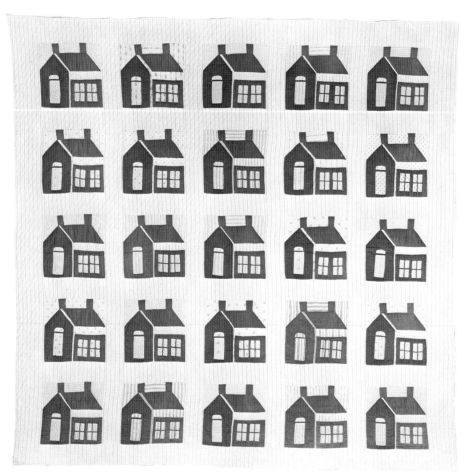

398. House quilt, appliqué, cotton, 82 x 79", c. 1875, Pennsylvania. Privately owned.

OPPOSITE: 399. Wedding quilt, pieced, appliqué and embroidery, cotton, approximately 80 x 80", 1876, found in Vermont. Formerly collection of Mrs. Clarence C. Wells.

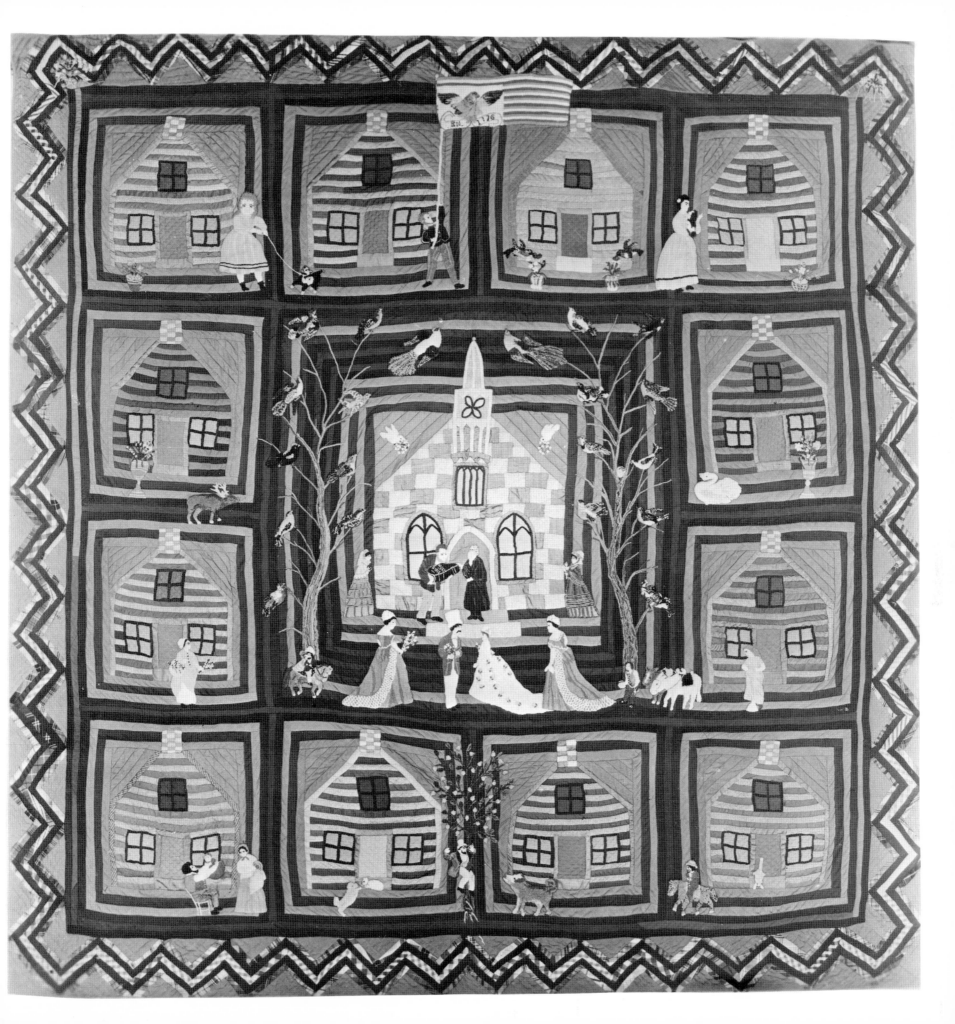

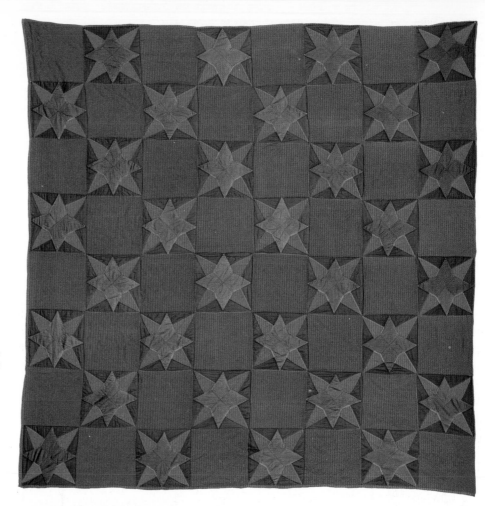

400. Quilt, pieced, polished cotton, 74½ x 72½″, c. 1875, Pennsylvania (Amish). Collection of George E. Schoellkopf.

401. Bars quilt, pieced, wool, 83½ x 69½″, c. 1870, Pennsylvania (Amish). Collection of Jonathan Holstein and Gail van der Hoof.

OPPOSITE: 402. Bird of Paradise bride's coverlet, appliqué, cotton, silk, wool and velvet on cotton muslin, 87 x 71½″, 1858–63, near Poughkeepsie, N.Y. Unquilted, unbacked, apparently never finished; dated from patterns for appliqués cut from newspapers. Collection of John E. Bihler and Henry S. Coger.

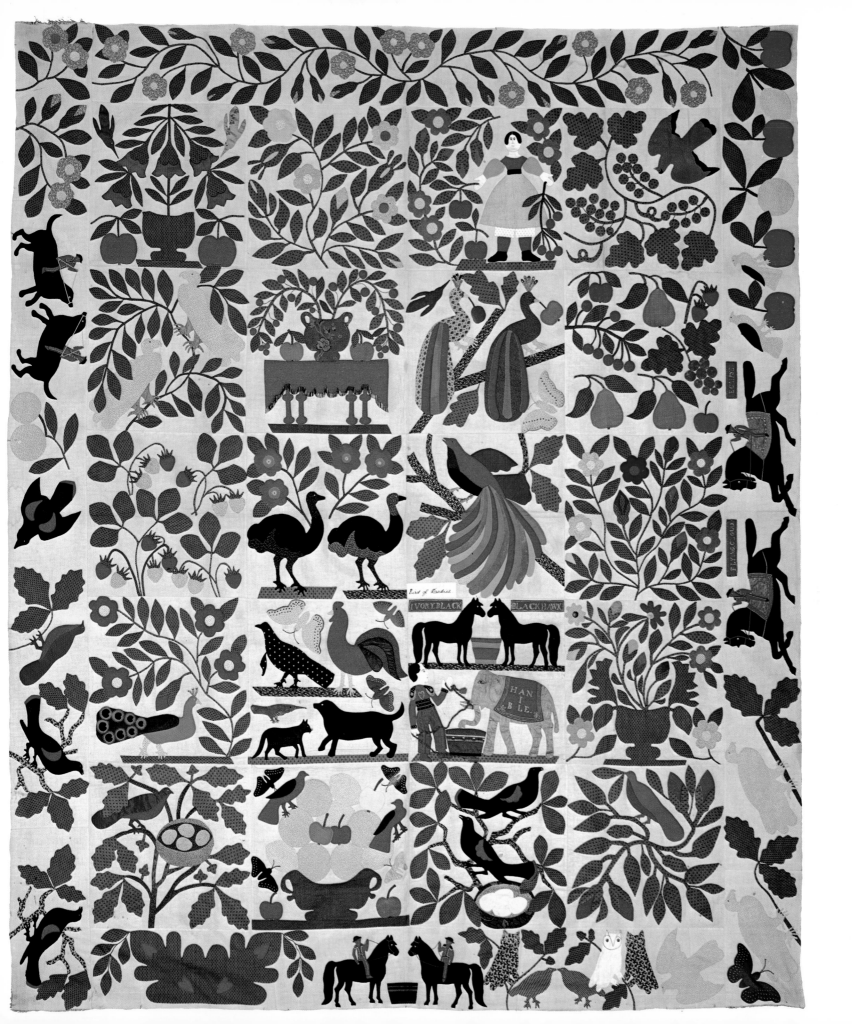

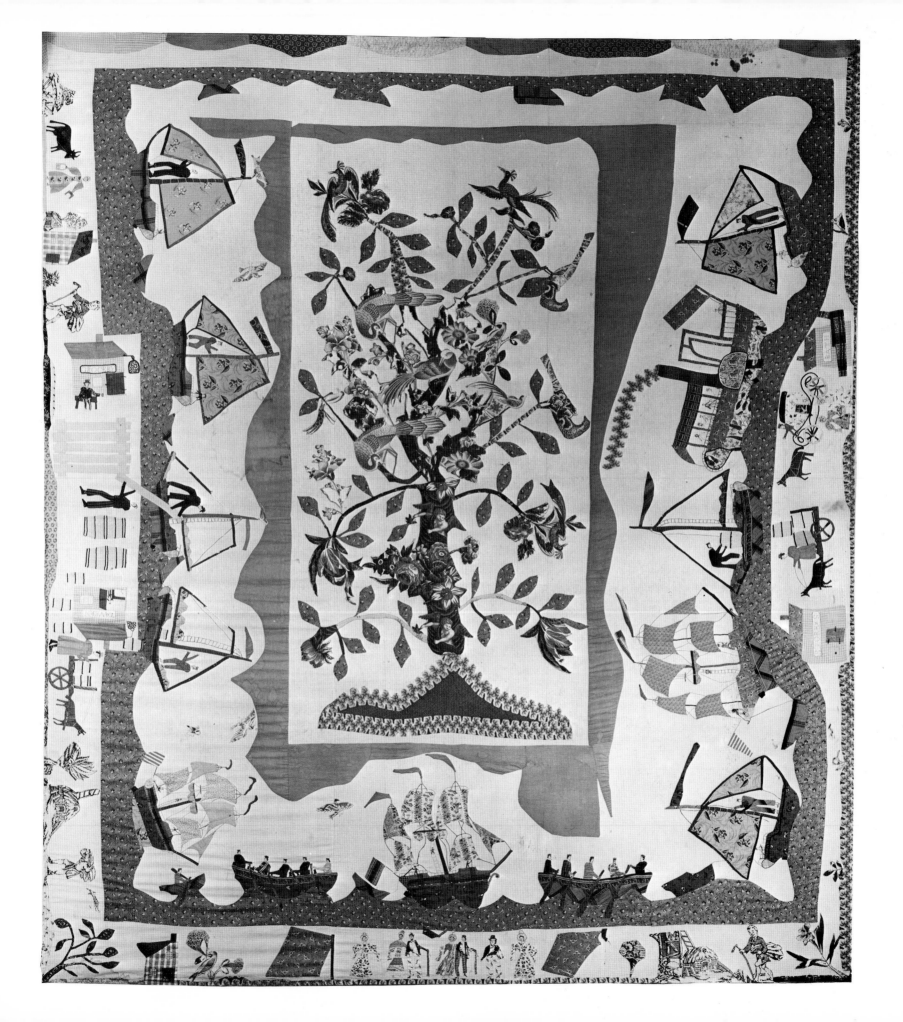

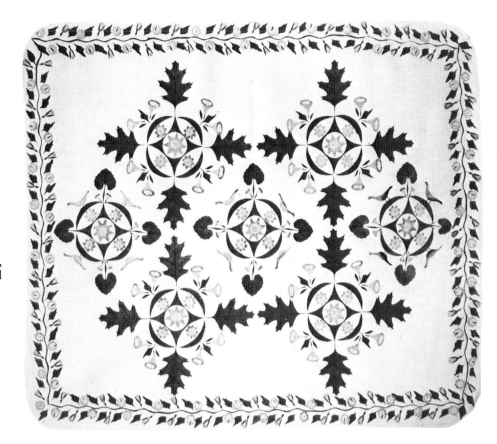

OPPOSITE: 403. Attributed to Hannah Stockton, Land and Sea quilt, appliqué, cotton on muslin, 103 x 91", c. 1830, Stockton, N.J. New York State Historical Association, Cooperstown.

404. Tablecloth, stenciled linen, 40 x 48", c. 1825, found in Connecticut. Collection of Howard and Jean Lipman.

405. Tablecloth, stenciled cotton, 28 x 26", c. 1825, found in Vermont. Collection of Howard and Jean Lipman.

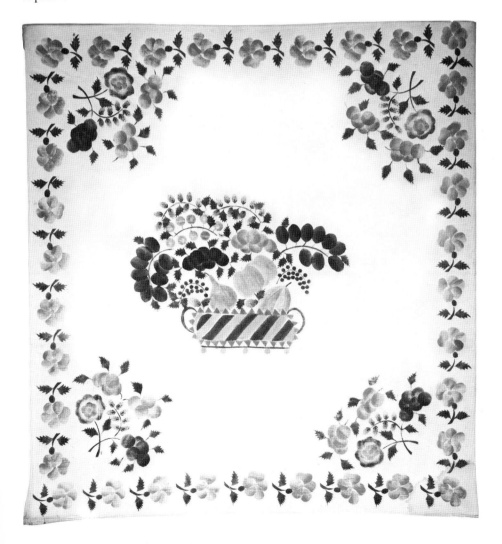

406. Table cover, wool embroidery and cotton appliqué on wool, 31½" diameter, c. 1870, Pennsylvania. Schwenkfelder Museum, Pennsburg, Pa.

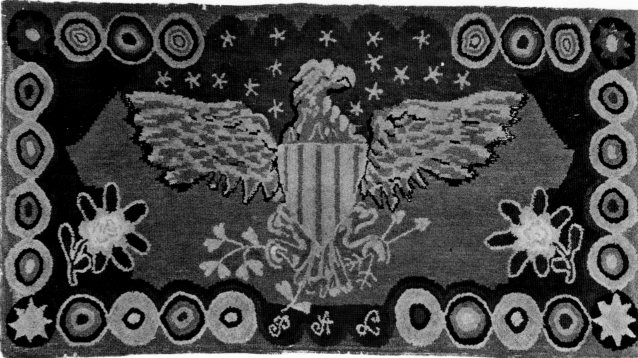

408. P. A. L. (unidentified), rug, wool hooked on linen, 36 x 69", c. 1800, Oneida County, N.Y. On loan to the New York State Historical Association, Cooperstown, from Constance Noyes Robertson.

409. J. J. (unidentified), rug, wool hooked on linen, 41¼ x 67", c. 1820, probably New England. Design possibly based on the Bengal tiger from Thomas Bewick's *Quadrupeds* (Philadelphia, 1810). Shelburne Museum, Shelburne, Vt.

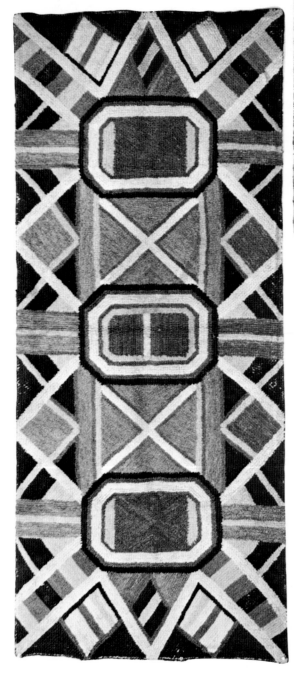

407. Rug, wool sewn on linen, 76 x 32½", 1800–35, Maine. Collection of Bertram K. and Nina Fletcher Little.

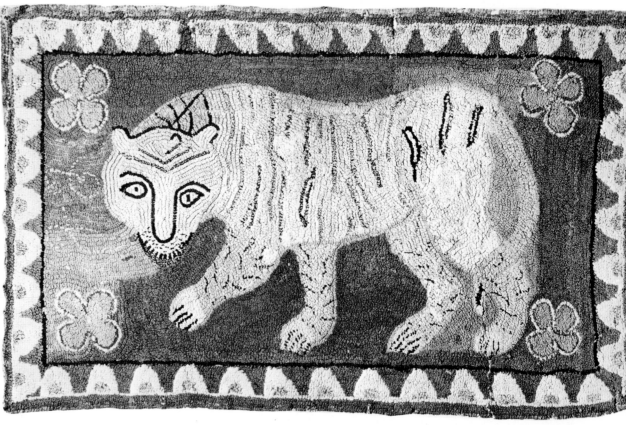

OPPOSITE: 410. Zeruah Higley Guernsey Caswell, Caswell carpet, wool embroidered on wool, 159 x 147", 1832–35, Castleton, Vt. Metropolitan Museum of Art, New York.

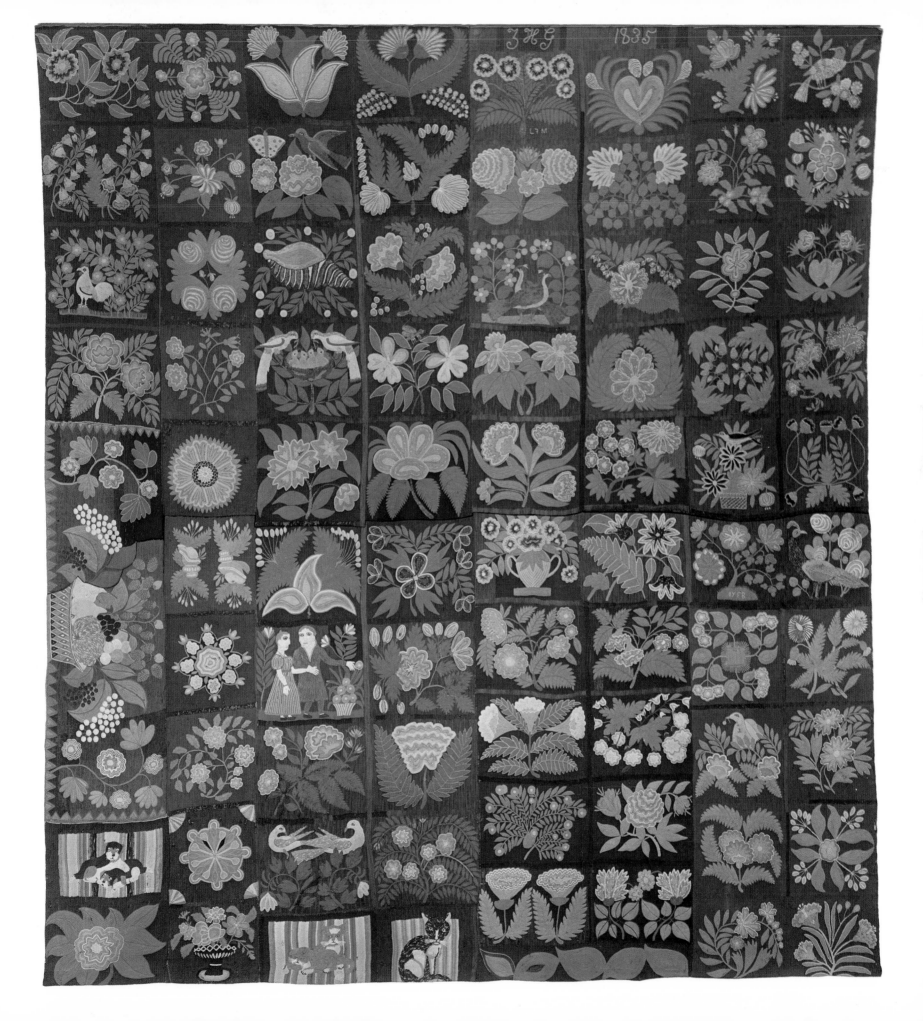

APPENDIX

BIOGRAPHICAL INDEX OF ARTISTS

Abbreviated bibliographical references (fully listed in Authors' Bookshelf) are included only when the artist is the subject of a monograph book, article or catalogue.

PICTURES

JAMES BARD (1815–1897). Born Chelsea (New York City), died White Plains, N. Y. Prolific marine painter (oil and watercolor). From 1827 to 1890 said to have made drawings and paintings of about 4000 ships built at or around port of New York. About 300 large paintings, mostly steamers, all pictured broadside, are recorded. Early works signed "J. & J. Bard"; John, James's twin brother, worked with him at that time. Most of James's work signed and complete address included. (Lipman–Winchester, *Primitive Painters in America*.)

WILLIAM THOMPSON BARTOLL (1817–1859). Born and died Marblehead, Mass. Work included many portraits of local people, some landscapes. Regular exhibitor at Boston Athenaeum 1834 to 1855. Also house and sign painter; said to have done murals on walls of his home.

RUTH HENSHAW BASCOM (1772–1848). Born Leicester, Mass., childhood in Worcester, lived and worked most of life in Gill, Mass. Made numerous profile portraits in pastels, almost all discovered in Franklin County, Mass., dating from 1830s. Said never to have accepted money for her portraits. Some cut out in silhouette and pasted on background paper, some ornamented with tinfoil or gold paper details. Diaries she kept for 57 years, describing daily life and work, owned by American Antiquarian Society, Worcester. (Lipman–Winchester, *Primitive Painters in America*.)

JOHN BRADLEY (I. J. H. Bradley, active c. 1832–1847). Oil portraits of subjects painted in New York or Staten Island, N. Y., between 1832 and 1847 variously signed "I. J. H. Bradley," "I. Bradley" and "J. Bradley." John Bradley was listed in New York City directories from 1836 through 1847 as "portrait and miniature painter." (Lipman, "I. J. H. Bradley.")

JOHN BREWSTER, JR. (1766–1854). Born Hampton, Conn., died Buxton, Me. Deaf-mute professional painter (oil). Received painting instruction in youth from Rev. Joseph Steward. Lived and worked in Connecticut and Maine, also worked in Massachusetts and New Hampshire. Late in life attended asylum for deaf and dumb in Hartford. (Little, "John Brewster, Jr.")

RICHARD BRUNTON (?–1832). Itinerant Connecticut engraver, served time in Newgate Prison, East Granby, for counterfeiting. One pair of oil portraits attributed to him. ("The Reuben Humphrey Portraits.")

EMMA CADY (active c. 1820). Known for single watercolor still life, New Lebanon, N. Y.

WINTHROP CHANDLER (1747–1790). Born Woodstock, Conn., where spent most of life, except for a few years in Worcester, Mass. Began as house painter, also did carving, gilding, illustrating and drafting; designated himself "limner." Most paintings are oil portraits of friends and relatives in Woodstock; also a few landscapes on canvas and overmantel panels. (Little, "Winthrop Chandler.")

PATTY COGGESHALL (1780–?). Known for single needlework sampler, Bristol, R. I.

HANNAH COHOON (1788–?). Known for a number of Shaker inspirational drawings made as a sister of the Hancock (Mass.) Church Family which she entered with two children, Harrison and Maria, in 1817. Her last known work is dated 1856.

COLEMAN (active c. 1858). Mate on ship *Joseph Grinell*, built in Massachusetts, 1858. Known for single whaling scene in colored chalks.

JOSEPH H. DAVIS (active 1832–1837). More than 100 watercolor portraits have been attributed to a Maine-New Hampshire itinerant who signed one "Joseph H. Davis Left Hand Painter." Sitters uniformly pictured in profile, typically in interiors with inscriptions in decorative penmanship at bottom identifying subjects, age, date painted. (Lipman–Winchester, *Primitive Painters in America*.)

NABBY DEXTER (1776–?). Known for single needlework sampler made at Miss Polly Balch's School, Providence, R. I.

EMILY EASTMAN (active c. 1820). Known for several watercolor portraits, adapted from prints, Loudon, N. H.

J. N. EATON (active c. 1830). Greene County, N. Y. Known for single "conversation piece" (oil on panel).

A. ELLIS (active c. 1832). Number of portraits (oil on panel) found in Maine and New Hampshire; documented subjects all from vicinity of Exeter, N. H., suggesting Ellis lived in this area.

JAMES SANFORD ELLSWORTH (1802–1873/74). Born Windsor, Conn., lived a number of years in Hartford, traveled west as far as Ohio, returned to New England, working chiefly in Windsor and Norwich, Conn. In old age lived in Pittsburgh, Pa., where he died in an almshouse. A few oil portraits and other subjects exist but best known for numerous watercolor miniature portraits—typically on thin paper in mahogany veneer frames—painted as itinerant in Connecticut and Massachusetts. Entirely self-taught, his portrait style may have developed from early work as silhouette cutter. (Lipman–Winchester, *Primitive Painters in America*; Mitchell, "James Sanford Ellsworth.")

J. EVANS (active c. 1827–1855). Numerous small watercolor portraits done around area of Portsmouth, N. H., and Boston. Faces always in profile, subjects almost without exception full length. (Savage, "J. Evans.")

R. FIBICH (active c. 1850). Known for single oil landscape of a York Springs, Pa., graveyard.

ERASTUS SALISBURY FIELD (1805–1900). Born Leverett, Mass., died Sunderland, Mass. Self-taught artist, studied briefly in New York City under Samuel F. B. Morse in 1824. Successful career, chiefly in New England, as itinerant portrait painter of low-priced oils; in 1838 was paid $29 for group of 11 portraits. Worked

in New York City as a daguerreotypist in 1840s. Later in life painted a few biblical, mythological and historical subjects. (Black, "Erastus Salisbury Field"; *Field, a Special Exhibition.*)

ELIZABETH FINNEY (1791–?). Known for single embroidered sampler made at Mrs. Leah Meguier's School, Harrisburg, Pa.

E. F. FIRTH (active c. 1812). Known for single watercolor birth record, New England.

JONATHAN FISHER (1768–1847). Minister of Congregational Church, Blue Hill, Me., for 41 years; all his life made drawings, oil and watercolor paintings, wood engravings. Was typical Yankee Jack-of-all-trades: linguist, inventor, architect, craftsman, surveyor, naturalist, teacher, poet—as well as parson and painter. (Winchester, "Rediscovery: Parson Jonathan Fisher"; *Versatile Yankee.*)

L. W. FRINK (active c. 1871). Known for single calligraphic picture, New York.

J. B. GILES (active c. 1810). Known for single ink drawing, found in Vermont.

DEBORAH GOLDSMITH (1808–1836). Born North Brookfield, N. Y., died Hamilton, N. Y. In her early twenties worked as professional itinerant portraitist (watercolor) in vicinity of Hamilton, traveling from house to house and living in patrons' homes. Met husband, George Throop, while painting his portrait in the Throop home in Hamilton. (Lipman–Winchester, *Primitive Painters in America.*)

WILLIAM HALLOWELL (1801–1890). Quaker doctor, Norristown, Pa. Known for two ink drawings, one of *The Peaceable Kingdom*, one of a turkey shoot.

RUFUS HATHAWAY (1770–1822). Born Massachusetts, probably Freetown. Itinerant portrait painter (oil); started in Taunton, Mass., in 1790. Settled in Duxbury, Mass., 1795, where became town doctor. Said to have made frames for his paintings, also watercolor miniatures, woodcarvings; at least one landscape, a still life and an overmantel panel attributed to him. (Little, "Doctor Rufus Hathaway.")

EDWARD HICKS (1780–1849). Born Langhorne, Bucks County, Pa. Most of life lived in Newton, Pa., beginning career as coach and sign painter. Active Quaker preacher. Painted number of landscape, farm and historical scenes (oil); most famous for his many versions of *The Peaceable Kingdom*. His memoirs, giving detailed account of his religious activities, published shortly after his death. (Ford, *Edward Hicks.*)

JOSEPH HENRY HIDLEY (1830–1872). Born in and spent entire life in Poestenkill, N. Y., where said to have been a cabinetmaker and taxidermist. His oil paintings on canvas and wood, principally views of Poestenkill and nearby villages, mostly date from 1840 to 1860. Also a few biblical scenes. (Lipman–Winchester, *Primitive Painters in America.*)

CHARLES C. HOFMANN (1820–1882). Born in Germany, came to U. S. in 1860, settled in Reading, Pa. From 1865 to 1881 painted large landscapes (oil on canvas or zinc) depicting the Berks County, Montgomery County and Schuylkill County almshouses. Committed himself to Berks County Almshouse in 1872; from then on, vagrant in and out of almshouse until his death. Almshouse entry register:

"Occupation, painter; Habits, intemperate; Cause of Pauperism, intemperance."

ANNA MARIA HOLMES (active c. 1820). Known for single memorial picture (ink and needlework on silk), New England.

MARTHA C. HOOTON (active c. 1827). Known for single needlework sampler, Pennsylvania.

F. B. HOYMAN (active c. 1870). Known for single calligraphic picture, probably Pennsylvania or New York.

CELESTA HUFF (active c. 1875–1889). Known for single oil of a Maine winter scene signed and dated 1889, and the earlier *Winter Sunday in Norway, Maine* attributed to her in this book.

JURGAN FREDERICK HUGE (1809–1878). Born in Germany, came to U. S. in his youth, settled in Bridgeport, Conn.; city directories listed him as "grocer and artist." Chiefly active as painter of large watercolor marines, also a number of "residence" paintings. Pictures almost all signed and dated, from 1838 to 1878. (Lipman, *Rediscovery: Jurgan Frederick Huge.*)

FREDERICK KEMMELMEYER (active 1788–1805). Worked in Baltimore, Md., painted portraits, miniatures, other subjects. Said to have worked as a drawing teacher. Best known for several versions (oil) of Washington reviewing Western Army at Fort Cumberland, Md.

MARY KEYS (active c. 1832). Known for single watercolor landscape of Lockport, N. Y.

PHEBE KRIEBEL (1837–1894). Born Worcester, Pa.; married Abraham K. Kriebel, Towamencin Township, Pa., a *Vorsinger* in the Schwenkfelder Church. Known for needlework picture dated 1857.

BETSY B. LATHROP (active c. 1812). New England, probably Massachusetts. Several schoolgirl paintings (watercolor on silk) attributed to her; one signed and dated.

JOSEPH WARREN LEAVITT (active c. 1824). Lived in Chichester, N. H. Known for watercolor scene of interior of the Moses Morse house in Loudon, N. H.; he was a cousin of Sally (Emery) Morse in the picture.

JACOB MAENTEL (1763–1863). Born Kassel, Germany, settled in Pennsylvania, then New Harmony, Ind., returned later to Pennsylvania. Number of full-length watercolor portraits exist, all showing subjects in interior or landscape settings; people specifically identified as living in New Harmony, Ind.; Lancaster, Lebanon and York counties, Pa.; one group in Robinson, Ill. (Black, "A Folk Art Whodunit.")

GEORGE WASHINGTON MARK (?–1879). Moved from New Hampshire to Greenfield, Mass., in 1817, lived there until his death. Portrait, landscape, historical and mural painter; furniture decorator (freehand and stenciled decoration on chairs); probably sign painter. Had exhibition gallery, charged admission.

SUSAN MERRETT (active c. 1845). Known for single picture (watercolor cutouts of people pasted on watercolor scene) of a picnic at Weymouth Landing, Mass.

ANNY MOHLER (active c. 1830). Known for single watercolor and presentation piece, Stark County, Ohio.

HARRIETT MOORE (active c. 1817). Known for single water-color memorial, Concord, Mass.

D. MORRILL (active c. 1860). Known for single oil painting of a banjo player, probably New England.

NOAH NORTH (active c. 1834). Known for single portrait (oil on wood) of a woman from Holley, N. Y.

SHELDON PECK (1797–1868). Born Cornwall, Vt., died Lombard, Ill. Painted single and family group portraits in Vermont, western New York, and then, as itinerant, from home in Lombard (near Chicago), where he settled in 1838. Early portraits, oil on wood; later, oil on canvas, many featuring frames with painted graining, some with simulated grained frames as part of canvas. One portrait (reproduced in color in this book) recorded as painted in exchange for a cow.

PRUDENCE PERKINS (active c. 1810). Rhode Island. Known for single ink and watercolor landscape.

AMMI PHILLIPS (1787/88–1865). Itinerant portrait painter active in a 200-mile area east and west of the Massachusetts, Connecticut and New York borders. Active over period of 50 years; more than 200 oil portraits, widely varied in style, have been identified. (Holdridge, *Ammi Phillips.*)

EUNICE PINNEY (1770–1849). Born Simsbury, Conn., lived and worked in Windsor, Conn.; after marriage to Butler Pinney, returned to Simsbury. All her paintings, watercolors of a variety of subjects, datable 1809–1826. She is mentioned in *A Memoir of the Life of Bishop Griswold* (her brother) as "a woman of uncommonly extensive reading" and "zealously instrumental in the first organization of our church." (Lipman–Winchester, *Primitive Painters in America.*)

ASAHEL LYNDE POWERS (1813–1843). Born Springfield, Vt., died Olney, Ill. Portraits in oil on wood and canvas, found in vicinity of Springfield, Vt., and in New York State, 1831–1840, and after that in Ohio. (Little, *Asahel Powers.*)

WILLIAM MATTHEW PRIOR (1806–1873). Born Bath, Me. Early in life advertised "fancy, sign and ornamental painting." Later painted portraits and landscapes as itinerant in New England and as far south as Baltimore. With in-laws, the Hamblen family, set up "The Painting Garret" in Boston, where the group turned out pictures at various prices, depending on size and style. Paintings done on canvas, cardboard, academy board and glass. (Lipman–Winchester, *Primitive Painters in America.*)

PRUDENCE PUNDERSON (1758–1784). Born Groton, Mass., died in her twenties. Known for single needlework picture showing herself in three stages of life.

DURS RUDY (active c. 1825). Known for ink and watercolor baptismal records, one initialed and dated; Broadheadville, Pa.

J. C. SATTERLEE (active c. 1866). Known for several calligraphic pictures, Corry, Pa.

PAUL A. SEIFERT (1840–1921). Born Dresden, Germany, graduated from Leipzig College, came to America in 1867. Painted large watercolor portraits of Wisconsin farms from 1860s to about 1915, charging $2.50 top price; major occupation, raising flowers, fruits and vegetables for sale. Along with painting farms as an itinerant, planted groves of trees and started fruit gardens for the farmers. In later life set up shop near Gotham, Wis., where he practiced

taxidermy and painting on glass. (Lipman–Winchester, *Primitive Painters in America.*)

HARRIOT SEWALL (active c. 1808). Known for single water-color graveyard scene, probably New England.

HENRY WALTON (?–1865). Numerous portraits (mostly water-color) of upstate New York people in vicinity of Ithaca, where he lived and worked in second quarter of nineteenth century. Also known for painted and lithographed town views, maps, and an oil scene on a parade banner. Left Finger Lakes region of New York for California in 1851; continued portrait and landscape painting and lithography there. Moved to Michigan in 1857, died in Cassapolis. Work typically signed "H. Walton" and dated. (*Henry Walton/19th Century Artist*; Rehner, "Henry Walton.")

MARY ANN WILLSON (active c. 1810–1825). Lived in log cabin in Greenville, N. Y., with a Miss Brundage, who farmed their land. Miss Willson sold her watercolors (paints made from berries, bricks and occasional "store paint"); according to a friend's letter that accompanied a portfolio of twenty Willson paintings, they were "rare and unique works of art." (Lipman–Winchester, *Primitive Painters in America.*)

JAMES HENRY WRIGHT (c. 1813–1883). A single oil marine dated 1833, when he was probably a mate on board the U. S. Ship *Constellation*, represents his early, relatively primitive style. Later he exhibited regularly in New York City at American Art Union, 1847–1852, and National Academy of Design, 1842–1860.

SCULPTURE

LABAN S. BEECHER (1805–?). Born Connecticut; at 17 went to Boston to learn shipcarving; first shop on Market Street, then Commercial Street, where made carvings for merchant and war ships. Soon after figurehead of Andrew Jackson was placed on the *Constitution* in 1834, sold shop to apprentice John Mason and went west to start lumber business near Sharno, Wis., where became a large landowner.

JOHN BELL (1800–1880). Born Hagerstown, Md.; in 1824 went to Virginia, established pottery in Chambersburg; later moved to Waynesboro County, Pa., where operated pottery until his death. His pots stamped, "J. Bell," "John Bell" or "John Bell, Waynesboro."

JOHN H. BELLAMY (1836–1914). Born Kittery Point, Me. Assisted father in building trade, then apprenticed as carver in New York City and in Boston to shipcarver Laban S. Beecher. Worked at Charlestown (Boston) Navy Yard, then returned to Kittery and worked at Portsmouth (N. H.) Navy Yard. Had workshop in Portsmouth, but most of active career in Kittery loft workshop. Specialized in carved eagles, from figureheads to small ornaments. His Portsmouth business card advertised "house, ship, furniture, sign and frame carving and garden figures."

JOHN BLAIR (active c. 1868). A sportsman from Philadelphia and Elkton, Md., known for decoys made for use on Delaware Bay.

CORBIN (active c. 1840). A farmer said to have carved a portrait of Henry Ward Beecher when he visited Corbin's home in Centerville, Ind., probably between 1839 and 1847, the years Beecher held a pastorate in Indianapolis.

ISAAC FOWLE (?–1832). Active as shipcarver in Boston from 1807, built up prosperous business which continued as Isaac

Fowle & Co. after his death. A carved hardware shop sign attributed to him, besides number of figureheads.

LOTHROP T. HOLMES (1824–1899). Decoy maker, hunter, farmer and seaman, Kingston, Mass.

JOB (active c. 1825). A slave said to have made a cigar-store Indian for a tobacconist in Freehold, N. J., about 1825.

SAMUEL KING (1749–1820). Known for a carved sign made c. 1810 for James Fales's instrument shop in Newport, R. I. King was a mathematical instrument maker and early tutor of the painter Washington Allston. His shop was located on Bannister's Wharf in New Bedford, Mass.

SAMUEL McINTIRE (1757–1811). Architect-craftsman, designed a number of great houses in Salem, Mass., and decorated fine furniture with elaborate carving; also shipcarver.

JULIUS THEODORE MELCHERS (1830–1908). Figure carver best known for cigar-store Indians. Born Germany, left for France in 1849, then England; in 1852 went to Detroit and carved first wooden Indian. Posed Indians as models and collected Indian curiosities for costumes; used old ship masts for timber. Prices $5 to $150.

ALBERT ORME (active c. 1875). Decoy maker and lighthouse tender, Southport, Me.

CAPTAIN OSGOOD (active c. 1849). Lived in Salem, Mass. A ship captain, he made voyages around the tip of South America to San Francisco and carved decoys during the trips.

JOSEPH REMMICK (active c. 1875). Cobbler, known for single wooden toy, Union, N. H.

WILHELM SCHIMMEL (1817–1890). Pennsylvania German itinerant woodcarver known as "Old Schimmel," said to have made 400 to 500 pieces in last 25 years of his life. Wandered about Cumberland Valley near Carlisle, Pa., whittling toys and household ornaments. Exchanged carvings for lodging in haylofts or cellars, for rum in local taverns; when sold, carvings cost only a few pennies. Tools were a jackknife, piece of glass for smoothing, a few paints and brushes. Died in an almshouse in Carlisle, buried in potter's field. (Flower, *Wilhelm Schimmel and Aaron Mountz.*)

CAPTAIN BEN SMITH (active c. 1850). Decoy maker, Monhegan Island, Me.

DECORATION

ERICK ALBERTSON (active c. 1870). Probably of Swedish origin, said to have spent time in New England before going to California, where worked as blacksmith and lumber mill hand in Mendocino. About 1870 built Masonic Temple in Mendocino, did ornamental carvings for the upstairs lodge room and large figure of Father Time for cupola. (Adams, "Query.")

WINTHROP CHANDLER. See PICTURES.

MOSES EATON (1796–1886). Born Hancock, N. H., lived in Dublin, N. H. Active in early years, before marriage, as itinerant wall painter. Decorated plaster walls in numerous Massachusetts, New Hampshire and Maine houses in variety of stenciled designs.

His stencil kit in museum of Society for the Preservation of New England Antiquities, Boston.

RUFUS HATHAWAY. See PICTURES.

JARED JESSUP (active c. 1800). Probably born Southampton, Long Island, during Revolutionary period. Moved to Richmond, Mass., shortly before 1800, soon after that to Connecticut, in or near Guilford, where began career as itinerant wall painter. Walls and overmantels in Guilford, Stonington and Old Lyme, Conn., and Deerfield and Bernardston, Mass., attributed to him and assistants.

RUFUS PORTER (1792–1884). Born Boxford, Mass., died New Haven, Conn. Itinerant mural landscape painter, active throughout New England, mid-1820s–mid-1840s; was, also, successively, shoemaker, fiddler and drummer, house and sign painter, schoolteacher, silhouette cutter and portrait painter (miniature watercolors), founder and first editor of *Scientific American*, author and editor of numerous other publications, prolific inventor. (Lipman, *Rufus Porter, Yankee Pioneer.*)

WILLIAM PRICE (active c. 1831). Wall painter, known for landscape murals in Ezra Carroll house, East Springfield, N. Y.

WILLIAM RICE (1773–1847). Born Worcester, Mass.; by 1818 working as a sign painter in Hartford, Conn.; later recorded as portrait painter in Norway, Me.

VAN CORTLAND (active c. 1775–80). Known for single overmantel panel said to have been painted for Dr. Joseph Tilton's house (later Gardiner-Gilman house) in Exeter, N.H., when he was a guest there.

J. H. WARNER (active c. 1840). Known for scenic and still-life decoration on plaster walls of house in Fitchburg, Mass., where he signed and dated a scroll over the mantelpiece.

NOAH WEISS (1842–1907). Inn-keeper in a Lehigh County, Pa., village; woodcarver and decorator of Pennsylvania barns, such as one illustrated here.

HOBART VICTORY WELTON (1811–1895). Connecticut farmer and engineer, embellished front yard of his family's Waterbury farm with carved stone ornaments, including fenceposts, a carriage step and a watering trough, as well as the wooden gate by which he is best known. As Waterbury's superintendent of highways for 25 years was responsible for Connecticut's first iron bridge and a system of reservoirs, and kept Waterbury's road maintenance expenditures to $800 annually.

ORISON WOOD (1811–1842). Lived in Auburn, Me., worked as itinerant wall painter in vicinity of Auburn, Lewiston and Lisbon about 1830, one of the Rufus Porter landscape "school." Listed in Wood genealogy as "a painter by trade," also schoolteacher.

FURNISHINGS

BENJAMIN BERGEY (active c. 1830–1840). Potter, Montgomery County, Pa., known for slip-decorated plates.

ESTHER S. BRADFORD (active c. 1807). Known for single appliqué and embroidery coverlet, Montville, Conn.

ZERUAH HIGLEY GUERNSEY CASWELL (active c. 1832–1835). Known for the Caswell carpet, Castleton, Vt.

ANSON CLARK (active c. 1825). Known for stenciled picture frames, West Stockbridge, Mass.

ELIZABETH ANN CLINE (active 1860s). Denver, Colo. In 1860s made pieced and appliqué quilts in various patterns, all for her own home. Her daughter, Charlotte Jane Whitehill, continued making quilts, following old designs; in 1955 gave her collection of 35 quilts, 6 made by her mother, rest by her, to Denver Art Museum.

RANSOM COOK (1794–c. 1875). Born Wallingford, Conn. Started working as a furniture maker in Saratoga, N. Y., in 1813; opened own shop in 1822 where specialized in decorated furniture and accessories. Also known as successful inventor.

MRS. AUSTIN ERNEST (active c. 1858). Her husband was in politics and on reception committee for Lincoln; known for single patchwork quilt made from material used to decorate stand from which Lincoln spoke in Paris, Ill., in 1858.

ANNA PUTNEY FARRINGTON (active c. 1857). Known for single appliqué quilt, Westchester County, N. Y.

JAMES FULIVIER (active c. 1825). Known for single painted tin coffeepot, Pennsylvania.

PREMELLA GOODALL (active c. 1790). Known for single embroidery coverlet, Buffalo, N. Y.

THOMAS G. MATTESON (active c. 1825). Maker and decorator of chests, South Shaftsbury, Vt.

JOHANNES NEESZ (1775–1867). Pennsylvania potter, known for sgraffito plates. Lived and worked in Tylersport, Montgomery County; his pottery was erected there before 1800. He was probably at one time a pupil of David Spinner.

DAVID SPINNER (1758–1811). Potter, Bucks County, Pa., best known for his sgraffito plates. Unlike other potters of that time in Pennsylvania, inscribed plates in English rather than German. Often signed pieces "David Spinner potter" or "David Spinner his make."

HANNAH STOCKTON (active c. 1830). Known for single appliqué quilt, Stockton, N. J.

MARY VAN VOORHIS (c. 1760–?). Known for single appliqué quilt made about 1850, southwestern Pennsylvania.

SARAH FURMAN WARNER (active c. 1800–1815). Known for single appliqué coverlet, Greenfield Hill, Conn.

AUTHORS' BOOKSHELF

The following books, articles and catalogues were actively used by the Whitney Museum's temporary folk-art department during the year-long preparation of this book. A number of these publications have extensive bibliographies which may be consulted by those desiring more specialized information on the various categories of folk art discussed in this book.

GENERAL

The American Museum, Claverton Manor, Bath [England]: A Guide Book, n.d.

Americana: Midwest Collectors' Choice (exhibition catalogue for Henry Ford Museum). Dearborn, Mich.: The Edison Institute, 1960.

Cahill, Holger. American Folk Art/The Art of the Common Man in America 1750–1900 (exhibition catalogue). New York: Museum of Modern Art, 1932.

Christensen, Erwin O. The Index of American Design. Washington: National Gallery of Art, 1950.

Davenport, Millia. The Book of Costume. 2 vols. New York: Crown Publishers, 1948; reprinted in one volume, 1972.

Drepperd, Carl W. American Pioneer Arts & Artists. Springfield, Mass.: Pond-Ekberg Company, 1942.

Early American Art (exhibition catalogue). New York: Whitney Studio Club, 1924.

An Eye on America. Folk Art from the Stewart E. Gregory Collection (exhibition catalogue). New York: Museum of American Folk Art, 1972.

Ford, Alice. Pictorial Folk Art/New England to California. New York: Studio Publications, 1949.

Hornung, Clarence P. Treasury of American Design. 2 vols. New York: Harry N. Abrams [1972].

Jones, Louis C., and Davidson, Marshall B. American Folk Art [The Metropolitan Museum of Art Miniatures]. New York: Metropolitan Museum of Art, 1953.

Kauffman, Henry. Pennsylvania Dutch American Folk Art. New York: American Studio Books, 1946. New York: Dover Publications, 1964.

Lichten, Frances. Folk Art of Rural Pennsylvania. New York: Charles Scribner's Sons, 1946.

Lichten, Frances. *Pennsylvania Dutch Folk Arts*. Philadelphia: Philadelphia Museum of Art, n. d.

Lipman, Jean, ed. *What Is American in American Art*. New York: McGraw-Hill Book Company, 1963.

Little, Nina Fletcher. *The Abby Aldrich Rockefeller Folk Art Collection* (catalogue). Williamsburg, Va.: Colonial Williamsburg, 1957; distributed by Little, Brown and Company, Boston.

Pennsylvania Dutch Folk Arts from the Geesey Collection and Others (catalogue). Philadelphia: Philadelphia Museum of Art, n. d.

Polley, Robert L., ed. *America's Folk Art*. New York: G. P. Putnam's Sons, 1968.

Robacker, Earl F. *Pennsylvania Dutch Stuff*. Philadelphia: University of Pennsylvania Press, 1944.

Selected Treasures of Greenfield Village and Henry Ford Museum. Dearborn, Mich.: The Edison Institute, 1969.

Stoudt, John Joseph. *Consider the Lilies How They Grow*. Allentown Pa.: Schlecter's, 1937.

Welsh, Peter C. *The Art and Spirit of a People. American Folk Art from the Eleanor and Mabel Van Alstyne Collection*. Washington: Smithsonian Institution, 1965.

"What Is American Folk Art? A Symposium." *Antiques*, Vol. 57, No. 5 (May 1950), pp. 355–362.

Wheeler, Robert G. *Folk Art and the Street of Shops*. (Henry Ford Museum.) Dearborn, Mich.: The Edison Institute, 1971.

Winchester, Alice. "Antiques for the Avant Garde." *Art in America*, Vol. 49, No. 2 (April 1961), pp. 64–73.

Winchester, Alice, ed. *The Antiques Treasury of Furniture and Other Decorative Arts*. New York: E. P. Dutton & Company, 1959.

PICTURES

American Folk Paintings. Horace W. Davis Collection (auction catalogue). New York: Parke-Bernet Galleries, 1946.

Andrews, Edward Deming and Faith. *Visions of the Heavenly Sphere/A Study in Shaker Religious Art*. Charlottesville, Va.: University Press of Virginia, 1969.

[Armstrong, Thomas N., III] *Pennsylvania Almshouse Painters* (exhibition catalogue). Williamsburg, Va.: Colonial Williamsburg, 1968.

Black, Mary, and Lipman, Jean. *American Folk Painting*. New York: Clarkson N. Potter, 1966.

Mary Black. "Rediscovery: Erastus Salisbury Field." *Art in America*, Vol. 54, No. 1 (January 1966), pp. 49–56.

Black, Mary C. "American Primitive Painting." *Art in America*, Vol. 51, No. 4 (August 1963), pp. 64–82.

[Black, Mary C.] *Erastus Salisbury Field 1805–1900, a Special Exhibition Devoted to His Life and Work*. Williamsburg, Va.: Colonial Williamsburg, 1963.

Black, Mary C. "A Folk Art Whodunit [Jacob Maentel]." *Art in America*, Vol. 53, No. 3 (June 1965), pp. 96–105.

Bolton, Ethel Stanwood, and Coe, Eva Johnston. *American Samplers*. Boston: Massachusetts Society of the Colonial Dames of America, 1921. New York: Dover Publications, 1973.

[Cahill, Holger] *American Primitives* (exhibition catalogue). Newark, N. J.: Newark Museum, 1930.

Fennelly, Catherine. *The Garb of Country New Englanders, 1790–1840*. Sturbridge, Mass.: Old Sturbridge, 1966.

Ford, Alice. *Edward Hicks, Painter of the Peaceable Kingdom*. Philadelphia: University of Pennsylvania Press, 1952.

Flexner, James Thomas. "Monochromatic Drawing: A Forgotten Branch of American Art." *Magazine of Art*, Vol. 38, No. 2 (February 1945), pp. 63–65.

Garbisch, Edgar William and Bernice Chrysler (with nine other authors). "American Primitive Painting, Collection of Edgar William and Bernice Chrysler Garbisch." *Art in America*, Vol. 42, No. 2 (May 1954), special issue.

[Garbisch] *American Naïve Painting of the 18th and 19th Centuries: 111 Masterpieces from the Collection of Edgar William and Bernice Chrysler Garbisch* (exhibition catalogue). New York: American Federation of Arts, 1969.

[Garbisch] *American Primitive Paintings from the Collection of Edgar William and Bernice Chrysler Garbisch* (exhibition catalogue). Washington: National Gallery of Art, 1954 (Part 1); 1957 (Part 2).

[Garbisch] *101 American Primitive Watercolors and Pastels from the Collection of Edgar William and Bernice Chrysler Garbisch* (exhibition catalogue). Washington: National Gallery of Art, n. d.

[Garbisch] *101 Masterpieces of American Primitive Painting from the Collection of Edgar William and Bernice Chrysler Garbisch* (exhibition catalogue). New York: American Federation of Arts, 1961.

The Gift of Inspiration/Religious Art of the Shakers (exhibition catalogue). Hancock, Mass.: Hancock Shaker Village, 1970.

Goodrich, Lloyd, and Black, Mary. *What Is American in American Art* (exhibition catalogue). New York: M. Knoedler and Company, 1971.

Harbeson, Georgiana Brown. *American Needlework*. New York: Coward–McCann, 1937. New York: Bonanza Books, n. d.

Henry Walton/19th Century American Artist (exhibition catalogue). Ithaca, N. Y.: Ithaca College Museum of Art, 1968.

Holdridge, Barbara and Lawrence B. "Ammi Phillips, 1788–1865." *The Connecticut Historical Society Bulletin*, Vol. 30, No. 4 (October 1965), special issue.

Holdridge, Barbara C. and Lawrence B. *Ammi Phillips, Portrait Painter 1788–1865*. New York: Clarkson N. Potter, 1969.

Jones, Agnes Halsey and Louis C. *New-Found Folk Art of the Young Republic.* Cooperstown, N.Y.: New York State Historical Association, 1960.

[Karolik] *M. and M. Karolik Collection of American Paintings 1815–1865* (catalogue for Museum of Fine Arts, Boston). Cambridge, Mass.: Harvard University Press, 1949.

[Karolik] *M. and M. Karolik Collection of American Water Colors and Drawings 1800–1875* (catalogue). 2 vols. Boston: Museum of Fine Arts, 1962.

Life in America (exhibition catalogue). New York: Metropolitan Museum of Art, 1939.

Lipman, Jean. *American Primitive Painting.* New York: Oxford University Press, 1942. New York: Dover Publications, 1972.

Lipman, Jean. "I. J. H. Bradley, Portrait Painter." *Art in America,* Vol. 53, No. 3 (July 1945), pp. 154–165.

Lipman, Jean. *Rediscovery: Jurgan Frederick Huge (1809–1878).* New York: Archives of American Art, 1973.

Lipman, Jean, and Winchester, Alice [eds.]. *Primitive Painters in America 1750–1950.* New York: Dodd, Mead & Company, 1950. Freeport, N.Y.: Books for Libraries Press, 1971.

[Little, Nina Fletcher] *Asahel Powers—Painter of Vermont Faces* (exhibition catalogue). Williamsburg, Va.: Colonial Williamsburg, 1973.

Little, Nina Fletcher. *Country Art in New England, 1790–1840.* Sturbridge, Mass.: Old Sturbridge, 1960.

Little, Nina Fletcher. "Doctor Rufus Hathaway, Physician and Painter of Duxbury, Massachusetts, 1770–1822." *Art in America,* Vol. 41, No. 3 (Summer 1953), special issue.

Little, Nina Fletcher, "John Brewster, Jr., 1766–1854." *The Connecticut Historical Society Bulletin*, Vol. 25, No. 4 (October 1960), special issue.

Little, Nina Fletcher. *Land and Seascape as Observed by the Folk Artist* (exhibition catalogue). Williamsburg, Va.: Colonial Williamsburg, 1969.

Little, Nina Fletcher. "Winthrop Chandler." *Art in America,* Vol. 35, No. 2 (April 1947), special issue.

Mitchell, Lucy B. "James Sanford Ellsworth, American Miniature Painter." *Art in America,* Vol. 41, No. 4 (Autumn 1953), special issue.

Pennsylvania German Fraktur and Color Drawings (exhibition catalogue). Lancaster, Pa.: Pennsylvania Farm Museum of Landis Valley, 1969.

Rehner, Leigh. "Henry Walton, American Artist." *Antiques,* Vol. 97, No. 3 (March 1970), pp. 414–417.

"The Reuben Humphrey Portraits." *The Connecticut Historical Society Bulletin*, Vol. 37, No. 2 (April 1972), pp. 42–50.

Richardson, Edgar P. *Painting in America. The Story of 450 Years.* New York: Thomas Y. Crowell Company, 1956.

Savage, Norbert and Gail. "J. Evans, Painter." *Antiques,* Vol. 100, No. 5 (November 1971), pp. 782–787.

Schiffer, Margaret B. *Historical Needlework of Pennsylvania.* New York: Charles Scribner's Sons, 1968.

Schloss, Christine Skeeles. *The Beardsley Limner and some contemporaries* (exhibition catalogue). Williamsburg, Va.: Colonial Williamsburg, 1972.

Sears, Clara Endicott. *Some American Primitives: A Study of New England Faces and Folk Portraits.* Boston: Houghton Mifflin Company, 1941.

Shelley, Donald A. *The Fraktur-Writings or Illuminated Manuscripts of the Pennsylvania Germans.* Allentown, Pa.: Pennsylvania German Folklore Society, 1961.

Sniffen, Harold S., and Brown, Alexander Crosby. *James and John Bard: Painters of Steamboat Portraits* (exhibition catalogue). Newport News, Va.: Mariners Museum, 1949.

[Tillou, Peter H.] *Nineteenth-Century Folk Painting: Our Spirited National Heritage* (selections from the collection of Mr. and Mrs. Peter H. Tillou; exhibition catalogue). Storrs, Conn.: University of Connecticut, William Benton Museum of Art, 1973.

Winchester, Alice. "Living with Antiques. Cogswell's Grant, the Essex Home of Mr. and Mrs. Bertram K. Little." *Antiques,* Vol. 45, No. 2 (February 1969), pp. 242–251.

Winchester, Alice. "Maxim Karolik and His Collections." *Art in America,* Vol. 45, No. 3 (June 1957), pp. 34–41.

Winchester, Alice. "Rediscovery: Parson Jonathan Fisher." *Art in America,* Vol. 58, No. 6 (November–December 1970), pp. 92–99.

Winchester, Alice. *Versatile Yankee: The Art of Jonathan Fisher.* Princeton, N. J.: Pyne Press, 1973.

SCULPTURE

Adams, Ansel, "Query [Erick Albertson]." *Art in America,* Vol. 48, No. 2 (Summer 1960), p. 12.

Barber, Joel. *Wild Fowl Decoys.* New York: Windward House, 1934. New York: Dover Publications, 1954.

Brewington, M. V. *Shipcarvers of North America.* [Barre, Mass.:] Barre Publishing Company, 1962. New York: Dover Publications, 1972.

[Cahill, Holger] *American Folk Sculpture* (exhibition catalogue). Newark, N. J.: Newark Museum, 1931.

Earnest, Adele. *The Art of the Decoy: American Bird Carvings.* New York: Bramhall House, 1965.

Fitzgerald, Ken. *Weathervanes and Whirligigs.* New York: Clarkson N. Potter, 1967.

Flayderman, E. Norman. *Scrimshaw and Scrimshanders/Whales and Whalemen.* New Milford, Conn.: N. Flayderman and Company, 1972.

Flower, Milton E. *Wilhelm Schimmel and Aaron Mountz: Wood-carvers*. Williamsburg, Va.: Abby Aldrich Rockefeller Folk Art Collection, 1965.

Forbes, Harriette Merrifield. *Gravestones of Early New England/ And the Men who made them, 1653–1800*. Boston: Houghton Mifflin Company, 1927. New York: Da Capo Press, 1967.

Fried, Frederick. *Artists in Wood*. New York: Clarkson N. Potter, 1970.

The Haffenreffer Collection of Cigar Store Indians and Other American Trade Signs (auction catalogue). New York: Parke-Bernet Galleries, 1956.

Lipman, Jean. *American Folk Art in Wood, Metal and Stone*. New York: Pantheon Books, 1948. New York: Dover Publications, 1972.

Mackey, William F., Jr. *American Bird Decoys*. New York: E. P. Dutton & Company, 1965.

Parker, Ann, and Neal, Avon. "Archaic Art of New England Gravestones." *Art in America*, Vol. 51, No. 3 (June 1963), pp. 96–105.

Pinckney, Pauline A. *American Figureheads and Their Carvers*. New York: W. W. Norton & Company, 1940.

Prendergast, A. W., and Ware, W. Porter. *Cigar Store Figures in American Folk Art*. Chicago: Lightner Publishing Corporation, 1953.

Wasserman, Emily. *Gravestone Designs, Rubbings and Photographs from Early New York and New Jersey*. New York: Dover Publications, 1972.

Webster, David S., and Kehoe, William, *Decoys at Shelburne Museum*. Shelburne, Vt.: Shelburne Museum, 1961.

Weitenkampf, F. W. "Lo, the Wooden Indian: The Art of Making Cigar-shop Signs." *The New York Times*, Aug. 3, 1890, p. 13, col. 1.

DECORATION

Brazer, Esther Stevens. *Antique Decoration* (27 articles reprinted from *Antiques*). The Historical Society of Early American Decoration, n. d.

Brazer, Esther Stevens. *Early American Decoration*. Springfield, Mass.: Pond–Ekberg Company, 1940. Memorial edition, 1947.

Klein, Rosemary L. "The Enduring Beauty of Stenciling." *American Home*, Vol. 75, No. 8 (August 1972), p. 43.

Lipman, Jean, and Meulendyke, Eve. *American Folk Decoration*. New York: Oxford University Press, 1951. New York: Dover Publications, 1972.

Lipman, Jean. *Rufus Porter, Yankee Pioneer*. New York: Clarkson N. Potter, 1968.

Little, Nina Fletcher. *American Decorative Wall Painting 1700–1851*. Sturbridge, Mass: Old Sturbridge, 1952. New York: E. P. Dutton & Company, 1972.

Little, Nina Fletcher. *Floor Coverings in New England Before 1850*. Sturbridge, Mass.: Old Sturbridge, 1967.

Roth, Rodris. "A Room from Martha's Vineyard at the Smithsonian Institution." *Dukes County Intelligencer* (Dukes County Historical Society, Edgartown, Mass.), August 1967, pp. 3–22.

Waring, Janet. *Early American Stencils on Walls and Furniture*. New York: William R. Scott, 1937. New York: Dover Publications, 1966.

FURNISHINGS

Blue-Decorated Stoneware of New York State (exhibition catalogue). Watkins Glen, N. Y.: American Life Foundation & Study Institute, n. d.

Carlisle, Lilian Baker. *Pieced Work and Appliqué Quilts at Shelburne Museum*. Shelburne, Vt.: Shelburne Museum, 1957.

"Country Furniture. A Symposium." *Antiques*, Vol. 43, No. 3 (March 1968), pp. 342–371.

Davidson, Marshall B. *The American Heritage History of American Antiques from the Revolution to the Civil War*. New York: American Heritage Publishing Company, 1968.

Davidson, Marshall B. *The American Heritage History of Colonial Antiques*. New York: American Heritage Publishing Company, 1967.

Denver Art Museum Quilt Collection (catalogue). [1963]

The Fabric of the State (exhibition catalogue). New York: Museum of American Folk Art, 1972.

Fales, Dean A., Jr. *American Painted Furniture 1660–1880*. New York: E. P. Dutton & Company, 1972.

The Great American Cover-up: Counterpanes of the Eighteenth and Nineteenth Centuries (exhibition catalogue). Baltimore: Baltimore Museum of Art, 1971.

[Holstein, Jonathan] *American Pieced Quilts* (exhibition catalogue for Smithsonian Institution Traveling Exhibition Service). Lausanne, Switzerland: Editions des Massons, 1972.

Lipman, Jean. "From the Golden Age of Tinware." *Life*, Vol. 63, No. 7 (Feb. 27, 1970), p. 10.

Quilts and Counterpanes in the Newark Museum (catalogue). Newark, N. J.: Newark Museum, 1948.

Rice, A. H., and Stoudt, John Baer. *The Shenandoah Pottery*. Strasburgh, Va.: Shenandoah Publishing House, 1929.

Safford, Carleton L., and Bishop, Robert. *America's Quilts and Coverlets*. New York: E. P. Dutton & Company, 1972.

Webster, Donald Blake. *Decorated Stoneware Pottery of North America*. Rutland, Vt.: Charles E. Tuttle, 1971.

ACKNOWLEDGMENTS

In the front of this book we list the people primarily responsible for its planning and production.

Here we wish to thank the institutional and private collectors who made possible the book, and the coordinated exhibition sponsored by Philip Morris Incorporated; their names appear in the captions. We are especially grateful to the museum directors and curators who collaborated on this project, and to their staff members who provided us with photographs and a great variety of information.

Our thanks for help in various special categories: Thomas N. Armstrong III, painting; Anne Avery, decoration (material from The Historical Society of Early American Decoration); Marianne Balazs, research on Sheldon Peck; Walter D. Bannard, scrimshaw; Robert Bishop, lists of collectors; Mary Black, research information on objects and artists; Millia Davenport, dating based on costume expertise; M.J. Gladstone, sculpture; Leah Gordon, pottery and chalkware; Jonathan Holstein, quilts; Barbara Johnson, scrimshaw; Karen Jones, Sarah B. Sherrill and other staff members of the magazine *Antiques*, research in its files; Caroline Keck, restoration; Myron and Patricia Orlofsky, quilts; Ann Parker and Avon Neal, New England gravestones; Howard Rose, paintings; Donald A. Shelley, fractur; Harold E. Yoder, Jr., Pennsylvania barns.

And for special photography we wish to thank: Ansel Adams (the Father Time carving in Mendocino, California); E. Irving Blomstrann; Geoffrey Clements; Quintina Colio; Lew Corbit, Corbit Studios; Sheldon Keck; Gerald Kornblau; Richard Merrill; Ann Parker (the New England gravestone portraits); George E. Schoellkopf; Arthur Vitols, Helga Photo Studio; and all the museum photographers who worked for us on this project.

For office assistance: Marion Keeley, Hilva Landsman.